The Early Modern Italian Domestic

Emphasizing on the one hand the reconstruction of the material culture of specific residences, and on the other, the way in which particular domestic objects reflect, shape, and mediate family values and relationships within the home, this volume offers a distinct contribution to research on the early modern Italian domestic interior.

Though the essays mainly take an art historical approach, the book is interdisciplinary in that it considers the social implications of domestic objects for family members of different genders, age, and rank, as well as for visitors to the home. By adopting a broad chronological framework that encompasses both Renaissance and Baroque Italy, and by expanding the regional scope beyond Florence and Venice to include domestic interiors from less studied centers such as Urbino, Ferrara, and Bologna, this collection offers genuinely new perspectives on the home in early modern Italy.

Erin J. Campbell is Associate Professor of Art History at the University of Victoria, Canada.
Stephanie R. Miller is Assistant Professor of Art History at Coastal Carolina University, USA.
Elizabeth Carroll Consavari is Lecturer in Art History at San José State University, USA.

VISUAL CULTURE IN EARLY MODERNITY

Series Editor: Allison Levy

A forum for the critical inquiry of the visual arts in the early modern world, *Visual Culture in Early Modernity* promotes new models of inquiry and new narratives of early modern art and its history. We welcome proposals for both monographs and essay collections which consider the cultural production and reception of images and objects. The range of topics covered in this series includes, but is not limited to, painting, sculpture and architecture as well as material objects, such as domestic furnishings, religious and/or ritual accessories, costume, scientific/medical apparata, erotica, ephemera and printed matter. We seek innovative investigations of western and non-western visual culture produced between 1400 and 1800.

The Early Modern Italian Domestic Interior, 1400–1700

Objects, Spaces, Domesticities

Edited by
Erin J. Campbell, Stephanie R. Miller and
Elizabeth Carroll Consavari

Routledge
Taylor & Francis Group

LONDON AND NEW YORK

First published 2013 by Ashgate Publishing

2 Park Square, Milton Park, Abingdon, Oxon OX14 4RN
711 Third Avenue, New York, NY 10017, USA

Routledge is an imprint of the Taylor & Francis Group, an informa business

First issued in paperback 2016

British Library Cataloguing in Publication Data
Campbell, Erin J.
 The early modern Italian domestic interior, 1400-1700 :
 objects, spaces, domesticities. -- (Visual culture in early modernity)
 1. Domestic space--Italy--History--To 1500. 2. Domestic space--Italy--History--16th century.
 3. Material culture--Italy--History--To 1500. 4. Material culture--Italy--History--16th century.
 5. Home--Italy--History--To 1500. 6. Home--Italy--History--16th century.
 I. Title II. Series III. Miller, Stephanie R. IV. Consavari, Elizabeth Carroll.
 392.3'6'0945-dc23

The Library of Congress has cataloged the printed edition as follows:
The early modern Italian domestic interior, 1400-1700 : objects, spaces, domesticities / edited by Erin J. Campbell, Stephanie R. Miller, and Elizabeth Carroll Consavari.
 pages cm. -- (Visual culture in early modernity)
 Includes index.
 ISBN 978-1-4094-6811-0 (hardcover)
 1. Interior decoration--Italy. 2. House furnishings--Italy. 3. Domestic space--Italy. I. Campbell, Erin J., editor of compilation. II. Miller, Stephanie R., 1968- editor of compilation. III. Consavari, Elizabeth Carroll, editor of compilation.
 NK2052.A1E27 2013
 747.0945--dc23

 2013000827

ISBN 978-1-4094-6811-0 (hbk)
ISBN 978-1-138-26961-3 (pbk)

Contents

Illustrations

Notes on Contributors

Allyson Burgess Williams received her PhD in Art History from the University of California, Los Angeles. She teaches art history of the early modern period at San Diego State University and her research interests include Italian courtly patronage (particularly that of the Este in Ferrara), gender issues, palace architecture and decoration, and the history of collecting. Her publications include an essay on the portraits of Lucrezia Borgia in *Wives, Widows, Mistresses, and Nuns in Early Modern Italy*, edited by Katherine McIver (2012) and an article on Titian's portraits of Alfonso I d'Este and Laura Dianti in *Visual Resources* (2012).

Erin J. Campbell holds a PhD in Art History from the University of Toronto (1998) and is Associate Professor of Early Modern European Art in the Department of History in Art, University of Victoria. She has won a number of awards for research and teaching, including the William Nelson Prize for the best article published in *Renaissance Quarterly* and the Faculty of Fine Arts Award for Teaching Excellence. She has also received significant support for her research from the Social Sciences and Humanities Council. Her research interests include cultural representations of old age, cross-cultural connections in European art, and the material culture of the early modern domestic interior. Her publications appear in a number of journals and essay collections, including the *Sixteenth Century Journal*, *Word & Image*, *Renaissance Quarterly*, *The Cultural Aesthetics of Eighteenth-Century Porcelain* and *To Have and To Hold: Marriage in Premodern Europe 1200–1700*. She is also editor and contributing author of *Growing Old in Early Modern Europe: Cultural Representations* (2006).

Elizabeth Carroll Consavari is a Lecturer in Art History at San José State University. She received her PhD at Indiana University in 2006 and has taught in Italy and the United States. She taught for the Colgate Venice Study Group and the Venice International University in Italy, and at Stanford University. Her articles have appeared in the *Burlington Magazine* and *Arte Documento* and her essay, "Tintoretto's Holy Hermits at the Scuola Grande di San Rocco,"

was included in the anthology *Mary Magdalene: Studies from the Middle Ages to the Baroque* (2012). She is currently working on a book manuscript, *Rivalling Bellini: Negotiating Artistic Exchange between Early Modern Venice and Vicenza.*

MARIA DEPRANO is an Associate Professor of Art History at Washington State University. Her research focuses on women's life passage rituals, portraiture, families, and the domestic interior in fifteenth-century Florence. Her work has been published in *Viator, The Medal,* and *Renaissance Studies.* She is completing a book on the art patronage of the Tornabuoni family with the support of an I Tatti Fellowship.

CATHERINE FLETCHER is Lecturer in Public History at the University of Sheffield. Her work explores the cultures of politics and diplomacy in Renaissance Europe. She has a PhD from the University of London and has held fellowships at the British School at Rome and the European University Institute. She is the author of *Our Man in Rome: Henry VIII and His Italian Ambassador* (2012) and of articles on the diplomatic household and political space in early modern Italy.

KATHERINE A. McIVER is Professor Emerita of Art History at the University of Alabama at Birmingham. She is the author of *Women, Art, and Architecture in Northern Italy, 1520–1580: Negotiating Power* (2006, winner of a Society for the Study of Early Modern Women Book Award), the editor and contributor of *Art and Music in the Early Modern Period* (2003), and of *Wives, Widows, Mistresses, and Nuns in Early Modern Italy: Making the Invisible Visible through Art and Patronage* (2012). She is also co-editor, along with Allyson Poska and Jane Couchman, and contributor of *The Ashgate Research Companion to Women and Gender in Early Modern* Europe (Ashgate, 2013). She contributed an essay to *Women and Portraits in Early Modern Europe: Gender, Agency, and Identity,* edited by Andrea Pearson (2008) and has published articles and essays on the artistic patronage of Italian Renaissance women in *Beyond Isabella: Secular Women Patrons of Art in Renaissance Italy,* edited by Sheryl E. Reiss and David G. Wilkins (2001), the *Sixteenth Century Journal, Artibus et Historiae,* and *Explorations in Renaissance Culture* among others. Her current project focuses on dining practices, kitchens, and the domestic interior in sixteenth-century Italy.

STEPHANIE R. MILLER is Assistant Professor at Coastal Carolina University, Conway, South Carolina. Her research interests include the glazed terracotta sculpture of Andrea della Robbia and the material culture of women and children in early modern Italy. Her publications include an article on fifteenth-century tin-glazed portraits in Italy in *The Sculpture Journal* (2013), a chapter on Andrea's Crucifixion altarpiece at La Verna in *The Anthology on Chapels* (2010), and she has authored a number of entries in the *Encyclopedia of Sculpture* (2004). She is also co-editor and contributing author of a special edition of *Visual Resources* (March 2012), which included her article, "A Tale of Two Portraits: Titian's Seated Portraits of Philip II."

ADELINA MODESTI is an Honorary Associate in the School of Historical and European Studies at La Trobe University, where she was an Australian Research Council Postdoctoral Fellow in Art History from 2008 to 2011, researching matronage networks in early modern Italy. She has also held the post of AEUIAFI Fellow at the European University Institute, Florence. An internationally recognized authority on Elisabetta Sirani, she has developed her deep knowledge of the Bolognese seventeenth century by carrying out extensive primary research at an international level, collaborating with European and US universities, government bodies, and public and private art institutions and collections. Former Lecturer in the History of Art at Monash University, she specializes in Renaissance and Baroque art, culture and social history, and has published widely on women artists, patronage, and the art market in the early modern period.

MARGARET A. MORSE is Associate Professor of Art History at Augustana College in Rock Island, Illinois. She is the author of "Creating Sacred Space: The Religious Visual Culture of the Renaissance Venetian Casa" (*Renaissance Studies*, 2007) and the essay, "From Chiesa to Casa and Back Again: The Exchange of Public and Private in Domestic Devotional Art," in *Venice in the Renaissance: Essay in Honor of Patricia Fortini Brown*, edited by Blake de Maria and Mary Frank (2013).

SUSAN NALEZYTY holds a PhD in Art History from Temple University (2011). A former museum curator, she worked as the Project Art Historian for the research database *The History of the Accademia di San Luca, c. 1590–1635*, CASVA, National Gallery of Art. She is now a professorial lecturer at the George Washington University. Her current book project, *Pietro Bembo as Art Collector*, aims to rethink standard narratives of the history of collecting by investigating this writer's deployment of visual art to inform his own literary output, while also exploring contemporary viewer reception of his Paduan studio, which was celebrated in its own day.

ADRIANA TURPIN is the Academic Director of international MA courses run by the Institut d'Études Superieures des Arts in Paris. She is also a founder member of the Seminar on Display and Collections at the Institute of Historical Research. She has written on subjects as far afield as the New World objects in the collections of Cosimo I de Medici and William Beckford's collecting of furniture at the beginning of the nineteenth century. Although she trained as a medievalist and then as a furniture specialist, she has become increasingly interested in art markets and the changing taste of collectors. With Jeremy Warren, Head of Collections at the Wallace Collection, she organized a conference on Auctions, Agents and Dealers.

JENNIFER D. WEBB is Associate Professor of Art History at the University of Minnesota Duluth. Her work focuses on the art and architecture of fifteenth-

century Italian Renaissance courts and her research interests include patronage questions. Her chapter, "Hidden in Plain Sight: Varano and Sforza Women of the Marche," was published in *Wives, Widows, Mistresses, and Nuns in Early Modern Italy* (2012). Her article "All is Not Fun and Games: Conversation, Play, and Surveillance at the Montefeltro Court in Urbino" (*Renaissance Studies*) reconsiders the decoration of Federico da Montefeltro's studiolo in the Palazzo Ducale in Urbino, while her article "Golden Age Collecting in America's Middle West: Chester and Clara Congdon's Glensheen Historical Manor and Raymond Wyer's 'An Art Museum'" (*Journal of the History of Collecting*, 2010) explores early twentieth-century American patronage and collecting.

SUSAN E. WEGNER is Associate Professor of Art History in the Art Department at Bowdoin College, Brunswick, Maine. She teaches Italian Renaissance and Baroque Art as well as a survey of ancient Mesoamerican and Andean arts. Her research interests include art and contemplation, Italian drawings and images of women in early modern Italy. In 2008 she curated an exhibition, "Beauty and Duty: The Art and Business of Renaissance Marriage," at the Bowdoin College Museum of Art, which presented *cassone* paintings and complete *cassoni*, set into the context of the household shaped for a newly married couple in Renaissance Italy.

Acknowledgments

This volume is the result of a collaborative process. The 2007 College Art Association conference session co-chaired by Stephanie Miller and Maria DePrano, "New Perspectives on the Italian Renaissance Interior, 1400–1600," was the catalyst for this project, and the editors are greatly indebted to Maria, who, along with Stephanie, laid the foundations for the present book. We wish to acknowledge the College Art Association as well as the Renaissance Society of America for the opportunity to host a number of conference panels. During the gestation of this volume, these sessions provided a lively research forum for the discussion of a myriad of domestic interior topics and allowed us to build a community of researchers to create the present book. All authors benefited from the wealth of scholarly exchange and rich conversations afforded by these opportunities. We also wish to thank the two anonymous readers who reviewed the text for Ashgate. Their comments and suggestions made an invaluable contribution to the final shape of the text. A number of individuals also contributed timely feedback and advice, including Denise Oleksijczuk and Arne Flaten, who read and commented on early drafts of the Introduction, and our undergraduate and graduate students, who provided an enthusiastic audience for the testing of ideas. Finally, we extend our gratitude to all of our contributors, whose unflagging passion and support for the project, along with their impeccable scholarship and insights, made this book possible.

Introduction
Early Modern Domesticities:
Integrating People, Spaces, Objects

Erin J. Campbell, Stephanie R. Miller, and Elizabeth Carroll Consavari

This book springs from the desire to enter the Italian palazzo or *casa*, to experience the rooms of the palazzo fully furnished and lived in, to understand the ways in which the early modern home was used, and to witness how inhabitants from a variety of Italian cities and courts lived, loved, and mourned within their *camere*. Early modern Italy is a distinctively rich time and place to pursue these interests, for the increase in both wealth and production is reflected in new consuming habits, civilized manners, and heightened self-consciousness. Richard Goldthwaite, in his groundbreaking study of the burgeoning "world of things" within the Florentine Renaissance palazzo, *Wealth and the Demand for Art in Italy, 1300–1600*, challenged scholars to "breathe a little social life into the Renaissance palace."[1] The present book reflects such a concern for the complete environment of the early modern home. By examining the people, spaces, and objects that constitute domesticities across regions, classes, and time, it is our contention that the domestic does not exist apart from the households that are productive of it – so that a Cardinal's temporary house in Rome, a woman artist's family home studio in Bologna, a Venetian patrician's residence, or the domestic quarters of a duchess all produce, shape, and re-shape early modern domesticities.

A place to call "home" is essential to our humanity. Gaston Bachelard, in *The Poetics of Space*, calls home "our first universe, a real cosmos in every sense of the word."[2] One of the goals of this book is to provide an historical perspective on the question "What is home?" and especially "What is the domestic?" In the modern world, the basic human right of secure habitation seems under assault, with homelessness, cultural displacement, and the willful destruction of homes occurring daily and on a seemingly exponential scale across communities around the globe. Yet, Europe during the early modern period also witnessed homelessness as an ever-present reality arising

from warfare, famine, disease, religious persecution, political dissention, and genocide.[3] In early modern Italy, certain social groups were prevented from making a home in the cities of various regions,[4] and over the course of the sixteenth century we see the growth of institutions across Italy designed to ameliorate the sufferings of the homeless "deserving poor," including orphans, women, the sick, and the elderly.[5] "Home" was thus a topical issue and the subject of public discussion in early modern societies, as evidenced by the numerous household economy books produced in this period, in which nascent social theorists sought to define, defend, and consolidate the set of ideals and best practices which would ensure the perseverance of the domestic as a sphere commensurate in importance to the spheres of church and state.[6]

Reflecting on the meaning of home in modern culture, and particularly on the processes that work to ensure its continuation, anthropologist Mary Douglas asks: what makes a home different from a hotel?[7] She argues that in contrast to the monetary economy of a hotel, the home is a moral economy dedicated to the perpetuation of the family as a self-sustaining community. Her idea of the household as a community based on a moral economy has its roots in the early modern period. Basing their authority on antique precedent,[8] the authors of early modern prescriptive books on the household sought to compare the governing of the home to the governing of a state, casting the household as a *picciola città* (little city) under the moral, spiritual, and financial governance of the *padre di famiglia*.[9] Giacomo Lanteri, in his treatise on the domestic economy, *Della economica* (1560), carefully articulates the range of households in Italy, uniting court households, the homes of the urban elite, and the residences of the merchant and professional classes under the umbrella of the moral economy of the household.[10]

Treatises such as Lanteri's, as Daniela Frigo argues in her study of household economy books, produce the home itself as "the most tangible symbol of the continuity of the family."[11] Such writings evoke the orderly integration of people, spaces, and objects as the most emphatic signs of the moral governance and sound financial economy that would ensure the perpetuation of the family. Thus, Torquato Tasso's treatise *Il padre di famiglia* (1583), published with the subtitle "In which briefly is treated the true economic, teaching with both ease and learning the governing of the house, both city and country, and also the true method to increase and conserve riches," describes the rooms of the house and the furnishings at the beginning of the dialogue, setting the stage for the description of the people of the household later in the text. This narrative strategy evokes the sense that the orderly arrangement of domestic space and its contents manifests the moral order of the family, so that both the order and the *disorder* of spaces and things in the house create its particular species of domesticity.[12]

Domesticities

Reflecting on both past conceptions of domesticity and the present state of research in this rapidly growing area of inquiry, we argue that to interrogate the nature of the early modern domestic sphere, we must approach domestic interiors as multi-layered, fluid, and contingent environments in which constantly shifting configurations of people, spaces, and things, over time and space, constitute and reconstitute, moment by moment, variable domesticities.[13] Recent studies of the socio-cultural implications of specific categories of domestic furnishings and objects have broadened the range of objects under our purview and have enriched our understanding of the complex and layered social functions and meanings of domestic objects.[14] The work by scholars on Florentine, Venetian, Roman and other region-specific domestic interiors has deepened our understanding of period specific, regional configurations of domestic spaces, and regional patterns of domestic, consumption, family life, and ideology.[15] Complementing both the object-based approach and the focused regional studies are recent exhibitions which draw on both of these trends to provide a synthetic overview founded on evidence from a variety of time periods, regions, and classes.[16] The chapters in the present volume build on and develop this body of scholarship by analyzing specific sites of domesticity across the propertied classes. At the same time, by including case studies and evidence from Urbino, Ferrara, Bologna, and Rome, the chapters of this book allow comparisons across regions, and by venturing well into the seventeenth century, the book deepens our understanding of domesticities by moving beyond the emphasis on the fifteenth- and sixteenth-century interior evident in much of the scholarship on the early modern domestic interior. Thus, the range of classes, regions, and chronology discussed herein allows us to calibrate sameness and difference across early modern Italian households, helping us to see both ruptures and continuities from courtly to urban elite to merchant and artisan.

Domesticities and the Public Sphere

The case study approach of this book also allows us to examine one of the key issues in the study of the domestic interior: the relationship between the public and domestic spheres. In the 2006 special edition of the *Renaissance Studies* journal devoted to the Italian Renaissance interior, the editors underscore the need to re-examine modern assumptions about the home as "private," arguing that it "clearly operated on a variety of levels, incorporating the needs of business and hospitality along with accommodation for daily living."[17] As Sandra Cavallo and Silvia Evangelisti argue in their recent study of domestic institutional interiors, there is "almost no evidence of a clear distinction between 'domestic' and 'institutional', according to which

domesticity would be associated with ideas of private life, personal choice and the secular sphere, while the institutional would refer to notions of communal life, standardization, depersonalization and religious life."[18] Significantly, Cavallo and Evangelisti's text demonstrates that the moral order of the home was constituted by domestic objects, rituals, and spatial features, so that an orphanage or convent, while not "home," nevertheless can be "home-like" in its quotation of the objects, rituals, and spaces of the domestic sphere.[19]

Cavallo and Evangelisti's study of "home-like" institutions cautions us to avoid drawing any hard and fast boundaries between the public sphere and the domestic, and calls into question the automatic association between domesticity and private life. Bronwen Wilson and Paul Yachnin contend in their recent book on early modern publicity that, in fact, "the domains of the public and private" were "mutually constituting"[20] during the early modern period. They argue that the public and the private are interpenetrating spheres that exist along a continuum capable of infinite calibration.[21] Similarly, Michael McKeon, in *The Secret History of Domesticity*, argues that the separation of the public and private spheres is actually a feature of modernity. Urging us to resist hardening the boundaries around "the domestic," he contends that we need to avoid collapsing domesticity into privacy or privacy into domesticity, suggesting instead that "in lived experience the norms and values of domesticity and privacy were found to be capable of obstructing one another."[22]

Such claims about the interpenetration of the public and the private, the contingency of such concepts, and the resistance to collapsing domesticity into privacy are substantiated by the evidence presented in this volume. Catherine Fletcher's study of the Casali residence and Susan Nalezyty's chapter on Bembo's households provide evidence of how the spatial organization of rooms and the display of particular kinds of objects constituted sociability across a continuum from public to more intimate. Margaret A. Morse's analysis of the public role of the Venetian *portego*, Adelina Modesti's chapter on the artist's home studio and salon, Maria DePrano on the *camera terrena* and Stephanie R. Miller on the spaces of childhood all study transitional spaces in the home which are sometimes "private" and sometimes public. Miller's study, for instance, shows that since the Renaissance palazzo did not include a special, dedicated space for young children, their presence together with their female caregivers could transform a domestic space that on occasion was quite public, such as the upstairs *sala*, but, with the presence of children and women, was deemed private. Katherine McIver's chapter demonstrates how the objects, spaces, and rituals of domestic dining were consummate performances of the public face of domestic identity. Jennifer Webb's analysis of rituals of courtly hygiene and Allyson Burgess Williams' study of the public nature of lying-in at court also demonstrate that the need to put the domestic economy of the court on display over-ruled the prerogatives of personal intimacy. The final part of the volume, on the

historical construction of the interior, with chapters by Adriana Turpin and Susan E. Wegner, allows us to complicate the incremental creation over time of the relationship between domesticity and privacy that underlies modern assumptions of the nature of home.

Domestic Objects and Social Processes

In addition to deepening our understanding of public, private, sociability, and their relationship to the domestic, the chapters in this volume also collectively ask us to reconsider domestic objects and their relation to social processes. As we have seen, scholars of the early modern domestic interior often privilege the object as the starting point of inquiry, hence the crucial role of exhibitions in furthering scholarship in the field, as noted above. This concern with the object is also evident in our period sources. Codifying the early modern Italian's concern with household objects, Leon Battista Alberti's Giannozzo offered housekeeping lessons to his wife in Alberti's treatise, *Della famiglia* (1433–41):

After my wife had seen and understood where everything was to be kept, I said to her: "My dear wife, you must take no less care than myself of those things which will be useful and convenient to you and to me both while we preserve them in good condition and whose neglect would bring harm and inconvenience. You have seen our possessions, which thank God, are such that we can be well satisfied. If we know how to take care of them, they will be useful to you, to me, and to our children. Therefore, my dear wife, it is your duty as well as mine to be diligent and take care of them."[23]

Giannozzo's exhortation effectively sums up the care with which families treated their material possessions. Heads of households carefully noted in their *ricordanze* or *zibaldoni* items given or received, loaned or returned, and painstakingly kept their accounts, guarding their hard-earned money. Objects associated with people, special occasions, and locations, not to mention quality, are also often observed. From the prosaic to the extraordinary, early modern Italians were concerned with their homes and the objects therein. For example, in a detailed description, Antonio Rustichi itemized 32 objects in the layette accompanying his first-born son, Lionardo, to his wet-nurse, including precisely six swaddling bands.[24] Contemporary sources also indicate prestige bestowed on objects made by estimable artists. Objects once purchased and valued primarily for the expense of their materials are by the Renaissance deemed more prestigious when made by a noted artist. Giovanni Rucellai records that his house included sculptures, paintings, and intarsia made by the "hand of the best masters,"[25] an indication of the emerging importance early modern consumers ascribed to an artist's hand and of how such consumers regarded the interiors of their homes.

Early modern Italian writings communicate subtle attitudes and notions about possessions, as well as ways in which belongings symbolized meaningful

issues in people's lives. The close association between family members, their hearths, and their possessions is emphasized by Alberti's Lionardo and Giannozzo, who underscore the centrality of household possessions to family honor, friendship, and memory:

> Lionardo: Tell us, however, you have named four private and domestic needs: family and wealth within the house, honor and friendship outside it – now which is dearest to your heart?
> Giannozzo: By nature, love and piety make the family dearest of all to me. And to govern the family you must have possessions; and to preserve the family and your possessions, friends are necessary.[26]

Brief references can also be found in letters by both men and women and in *ricordanze* that reveal the significance of household objects which, over time, were bought, sold, cherished, and bequeathed. These notations communicate the not surprising desire to decorate with beautiful, well-made objects, pride of ownership, and the manner in which objects can possess memory, instruct, or hold hopes for an improved future. In addition to describing an appreciation for and the quality of objects in one's home, letters and *zibaldone* also mention how or from whom pieces were acquired. Letters written by women, such as those by Alessandra Strozzi,[27] occasionally mention mundane objects, cherished valuables, and even furnishings, providing an opportunity to see a woman's perspective on domestic objects.[28]

Building on the concern with the object evident in our period sources, the chapters in this volume underscore the primacy of domestic objects in creating the social spaces of the early modern home, demonstrating that within the home, the material and social are woven together. We did not ask authors to conform to one theoretical stance; however, sociologist Bruno Latour's ideas concerning the role of the object in social life illuminates the centrality of the object in the studies in our book. Expanding upon Latour's contention that "the social" itself is an ongoing, mobile, chaotic, and contingent process of binding together what constitutes society,[29] the chapters in this volume show that within such fluid and chaotic social processes, objects in the home are key agents in the social processes that constitute the domestic. The goal is not to assign human intentionality to things, but to recognize that objects without intentions shape domesticities.[30] Inspired by Latour's ideas about the social role of objects, we thus suggest that "the domestic" is not a pre-existing abstract structure, but rather that what we are documenting in this book is how domesticities are constituted by a wide range of ever-changing *associations* among people, spaces, and objects, including the personal/familial/civic, wife/husband/child, father/brother/son, patrician/client, courtier/subject, and so on. Furthermore, the mobility implied by the word "association" works well to capture the fluidity and contingency of early modern domestic sociability. It allows us to see domestic objects as mobile connectors and mediators in the creation of social relationships

within and across households, connecting the household members to each other and to the world of people and social associations beyond the home.[31]

The role of art objects as mobile mediators of social processes in the reception rooms and chambers of the Bolognese, the Venetians, and the Florentines is documented in chapters by Morse, Miller, Erin J. Campbell, and Elizabeth Carroll Consavari. The fundamental contribution of objects to the creation of domestic spaces is made eminently clear, as well, for example, in McIver's essay on dining, which draws in part on Bartolomeo Scappi's treatise on the papal kitchen (*Opera dell'arte del cucinare*, 1570). In Scappi's treatise, the "kitchen" is actually a series of rooms whose functions are determined by the specific configuration of tables and implements dedicated to different types of food preparation.[32] At night, the "kitchen" becomes a bedroom for the kitchen boys by virtue of cupboards that transform into sleeping compartments;[33] the papal kitchen is not defined by the rooms and walls, but is in fact a set of portable objects to be carried into the country or on journeys;[34] and the domesticity of a cardinal is defined by the portable objects that reproduce domestic comfort during conclaves, so that the objects themselves constitute a portable home.[35]

The ability of domestic objects to forge various and changing social relationships by virtue of their mobility is also demonstrated, for example, in Nalezyty's study of Cardinal Bembo's mobile household objects that constituted his domestic identity as he moved from one residence to another. The role of mobility with respect to domestic objects is also documented in Fletcher's chapter on the Casali residences, which shows how domestic furnishings shift from home to home with the seasons and how houses themselves are objects that were remade over time. Similarly, the mobility of Elisabetta Sirani's paintings was essential to the forging of social relationships both between home and away, and also within and between other households, as documented by Modesti. Mobility is also central in Miller's discussion of the key function of the infant's layette in extending the patrician identity of the family beyond the walls of the palazzo to the home of the *balia*. Moreover, the social connecting power of materiality itself is exemplified by the consumption of food in feasts as discussed by McIver, for example, and by the specific materials used as a support for painting, as in the paintings on copper made for brides and novices discussed by Campbell.

Finally, the volume's concern with examining domestic objects and their role in social processes is underscored in the fourth, historiographical part of the book, in which Turpin and Wegner analyze the historical desire to contextualize early modern Italian domestic objects across time and in different cultures. These studies, and indeed all of the chapters, show how domesticity is created through relationships with objects and materials that bring together in unpredictable and dynamic ways inside/outside, home/away, here/there, near/far, and past/present.

Integrated Domestic Environments: Sources, Evidence, People

To "breathe a little social life into the Renaissance palace," the chapters in this volume integrate the objects within specific environments and with the residents or guests of the household by drawing on the greatest range of evidence. Connoisseurial-based object studies, though penetrating, can divorce the item from its intended, experienced environment, thus limiting the appreciation for its original context.[36] Certainly, the objects "speak" to us as primary sources, but as Marta Ajmar-Wollheim and Flora Dennis note, addressing the objects in isolation or without corroborating evidence is tricky, for the "objects rarely speak for themselves."[37] Introducing the various types of written accounts, such as *ricordanze*, inventories, treatises on the home and its care and management, and other literary references assist in the triangulation of people, spaces, and objects. One of the express goals of the book is to address people, spaces, and things within precisely determined contexts, building up a full impression of specific households in an effort to touch and see these objects through the eyes of early modern Italians. While this book does not offer a comprehensive room-by-room account of Italian *palazzi* or *case*, our examination of people, household spaces and domestic objects through selected case studies captures the complexity and contingency of the early modern home in Italy and demonstrates the idiosyncratic nature of households, their interests, and their varying relationships to domestic material culture.

Literature has often focused on the palace as a construct of identity. Rather than strictly a reflection of the homeowner's magnificence or splendor, the palace and its contents can communicate different messages that depend on diverse identities and viewers from within and without the household. The variables of age, gender, and status of residents or guests to a home or room indicate the versatility and vitality of the early modern Italian home and its material culture. To reveal the dynamic character of the early modern household, expanded and varied representations of it can simultaneously broaden and problematize our current understanding of this environment. To this end, this book presents the multiple ways that individuals or families responded to or created their domestic spaces, defined it, or were defined by it. Together, the chapters provide innovative ways of looking at familiar problems by using new and diverse documents to reconsider domestic spaces and material goods, as well as family dynamics and social rituals. In these chapters, we see family interactions that range from educating children to dining, and to familial piety. Other social relationships also emerge, those that engage the visitor in the home through issues of hospitality, hygiene, salon-style socializing, and the prestige of collecting. The variety of specific homes, rooms, goods, and people provides fresh ways of looking at the early modern home and consequently offers greater detail and depth to this evolving field of study.

Hence, a substantial component of the volume is devoted to bringing forward new evidence for the wide range of people who lived within the *casa*, women and men, married and chaste, the young and the old, their projected familial or individual self-fashioning, examining the activities they pursued within the palazzo, their rituals, collecting practices, and the preservation of memory. Such evidence broadens, deepens, and complicates our understanding of people in the home by considering different viewers and types of homes based on new documentary evidence and sources, such as Bolognese notarial records, domestic inventories of merchant and artistic families, prescriptive writings, and cooking manuals. Not only does new documentary evidence permit analysis of previously under-studied families, such as the Casali family of Bologna or the Tornabuoni of Florence, thus integrating people, rooms, and things within specific, historically contingent contexts, examining different kinds of families and distinctive viewers of the household and its material goods, but also the evidence of inventories, prescriptive writings, and other documents and sources builds new understanding of the perspective of women, children, and other family members, including women patrons, such as the noblewoman Lucrezia Borgia discussed by Burgess Williams, women artists, as in Modesti's chapter on Elisabetta Sirani, children as viewers in Miller's discussion of the material culture of childhood, and the family audiences evoked in Campbell's chapter on paintings in the seventeenth-century Bolognese interior.

The Organization of the Book

To substantiate the central contention of this volume that early modern domesticities are constituted by contingent and shifting concatenations of people, spaces, and objects, and to organize the spectrum of social relationships forged by domestic objects, the chapters in this volume are organized into four interconnected parts which move from the household in its entirety, to associations within the household, to associations within and between households, to conclude with an historiographical reflection on the interventions of time, chance, and scholarship with respect to the historical life of the domestic interior as an object of scholarly inquiry. Thus, Part I, "Domesticities" addresses the house as a totality of people, spaces, and things, considers the organization of that space, and shows how that space is produced by the interior-exterior flow of people and things within and between domestic spaces. Drawing on inventories, letters, and other documents, three case studies of different types of households, including a patrician's household, the household of a cardinal, and an artist's home studio, demonstrate the mobility and permeability of early modern domesticities. This section also provides new evidence for households in Bologna and Rome, cities that have been under-represented in studies of the domestic interior.

Part I opens with "'*Uno palaço belissimo*': Town and Country Living in Renaissance Bologna," in which Catherine Fletcher examines the mobile household of the Bolognese merchant Francesco Casali. Fletcher's analysis of a 1502 inventory details room-by-room the contents of Casali's palace. Her study offers a useful model not only for the variety of domestic spaces inhabited by Bologna's patrician families and for the movement of household goods between them, but also, as the opening chapter of the book, provides a sense of the spectrum of spaces, objects, people, and residences that contribute to the formation of the domestic sphere as a whole. Highlighting in particular issues of family prestige, religious devotion, and contrasts between town and country living, the chapter also identifies a number of significant parallels with the Florentine interior.

Providing further evidence of the role of mobile domestic objects in the production of domestic identities is Susan Nalezyty's analysis of moveable goods and borrowed spaces in "From Padua to Rome: Pietro Bembo's Mobile Objects and Convivial Interiors." Bembo imported from his home in Padua to Rome his personal collection of medals, gems, statuettes, and books in a manner that accentuates them as objects to promote conversation, maintain social connections, and advertise his knowledge of visual things. Through an examination of letters concerning Bembo's temporary use of the Roman Palazzo Baldassini, Nalezyty shows how this borrowed space functioned as an impromptu court, remarkably similar to Bembo's own renovated palazzo in Padua, which at this time hosted Cardinal Reginald Pole in Bembo's absence.

Adelina Modesti's "*A casa con i Sirani*": A Successful Family Business and Household in Early Modern Bologna" contributes to the theme of mobile and permeable domesticities through an examination of the Sirani family inventories, contemporary testimonials, and supporting archival documentation. Modesti's study analyzes the fluid household structure and social dynamics of the successful Bolognese Baroque painter and printmaker Elisabetta Sirani (1638–65) and her artist family, and throws light on seventeenth-century artistic domestic sociability. Demonstrating the continuum between public and private space, between the domestic and the civic, the Sirani household and the studio-cum-salon, with its constant "via vai" of local artists and patrons – nobility (in particular patrician women), intellectuals and ecclesiastics – as well as reception of important visiting dignitaries, *principi*, and diplomats serves as a microcosm of early modern European domestic sociability, which promoted fluid and permeable gender and class distinctions.

Part II, "People, Spaces, Objects," concentrates on the objects that connect members of the household to the social and religious ideals of family life, such as piety, honor, the raising of children, and life stages. Each case study takes a different region and time period as its primary focus to show the continuing importance, across regions and time, of domestic objects within domestic social processes. Stephanie R. Miller, whose focus is the Florentine patrician

family of the fifteenth century, begins this section with "Parenting in the Palazzo: Images and Artifacts of Children in the Italian Renaissance Home," which analyzes domestic representations of children, their material culture, and the domestic spaces of childhood, in an effort to illuminate how children were perceived, visualized, and cared for by Renaissance adults. Images of children are among the most ubiquitous of fifteenth-century Italy and this century appears to be an awakening in the common regard of children and an appreciation for the distinct ages and stages of childhood. Given this growing awareness, the chapter explores children's presence in the home and how the palazzo served the needs of parents raising their children.

Continuing the focus in this part on objects, imagery, and domestic spaces that actively shape the social processes of family life, but within a different regional context and time period, the next chapter focuses on the Venetian patrician household in the sixteenth century. Thus, in "The Venetian *portego*: Family Piety and Public Prestige," Margaret A. Morse investigates the Venetian *portego* or hallway as a site for the self-presentation of familial piety. The *portego* was the most public space in the Venetian domestic interior; its contents were therefore critical in shaping familial identity. The consistency of sacred images in the *portego* sheds further light on the role of this room in daily life, and the place of religion in the Renaissance household. Erin J. Campbell's "Art and Family Viewers in the Seventeenth-Century Bolognese Domestic Interior" also examines the role of art objects in domestic social processes, extending the inquiry into the seventeenth century. Drawing in particular on household inventories, prescriptive writings, and the paintings themselves, Campbell's chapter analyzes the social and religious functions of pictures within the homes of the urban elite in Bologna, a city that, as noted above, has not received much attention in studies of the domestic interior.

Part III, "Domestic Objects and Sociability," demonstrates how domestic objects are essential to the production of early modern sociability for both the urban elite and the court, as essential agents in social rituals which foster the interpenetration of the domestic and public spheres, connecting household to household, and bringing the outside into the home.

This part opens with two chapters that consider objects related to leisure and entertainment, and their roles in social rituals that forge bonds of sociability across the households of the urban elite. In *"Chi vuol esser lieto, sia*: Objects of Entertainment in the Tornabuoni Palace in Florence," Maria DePrano relies on the inventory made upon the death of Lorenzo Tornabuoni in 1497 to consider entertainment in the domestic interior of the Tornabuoni palace by focusing on the *camera terrena in sul androne*, the ground-floor chamber by the passageway. While the *camera terrena* in Florentine palaces has been identified as a place for meeting clients and as a summer bedroom for the palace patriarch, this chapter proposes that for elite palaces, the *camera terrena* may also have been used as a location for patrician leisure, that is, a chamber for music, informal theatrical interludes, and learned conversation. Building on the concept of domestic sociability,

Venetian domestic paintings are explored by Elizabeth Carroll Consavari in "*Il mare di pittura*: Domestic Pictures and Sociability in the Late Sixteenth-Century Venetian Interior." This chapter focuses on the role of paintings as they forge domestic social relationships both inside and outside the home, contributing to the interpenetration of the public and the domestic sphere. Consavari brings together the two areas of collecting and the domestic interior to explore paintings as a form of the sociable arts or learned entertainment at home in Venice. The practices of display that developed within the domestic interiors of the urban elite transformed their interior spaces into domestic art galleries, creating an emblematic Golden Age, thus becoming a part of the family enjoyment connected to home.

In "Let's Eat: Kitchens and Dining in the Renaissance Palazzo and Country Estate," Katherine McIver shows the key role of hospitality and dining in sociability both within and between patrician and courtly households. While McIver argues that we now have a much clearer picture of domestic life, issues such as food preparation, eating, hospitality and the sociability of dining still remain somewhat murky. Relying on palace inventories, letters, expense accounts, architectural treatises and plans, and cooking manuals, McIver address how kitchens were outfitted, where people ate, and the nature of dining practices in the sixteenth century.

This part concludes with two chapters that consider the interpenetration of the domestic sphere with the institutional demands of court culture. In "Silk-Clad Walls and Sleeping Cupids: A Documentary Reconstruction of the Living Quarters of Lucrezia Borgia, Duchess of Ferrara," Allyson Burgess Williams analyzes contemporary descriptions and inventories of the tapestries, fabrics, and furniture on display after the birth of the ducal heir. The analysis reveals the degree to which Lucrezia's seemingly "private" chambers were in fact designed to meet the social, political, and diplomatic needs of the ducal court. In "'All That is Seen': Ritual and Splendor at the Montefeltro Court in Urbino," Jennifer Webb uses the text of the "Ordine et officij de casa de lo Illustrissimo Signore Duca de Urbino" (*The Rules and Offices of the Court of the Duke of Urbino*), likely written by a head servant or the "maestro di casa," to similarly consider how rituals and spaces that were ostensibly domestic were in fact essential to the creation of public magnificence in the court of Urbino. Taking into account the physical spaces of the palace, Webb explores the rituals surrounding food preparation and presentation, as well as those related to the health and hygiene of Federico da Montefeltro, such as hand washing and bathing.

Part IV, "Objectifying the Domestic Interior," reflects on the historical and contemporary methods and approaches to studying the domestic interior and its objects. An historiographical reflection on the modern history of collecting and display reveals how audiences and scholars are potentially conditioned to understand or approach the domestic interior. The chapters are timely, given the recent museum exhibitions and the scholarship generated by them. Under (gentle) assault in both chapters is the notion of a static,

Renaissance period room, with exclusively "Italian Renaissance" objects. Despite the necessity of museum curators/buyers and collectors to acquire authentic objects, the display of these objects, historically and contextually speaking, need not be so restrictive; the original, early modern owners of such objects would likely not have objected to a more eclectic display.

This part opens with "Objectifying the Domestic Interior: Domestic Furnishings and the Historical Interpretation of the Italian Renaissance Interior" by Adriana Turpin. Collectors and dealers of the later nineteenth century, who created ensembles in the Renaissance style, formed the concept of what the Renaissance interior looked like. Turpin's chapter scrutinizes the development of settings that draw the viewer into an historical experience in view of early collections of domestic furnishings in Britain, America, and Italy. She makes a case for an experiential study and understanding of the Renaissance interior and considers some of the underlying assumptions during the nineteenth-century rediscovery of the Italian Renaissance.

Based on recent experiences at Bowdoin College, in "Recreating the Renaissance Domestic Interior: A Case Study of One Museum's Approach to the Period Room," Susan E. Wegner examines the ethical and practical underpinnings and quandaries associated with creating a period room in a smaller museum, which must combine objects from different time periods and geographical regions. She also asks whether the resulting rooms are successful for teaching and research.

In conclusion, the book addresses the questions "What is home?" and "What is the domestic?" by positing that the interiors studied herein form part of fluid, chaotic, and contingent social processes that produce early modern domesticities – processes that continue to this day to produce our modern constructs of "home." Collectively, the chapters in this volume show that a nuanced understanding of domesticity in all its social and material complexity depends not only on object-focused studies, regional synchronic studies, or synthetic, diachronic studies, but also by proceeding *case study by case study* to observe and analyze the production of domesticities from the ground up. Thus, through the following chapters, which analyze the fluid social associations of people, spaces, and things that are constitutive of early modern domesticities, we offer new perspectives on the early modern domestic interior.

Notes

1 Richard Goldthwaite, *Wealth and the Demand for Art in Italy 1300–1600* (Baltimore: Johns Hopkins University Press, 1993), 237–8.

2 Gaston Bachelard, *The Poetics of Space,* translated by Maria Jolas (New York: Orion Press, 1964), 4.

3 Raffaella Sarti, *Europe at Home: Family and Material Culture 1500–1800,* translated by Allan Cameron (New Haven: Yale University Press, 2002), 9–14.

4 Regarding the exclusion of Jews from various early modern Italian cities, see Kenneth R. Stow, "Stigma, Acceptance, and the End to Liminality: Jews and Christians in Early Modern Italy," in *At the Margins: Minority Groups in Early Modern Italy,* edited by Stephen J. Milner (Minneapolis:

University of Minnesota Press, 2005), 84–5. See also, for example, the *Bando contra li zingari* published in Bologna on September 3, 1592 decreeing the expulsion of gypsies ("zingari") from the city. The decree is reproduced in Fabio Giusberti, "Elementi del sistema assistenziale Bolognese in età moderna," in *Storia illustrata di Bologna*, edited by Walter Tega (Milan: Grafica Sipiel S.R.L., 1989), vol. II, p. 115, fig. 13. Such exclusions were exacerbated at times of civic distress, so that during the period of famine in Bologna in the second half of the sixteenth century, strict distinctions were made between the local impoverished and outsiders, and the latter had to leave the city unless they could prove they had lived in Bologna for three years. See Rolando Dondarini and Carlo De Angelis, "Da una crisi all'altra (secoli XIV–XVII)," in *Atlante storico delle città Italiane: Bologna*, edited by Francesca Bocchi (Bologna: Grafis Edizioni, 1997), vol. III, p. 151.

5 See, for example, Philip Gavitt, "From Putte to Puttane: Female Foundlings and Charitable Institutions in Northern Italy, 1530–1630," in *At the Margins* (see note 4), 111–29; Nicholas Terpstra, *Abandoned Children of the Italian Renaissance: Orphan Care in Florence and Venice* (Baltimore: Johns Hopkins University Press, 2005); Nicholas Terpstra, *Lost Girls: Sex and Death in Renaissance Florence* (Baltimore: Johns Hopkins University Press, 2010); Lucia Ferrante, "Honor Regained: Women in the Casa del Soccorso di San Paolo in Sixteenth-Century Bologna," in *Sex and Gender in Historical Perspective,* edited by Ed Muir and Guido Ruggiero (Baltimore: Johns Hopkins University Press, 1990), 46–72; Philip Cottrell, "Poor Substitutes: Imaging Disease and Vagrancy in Renaissance Venice," in *Others and Outcasts in Early Modern Europe: Picturing the Social Margins*, edited by Tom Nichols (Aldershot: Ashgate, 2007), 63–86; and Tom Nichols, "Secular Charity, Sacred Poverty: Picturing the Poor in Renaissance Venice," *Art History* 30(2) (April 2007): 139–69.

6 For a useful analysis of the key importance of this genre of prescriptive text in early modern Italian society, see Daniela Frigo, *Il padre di famiglia: Governo della casa e governo civile nella tradizione dell' 'economica' tra cinque e seicento* (Rome: Bulzoni Editore, 1985).

7 Mary Douglas, "The Idea of a Home: A Kind of Space," *Social Research* 58(1) (Spring 1991): 297.

8 Frigo, *Il padre di famiglia*, 17–64; see especially 18–22.

9 Giacomo Lanteri, *Della economica* (Venice: Vincenzo Valgrisi, 1560), 159. As Lanteri writes: "Fa stima, che questa nostra casa ad ambidue noi & alla nostra famiglia commune, sia una picciola città (che così la possiamo chiamare per comparatione) …".

10 Ibid., 13–14.

11 Frigo, *Il padre di famiglia*, 133. All translations are by the editors unless otherwise noted.

12 Torquato Tasso, *Il padre di famiglia. Dialogo del s. Torquato Tasso, nel quale brevemente trattando la vera economica, s'insegna, non meno con facilità che dottamente, il governo non pur della casa, tanto di città quanto di contado, ma ancora il vero modo di accrescere e conservar le ricchezze* (Venice: Aldine, 1583). For this introduction we have used the following edition: Torquato Tasso, "Il padre di famiglia," in *La letteratura Italiana: Storia e testi*, vol. 22, Torquato Tasso, *Prose*, edited by Ettore Mazzali (Milan and Naples: Riccardo Ricciardi Editore, 1959), 75–123, citation at 78.

13 Recent work on the domestic interior has stressed its fluid and fragmentary nature. See, for example, Ann Matchette's study of the disposal of household furnishings, which emphasizes the home as a site of mobility and reconfiguration to the extent that even door jambs and mouldings were dismantled and reused for other buildings. Ann Matchette, "To Have and Have Not: The Disposal of Household Furnishings in Florence," *Renaissance Studies* 20(5) (2006): 703, 710.

14 For earlier contributions to the study of Renaissance domestic furnishings, see Adriana Turpin's chapter in this volume. For recent work, see, for example, Jacqueline Marie Musacchio, *Art, Marriage, and Family in the Florentine Palace* (New Haven: Yale University Press, 2008); Geraldine A. Johnson, "Beautiful Brides and Model Mothers: The Devotional and Talismanic Functions of Early Modern Marian Reliefs," in *The Material Culture of Sex, Procreation, and Marriage in Premodern Europe*, edited by Anne L. McClanan and Karen Rosoff Encarnación (New York: Palgrave, 2002), 135–61; Sara F. Matthews Grieco, "Persuasive Pictures: Didactic Prints and the Construction of the Social Identity of Women in Sixteenth-Century Italy," in *Women in Italian Renaissance Culture and Society*, edited by Letizia Panizza (Oxford: 2000), 285–314; Paola Tinagli, "Womanly Virtues in Quattrocento Florentine Marriage Furnishings," in *Women in Italian Renaissance Culture and Society*, 265–84; Marta Ajmar, "Toys for Girls: Objects, Women and Memory in the Renaissance Household," in *Material Memories*, edited by Marius Kwint, Christopher Breward, and Jeremy Aynsley (Oxford: Berg, 1999), 75–89; Jacqueline Marie Musacchio, *The Art and Ritual of Childbirth in Renaissance Italy* (New Haven: Yale University Press, 1999); Cristelle L. Baskins, *Cassone Painting, Humanism, and Gender in Early Modern Italy* (Cambridge: Cambridge University Press,1998); Anne Barriault, *Spalliera Paintings of Renaissance Tuscany: Fables of Poets for Patrician Homes* (University Park, PA: Pennsylvania State, 1994); Peter Thornton, *The Italian Renaissance Interior, 1400–1600* (New York: Abrams, 1991).

15 For Florence, see most recently Beatrice Paolozzi Strozzi, and Marc Bormand (eds), *The Springtime of the Renaissance: Sculpture and the Arts in Florence 1400–60.* (Florence: Mandragora, 2013). James R. Lindow, *The Renaissance Palace in Florence: Magnificence and Splendour in Fifteenth-Century Italy*

(Aldershot: Ashgate, 2007). See also Brenda Preyer, "Planning for Visitors at Florentine Palaces," *Renaissance Studies* 12 (1998): 357–74; Richard A. Goldthwaite, *Wealth and the Demand for Art in Italy 1300–1600* (Baltimore: Johns Hopkins University Press, 1993); John Kent Lydecker, "The Domestic Setting of the Arts in Renaissance Florence" (PhD dissertation, Johns Hopkins University, 1987). For Venice, see Isabella Palumbo-Fossati Casa, *Intérieurs Vénitiens à la Renaissance* (Paris: Michel de Maule, 2012); Monika Schmitter, "The Quadro da Portego in Sixteenth-Century Venetian Art," *Renaissance Quarterly* 64(3) (Fall 2011): 693–751; Patricia Fortini Brown, *Private Lives in Renaissance Venice: Art, Architecture and the Family* (New Haven: Yale University Press, 2004). For Rome, see Elizabeth Cohen and Thomas Cohen, "Open and Shut: The Social Meaning of the Cinquecento Roman House," *Studies in the Decorative Arts* (Fall–Winter 2001–2002): 61–84.

16 Marta Ajmar-Wollheim and Flora Dennis (eds), *At Home in Renaissance Italy* (London: V&A Publications, 2006); Andrea Bayer (ed.), *Art and Love in Renaissance Italy* (New Haven: Yale University Press, 2008). The contribution of contemporary exhibitions to our understanding of the domestic interior is examined in Susan Wegner's chapter in this volume. The catalogue to the 2013 exhibition *The Springtime of the Renaissance: Sculpture and the Arts in Florence 1400–1460* (Florence, Palazzo Strozzi and Paris, Museé du Louvre) includes chapters and objects dedicated to art and objects within fifteenth-century Florentine homes.

17 Marta Ajmar-Wollheim, Flora Dennis, and Ann Matchette, "Introduction – Approaching the Italian Renaissance Interior: Sources, Methodologies, Debates," *Renaissance Studies* 20(5) (2006): 627–8, quotation at 625. Republished with an additional essay by Margaret Morse as *Approaching the Italian Renaissance Interior: Sources, Methodologies, Debates* (Oxford: Blackwell, 2007). See also Catherine Fletcher, "'Furnished With Gentlemen': The Ambassador's House in Sixteenth-Century Italy," *Renaissance Studies* 24 (2010): 518–35, which analyzes the intermingling of the official and familial in the domestic environment.

18 Sandra Cavallo and Silvia Evangelisti, "Introduction," in *Domestic Institutional Interiors in Early Modern Europe*, edited by Sandra Cavallo and Silvia Evangelisti (Aldershot: Ashgate, 2009), 6.

19 Cavallo and Evangelisti, "Introduction," in *Domestic Institutional Interiors*, 18.

20 Bronwen Wilson and Paul Yachnin, "Introduction," in *Making Publics in Early Modern Europe: People, Things, Forms of Knowledge*, edited by Bronwen Wilson and Paul Yachnin (New York and London: Routledge, 2010), 2.

21 Ibid., 11–12.

22 Michael McKeon, *The Secret History of Domesticity: Public, Private, and the Division of Knowledge* (Baltimore: Johns Hopkins University Press, 2005), xxi.

23 Leon Battista Alberti, *I primi tre libri della famiglia*, edited by F.C. Pellegrini (Florence: Sansoni, 1946), 349; Leon Battista Alberti, *The Albertis of Florence: Leon Battista Alberti's Della famiglia*, edited and translated by Guido A. Guarino (Lewisburg: Bucknell University Press, 1971), 219.

24 James Bruce Ross, "The Middle-Class Child in Urban Italy," in *The History of Childhood*, edited by Lloyd deMause (New York: Psychohistory Press, 1974), 191. Ross cites from Rustichi's *ricordanze* (1412–36) in the Florence State Archives, *Carte Strozziane*, series II, vol. 11, folios 11 *recto* to 71 *verso passim*. The birthdate for Lionardo was 6 March 1417. Another example is Niccolaio and Giovanni Niccolini's recorded expenditures on behalf of their nieces, including the buttons, tassels, and shoes purchased. See Ginevra Niccolini di Camugliano, *The Chronicles of a Florentine Family* (London: Jonathan Cape, 1933), 37–59, especially 52–9.

25 "… we have in our house many objects of sculpture and painting and intarsia by the hand of the best masters who have existed for a good while back not only in Florence, but in Italy as a whole," in Giovanni Rucellai, *Giovanni Rucellai ed il suo zibaldone, I. "Il Zibaldone Quaresimale,"* edited by Alessandro Perosa (London: Warburg Institute University of London, 1960), 23–4. English translation in *Italian Art, 1400–1500: Sources and Documents*, translated by Creighton Gilbert (Englewood Cliffs, NJ: Prentice Hall, 1980), 112.

26 Leon Battista Alberti, *I libri della famiglia*, translated and introduced by Renée Neu Watkins (Columbia, SC: University of South Carolina Press, 1969), 180.

27 For instance, in a letter dated November 15, 1465 to both of her exiled sons, Filippo and Lorenzo, Signora Strozzi demonstrated how the memory of past kindnesses could remain with objects. Her poignant itemization of soup bowls and salad plates reflects her palpable desire to have her sons return from exile and her longing to care for them. The dishes allow her to envision her family reunited and eating a meal together in Florence. Alessandra Macinghi negli Strozzi, *Lettere di una gentildonna fiorentina ai figliuoli esuli*, edited by Cesare Guasti (Florence: G.C. Sansoni, 1877), 516–17. English translation from Alessandra Strozzi, *Selected Letters of Alessandra Strozzi*, translated and introduced by Heather Gregory (Berkeley and Los Angeles: University of California Press, 1997), 181–3.

28 Strozzi, *Lettere di una gentildonna*, 206. Strozzi, *Selected Letters*, 93.

29 Bruno Latour, *Reassembling the Social: An Introduction to Actor Network Theory* (Oxford: Oxford University Press, 2005), 4–7. Thus, for example, Latour writes that: "I am going to define the social not as a special domain, a specific realm, or a particular sort of thing, but only as a very peculiar movement of re-association and reassembling" (7).

30 Ibid., 63–86.

31 Material mediators are not 'intermediaries' – intermediaries simply transport; instead, mediators "transform, translate, distort and modify the meaning of the elements they are supposed to carry." Ibid., 39.

32 Bartolomeo Scappi, *The Opera of Bartolomeo Scappi (1570)*, translated with commentary by Terence Scully (Toronto: University of Toronto Press, 2008), 100–106; plates 1–4.

33 Scappi, *Opera*, plate 1.

34 Scappi, *Opera*, plates 5, 6, and 24.

35 Scappi, *Opera*, plates 22 and 26. For the domestic furnishings of cardinals during a conclave, see also Henry Dietrich Fernández, "A Temporary Home: Bramante's Conclave Hall for Julius II," in *Domestic Institutional Interiors in Early Modern Europe* (see note 18), 27–50.

36 See Curtis Perry, Introduction to *Material Culture and Cultural Materialisms in the Middle Ages and the Renaissance*, edited by Curtis Perry (Turnhout, Belgium: Brepols Publishers, 2001), xxiii and his comments on Douglas Bruster's essay, "The New Materialism in Renaissance Studies."

37 Marta Ajmar-Wollheim and Flora Dennis, "Introduction," in *At Home in Renaissance Italy* (note 16), 15.

Part I
Domesticities

"Uno palaço belissimo":
Town and Country Living in Renaissance Bologna[1]

Catherine Fletcher

In a description of 1511, the Bologna palazzo of the Casali was said by Fileno dalla Tuata, a chronicler of the city, to be most beautiful (*uno palaço de Chaxali belissimo*).[2] This chapter explores some contrasts between that palazzo and a fifteenth-century house in the Bolognese hills owned by the same family. Based on a close reading of the 1502 post-mortem inventory of Francesco Casali, a merchant, banker and papal treasurer, it argues for an image of the domestic interior that is dynamic rather than static. It shows how the domestic life of the Casali family shifts from house to house, and shifts within each house. The interior spaces of their palazzo and villa can be transformed and adapted; the objects within them can be recycled and remade. Their "domesticities" change across days, seasons and years to accommodate child-rearing, entertaining, business transactions and religious devotion.

By comparison to their counterparts in Florence and Venice, the patrician palaces of Renaissance Bologna have been little studied. The principal exception is the Bentivoglio palace, seat of the city's ruling family in the second half of the fifteenth century.[3] Yet, as the second city of the Papal States, Bologna was an important center and was far from isolated from cultural developments on the peninsula. In terms of the city's patrician housing, from the middle of the fifteenth century, Florentine influence was apparent, mixing with vernacular style to produce some vibrant examples of palazzo architecture.[4] However, in the course of the papal-Bentivoglio conflict of the early sixteenth century, not to mention the broader Italian wars, the city fabric of Bologna suffered considerable damage. The impact of warfare was exacerbated by an earthquake in 1505. This may go some way towards explaining why architectural historians of early modern Bologna have tended to focus on those palazzi constructed after that conflict was over, during the period of extensive property redevelopment in the later sixteenth century and after, many of which survive to this day.[5] Interest in the Casali palazzo follows much the same pattern, lying primarily in the family's patronage of

the Carracci in the later sixteenth or early seventeenth centuries.[6] That interest reflects another tendency in histories of Bologna: to focus on the house as a site of architectural and artistic endeavor rather than, as this chapter seeks to describe it, a place for everyday living.

Neither of the properties under consideration here survives in its original form: the palazzo was demolished in the nineteenth century when the present Via Farini was constructed, while the country house was rebuilt beginning in the later sixteenth century following wartime damage. Fortunately, the two Casali family archives are a rich source of documentary evidence with which to reconstruct these homes and their uses.[7] The inventory alone runs to 25 folios and nearly 10,000 words in length, with a total of over 500 entries for the townhouse, over 180 for the country property, and a further 86 for a house apparently used by tenant farmers. Drawn up by Alessandro Paleotti, a Bolognese notary, on August 31, 1502 and written in a late Latin heavily dependent on contemporary Italian vocabulary, it is a relatively early surviving example of a room-by-room inventory and lists not only furniture but also textiles, clothing and kitchen equipment.[8] Other family documents, in particular a *Donatio* (gift, or donation) of 1497, add contextual information about the three properties,[9] and it has been possible to reconstruct them in some detail, offering a remarkable illustration of the types of domestic spaces inhabited by the city's patrician families, their tenants, and households. By their nature, inventories present a snapshot, and sometimes a partial one, of the goods present in homes at any one time. They are valuable indeed for the historian, but their problems as a source are well known: they are produced by interested informants, who may not have been telling the whole truth, and their snapshot effect can hide processes such as the repair of goods, or their removal from one family house to another, not to mention the impact over time of property improvement and refurbishment.[10] However, as this chapter demonstrates, a close reading of inventories can in fact reveal much about the dynamic nature of domestic environments, about property development and about the seasonal nature of living arrangements. The chapter further raises questions about town and country living and about distinctions relating to social status and gender. Overall, it aims to add to our understanding of how members of the Bolognese patriciate lived at the start of the sixteenth century, in the latter days of Bentivoglio rule of the city. It begins, however, with an introduction to the family and homes under consideration.

When, in 1502, the post-mortem inventory of Francesco Casali was drawn up, his family was already well on its way up the social ladder.[11] By comparison to some patricians they were relatively recent immigrants to Bologna. Francesco's father, Andrea, a merchant, had moved there from Imola in 1434, becoming a citizen 20 years later.[12] Andrea was married to Camilla Tartagni, daughter of a prominent Imola jurist, whose brother Alessandro lectured in law at the University of Bologna.[13] They had at least five children. In 1456 they bought the land on which the family's country house would be built; they also owned a house in Via Castiglione, near

Piazza Maggiore and the Duomo, the Piazza della Mercanzia, and the family bank.[14] When Andrea died in 1465, his estate was divided between his three sons: Michele, Catellano, and Francesco.[15] In 1475, Michele, probably the eldest of the three, paid 3,000 lire to purchase three houses adjoining the Via Castiglione property from the widow (Elisabetta Bentivoglio) and heirs of Romeo Pepoli. Buying up older contiguous properties with the intention of incorporating them into a new family palazzo was by no means unusual: the Bentivoglio rulers of Bologna had done the same in the 1450s, and it was common practice in Florence too.[16] In 1497, the three Casali brothers, when they were in Bologna, all lived in one main family house bounded by Via Castiglione, Via Miola and Via de' Vivaro.[17] In 1503, the family paid another 2,000 lire to purchase from the family of Francesco's wife, the Aldrovandi, a further house with an oratorio in this block.[18]

Michele and his brother Francesco followed their father into trade, dealing, among other commodities, in salt; the third brother, Catellano, studied law and pursued an ecclesiastical career at the Roman curia, rising by the end of the century to be a secretary to Pope Alexander VI.[19] In this he may well have been assisted by his Tartagni relatives and was certainly patronized by Cardinal Raffaele Riario. Michele, too, moved to Rome, where he married Antonina Caffarelli, a member of an influential noble family. Their sisters Giovanna and Caterina married into the Sampiero and Lupari families of Bologna,[20] and that left Francesco as head of the Casali household in Bologna. Francesco was a papal treasurer, an office that could be highly advantageous in terms of social mobility,[21] and was married to Ginevra, daughter of Niccolò Aldrovandi. Her family held a number of city offices under the Bentivoglio regime, and in 1488, Gianfrancesco Aldrovandi, probably Ginevra's brother, was appointed to the ruling Council of Sixteen, although he is better known for his role as Michelangelo's host during the artist's 1494–5 sojourn in Bologna. The family owned property in Via de Vivaro adjoining the Casali houses.[22] While the Aldrovandi had already reached senatorial rank, the Casali did not hold this office in Bologna until 1525: Francesco had married well. The three Casali brothers died in relatively quick succession: Catellano in 1501, Francesco in 1502, and Michele in 1506. The latter were survived for many years by their wives, and their sons made names for themselves as mercenaries and diplomats during the Italian wars of the 1520s. At the time of this inventory, the members of the family were therefore relatively recent arrivals in the city, upwardly mobile, with contacts in Rome via Catellano and Michele, and engaged primarily in mercantile business.

The Casali house in Via Castiglione was a property well adapted to entertaining and in 1506, when the papal court came to Bologna to celebrate Pope Julius II's victory over the Bentivogli, was considered suitable accommodation for Cardinal Raffaele Riario. It was a substantial building arranged around a courtyard with what may have been a double loggia, for the inventory refers separately both to a courtyard loggia (*logia cortillis*) and a lower loggia (*logia inferiori*). Such two-tier arrangements (which did

not necessarily extend to all four sides of the courtyard) featured in several contemporary Bologna palazzi, including those of the Bentivoglio and Poeti families.[23] Underneath the courtyard loggia, which was decorated with 15 painted shields (*targoni*), were a walnut trestle table, 12 *braccia* (7.68 m) long for dining, and two pine tables, one described as "small, for the household." However, the inventory commences with some ground-floor rooms, itemizing property in an antechamber (*guardacamera*) adjoining the courtyard of a neighboring house. There follows a chamber (*camera*), adjoining the same house, which has two beds, one with a gilded Virgin Mary at its head, and a truckle-bed. In his *De re aedificatoria*, Alberti had recommended that guests "should be accommodated in a section of the house adjoining the vestibule," and the young men over the age of 17 opposite them,[24] and it is certainly possible that this was either a guest room or accommodation for young male members of the household (related to this point is Stephanie Miller's "Parenting in the Palazzo" in Chapter 4 of this volume). Next comes a large lower chamber (*camera magna inferiori*) looking on to the courtyard. Also containing a bed and mattresses, this room corresponds to the Florentine *camera terrena*, which might function as either a guest room or the master's summer accommodation.[25] This was evidently a room where visitors might be received, and the first of two studies to be found in the palazzo is located here. This lower study was equipped with a number of items related to business affairs. There were two walnut tables for counting money, one described as inlaid with white bone in the Turkish style, and a little box, similarly inlaid, for writing, in which were letters and other writings. There was a gilded pottery inkwell, decorated with a Turk (or a Trojan) on a horse,[26] and a second inkwell covered in red leather in the style of a little box. A worn courier bag (*bolzietta corij usitata*) was decorated with the family arms. The second study apparently adjoined Francesco's room upstairs, and the presence of two such rooms conforms to contemporary prescriptions that the merchant should have one study on the ground floor for business, and another, upstairs, for more leisurely study.[27] The Casali *camera magna inferiori* contained none of the entertainment objects that Maria DePrano's chapter in this volume identifies in the equivalent room of the Tornabuoni palazzo, but, as we will see, this is perhaps because they had been relocated for the summer season.

The notaries compiling the inventory now seem to move upstairs and detail three chambers, one of them large and probably containing a fireplace, all looking on to the courtyard of what they describe as the old house (*domus antique*), plus a fourth chamber, looking on to an unspecified courtyard. The *sala* or hall was also, as one would expect, located upstairs on this *piano nobile*. Like its Venetian equivalent, the *portego*, discussed in Margaret Morse's chapter in this volume, it was minimally furnished, containing only a large table with a coat of arms, and a lead pipe for bringing water into the chamber (*unum lambicum plombi pro faciendis aquis in camera*).[28] Blue-edged linen was stored in its new antechamber, intriguingly described as *anticamera nova sale facta seu picta a listis morellis et bertinis*. Perhaps it was painted to create an

effect of deep red and gray-fringed hangings. Next comes the room where Francesco Casali had slept in winter (*ubi dormiebat D. Franciscus in ieme*), referred to as the upper hearth (*camini superioris*) but also as the chamber of the hearth (*camera camini*), and presumably adjacent to the main fireplace. It looked on to the courtyard, and here are to be found the household valuables (however, see the discussion below). Alberti wrote that "a luxurious house would have different bedrooms for summer and winter," and that seems to be the case here.[29] The *guardacamera* of this chamber may have accommodated Ginevra Casali, for as well as a bed, it contained large quantities of linen for needlework and items clearly intended for her daughters' trousseaux.[30] There follow in the inventory details of two related rooms: the family chapel, of which more below, and the second study. At this point, the sequence of the inventory becomes confused, which may reflect a rather haphazard layout of a palazzo combining old and new buildings, and it is hard to interpret its entries as representing any sort of sequence. However, it is clear that further upstairs rooms included a kitchen (*coquina superiori*), a well-room (*stantia putei*) next door, and a small chamber (*camerino*).[31] There are three rooms connected with household members: a new chamber (*camera nova*) where the maids slept, looking out on to a side-street, a chamber for the children's tutor (*camera in qua stat magister puerorum*), looking onto the courtyard, and, downstairs by the front door, the *camera famulorum*, a chamber for the male servants or, perhaps, for young men apprenticed to Francesco. Finally, downstairs was a second kitchen which seems to have served as an informal dining room and contained, as well as the ubiquitous bed, a useful device for doing laundry: a copper tub walled into a little oven (*una caldaria rami murata in uno fornetto pro faciendis bugatis*). Several storerooms complete the inventory.

The overall appearance of the Casali palazzo suggests significant parallels with contemporary patrician homes in Florence. Its magnificence is not untypical of the Bolognese palaces of the period.[32] Moreover, although the inventories are more than a century and a half apart, there are some similarities with the Sirani palazzo discussed in Modesti's chapter in this volume: the presence of ground-floor bedrooms, for example, and of principal apartments on the *piano nobile*. The rather hazy boundary between the familial and professional spaces of the Sirani palazzo is, as would be expected, even hazier in the earlier period. In the Casali house there is no space that might conceivably be described as "professional": the ground-floor study, although clearly equipped for business dealings, is located in a room also containing a bed.

The family's country estate, of 250 *tornature* (approximately 52 hectares), was located near San Lorenzo in Collina, in a place known as Montevecchio, about 10 miles west of the city. Two houses were located on this property: one for the family's use and the other for the farmers who ran the estate. Some contents of the latter are detailed in the inventory, but, for reasons of space, will not be discussed here; however, it should be noted that there may have been some overlap in the use of the two properties. For example, the loggia

of the second house was set up for dining with tables and benches, including a medium table *pro familia*, while that of the Montevecchio property was not. The family home derived from a medieval building with a tower, but, as we will see, had been altered. Sections of these buildings were incorporated into the present villa, which was constructed in stages beginning, probably, in the second half of the sixteenth century.[33]

The villas of Renaissance Bologna and the hills around the city are the subject of even fewer studies than the city's palazzi, and once again it is the villas of the later sixteenth century and after, that have tended to attract scholarly attention.[34] Therefore, it is difficult to find obvious points of comparison for the Casali country house. This property consisted of eight or nine chambers (it is not clear whether the notaries returned to one of them for a second time), including one specifically identified as that of Ginevra Casali, located by the hearth room (*apud d. caminum*) and the *camino* itself, presumably once again a room with a hearth, furnished with a card table, three plaster heads in the image of emperors, and one plaster image depicting the powers of Hercules (*vires herculis*). There was a loggia, with benches and a table, an underground kitchen, a wine-store and a storeroom (*salvarobba*). Unlike the palazzo, the country house had no specific accommodation for servants, suggesting a less segregated environment than that of the townhouse. Although I have found no contemporary description of it as a "villa," it shares some of the characteristics of such later properties. The same is true of Florentine country houses of the period, which are generally referred to as *palagio, casa*, or *casamento*.[35]

Some contrasts between the town and country houses are immediately apparent. For a start, the latter was significantly smaller. Its furnishing was, in general, rather more rustic: plain blue and white linens were the favored fabrics for bed-hangings rather than the more extravagantly colored, lined, and embroidered hangings to be found in the palazzo. That may have been a stylistic choice, but might also reflect the exigencies of the season. The clearest distinction, though, and one that points to this property as a "villa" in the classical tradition, relates to work and leisure. The palazzo, and in particular the large ground-floor *camera* containing the study, included a number of items clearly related to business activity: desks and inkwells for writing, tables for counting money, account-books for the family bank, and a painted map for navigating. In contrast, the villa did not. It did, though, contain several leisure-related objects, including a table for playing cards, "a tambourine for playing," and two lutes, one small and one medium. Lutes were among the most common instruments in the Renaissance home.[36] That the notaries were able to identify the table's function suggests that it was specially adapted to card-playing in some way – perhaps inlaid.[37] No parallels are to be found in the palazzo, although we should bear in mind that these objects may have been moved according to the season. The balance of objects reflects very well the idea of the villa as "a retreat for the enjoyment of a peaceful, private life removed from either the political duties or mercantile affairs of the city."[38]

The two homes have in common the presence of both devotional and classicizing works of art. In the palazzo are eight images of the Virgin Mary, one of the young Christ and one each of the saints Bernardino and Girolamo. For only two artworks is a location within a room specified. A Virgin Mary, of gilded plaster, was placed at the head of the bed in a chamber, and a painted canvas in the French style, depicting a man and a woman, hung over the door of Francesco's winter room. Such locations are typical of the period.[39] With the exception of those in the chapel, all of the devotional images were located in *camere*. Two images of the Virgin and one of the young Christ were in the *camera magna inferiori*, where the study was located. All three were gilded, and it is no surprise to find these more prestigious works in a room that visitors meeting Francesco on business would undoubtedly see. Their function here has some parallels with that of the religious paintings in the Venetian *portego* discussed in Morse's chapter in this volume, although the two rooms are not straightforward counterparts. As a location for dining, the *portego* has greater commonalities with the Bolognese *sala*, but no religious artworks are recorded in the Casali *sala* at all. (Whether fashions in the display of devotional imagery shifted as the religious climate changed through the sixteenth century is an intriguing question, but is outside the scope of this chapter.) Elsewhere in the property, the artworks were plainer. Another Virgin Mary, old and well-worn (*antiqua et usitata*), was in the study itself; a plaster image of the Virgin Mary was in one upstairs chamber and a San Girolamo with a plain frame in another; and a final Virgin Mary with various unspecified saints was in the *guardacamera* of Francesco's room, where his wife Ginevra may have slept. Here the images of saints would have been understood to watch over the sleeping family. A further two images of the Virgin and one of San Bernardino were in the chapel (discussed below). There was a portrait of Francesco Casali in the study and some secular images, in the French style, one featuring "a nude woman in the middle and other figures in a bath." This latter image, along with another French-style painting, was situated in the lower kitchen/dining room.

The only item in the palazzo that can be clearly categorized as classicizing is a little round plate depicting Hercules, found in the downstairs *camera magna*, but there are also a number of *targoni* with unspecified subjects, which makes it difficult to be too definitive on this point. Identifications are relatively easier in the villa, where Hercules appears again in a plaster image, and we further find two sets of "three plaster heads in relief in the image of emperors." One set of imperial portraits was located in Ginevra's room; the other, along with the Hercules, in the *camino*. There were also three devotional artworks in the country house, one in each of three *camere*: "one gilded image of the Blessed Virgin Mary in wood"; "a little painted panel with San Girolamo"; and a "gypsum image of the Blessed Virgin Mary in a tondo." The absence of secular paintings in the villa once again has parallels in Florentine practice.[40] As was the convention of the time, the family arms were liberally displayed around the townhouse, on items including a brass

basin and ewer with the arms in silver; a casket and bedside chest, which may have been wedding items, because they also showed the Aldrovandi arms; on some painted caskets in the lower kitchen; on some benches; and even on an embroidered mule cover.[41] In contrast, there are no such items listed in the country property.

The palazzo also includes a much more cosmopolitan set of furnishings, a characteristic shared with the lodgings of Pietro Bembo discussed in Susan Nalezyty's chapter in this volume (it is notable that Bembo and Francesco Casali's nephew Giambattista were friends).[42] Beyond the Turkish-style inlaid items in the study, there are paintings in the French style; linen from Rheims; in an upstairs chamber even "one green silk bed-cover worked in the style of Rheims," but in fact "made in Turkey." We find a linen bed-curtain embroidered "in the Moorish style," a knife "in the Neapolitan style and worked in the Spanish style" and even one parrot or parakeet, in a beautiful gilded cage on the loggia. In contrast, in the villa we find none of these "cosmopolitan" objects. While display – of family arms, prestigious gilded artworks, secular art, and exotic objects – was evidently important in the city as a means of emphasizing the family's status to visitors, it seems to have been rather less so in the countryside.

Also notable is the existence of a chapel in the family home. Francesco Casali was a papal treasurer, but it is impossible to say whether the presence of the chapel points to personal devotion, was considered appropriate to his role, was more a matter of following fashion, or indeed was all three.[43] The family had ties to the Dominicans, and Francesco may have been aware of the writings of Giovanni Dominici on the subject of domestic altars (discussed in Morse's chapter). Moreover, laymen required a papal or episcopal license to establish a chapel and the family may have benefited from the expansion of such concessions in the fourteenth and fifteenth centuries.[44] Domestic chapels, however, remained far from common. The Casali chapel contained an image of the Virgin Mary made with precious stones in many colours and a San Bernardino in plaster, depicted with an open book in his hands, wearing a diadem. The altar was covered with a checked cloth, and on it were two candelabra. The centerpiece of the display was a Flemish painting of the Virgin Mary and the three Magi, on canvas, in a frame of fine gold. There was a low stool before the altar, for praying, and a brass basin to hold holy water. Unfortunately, beyond the limited references to the geographical origins of these artworks, we know little about them. Few commissions can be definitively linked to this generation of the Casali. One is the altarpiece by Filippino Lippi, dated 1501 and depicting Saint Catherine, which still hangs in their family chapel in the church of San Domenico in Bologna.[45] Another is the medal, by Sperandio of Mantua, depicting Francesco's brother Catellano in 1484 or after,[46] intriguing in this context because Sperandio was involved in a number of architectural projects in Bologna,[47] although there is no evidence to link him specifically to the homes under discussion here.

Reading the Casali inventories, there is relatively little that is surprising in terms of the objects in these properties. This particular Bologna interior

shared much with its Florentine counterparts, both its splendor and its layout, although further research will be needed to establish whether this was a common pattern. However, the final section of this chapter will highlight a number of features relating not, straightforwardly, to the contents of the properties, but rather to the way that they were changed and adapted over time, and the ways in which objects and rooms were associated with particular household members. That the Casali expanded their property through purchase in the 1470s has already been noted, but this inventory also suggests further alteration. In the palazzo, one upstairs *camera* is described as looking on to the courtyard of the *domus antique*. As we have seen, the *sala* had an *anticamera nova*, and the maids slept in a *camera nova*. The people making up the inventory could clearly distinguish these rooms from older sections of the property, and we might speculate that the house was gradually being melded into a new family palazzo. There is further evidence, beyond the inventory, for rebuilding processes. The palazzo suffered serious damage around 1511 during the papal-Bentivoglio conflict, and had to be rebuilt to the extent that in 1517 it was described as a "large house, almost new" (*casa grande quasi nuova*).[48] Equally, there is evidence that the Montevecchio house had been altered. Three rooms are referred to in the inventory as *camera antiqua*, suggesting the existence of at least two phases of building work. These older rooms may have formed part of a medieval tower on the site, parts of which still survive. Later, in 1527, this house would be burnt by Spanish soldiers.[49] Reconstruction began in the second half of the sixteenth century, but the building was not completed for many decades.[50] There was, then, a continuous process of adaptation, demolition, sometimes damage or even destruction, then building. Contents too had their "old" and "new" aspects. For example, in an upstairs chamber of the palazzo were to be found "two large antique figured satin cloths which were in the house in the old days." Indeed, the majority of the hangings, cloths, and covers itemized in the inventory are either *usitata* or *antiqua*: only occasionally is there mention of one *quasi novum*. The categorization here reflects the division betwee *antico* (venerable), *vecchio* (well-worn – here *usitata*) and *triste* (worn-out) identified by Patricia Fortini Brown in relation to Venetian inventories.[51] Although the inventory alone affords little evidence for attitudes towards old and new objects, the quantity of older and used items is certainly worthy of note. Fourteen entries feature items described as *antiqua* and no fewer than 71 *usitata*, although only eight mention *triste*. There are 13 new items, and a further five "almost new," although this count is complicated by a number of items "newly worked" and the like, which in itself suggests a process of recycling in the early modern household.

While property development and alteration was a relatively long-term business, taking place over years or even decades, the early modern home also saw more rapid change, not least from season to season. One of the notable features of this inventory is its date: August 31, a time of year when it was highly desirable to escape the city heat. It is not surprising, therefore, to find the possessions of Ginevra Aldrovandi-Casali and her son Andrea listed

at the hillside villa. The compilers of the inventory referred twice to seasonal functions. As we have seen, Francesco Casali's winter sleeping quarters were noted, as was a square table in the lower kitchen, labeled "for dining by the fire in winter" (*pro comedendo ad ignem in ieme*). Morse's chapter in this volume likewise notes a reference to one *camera* in the Venetian palace of Ca' Foscarini as the location for winter dining. The objects found in this domestic interior were often explicitly adapted to easy removal. Under the lower loggia was a small table for dining which had evidently been dismantled. There were truckle-beds to be pulled out and trestle tables to be made up. Hangings could be unpacked from chests. It is important to appreciate this mutability in the domestic environments of the period, and to exercise caution in apportioning distinct positions to one or other object.

Turning to associations with people, a number of rooms in both palazzo and villa are identified with particular individuals. In the palazzo, these include Francesco Casali's winter sleeping quarters, a room for the children's tutor, and two rooms for servants. In the villa description, Ginevra Casali's room is detailed, but no servants' accommodation is specified; children figure not at all in the description of rooms, a point discussed further below. Beyond the necessities for sleeping, the main items remaining in Francesco's winter room were valuables: silver basins, cups and salvers, jewels including diamonds, pearls, an emerald and ruby, and a beautiful pergamen breviary. It is possible that some, or all, of these objects would originally have been kept in the upstairs study, which according to the inventory contained only a small box with documents inside, a painted map for navigating, and a little flask in the Moorish style. Ginevra Casali had few possessions specifically itemized in the palazzo, other than some striped chemises and linen cloths, packed away in a white leather casket. However, the contents of her room at Montevecchio are itemized and suggest that it was relatively simply furnished. She had a litter "in the curial style" with its mattresses, bed and bolsters, and white linen hangings. The precise meaning of this *ad modum curialem*, used in relation to no less than 14 beds and sets of trestles found in the Casali household, is difficult to pin down. Ginevra's room also had a small desk "in the style of a credenza," a pine table, three gypsum heads in relief in the image of emperors, and two *carte picte*, perhaps painted maps. The items listed as her personal possessions, as opposed to family property, are principally clothes, but include a gilded image of the Virgin Mary and a gilded mirror that may have been kept in her room.

The palazzo rooms of the servants make for interesting comparisons. The male servants' room was probably located on the ground floor. It contained a bed on trestles, with a truckle-bed underneath, three mattresses (one in the truckle-bed) and three feather-beds or cushions, each weighing 90 lb. There was one large chest in which one Petrus, an "old servant," kept his own linen, and two other chests also for servants' personal linen. Beyond that we find bed-linen, bolsters, a bench, a couple of chests in which books and papers were stored, and some horse-tack. The maids' room likewise had a bed and

truckle-bed, plus a number of chests. One of these was for the maids' personal use; others stored household linen and flour. There was also a wooden bath, the only one in the house, although presumably this could be moved from room to room as required. It is notable that there is only one "torn" item in the maids' room, and nothing identified as "used" or "old." Unlike the Tornabuoni bankers of Florence, whose maids' furnishings in 1497 were "old" and "sad,"[52] the Casali do not appear to have relegated their worn-out items to the servants' quarters. We find a fairly similar picture of furnishings in the room belonging to the children's tutor: a bed with a mattress and feather-bed, a hanging of white cloth, three used tables for studying, one dismantled table, a variety of trestles, and a bench for sitting on. While these rooms are far from elaborate, they are by no means poorly equipped.

The inventory gives few clues as to where the Casali children spent their time. Presumably they studied in their tutor's room, but it is not clear where they slept. However, in the maids' room are also to be found children's bed-covers, raising the question of whether they might have slept here. At the date of the inventory, the family had young children: one son, Vicenzo, was still an infant, and his brother Andrea was aged about eight; there were sisters too.[53] As might be expected, we consequently find a number of items connected with child-rearing in the houses. In the palazzo there are two white cloth cradle-covers: one in the downstairs chamber apparently used for sleeping (perhaps by guests or young men of the household) and also containing two beds and a truckle-bed; this would be a candidate for the children's room, not least in the summer, if they had moved downstairs to escape the heat. The other cradle-cover was packed away in a large chest in an upstairs chamber. A white damask baptismal cloak was kept, along with other valuables, in the upstairs hearth area of the palazzo where Francesco Casali had slept. Other items connected with children include girls' chemises and linen for making more, and a number of items referred to as "a sponsa," perhaps intended for the girls' trousseaux. However, most of the children's clothes, as one would expect given the season, were kept at Montevecchio. As with seasonal changes in use, and medium- to long-term property development, transitions in the use of certain domestic spaces as the children grew up, moved into other households and married, are only to be expected. The mobility of objects associated with infancy and the vaguely articulated domestic spaces for slightly older children in the household are not unique to Bologna and are discussed in Miller's chapter in this volume on parenting in the Florentine palace.

Given that the Casali did not yet hold senatorial rank in Bologna, the lavishness of their domestic environment is striking indeed. Their palazzo is clearly comparable in its magnificence to the Florentine palaces of the period; it appears to have been built by means of a compounding of older properties typical to Florence, and its rooms have similar functions to their Florentine counterparts. The parallels with Venetian palazzi are less straightforward: the functions of the Venetian *portego*, for example, are reflected here in both the

sala and *camera magna inferioris*. In broad terms, however, patrician preoccupations with displays of family prestige and religious devotion in the domestic context probably did not change much from city to city. A close reading of the Casali inventory draws attention to several significant aspects of the early modern interior. First, it highlights the process of property improvement and development – that buildings and the rooms within them might be torn down, added to, and adapted. So too might their contents. Goods might be "used"; they might be old or "antique"; they might be worn-out. Households had a mixture of old and new. Second, the inventory illuminates the seasonal nature of property use, as prescribed by Alberti, in practice. So, while in winter one might sleep by the hearth and dine by the fire, in summer one might move out of town entirely to enjoy the mountain air, packing away domestic objects back at the palazzo. In providing a snapshot of the early modern home at a single point in time, inventories offer a deceptively static image of what such homes were like. But by reading closely, it is possible to envisage at least some of the dynamism of domestic life.

Notes

1 My initial study of the Casali family documents formed part of doctoral research at Royal Holloway, University of London, supervised by Professor Sandra Cavallo. That project was funded by the Arts and Humanities Research Council (UK) and a Scouloudi fellowship at the Institute of Historical Research. Aspects of my research touching on the house and household were presented at the Victoria & Albert Museum conference on the Renaissance Home (2006) and the annual meeting of the Renaissance Society of America (2010). I am grateful for the helpful comments received on both occasions. The present chapter was written during my term as Rome Fellow (2009–10) at the British School at Rome.

2 Fileno dalla Tuata, *Istoria di Bologna: Origini–1521*, edited by Bruno Fortunato, 3 vols (Bologna: Costa Editore, 2005), 2:618. For further details, see Giampiero Cuppini, *I palazzi senatorii a Bologna: Architettura come immagine del potere* (Bologna: Zanichelli, 1974), 293.

3 Most recently in Armando Antonelli and Marco Poli, *Il palazzo dei Bentivoglio* (Venice: Marsilio, 2006).

4 Maurizio Ricci (ed.), *L'architettura a Bologna nel Rinascimento (1460–1550): Centro o periferia?* (Bologna: Minerva, 2001).

5 See, for example, Giancarlo Roversi, *Palazzi e case nobili del '500 a Bologna: La storia, le famiglie, le opere d'arte* (Bologna: Grafis, 1986) and, for a more recent case study, Michele Danieli and Davide Ravaioli (eds), *Palazzo Bocchi* (Bologna: Minerva, 2006). On the fifteenth century, Francesco Malaguzzi Valeri, *L'architettura a Bologna nel Rinascimento* (Rocca S. Casciano: Cappelli, 1899) remains valuable.

6 According to Malvasia's 1678 account, Ludovico Carracci frescoed two chimney-pieces for the Casali and his cousin Agostino retouched a copy of his own *Last Supper* for the family. The Casali honored Ludovico with a memorial in their chapel in the Church of San Domenico, Bologna. See Carlo Cesare Malvasia, *Malvasia's Life of the Carracci: Commentary and Translation*, edited by Anne Summerscale (Pennsylvania: Pennsylvania State University Press, 2000), 234, 313, 319.

7 The Casali family archive is divided in two. The Casali di Monticelli archive, belonging to the descendants of Francesco's nephew Gregorio, is described in Gustavo Di Gropello and Carlo Emanuele Manfredi, "Un'eredità di carte: archivi storici presso le famiglie piacentine," *Bollettino Storico Piacentino* 98 (2003): 11–35. The documents belonging to the Bologna branch of the family were incorporated into the Isolani-Lupari archive in the early nineteenth century after the Casali line became extinct; unfortunately, some have since been damaged by fire. I am grateful to both families for allowing me to consult their archives.

8 In translating the inventory, Peter Thornton, *The Italian Renaissance Interior 1400–1600* (London: Weidenfeld & Nicolson, 1991) and, for the Latin terminology, Du Cange et al., *Glossarium mediæ et infimæ latinitatis* (Niort: L. Favre, 1883–7), available at http://ducange.enc.sorbonne.fr (accessed May 31, 2013) have been invaluable.

9 The *Donatio* descriptions: "Plures domos contiguas cuppatas et balchionatas positas Bononiae …
 in contrata strate Castelionis"; "Unam possessionem terre arat. arborat. vidat. prature maronete et
 buschine cum duabus domibus viz. una pro habit. ipsorum fam.: et alia pro habitat. colonj, curia,
 furno et alijs superextantibus; tornaturarum ducentarum quinqueginta vel circha posit. in guardia
 S. Laurentij in coline in loco dicto Monte Vechio." Archivio Casali di Monticelli (henceforth
 ACdM), cassetta I, no. 4, October 16, 1497.

10 Lena Cowen Orlin, "Fictions of the Early Modern English Probate Inventory," in *The Culture of
 Capital*, edited by Henry S. Turner (New York and London: Routledge, 2002), 51–83; James R.
 Lindow, *The Renaissance Palace in Florence* (Aldershot: Ashgate, 2007), 135–7.

11 For more on the Casali family, especially the subsequent generation, see my "'Furnished with
 Gentlemen': The Ambassador's House in Sixteenth-Century Italy," *Renaissance Studies* 24 (2010):
 518–35 and "War, Diplomacy and Social Mobility: The Casali Family in the Service of Henry VIII,"
 Journal of Early Modern History 14 (2010): 559–78.

12 Archivio di Stato di Bologna, Fondo Comune-Governo no. progressivo 429. Cittadinanze no. 30,
 dated April 3, 1454.

13 On Alessandro's career, see Aurelius Sabbatini, *De vita et operibus Alexandri Tartagni de Imola*,
 Quaderni di "Studi Senesi" 27 (Milan: Giuffrè, 1972).

14 Giuseppe di Gio. Battista Guidicini, *Cose notabili della città di Bologna*, 4 vols (Bologna: Società
 Tipografica dei Compositori, 1870), 3:242–3. For the bank's location in the parish of Santa Maria
 del Carobbio, see Biblioteca Universitaria di Bologna, MS 4207, L. Montefani-Caprara, *Famiglie
 Bolognesi*, vol. 24 (Carr-Casta), fol. 106v.

15 His testament, dated October 13, 1465, is in ACdM I (1420–1547); a note of its contents is in the
 Archivio Isolani-Lupari, Fondo Casali B18. It was registered by ser Petrus de Machiavellis, a
 Bolognese notary.

16 William E. Wallace, "The Bentivoglio Palace: Lost and Reconstructed," *Sixteenth Century Journal*
 10(3) (1979): 97–113 (at 100), with bibliography.

17 ACdM I, no. 4.

18 Guidicini, *Cose Notabili*, 3:242–3.

19 On Catellano's career and relationship with Riario, see my "Notes on Catellano Casali," *The Medal*
 54 (Spring 2009): 35–6.

20 Archivio Isolani-Lupari, Fondo Casali B18. The Sampieri held senatorial rank from 1478, while
 the Lupari did so from 1528. See Giuseppe Guidicini, *I riformatori dello stato di libertà della città di
 Bologna*, 3 vols (Bologna: Regia Tipografia, 1876), 1:64, 2:23.

21 Cesarina Casanova, *Gentilhuomini ecclesiastici: Ceti e mobilità sociale nelle legazioni pontificie
 (secc. XVI–XVIII)* (Bologna: CLUEB, 1999), 9.

22 The Aldrovandi genealogy is not entirely clear. Both Gianfrancesco and Ginevra were children of
 Niccolò, but more than one family member had that name. See Pompeo Scipione Dolfi, *Cronologia
 delle famiglie nobili di Bologna* (Bologna, 1670, facsimile edition Milan: Orsini di Marzo, 2005), 40,
 42. On Michelangelo, see Giorgio Vasari, *La vita di Michelangelo*, edited by Paola Barocchi, 5 vols
 (Milan: Ricciardi, 1962), 2:135; Guidicini, *I riformatori*, 1:51, 2:51.

23 Wallace, "The Bentivoglio Palace," 108–13. Carolyn James, "The Palazzo Bentivoglio in 1487,"
 Mitteilungen des Kunsthistorischen Institutes in Florenz 41 (1997): 188–96, at 191. See also Valeri,
 L'architettura, 54, noting double loggias in the casa Rizzi già Campeggio and Palazzo Fava-
 Ghislardi (55, 132).

24 Leon Battista Alberti, *On the Art of Building in Ten Books*, translated by Joseph Rykwert, Neil Leach,
 and Robert Tavernor (Cambridge, MA: MIT Press, 1988), 149.

25 Lindow, *The Renaissance Palace*, 123–4.

26 The word used in this late Latin for both Turks and Trojans is *teucri*. In the case of the inlaid
 furniture, the reference is clearly to Islamic-style geometric patterning: see Thornton, *Interior*, 93.
 Whether the inkwell featured a Turk or a Trojan must remain a matter for conjecture.

27 On prescriptions for two studies, see Dora Thornton, *The Scholar in His Study: Ownership and
 Experience in Renaissance Italy* (New Haven: Yale University Press, 1997), 31–2; Lindow, *The
 Renaissance Palace*, 132–3.

28 This probably functioned with a pulley system. See Sandra Cavallo, "Health, Beauty and
 Hygiene," in Marta Ajmar-Wollheim and Flora Dennis (eds), *At Home in Renaissance Italy* (London:
 V&A Publications, 2006), 174–87, at 183.

29 Alberti, *On the Art of Building in Ten Books*, 149.

30 On the use of the *guardacamera* in Tuscany to accommodate the householder's wife, see Thornton, *Interior*, 295.

31 Again, the kitchen location parallels Florentine practice. See John Kent Lydecker, "The Domestic Setting of the Arts in Renaissance Florence" (PhD dissertation, The Johns Hopkins University, 1987), 32.

32 For a Bolognese comparison, see the 1505 inventory of Nicolosa Castellani cited in Lodovico Frati, *La vita privata di Bologna* (Rome: Bardi, 1968), 21–2.

33 Giampiero Cuppini and Anna Maria Matteucci, *Ville del Bolognese*, 2nd edn (Bologna: Zanichelli, 1969), 41–2, 338.

34 Ibid., 41–2, 338.

35 Amanda Lillie, *Florentine Villas in the Fifteenth Century: An Architectural and Social History* (Cambridge: Cambridge University Press, 2005), 59.

36 Flora Dennis, "Music," in *At Home in Renaissance Italy* (see note 28), 228–43 (at 230).

37 For inlaid gamesboards in the late fifteenth century, see Thornton, *Interior*, 92. For a later example, see Patricia Fortini Brown, *Private Lives in Renaissance Venice: Art, Architecture and the Family* (New Haven: Yale University Press, 2004), 132.

38 David R. Coffin, *The Villa in the Life of Renaissance Rome* (Princeton: Princeton University Press, 1979), 11.

39 Peta Motture and Luke Syson, "Art in the Casa," in *At Home in Renaissance Italy* (see note 28), 268–83, esp. 271–8.

40 Lillie, *Florentine Villas*, 145.

41 Brown, *Private Lives*, 15–16.

42 Catherine Fletcher, *Our Man in Rome: Henry VIII and His Italian Ambassador* (London: Bodley Head, 2012), 133.

43 Donal Cooper, "Devotion," in *At Home in Renaissance Italy* (see note 28), 190–203 (at 199).

44 Philip Mattox, "Domestic Sacral Space in the Florentine Renaissance Palace," *Renaissance Studies* 20 (2006): 658–73 (at 660).

45 Patrizia Zambrano and Jonathan Katz Nelson, *Filippino Lippi* (Milan: Mondadori Electa, 2004), 604.

46 G.F. Hill, *A Corpus of Italian Medals of the Renaissance Before Cellini* (London: British Museum, 1930), n. 397.

47 Valeri, *L'architettura*, 77–81.

48 Dalla Tuata, *Istoria di Bologna*, 2:618. Guidicini, *Cose notabili*, 3:242, based on the information in ACdM I, no. 11.

49 Marin Sanudo, *I Diarii*, edited by Rinaldo Fulin et al., 59 vols (Bologna: Forni, 1969), 44: column 472.

50 Cuppini and Matteucci, *Ville*, 338.

51 Brown, *Private Lives*, 65.

52 Lindow, *The Renaissance Palace*, 128.

53 According to their memorials in the church of San Domenico, Bologna, Andrea died in 1550 aged 56 and Vicenzo in 1529 aged 28. Two sisters, Camilla and Violante, are named in Andrea's 1547 testament: Archivio di Stato di Bologna, Archivio Notarile, Tommaso Barbieri 1546–57, filza 1, doc. 530. Pompeo Litta, *Celebri famiglie italiane*, 11 vols (Milan and Turin, 1819–99), fasc. LVII, Casali di Cortona, suggests that there were a further two sisters, but his genealogy of the Casali is not entirely reliable.

From Padua to Rome:
Pietro Bembo's Mobile Objects and Convivial Interiors

Susan Nalezyty

The Palazzo Baldassini – praised by Vasari as one of the most comfortable dwellings in Rome – was offered to Cardinal Pietro Bembo while its owner, the poet and cleric Giovanni della Casa, was resident in Venice. By the mid-sixteenth-century, the celebrated early sixteenth-century palace was adorned with textiles, antiquities, and paintings, as described by Bembo, the grateful tenant. Bembo imported his own works, medals, gems, statuettes, and books, which were stored and shipped in a manner that confirms their function as instruments for thinking and tools for conversation, apparatus for maintaining his network and advertising his specialist's knowledge of visual things. This borrowed space functioned as an impromptu court, remarkably similar to Bembo's own renovated palace in Padua, which at this time hosted Cardinal Reginald Pole in his absence. Bembo endeavored tirelessly to display the family's art collection in an elegantly decorated home within the academic orbit of Padua, a university town with an international attraction for scholars. An examination of these mobile, humanist churchmen confirms that ideas circulated within and between the rich interiors and the urban gardens of Padua and Rome. Their impressions of these lent accommodations underscore the importance of the early modern domestic interior as a striking backdrop for collected antiquities and contemporary art, and its role in promoting intellectual inquiry and convivial happenings.

Cardinal Pietro Bembo's accomplishments as a poet and literary theorist are well known. His imitation of fourteenth-century writers was influential in establishing Tuscan as a language for scholarly and creative writing equal to Latin. His treatise on the vernacular, *Le prose della volgar lingua*, definitively inaugurated the Petrarchan movement in Italian literature. During his own lifetime, he was perceived as a cultivated Renaissance man of letters. This reputation derived not only from his refined writing style but also from the broad network he wove among literary and artistic luminaries at some of the most prominent courts in Italy, some of which he visited at a young age with his father Bernardo Bembo, himself a well-traveled ambassador for the

Venetian Republic. With his father, he stayed in Lorenzo de' Medici's Florence and Pope Julius II's Rome.[1]

After retiring from public life following his service as secretary to Pope Leo X, Bembo bought a house in 1527 where he would install the family art collection, which he himself had enlarged over the years. But he could not take up residence until the current owner died five years later. He was elated with the acquisition, but lamented the house's bad condition, describing it as "completely ruined" in 1529.[2] Complaining of the effort it would take to make it habitable, he wrote in a letter that his lifetime friend and secretary, Nicola Bruno ("Cola"), was capable at following through with the building's restoration.[3] Because Bembo was often away, he needed a surrogate curator and exhibition designer. Cola seems to have served in exactly this role. His position in the creation of Bembo's study is constantly confirmed in their correspondence. The same year that Bembo and his household took up residence in this house, he began splitting his time between his new home, the family villa outside Padua, and rented accommodation in Venice, where he served the Republic as historian and librarian.[4] After the house was settled in 1538, Cola put on a special exhibition of works for visitors who were in town for the feast day of St Anthony. Responding to his friend's request for objects to be featured in the Paduan show, Bembo sent from Venice some medals, gems, and a sculptural bust, an exchange betraying an affiliation less like master to servant but more like museum director to curator.[5] As with this exchange, letters between him and his friends back home are important sources throughout his life. Not only do they tell of objects that he needed while living away from home, but they also betray conditions of his interiors in Padua through his precise instructions.

Bembo's life changed when he was consecrated cardinal by Pope Paul III at the end of 1539.[6] His elevation lured him out of his quiet life in the Veneto. He moved to Rome that fall and stayed in the Vatican palace.[7] In 1543, he went to Gubbio as bishop; the reason he explicitly stated for leaving Rome was to save money after the considerable expense of the marriage of his daughter.[8] Before this move, which he saw as temporary, he asked a friend to see to renting his rooms in the Vatican palace to someone who would defend and vacate them upon his return. He further instructed his friend to lend his tapestries and other materials that could be moth-eaten to friends for safekeeping.[9] Gubbio, a center for tin-glazed pottery within the Duchy of Urbino, is the place where he likely acquired a historiated plate now located in the British Museum, which bears his family's crest under a cardinal's hat (Figure 2.1).[10]

Bembo's modest financial circumstances argue against the idea that he commissioned this maiolica piece, which quotes a figure group of Michelangelo's famed cartoons for the never-executed fresco of the Battle of Cascina. For lack of evidence, we cannot precisely pinpoint how Bembo acquired this plate, which showcases earthenware manufacture of local artisans. Correspondence between him and the Duchess of Urbino suggests that this work could have been a token of affection from Eleonora.

2.1 Probably by Painter of the Coal-Mine service, Plate with Scene from Michelangelo's *Battle of Cascina* cartoon, diameter 27.2 cm, tin-glazed earthenware (maiolica), c. 1543–4, the British Museum, London

She had traveled to Gubbio to graciously receive him upon his arrival.[11] A long-time patron of this writer – now Cardinal Bembo – the Duchess invited him and his staff to move into the ducal palace in Gubbio.[12]

Even with the Duchess' generosity, Bembo endured four miserable months here. His luck, however, changed again due to a friend's generosity. Giovanni della Casa had moved to Venice as *nuncio*, the envoy for Pope Paul III, leaving vacant his home in Rome, the Palazzo Baldassini, which he offered rent-free to Bembo. Elated by his friend's hospitality, Bembo delightedly wrote to his friend Girolamo Quirini in Venice, telling him that della Casa would lend him:

a beautiful little room, adorned with very rich and beautiful hangings, and a velvet bed and some antique statues and other beautiful paintings … This house, for all that it is, is the most beautiful in all of Rome … Beyond this, he has given me for the same time period access to a vineyard outside the most beautiful door of Rome, the Porta del Popolo; for all of this I am being given at no charge.[13]

This letter identifies domestic improvements to his busy and mobile lifestyle. These impressions of the desirable items in his little Roman room shed light on the things that he valued for his satellite accommodations.

This was certainly not the first time Bembo arrived in a city, pressed to make a suitable place for him and his staff. Movement up and down the peninsula was a perennial occurrence in his life. His letters, of which 2,500 survive, provide evidence of the practical logistics of a noble humanist and churchman relocating. In the above letter, he notes the sumptuous velvet bed in which he would sleep. As a young man, the subject of velvet beds appears to be significant in a number of letters as important backdrops for a bedroom, which would serve as audience chamber. In 1500, for example, a bed canopy was the point of debate with his current love, Maria Savorgnan, who insisted on keeping a borrowed canopy from Bembo until her guests had left.[14] In 1513, the embellishment of his bed in his rooms in the Vatican palace plays as an important part in another letter. As secretary to Leo X, Bembo filled three folios with a detailed commission for a bed canopy.[15] He ordered it made of double twill Flemish wool, alternating in stripes of deep blue and green with black voided velvet trim. What is interesting here is that he references the taste of his young niece Marcella, the daughter of his sister Antonia. She had apparently sent him two caps, which she had sewn from velvet cut with a foliage pattern, a choice of material that greatly pleased Bembo. He hoped to reproduce the richness of this fabric in his canopy. He insisted that it must be delivered by Christmas, at which time the Pope and his entire court were to come to Bembo's room as mass was given to the people from his bedroom window. Bembo's urgent tone and meticulous instructions emphasize that he saw it as a striking backdrop for a religious service attended by the politically influential. This event introduces the larger subject of a bedroom's function, which appears in early modern Italy to be a transitional space, both private and public. Margaret Morse and Stephanie Miller's chapters in the current volume illustrate the ways in which a palace could serve the domestic and social needs of its inhabitants. A visitor's status determines room use. To be sure, Bembo's Vatican room with a view of St Peter's Square was not average by any standards. Bed canopies like the one he describes were a fashionable item in Rome, analogous to the one we see in the background of Carpaccio's painting *Arrival of the English Ambassador to Brittany* (Figure 2.2).

This canopy hung from the ceiling and, when tied back to wall hooks, resembled the outspread wings of a hovering bird of prey. In his letter, Bembo calls this tent-like curtain the *sparvier da letto*, an alternate name, which translates to "sparver" in English, from the Latin *sparverius*, meaning sparrowhawk.[16] The advantage of this type of bed covering was that it could be removed intact and reinstalled in another location, a portable piece of grandeur that could be reconfigured in another space. Thus, della Casa's rich tapestries and velvet bed, which pleased Bembo as a mature cardinal back in Rome in 1544, function similarly as a rich backdrop to host visitors, as indicated by the way in which a mutual friend characterized him while staying at della Casa's house. Carlo Gualteruzzi reported to della Casa in a letter of January 12, 1545: "Today there were so many cardinals in

Your Lordship's house that the street was full of horses from the house of Master Damiano right up to Sant Agostino."[17] Apparently, Bembo was filling the chilly winter days with entertaining at della Casa's house, a setting for an impromptu court of sorts.

Bembo's social nature repeatedly comes up in his biographies, congruous with his character in Castiglione's *The Courtier*. As constantly confirmed in his letters, he saw visual works as catalysts for inquiry. That visual works could serve as the basis for social pursuits is demonstrated in Adelina Modesti's chapter in this volume. The household and studio of Elisabetta Sirani functioned similarly as a collective space, both private and public, for family and friends, for local artists and students, and for patrons and potential buyers. Here, as in Bembo's residences in Rome and Padua, books and artifacts were tools for conversation and social markers. Bembo keenly described della Casa's antiquities at the Palazzo Baldassini in his 1544 letter to Quirini, but he had some of his own small-scale antiquities with him. When he first moved to Rome in 1542, staying at the Vatican palace at first, he arranged with his secretary to bring from Padua medals, gems, and small statuettes, movable treasures from his own study.[18] Pausing to consider Bembo's conscious deployment of objects from Padua to Rome can inform us of the social collateral these desired works held, thus inserting a neglected interdisciplinary consideration to art-historical material. Anthropologist Arjun Appadurai recognized that "from a methodological point of view it is the things-in-motion that illuminate their human and social context."[19] These traveling works held special meaning. Bembo could not live in Rome without them. The visitors to the Palazzo Baldassini, who were clogging up the street with their horses, were Bembo's public: he had something to show the *cognoscenti* that crossed his threshold. Because of his extensive travel, his domestic space, whether his own or borrowed, was defined by objects of beauty and rare significance.

If we closely read Bembo's letter from Rome in 1542 to his secretary, much can be gleaned of his storage of medals and gems in his Paduan study, the ordering principle for the display of an array of objects, and the ways in which they were used:

2.2 Vittore Carpaccio, *Arrival of the English Ambassador to Brittany*, detail of King Maurus and his Daughter Ursula in Her Room, 1494, 275 x 589 cm, canvas, Accademia, Venice. Photo credit: Scala/Art Resource, NY

All the gold medals; all the silver, including those outside in the last larger bowl of Indian cane, which are more numerous than the others; the bronze ones from the first four bowls of that sort, and more if you think you ought to bring them; the bronze Jupiter, Mercury and Diana, and whatever in addition to this you choose to bring me. You will find in the Spanish medal room four or five mats of crimson silk which separate the shelves of the little chest where the gold medals are. These are put across the said shelves so that, when you carry the case, they do not escape from their slots. And the little velvet box goes into another box, covered in leather, which I keep on the floor under the wooden cupboards on the side of the said Spanish study. And so both the medals and the velvet box can be carried and sound. Put the other seventy-two gold medals in a little bag, those of each separate bowl in separate bags. And bring me also their little bowls … and that damascene pot where the seventy-two gold medals are. Bring me also that bowl with the rings and the carnelians and the other little things. And of the other things of little weight all that you can think that you can bring me. And do not tell anyone about this, because I do not want this to be known.[20]

His instructions show that the medals were in bowls, sorted by metal type: gold medals were stored together (some in a Damascene pot or vase), silver with silver (some in a large bowl of Indian cane), and bronze with bronze (in at least four separate bowls). His gold medals were stored between mats of crimson silk separated into individual slots and on a tray for each medal inside a little velvet chest that fitted within another leather-covered box for travel. His rings and carnelians were also held together in bowls. These vessels for storage, Bembo underscores, must also come with the medals to Rome for reinstallation – to reconstitute his domestic space in Padua. This is a working collection. This method accords with Luke Syson's study on the display of medals in early modern Italy as a type of presentation that lends itself more to study than to decorative ornamentation of an interior. Weighing physical examination of surviving examples with documentary evidence, Syson brilliantly observes that medals were increasingly pierced or appended with loops, suggesting that they were to be set into some sort of more permanent display. The affixed works could not be held and turned in one's hand, thus limiting examination to the exposed side on display. In this way, the works may only be experienced visually. This method of exhibition implies that the specimens were more advertisements or symbols of their owner's learning.[21] By contrast, Bembo's medals were sorted in bowls or slotted boxes from which a scholar might retrieve a specimen. The researcher could examine, turn over, compare to another, or even pass to someone else for discussion and then return the piece without disturbing a permanent display.

Noteworthy too is Bembo's designation of the receptacles: a damascene pot or vase, perhaps made of highly prized Middle Eastern inlaid metalwork,[22] and an Indian cane bowl, maybe an imported woven basket. The mode of decoration for the study in which these vessels were installed reached beyond the peninsula. In his funerary oration on Bembo, his close friend Benedetto Varchi notes:

The house of Bembo was like a public, worldly temple dedicated to Minerva: a family of pure and most chaste clergymen, where all who entered and presented themselves to pose questions to the science professors from the university, and with humility and much glory he [Bembo] sat, almost a new Apollo giving responses.[23]

In Varchi's poetic phrasing, Bembo's "temple" was not defined by architecture or objects, but by the visitors that sought knowledge and the exchange of ideas. Varchi's word choice brilliantly summarizes this sometimes-crowded residence: cosmopolitan, much like its inhabitant, the well-traveled Bembo. His home displayed objects for visitors, consciously orchestrated as a place that was neither temporally nor geographically neutral. Writing to Bembo's son Torquato, Pietro Aretino commented on this house: "It certainly appears that Rome itself has been transferred to Padua."[24] Certainly, Aretino referred to the Roman antiquities that graced the interior and exterior, but it may also have been a reference to the house's interior decoration. Two eighteenth-century travel writers, Charles-Nicolas Cochin and Giovanni Battista Rossetti, tell of a ceiling of one of the main rooms on the ground floor as being painted with ornate arabesques of 195 grisaille, faux compartments, within which are mostly female figures, some quite large, painted *all'antica*, in the style of Raphael.[25] Attributing the work to Giovanni da Udine, Cochin adds that, although the work was conceived in good taste, it was badly executed, but this could be taken to mean the state of conservation rather than the relative quality of the composition. Rossetti specifies the location as the second room to the right when entering the house, above the four doors. Although the house still survives, these paintings no longer exist, and where exactly they resided remains unclear.[26] The subject resonates with Varchi's poetic characterization of the space and Bembo's place within it as Apollo, the patron god of poetry. Could the figures have been muses, a subject etymologically matched for a museum setting? In Paula Findlen's study on the sixteenth- and seventeenth-century social and linguistic construction of the word "museum," she plausibly connects Petrarch's notion of the Muses with the renewal and study of antiquity.[27] As an advocate of Petrarch, Bembo speaks of a similar concept of the Muses, referring in his letters to these goddesses of creative inspiration within the context of his own ability to compose text. In 1539, a time around which Giovanni would have taken a commission for the ceiling decoration of Bembo's home, he writes of "my antique Muse" within the context of his composition of a sonnet about his long-time love and mother of his children, Morosina, who had died four years earlier. He was sharing the sonnet with his dear friend, Elisabetta Quirini, in the hope of attaining her impressions of the written piece. In 1534, he writes to Carlo Gualteruzzi that he was pleased with the sonnet by Francesco Molza that Gualteruzzi had sent him, lamenting that his own "vulgar muses" were at present far from him.[28] The spatial force of a ceiling graced with images of these ancient companions to Apollo could have conceptually united the array of antique and contemporary works on display below. Could these lost paintings have been part of Bembo's ordering

principle for the deployment of objects, for his poetic works, or for his finely tuned sociability in his study?

There is not, in fact, sufficient evidence to come to a positive solution to this question. To be sure, Giovanni da Udine was someone with whom Bembo would have been acquainted during his years in Rome when Bembo was secretary to Leo X, especially in connection to the artist's work in 1516–17 on Cardinal Bernardo Bibbiena's suite in the Vatican palace. Because Bibbiena was living away, Bembo served as intermediary between the cardinal and Raphael with his workshop, which included Giovanni da Udine.[29] From 1537 to 1540, the artist worked in Venice in the Palazzo Grimani in S. Maria Formosa, decorating with stucco the *Stanza di Diana* and the *Stanza di Apollo*.[30] Bembo was living almost exclusively in Venice from January 1538 until October 1539, and thus could have witnessed firsthand the progress of Giovanni, who, while in the area, could have taken a commission from Bembo.[31]

Since no detailed inventory survives of Bembo's Paduan house and its contents comparable to Catherine Fletcher's comprehensive documentary evidence for the Casali palace, discussed in Chapter 1 of this volume, we must access this residence indirectly from visitors' accounts and epistolary evidence. From the letter that introduced this discussion of display, we read that Bembo points his secretary to the "Spanish study for medals."[32] This could or could not be the same space with the frescoed ceiling, but the reason for this space's designation as being Spanish is tantalizingly mysterious. A fashionable scheme exported from Spain to other countries was gilt, stamped, or embossed leather, which could either be applied directly to the wall or sewn together to make hanging panels.[33] Bembo would have been familiar with the use of leather as a wall covering from Bernardo Bibbiena's suite within the Vatican. In one of his letters, he reports to Bibbiena that the decorative campaign was finished, along with the leather vestments, "i paramenti del cuoio."[34]

Sabba da Castiglione praised the import of foreign styles, describing this distinct form of wall decoration as "Spanish leather ingeniously wrought." He goes on to write that it reflected favorably on the owners of such ornamented spaces, as an indication of "judgment, culture, education, and distinction."[35] The manner in which the tangible decoration of one's home could stand for the intangible idea of the owner's reputation is underscored in Leonardo Fioravanti's 1567 comments that this type of interior decoration has its origins in Spain, but that "all important people are now interested in this work and it is the height of fashion in Rome, Naples and Bologna."[36] Early in the next century, Thomas Croyant commented on the gilt leather he saw during his tour of the Veneto, describing interior rooms of Venetian palaces and the office of the municipal administrator of Padua, the *podestà*, decorated with this scheme: "For their fairest rooms are most glorious and glittering to behold. The walles round about being adorned with most sumptuous tapestry and gilt leather."[37]

This leather wall covering in Bembo's study would have been valued for both its decorative and sound-proofing qualities, both desirable traits to grace the walls of a small space set aside for studying coins and composing text. Cardinal Reginald Pole reveled in Bembo's study. He stayed in the Paduan house for two months in 1546 while Bembo was in Rome at the Palazzo Baldassini. Writing to their mutual friend, the poet Vittoria Colonna, he praised the tranquil place that Bembo had created, singling out the studio and the garden as exceptional.[38] The exterior grounds of Bembo's house endured for centuries, was celebrated as late as the early eighteenth century, and was cited as still noteworthy in a collection of Bembo's works published in 1729.[39] In his funerary oration on Bembo, Benedetto Varchi wrote:

> this universal man [Bembo] born to all things beautiful and good worked toward
> an understanding of simples [medicinal plants] ... waves of which could be seen
> in his most beautiful garden in Padua, infinite herbs, native and exotic, which
> have been deservedly praised by those who have noted such things.[40]

Here a wide variety of plants for scientific, medicinal, and ornamental purposes were cultivated around the home's exterior. For example, in 1596, Caspar Bauhin noted seeing in the garden *menta cataria minor*, a species significant and rare enough to be noted in both of his botanical treatises.[41] This type of mint can be traced back to its use in ancient Greece and Rome.[42] In 1616, John Bauhin listed specific plant species in Bembo's garden in his treatise *Istoria universale delle piante*.[43] One plant type mentioned was a perennial, fragrant flower, Jupiter's beard or red valerian, which, in some varieties, is edible and is used today for its sedative qualities. This plant, with a name referring to the Roman god, was an appropriate backdrop to antique sculptures that were known to stand in this botanic garden: antique marble heads of Juno and Apollo.[44] Thus, the garden in Padua represents Bembo's activities as a collector seeking interwoven contexts for the revival of antiquity, informed by the scientific study of botany. His garden pre-dates by a decade the 1545 founding of Padua's Orto botanico, a place noted for its design and collection of medicinal plants for teaching affiliated with the University of Padua.[45]

Members of the faculty from the university were among the "family" of learned men that, Varchi says, frequented Bembo's study in Padua, but Bembo had his own actual family. He fathered three children: Lucilio (who died aged nine), Torquato, and Elena, by his long-time love, Morosina, who died at a young age when her surviving children were only 10 and seven years old respectively. Because he was often away, Bembo struggled to nurture them after her death, depending on his friend Cola, whom Elena once described as her "dear, almost father."[46] In one letter, Bembo urges Cola to show Torquato medals in the hope of sparking some interest in his ambivalent teenage son, writing that Torquato should know "my antiquities, which are not few nor of little excellence." In short, he should learn of the things he shall inherit.[47] A month later, he received good news from Cola that Torquato was starting

to show diligence in his studies. In response, Bembo delightfully notes: "It pleases me that he is acquiring knowledge from the ancient things, which always has been the care and study of genteel souls."[48]

Torquato's commitment was not sustained. In the year in which Bembo was drafting his will, he wrote in the frustrated words of a father to his friend and executor Girolamo Quirini that "if there is no hope that Torquato shall become learned, as you write me, I will leave my house in Padua and the study, with all its contents to Elena."[49] Threats aside, his son nevertheless was his universal heir.[50] Bembo's will is a collector's attempt to control, even after his death, the environment of the objects he had assembled. A will, and the related intentions imparted by that document, crystallize a moment in time and may make us wrongly assume that works that are asked to remain in a place in perpetuity are most highly valued. As Ann Matchette so ably points out, these clauses to keep collections together signal cultural ideals, but the preservation of such collections was not the norm. If we seek a more flexible model that sees accumulation as one stage in a cycle of ownership that also includes resale, then we may approach the early modern interior as a more dynamic mechanism for managing the economic life of a family.[51] As a case in point, Bembo himself sold an elaborate silver service to partially fund the acquisition of the house in Padua.[52]

Despite Bembo's best hopes that his son would see his collection and house as a monument, as he states in his will, to be used in comfort to honor his memory, Torquato did not carry out these wishes. The dispersal of family collections is not unusual; with changed economic circumstances, liquidation of assets follows.[53] As Matchette so ably observes, the movement of goods can elucidate the nature of a person's relationship to the objects accumulated or sold.[54] The sad truth in this instance is that Pietro Bembo's career in the Church, which forbade him from marrying, determined the social position for his children. Unlike Bernardo Bembo, who took his legitimate son Pietro with him on diplomatic missions, Pietro traveled without his illegitimate son. Although Torquato was legitimized by Pope Clement VII, it is, perhaps, this missed experience with his father that formed Torquato in such a way that Pietro complained of his son's lack of diligence in his letters.[55] This weighed on Pietro. He once pointed out in anger to his son that he must work even harder than his own father, given his lower birth status.[56] The collection was not Torquato's intellectual legacy because Pietro, the creator of it, had not himself engendered in his son a love for the studio in Padua. Pietro held a deep and sustained loyalty for that city, writing to his friend Federigo Fregoso that it was a beautiful place that drew brilliant men to its limits as a place for writing and study.[57]

Among those men, in one instance, was Cardinal Pole, who found peace in his studies in the cultivated natural environment of Bembo's garden, while Bembo sought refuge in the vineyard in Rome borrowed from Giovanni della Casa. In the above 1544 letter that Bembo sent to his friend Girolamo Quirini describing the room in della Casa's house, we see one of many instances

when he left his beloved studio. By way of conclusion, we see that staying at Palazzo Baldassini allowed Bembo to negotiate the complicated urban landscape of housing in Rome for resident cardinals and to interact with the court life of the Vatican without becoming embroiled in the day-to-day politics. Most importantly, it was a place to host guests and to further his own studies in an elegant and noble interior, much under the going prices for renting rooms in Rome – for free. The Roman palazzo constituted a happy home for the people who graced his door and for the objects he displayed, remaining there until his death in 1547. The early sixteenth-century Palazzo Baldassini was a building erected contemporarily to his public life with Leo X, a time in Bembo's own history that informed the renovation of his Paduan house, which Benevenuto Cellini once described as a residence in which a visitor could stay in rooms, "too grand for a cardinal."[58] Thus, Bembo's homes, borrowed accommodation or his own house in Padua, shed light on the distinctive social component of his activities as a writer, courtier, churchman, and collector. His study in Padua was not a place fixed in geography, but, rather, a dynamic mechanism for transmitting the analytic power and poetic potential he located in the visual.

Notes

1 This chapter derives from research conducted for my dissertation at Temple University. I am grateful to Tracy E. Cooper for her unwavering support and help during the long life of this project. I would also like to thank Marcia Hall, Peter Lukehart, Elizabeth Bolman, and Monika Schmitter for their contributions. This study began as a paper presented at the Renaissance Society of America's annual meeting in Montreal in 2011. I would like to thank Barbara Furlotti and Frances Gage for inviting me to speak in one of their sessions, and Gail Feigenbaum for her positive comments on my presentation. Research was funded by Temple University, the Gladys Krieble Delmas Foundation, and the Kress Foundation. Translations are mine except where otherwise noted.
 In July 1478, Bernardo was elected as ambassador to Florence, until May, 1480, and he brought the eight-year-old Pietro. Carlo Dionisotti, "Pietro Bembo," in *Dizionario biografico degli Italiani* (Rome: Instituto della enciclopedia italiana, 1966), 133. During April and May 1505, father and son traveled to Rome to congratulate Julius II upon his elevation as Pope. Pietro Bembo, *Lettere, edizione critica: collezione di opere inedite o rare*, ed. Ernesto Travi, 4 vols (Bologna: Commissione per i testi di lingua, 1987–93), 1:205.

2 Bembo, *Lettere, edizione critica*, 3:1005.

3 Ibid., 3:1391.

4 For a timeline of Bembo's life, see Susan Nalezyty, "Il collezionismo poetico: Cardinal Pietro Bembo and the Formation of Collecting Practices in Venice and Rome in the Early Sixteenth Century" (PhD dissertation, Temple University, 2011), 404–15.

5 Bembo, *Lettere, edizione critica*, 4:1935.

6 Ibid., 4:2190.

7 Ibid., 4:2103, 2130, 2132, 2133, 2139. Bembo had written to Cardinal Alessandro Farnese asking him to advocate on his behalf to be given the rooms in which he had previously lived while secretary to Leo X. He was unable to move into them because they were presently inhabited by Cardinal Campeggio, so he eventually stayed in the rooms of Jacopo Simonetta instead.

8 Bembo, *Lettere, edizione critica*, 4:2380.

9 Ibid., 4:2384.

10 Dora Thornton and Timothy Wilson, *Italian Renaissance Ceramics: A Catalogue of the British Museum Collection* (London: British Museum Press, 2009), 321–2. Stylistically, Mallet dates the plate within

the artist's oeuvre to 1542–3, the same time period when Bembo was living in Gubbio. See John V.G. Mallet, "Michelangelo on Maiolica: An Istoriato Dish at Waddeson," *Apollo* 139 (1994): 50–52, fig. 1.

11 Bembo, *Lettere, edizione critica*, 4:2383.

12 Ibid., 4:2384.

13 Ibid., 4:2444. Translation partially from Carol Kidwell, *Pietro Bembo: Lover, Linguist, Cardinal* (Montreal: McGill-Queen's University Press, 2004), 374. The original Italian text reads "un bellissimo camerino acconcio de' suoi panni molto ricchi e molto belli, e con un letto di velluto, e alquante statue antiche e altre belle pitture … Questa casa è, per quanto ella è, la più bella e meglio fatta che sia in tutta Roma … Mi dà ancora, e lascia per questo medesimo tempo, una bellissima vigna poco fuori della più bella porta di Roma, che è quella del Popolo, senza che io abbia ad aver di lei spesa alcuna." In return for his generosity, Quirino provided della Casa with accommodation in Venice. See Bembo, *Lettere, edizione critica*, 4:2465.

14 Kidwell, *Pietro Bembo*, 67. This evidence comes by way of a letter from Savorgnan. See Carlo Dionisotti (ed.), *Maria Savorgnan-Pietro Bembo, carteggio d'amore (1500–1501)* (Florence: Biblioteca rara, 1950), D73.

15 Bembo, *Lettere, edizione critica*, 2:332. This letter is undated, but based on the content, Travi estimates it to be from the early fall, perhaps September of 1513. For a translation of this letter, see Kidwell, *Pietro Bembo*, 168–71. Kidwell, however, translates certain terms inaccurately. She reads *sarza* as silk, but, according to the Venetian dialect, the term denotes a type of ordinary wool, or *sargia* or *sarge*, which can also be defined as a curtain for a bed. See Giuseppe Boerio, *Dizionario del dialetto veneziano*, 2nd edn (Venice: Giovanni Cecchini Edit, 1856), 602; John Florio, *Florio's 1611 Italian/English Dictionary: Queen Anna's New World of Words* (London: Melch Bradwood, 1611), 464. Peter Thornton writes that this type of material was a heavier version of *saia* or *say*, a fine cloth with a twill weave from the Low Countries, notably Bruges, which was famous in the sixteenth century, and may be the type that Bembo says in the letter that he preferred if he could afford it. *Sargia* can be understood as a distinctive class of woolen bed-cover, which could also be rigged as hangings, as Boccaccio describes. See Peter Thornton, *The Italian Renaissance Interior, 1400–1600* (New York: Harry N. Abrams, 1991), 75–6, 164–5. Kidwell also reads *pagonazza* as peacock blue, but, as an alternate spelling of *paonazzo*, it is not a simple color to define. Lisa Monnas offers that this color was often used when dying wool and can be of varying shades of violet, purple, or pink. See Lisa Monnas, *Merchants, Princes and Painters: Silk Fabrics in Italian and Northern Paintings 1300–1550* (New Haven: Yale University Press, 2008), 302, 314–15. In Venetian dialect, it is defined as a color between azure and black: Boerio, *Dizionario del dialetto veneziano*, 469.

16 Thornton, *The Italian Renaissance Interior, 1400–1600*, 125–9.

17 Partial translation from Kidwell, *Pietro Bembo*, 375. Ornella Moroni (ed.), *Corrispondenza Giovanni della Casa, Carlo Gualteruzzi (1525–1549)*, vol. 308, *Studi e testi* (Vatican City: Biblioteca apostolica vaticana, 1986), 91, esp. n. 6. The original Italian text reads: "Hoggi sono stati tanti cardinali in casa di Vostra Signoria che la strada era tutta piena di cavalli che tenevano da casa Mastro Damiano fino a Santo Agostino." Moroni notes that the house of Master Damiano was at the opposite end of the street, via delle Copelle.

18 Bembo, *Lettere, edizione critica*, 4:2347.

19 Arjun Appadurai, "Introduction: Commodities and the Politics of Value," in *Social Life of Things: Commodities and the Politics of Value*, edited by Arjun Appadurai (Cambridge: Cambridge University Press, 1986), 5.

20 Bembo, *Lettere, edizione critica*, 4:2347. Translation from, Kidwell, *Pietro Bembo*, 371–2.

21 Luke Syson, "Holes and Loops: The Display and Collection of Medals in Renaissance Italy," *Journal of Design History* 15(4) (2002): 229–44.

22 For a discussion of these sorts of objects, see Rosamond Mack, *Bazaar to Piazza: Islamic Trade and Italian Art, 1300–1600* (Berkeley: University of California Press, 2002), 139–48.

23 Benedetto Varchi, *Orazione funebre sopra la morte del reverendissimo Cardinal Bembo* (Florence: Anton Francesco Doni, 1546), C. The original Italian text reads: "Era la casa del Bembo come un pubblico, and mondissimo tempio, consacra á Minerva: la sua famiglia puri, e castissimi sacerdoti, dove tutti entravano o ad offerire o per dimandare i professori delle scienze, e egli humile in tanta gloria, si sedea quasi nuovo Apollo dando i responsi."

24 Ettore Camesaca and Fidenzio Pertile (eds), *Pietro Aretino, Lettere sull'arte*, vol. 2, *Vite, lettere, testimonianze di artisti italiani* (Milan: Edizioni del Milione, 1957), 2:392–3.

25 Charles-Nicolas Cochin, *Voyage d'Italie, ou recueil de notes sur les ouvrages de peinture et de sculpture qu'on voit dans les principales villes d'Italie*, edited by M. Gault de Saint-German (Geneva: Minkoff, 1751; reprint, 1972), 161. The French text reads : "La Maison du Cardinal Bembe. On y voit un

portique dont l'architecture est assez belle, surtout pour le temps où elle été faite, une salle et quelques cabinets peints par Jean da Udine. Tout est orné d'arabesques d'assez bon goût, mais foiblement exécutés. Il y a quelques grandes figures, qui n'ont de bon que quelque idée du goût de Raphael, & de petits bas-reliefs en peinture, assez passablement touchés, & qui tiennent du goût de l'antique." Giovanni Battista Rossetti, *Descrizione delle pitture, sculture, ed architetture di Padova, con alcune osservazioni intorno ad esse, ed altre curiose notizie*, 2 vols (Padua: Stamperia del Seminario, 1765), 2:327–8. The Italian text reads: "In poca distanza dal Santo, sulla strada che conduce a S. Giustina press il Ponte del Businello vi è la Casa, che un tempo fu abitata dal Cardinale Pietro Bembo. Questa era adorna di statue, di mosaici, di stuchi, e d'altre cose degne di que grand'Uomo, le quali sono andate a male, trattene alcune Pittura, ed un soffitto della seconda stanza terrena, alla parte destra entrando in Casa, che ne'Viaggi d'Italia dell'altrove mentovato M. Cochin ritrovai descritte. Portatomi a vedere questa Casa, che oggi è abitata dal Nobile Uomo Signor Filippo Farsetti (a), vidi a chiaro-scuro alcune cose sopra le quattro porte, che sono nella sala terrena, e nella mentovata Stanza il soffitto diviso in 195 comparti, in ognuno de' quali vi sono dipinte a chiaro-scuro una, or più figure, la maggior parte di donne, da Giovanni da Udine, d'un gusto antico, a Raffaellesco. De questa notizia ne son debitore al suddetto M Cochin."

26 The present author gained access to this building, currently a museum to the Italian Third Army.

27 Paula Findlen, "The Museum: Its Classical Etymology and Renaissance Genealogy," *Journal of the History of Collections* 1 (1989): 59–63.

28 Bembo, *Lettere, edizione critica*, 3:1569; 4:2100.

29 Ibid., 2:372, 376, 377, 384. See also Nicole Dacos, "La Loggetta du Cardinal Bibbiena décor à l'antique et rôle de l'atelier," in *Raffaello a Roma: il convegno del 1983* (Rome: Edizioni dell'Elefante, 1986), 225–36; Nicole Dacos and Caterina Furlan, *Giovanni da Udine (1487–1561)*, vol. 1 (Udine: Casamassima, 1987), 34–94; Angelica Pediconi, "Cardinal Bernardo Dovizi da Bibbiena (1470–1520): A Palatine Cardinal," in *The Possessions of a Cardinal: Politics, Piety, and Art 1450–1700*, edited by Mary Hollingsworth and Carl M. Richardson (University Park, PA: Pennsylvania State University Press, 2010), 92–112.

30 Marilyn Perry, "A Renaissance Showplace of Art: The Palazzo Grimani at Santa Maria Formosa," *Apollo* 13 (1981): 215–21. See also Annalisa Bristot, *Palazzo Grimani a Santa Maria Formosa: Storia, arte, restauri* (Verona: Scripta, 2008); Dacos and Furlan, *Giovanni da Udine (1487–1561)*, 165–73.

31 Bembo, *Lettere, edizione critica*, 4:1912–2072.

32 Ibid., 4:2347.

33 John W. Waterer, *Spanish Leather* (London: Faber & Faber, 1971), 53–4. Waterer points out that Titian painted such hangings in the background of his *Venus of Urbino*. See also Francis Lenygon, "Gilt Leather Rooms," *The Art Journal* (September 1911): 281–5; Thornton, *The Italian Renaissance Interior, 1400–1600*, 85–6. A beautiful sixteenth-century example of this type of decoration survives in the Palazzo Madama in Turin (inventory no. 126/CU).

34 Bembo, *Lettere, edizione critica*, 2:377.

35 Quoted in Patricia Fortini Brown, *Private Lives in Renaissance Venice* (New Haven: Yale University Press, 2004), 89.

36 Leonardo Fioravanti, *Dello specchio di scientia universale* (Venice: Andrea Ravenoldo, 1567), 1:41, 92–3. The Italian text reads: "Certamente che colui, il quale trovo questa arte de i corami l'oro, fu huomo singulare, & di gran giuditio; ben che io non credo, ne crederò mai, che un solo ne fusse l'inventore, & la tirasse a quella perfettione, & bellezza, che oggi dì si fà; & questa arte, credo io che havesse origine & principio in Spagna: percioche di quella provintia sono usciti i migliori maestri, ch' in questa nostra età habbino fatta tal arte: la quale è oggi dì in grandissima riputatione appresso gli huomini grandi, & molto in uso in Roma, in Napoli, in Sicilia, in Bologna."

37 Thomas Croyate, *Coryat's Crudities* (Glasgow: J. MacLehose & Sons, 1611; reprint, 1905), 294, 403.

38 Ermanno Ferrero and Giuseppe Müller (eds), *Vittoria Colonna Marchesa di Pescara, Carteggio*, 2nd edn (Turin: Ermanno Loescher, 1892), 311. The Italian text reads: "grande commodità che io ho qui in casa rev.[mo] Bembo, dove sto prima con tanta sicurtà contentezza dell'animo come, se io stessi in casa de padre poi con quella comodità che io non potrei desiderar meglio a questo tempo massime di due cose nelle sempre ho sentito gran piacere cioè d uno studio d un giardino i quali io ho trovati tutti dui qui belli che non saprei dove poterli trovare più al mio gusto." For Bembo's instructions to his contact in Padua, Gabriel Boldù, to accommodate Pole's entrance into the studio, getting keys from Luigi Priuli, see also Bembo, *Lettere, edizione critica*, 4:2550, 2553.

39 In the 1729 edition of Bembo's *Opere*, in the index of "Notable Things," the garden is mentioned as still extant: Pietro Bembo, *Opere di Pietro Bembo* (Venice: Librajo all'insegna della Roma Antica, 1729).

40 Varchi, *Orazione funebre sopra la morte del reverendissimo Cardinal Bembo*, B3. The Italian text reads: "Diede ancora opera questo huomo universalissmo nato a tutte le cose, o belle, buone, alla cognizione de' semplici … in Padova nel suo bellissimo giardino si potevano vedere da chiunche voleva infinite herbe così nostrali come straniere, la qual cosa tanto merita lode maggiori quanto allora si trovavano più radi coloro i quali di simili studi havessero alcuna cura o notizia."

41 Kaspar Bauhin, *Phytopinax* (Basel: Sebastianum Henriepetri, 1596), 354; Kaspar Bauhin, *Prodromos theatri botanici* (Frankfurt: Jonnis Regis, 1620), 110.

42 Alfred C. Andrews, "The Mints of the Greeks and Romans and their Condimentary Uses," *Osiris* 13 (1958): 131. According to Andrews, this species is also known as *menta dei gatti* in Tuscany and *menta gattaria* in Sicily.

43 John Bauhin, *Historia plantarum universalis*, 3 vols (Ebroduni: Franciscus LVD A Graffenried, 1650–1651), 1:295. This work was published 40 years after the author's death; thus, Bauhin likely visited the garden in the late sixteenth century or early seventeenth century. See also Giovanni Marsili, *Notizie del pubblico giardino de' semplici di Padova* (Padua: Coi Tipi del Seminario, 1771; reprint, 1840). Marsili quotes Bauhin's 1616 account, describing it as Torquato Bembo's (Pietro's son) "orto semplice."

44 Jacob Stockbauer, *Die Kunstbestrebungen am Bayerischen Hofe unter Herzog Albert V. und Seinem Nachfolger Wilhelm V* (Vienna: Wilhelm Braumüller, 1874), 55.

45 Alessandro Minelli, *L'orto botanico di Padova: 1545–1995* (Venice: Marsili, 1995).

46 Francesco Sansovino (ed.), *Delle lettere da diversi re, et principi, et cardinali et altri huomini dotti a Mons. Pietro Bembo* (Venice: Francesco Sansovino and Company, 1560), 1:31.

47 Bembo, *Lettere, edizione critica*, 4:2210. The Italian text reads: "Ho pensato che vorrei che gli mostraste alcuna volta di quelle medaglie, acciò che esso incominciasse a conoscerle e a dilettarsene, a pigliasse alcuna intendenza in quelle pratiche. Perciò che avendo quelle mie anticaglie, che non son né poche né di poca eccellenza, ad esser sue quando a N.S. Dio piaccia, vorrei che egli sapesse che cosa elle siano: ché gli sarebbono tanto più care."

48 Ibid., 4:2246. The Italian text reads: "Piacemi ancora che egli prenda qualche conoscenza delle cose antiche. Il che è sempre stato cura e studio di gentili animi."

49 Ibid., 4:2438. The Italian text reads: "se non che, se non ci è speranza che Torquato si possa far dotto, come V.S. mi scrive, io lascerò la mia casa di Padova e lo studio, con ciò che in esse e in essa è, alla mia Elena."

50 Biblioteca Nazionale Marciana, It. XI, 25 (= 667), 1r–8v. On September 5, 1544, Bembo edited his first will, incorporating new language while letting other parts of the first stand. Cian published the will in its entirety: Vittorio Cian, *Un decennio della vita di M. Pietro Bembo (1521–1531)* (Turin: E. Loescher, 1885), Appendices VI and VII, 201–3.

51 Ann Matchette, "To Have and Have Not: The Disposal of Household Furnishings in Florence," *Renaissance Studies* 20(5) (2006): 705–9.

52 Bembo, *Lettere, edizione critica*, 2:802, 806, 813, 814. In a letter of August 9, 1527, he describes in detail the silver service, and a few days later on August 16, he mentions that it might not be available.

53 Paula Findlen, "Ereditare un museo. Collezionismo strategie familiari e pratiche culturali nell'Italia del XVI secolo," *Quaderni storici* 115 (2004): 45–81.

54 Matchette, "To Have and Have Not," 702.

55 Pope Clement VII legitimized Lucilio and Torquato, thus allowing church benefices and family possessions to legally pass from father to son: Kidwell, *Pietro Bembo*, 257. By papal brief he legitimized Lucilio, with a postscript stating that the same rites would be given to Torquato when he reached the age of seven. Two years later, on January 19, 1532, Bembo wrote to Clement VII asking him to legitimize Torquato: Bembo, *Lettere, edizione critica*, 3:1322.

56 Bembo, *Lettere, edizione critica*, 4:2226.

57 Ibid., 2:428.

58 Charles Hope and Alessandro Nova (eds), *The Autobiography of Benvenuto Cellini* (Oxford: Phaidon, 1983), 93.

"A casa con i Sirani": A Successful Family Business and Household in Early Modern Bologna

Adelina Modesti

Introduction

The dichotomy of public/private which traditionally has seen a separation of the domestic sphere of the household from the external world of work and cultural diplomacy breaks down when we look at the casa-studio of professional artists such as the Sirani working in the early modern period. This chapter emphasizes a new perspective on the domestic interior as a fluid organization of space which is in continual flux, produced and transformed by the comings and goings of people and objects. This interior-exterior flow of people and things marks the household spaces as a malleable "open" site of production and consumption. The workshop space extends beyond its practical usage as a place of work only, to incorporate teaching rooms, *maggazini* (storerooms), a library, and a reception hall for the Sirani's many distinguished clients and guests. The domestic interior thus becomes a *via-vai* (coming and going) passage for the display and circulation of objects (artworks, gifts), diplomatic exchanges and ideas, as the Sirani casa-studio is transformed into a cultural *salotto*. It is this dynamic and fluid nature, especially the use of previously designated "private" domestic spaces as semi-public sites of reception and entertainment, which links this chapter to the other two case studies in this part. The Sirani aspired to the aristocratic pretensions of the likes of the Casali of sixteenth-century Bologna or the cultural grandeur of Cardinal Bembo's portable Studiolo. Bembo's use of his humanist studio as an impromptu court can be compared with the Sirani casa-studio's reception of visiting dignitaries. Yet, as artists from a humble merchant background, theirs was a less grand manifestation of a similar socio-cultural ambition. Their home for example was not a palazzo like the Casali, but a modest two-storey townhouse. Nonetheless, the family successfully fraternized with

and entertained in their home the most important noble families of Bologna, and visiting royalty, who all came to the Sirani casa-studio to witness the extraordinary talents of its star attraction, the young female painter Elisabetta Sirani (1638–65).

An Artist and Her Family in Early Modern Bolognese Society

The Sirani family of seicento painters and printmakers – Giovanni Andrea Sirani (1610–70) and his daughters, Elisabetta, Barbara, and Anna Maria – came from a family of artists, artisans, *commercianti*, and *speziali* (apothecaries). The family also had a noble branch constituted by Virgilio Sirani and the "illustriss. Giovanni Simone Sirani" – for whom the highly successful but short-lived Elisabetta Sirani, the jewel in the Sirani artistic crown, produced a *Rest on the Flight into Egypt* in 1659.[1] Along with other artist families of Bologna like the Pasinelli and the Colonna, the Sirani were included in Giuseppe Guidicini's nineteenth-century genealogy of Bolognese families as "*Cittadini*"; they had their own family citizen *stemma*;[2] and they were property owners. We know that the household-head Giovanni Andrea Sirani, Elisabetta's father-teacher (*padre-maestro*), owned a residence in Vicolo Broilo de'Oiatesi, opposite the Piazza del Nettuno, as well as a *casa di campagna* outside Porta San Mammolo. He also rented out two apartments in the Palazzo de' Paselli, in the parish of S. Maria Maggiore, where his friend and patron Conte Corrado Ariosti also owned property.[3] The Sirani family lived in the S. Maria district from circa 1650 to at least 1653.[4] Prior to this, Giovanni Andrea Sirani had his residence and studio in the complex of the *Ospedale della Morte* near Piazza Maggiore.[5] By the time Elisabetta Sirani was painting professionally in the mid-1650s, the family and the Sirani studio had moved again, to the parish of S. Michele Arcangelo, where they were recorded in the parish records in 1654.[6] By 1656, the artist was living and working back in the Sirani family parish of S. Mammolo in a two-storey townhouse and studio in Via Urbana, 257 (see Figure 3.1) with her extended family comprising her father, mother, Margarita Masini[7] (dalla Mano), a paternal aunt, Giacoma Sirani, a maternal aunt, Isotta Masini, and her younger sisters and brother, Barbara, Anna Maria, and Antonio Maria.[8]

The Sirani casa-studio is the focus of this study. Giovanni Andrea Sirani rented the Via Urbana residence, located opposite the Convent of Corpus Domini, from the Barnabite priests of S. Paolo (in adjacent Via Collegio di Spagna)[9] next to the Collegio di Spagna (Figure 3.2), and close to the Palazzo Zambeccari, home of one of the most important senatorial families of Bologna.

The Zambeccari were among the Sirani's many patrician patrons. Documents in the Archivio di Stato di Bologna indicate the family was in a position to hire notaries to draw up official contracts, attesting to the Sirani's economic and social prestige within the community.

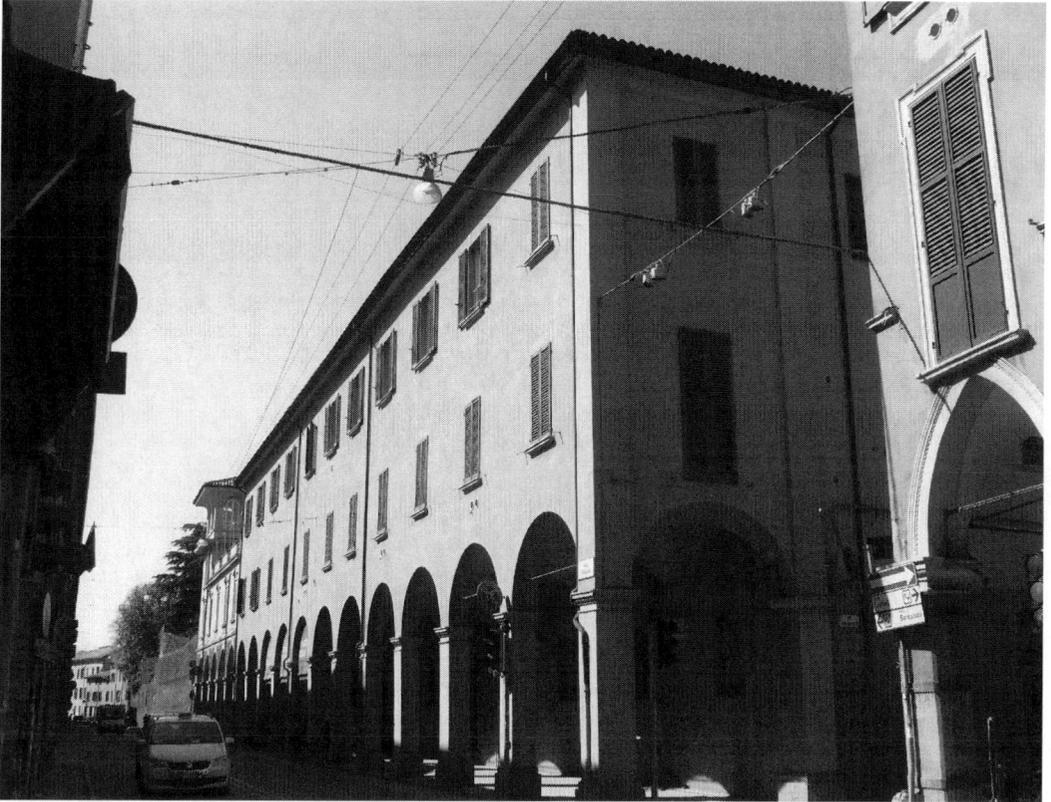

3.1 The Sirani house, as it is now, in Via Urbana, Bologna. Photo credit: Author, 2010

The Sirani family also had female domestic retainers, referred to as "le donne di casa," one of whom, Lucia Tolomelli, resided with the family in Via Urbana and was later accused, tried, and acquitted of having poisoned Elisabetta Sirani.[10] Another domestic, a Signor Antonia Donnini and her daughter Anna Maria, appear to have been neighbors who helped out the family on occasion as required, with Anna Maria described by Giovanni Andrea Sirani as "our neighbour and usually working in our house."[11] Lucia Tolomelli testified at her trial[12] that the Donnini mother and daughter "went here and there about Bologna undertaking the services ordered by the said *signori* Sirani,"[13] as when Anna Maria delivered a painting in August 1665 to Sirani patron Count Annibale Ranuzzi (perhaps the allegorical portrait of his sister as Charity that Ranuzzi had ordered from Elisabetta Sirani that year). Donnini herself confirmed that she often was "in the house of the Signor Giovan Andrea Sirani, where I usually worked."[14] Sometime around 1660, the Sirani further retained a carpenter, Angiolino Riva, to prepare Elisabetta's frames and much sought-after canvasses, as he himself testified: "being a carpenter, I stretched the canvasses for the paintings of the said Elisabetta Sirani, who was a paintress, that is she painted."[15] Anna Maria Donnini also refers to other unspecified "people of the household of said Signor Sirani, who at that time [Elisabetta's death], were not in the kitchen."[16]

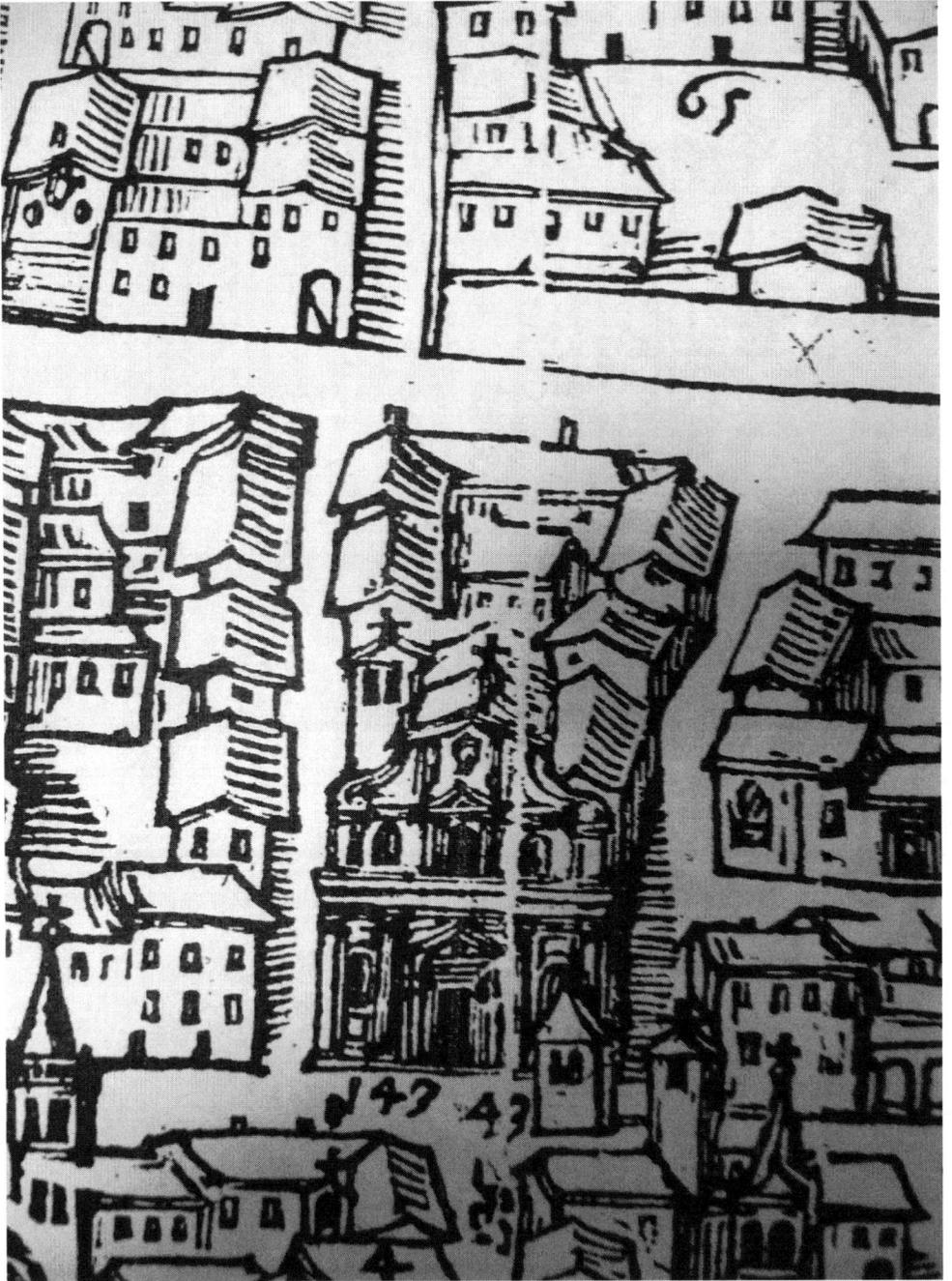

3.2 Matteo Borboni, Map of Bologna, 1638.
Detail showing S. Paolo Barnabiti and Via Urbana.
Photo credit: Biblioteca Comunale dell'Archiginnasio,
Bologna (BCABo), Gabinetto Disegni e Stampe (DGS)

They would have been apprentices, students, and models of the Sirani bottega who occupied the other spaces of the Sirani casa such as the studio and the *magazzini*.

The Sirani Bottega

Giovanni Andrea Sirani, "perito, professore e maestro,"[17] had become Guido Reni's principal assistant, after having studied with Giacomo Cavedone and a number of minor artists, including Giovanni Andrea Curti, Benedetto Possenti, and Florio Macchi.[18] After the master's death in 1642, the 32-year-old, a father of two young girls (Elisabetta and Barbara), established one of the most successful art studios operating in Bologna in the mid-seicento. The Sirani *bottega*'s cultural production consisted not only of original fine art in the form of drawings, painting, and prints on commission from Bologna's aristocratic patrons and merchants, but also commercial and pietistic material for the popular and professional market. These included the serial production of religious and secular prints, book illustrations and frontispieces, thesis conclusions to serve the city's large intellectual community, and printed popular devotional images for religious and lay pious institutions and private domestic use,[19] such as the examples from Elisabetta and her pupils' artistic production discussed in my monograph on the artist.[20]

Giovanni Andrea Sirani's pupils and assistants included not only his own daughters Elisabetta, Barbara, and Anna Maria (the latter two also taught by Elisabetta), but also Lorenzo Tinti (1626/34–72) and Lorenzo Loli (1603–72), who became noted printmakers in the second half of the seicento. Other members of the Sirani *bottega* were Giuseppe Diamantino from Frossombone, Conte Giovanni Battista Zani, a painter, printmaker, and poet who, like Elisabetta, died tragically young at the age of 29;[21] Giuseppe Aldrovandini;[22] Don Mario Macchiavelli, "priest and Doctor of Law";[23] the nobleman Bartolomeo Musotti – also a sculptor who studied under Algardi in Rome – described by Malvasia as a "a great intelligent dilettante, (and) good drawer/designer";[24] Bartolomeo Zanichelli, who began his apprenticeship as a youth of 18 circa 1651 and was to remain with the Sirani for over 15 years;[25] Marco Antonio Donzelli detto "il Novellaro"; and Giulio Benzi (1647–81), who joined the Sirani studio circa 1660 as a boy of 13 during Elisabetta's own maturing as a professional artist. Benzi's testimony at the inquest into Elisabetta's early death in 1665 at the age of 27 indicates the close professional and familial relationship between the young apprentices of the Sirani *bottega*, with Elisabetta, whom Benzi knew "very well (*benissimo*)," in all likelihood treating the boy as a younger brother.[26] The painters Domenico Maria Canuti and Marco Bandinelli also studied and worked with Giovanni Andrea Sirani, but were no longer with the *bottega* when his daughter Elisabetta began her own training circa 1648.[27]

In what sort of *casa-bottega* did the Sirani live and work? From inventories and court testimonies, we can gage its spatial layout and contents. It was a

two-storey modest palazzo, with an "upstairs apartment" described by Lucia Tollomelli as the "house of the signori Sirani"[28] located on the *piano nobile* with a small reception hall, a "room for the owners"[29] where meals were eaten (*cenacolo*), with the domestic help eating in the "cucina" (kitchen) where "Lucia took care of and did all the household duties."[30] The family's bedrooms were located down the stairs in the "apartment below"[31] where "Madonna Margherita," la signora Sirani, and the younger daughter Barbara would often retire when unwell (as testified by Sirani domestic Lucia Tolomelli).[32] Further below this was the "cantina" for the family's stores. This accords with the 1629 bill of sale, when the Barnabiti bought the former Fabrica della Congregazione di Strada Urbana, which describes "portico," "cantine," "cucinotto," "cucina" and "camera," over two levels.[33] This also compares similarly with the (undated) plan[34] of an apartment behind S. Paolo's sacristy (Figure 3.3), in the same new building complex as the Sirani house, with its "cucina," "cucinotto," "sala da ricevere," and "salotto" ("a handsome dining chamber").[35]

A seventeenth-century fresco in the Palazzo Comunale, Bologna represents the newly constructed Via Urbana[36] (Figure 3.4) and shows the common porticoes at ground level, extending the length of the block, with small windows on the upper level.

Elisabetta Sirani died on 28 August 1665 in the "room at the bottom of the house" (as recounted by her neighbor Petronio Barilli)[37] in the lower apartment. She was in her mother's bedroom, as her mother Margherita Masini testified: "I led her into my room and having undressed her I placed her in my bed … and at 23 hours circa, she passed from this to the next life."[38] Elisabetta's paternal aunt Giacoma Sirani also recalls seeing Elisabetta doubled over in pain "as she descended the stairs to go to the lower apartment,"[39] that is, coming from the upper level, where the artist had been working on a painting for Grand Duchess of Tuscany Vittoria della Rovere, to the ground floor where the bedrooms were located, and where her sister Barbara was also ill.

Within close proximity of the family quarters on the *piano nobile*, the Sirani artist studio and workshop consisted of a number of rooms for teaching (including theory and life-drawing), the painting studio, for the production of connoisseur works for private patrons, and an avant-garde printmaking studio, where much of the serial artistic production took place, to furnish the wider market. Malvasia indicates that Giovanni Andrea Sirani experimented with the latest etching techniques (*acquaforte*), which he passed on to Elisabetta and his male apprentices. The biographer also suggests that the professional studio spaces of the workshop were easily accessible from the domestic spaces of the household, when he recounts an anecdote regarding mother Margherita who, on entering the studio, commented on the radiance of baby Elisabetta, then only 18 months old, as she posed for a painting of a Madonna and Child being worked on by her father.

3.3 Plan of a similar-sized house located between the sacristy of
San Paolo Barnabiti and the Sirani house.
ASBo, Fondo Demaniale (Barnabiti), Corporazioni religiose soppresse, 87/4979,
Campione di Piante. Photo credit: su autorizzazione del Ministero per i Beni e le Attività
Culturali – Archivio di Stato di Bologna, Autorizzazione n. 1000 del 19 marzo 2012

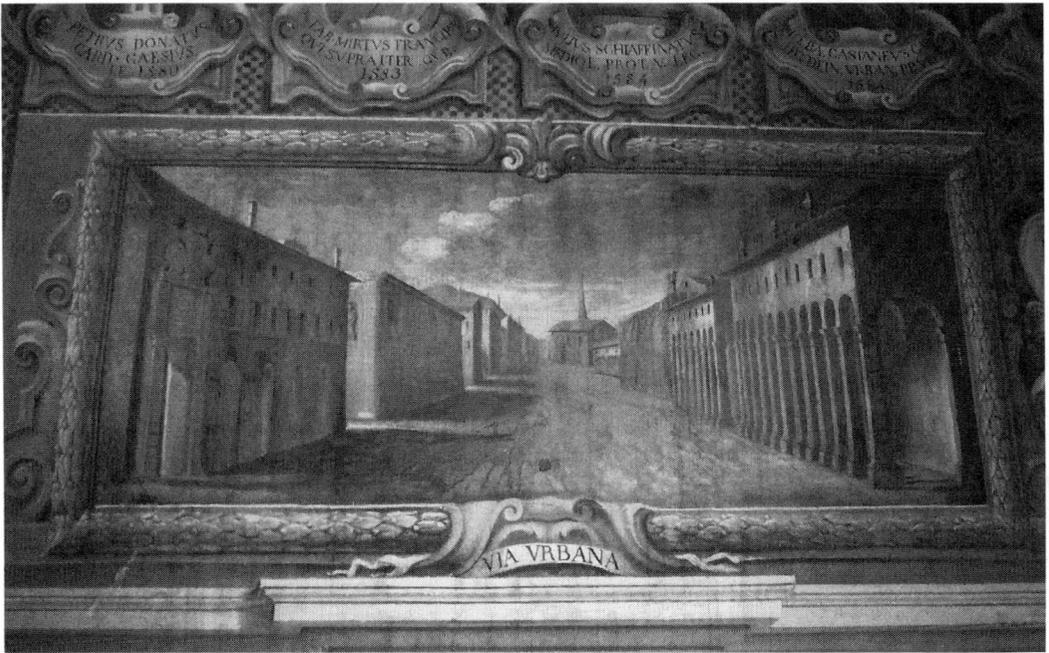

3.4 Seventeenth-century fresco of the new Via Urbana, constructed 1629, showing the Casa Sirani on the right, opposite the Convent of La Santa. Sala Urbana, Palazzo d'Accursio (Comunale), Bologna. Photo credit: Author, 2010

Giovanni Andrea (in patriarchal fashion) immediately berated his wife to return "inside" (i.e. supposedly to the kitchen) where she could more verily "observe/osservare" her own business![40] What this anecdote tells us is the permeability of the liminal, internal spaces of the Sirani casa-studio, which we shall see further below, with the myriad of guests who visited, mingling with family, domestic retainers, artists and pupils, male and female, and probably also encountering the models posing for the allegorical, religious, and historical paintings that were the bread and butter of the family business.

The *bottega* also had storerooms (*magazzini*), in which were deposited *bozze*, canvases of various subject matter, produced to a sketched in stage, which prospective clients could choose to have quickly worked up and completed by Elisabetta, her father, or other members of the Sirani studio as desired. The Sirani inventories from the family's 1672 *Divisione dei beni* (estate division) register a ladder and easels left to his youngest daughter Anna Maria, "needed for her painting/per servirssene a dipingere."[41] Anna Maria continued as a professional painter after her late marriage in the 1670s. There were also numerous drawings, prints, and plaster casts, including works by Albrecht Durer, Lodovico Carracci, and Michelangelo, and unfinished paintings by Sirani's *maestro* Guido Reni which Giovanni Andrea had acquired at his master's death,[42] from which the apprentices would study and practice drawing from. The male apprentices would soon move on to drawing from the live model, a practice barred to Elisabetta and her female assistants and pupils.

The wonderful collection of drawings, which also included those that regularly passed through the Sirani studio in large lots from Prince Leopoldo

de' Medici for Giovanni Andrea to appraise,[43] as well as all those formerly owned by the artist Cesare Baglione which Sirani had acquired from his widow,[44] the plaster casts of classical works, prints, together with Reni's in-house paintings – all of these would have been indispensible for the cultural formation of the female members of this highly productive studio. They most probably also drew each other and their younger siblings rather than the models that populated their father's studio. The 1672 inventory also refers to about 80 texts, covering classical literature (Ovid), history (Pliny, Plutarch), mythology (Cartari), biblical narratives, hagiographies, and then extending to the latest contemporary writings on art and theory by Lomazzo, Malvasia, and Vasari, including the artist's bible, Cesare Ripa's *Iconologia*.

This Sirani professional library was accessible to Elisabetta and her pupils, as well as to her brother, who studied medicine and philosophy.[45] This wealth of literary sources would have been especially crucial for the artistic training and cultural formation of the female students of the Sirani *bottega*, including Elisabetta's two younger sisters, Barbara and Anna Maria, who could not travel outside Bologna, or even much beyond the confines of the family home and studio, as their male counterparts could to study works of art or pursue an education.

Elisabetta Sirani's artistic formation, as well as her classical humanist education, was in this *initially* male-dominated family studio[46] alongside the boy apprentices of this "florida scuola/flourishing school," as it was referred to by Luigi Crespi. In this family studio, Giovanni Andrea Sirani, a noted *professore* also at the city's life-drawing academies, taught his pupils the latest drawing, painting, and printmaking techniques.[47] Some of these male colleagues were to become Elisabetta's own pupils and assistants when she became *caposcuola/head* of the Sirani bottega after her father could no longer work due to illness in the 1660s.[48] Lorenzo Tinti, who produced a posthumous presentation portrait of his *maestra*, and even more so Lorenzo Loli, were to collaborate with the mature Elisabetta, producing prints from her designs and *stampe di traduzione* of her more noted works.[49] Bartolomeo Zanichelli specialized as copyist of her works after the demand for them grew in the 1660s.[50] The scholar and prelate Macchiavelli also "was a student of the famous Elisabetta Sirani … and developed into a good figure drawer,"[51] according to Marcello Oretti, who further mentions a certain Giovanni Maria Bergami as having attended the "famous school of Elisabetta Sirani,"[52] which, as we shall see, was to become an exclusively all-female affair.

In this environment, the Sirani family painting and teaching casa-studio was developed by Elisabetta Sirani into an important cultural site in early modern Bologna, where she practiced as the city of Bologna's most successful and significant female exponent of the arts and letters. Sirani and her famed studio and academy for young women, affectionately dubbed "la sua scuola/ her school" by her lifelong mentor and biographer Count Carlo Cesare Malvasia,[53] not only became the dynamic center of her own female artistic circle but was also the heart of Bologna's cultural and diplomatic world in

the mid-seventeenth century. The city's social, intellectual, political, and ecclesiastical elite, as well as important foreign visitors, would converge here to discuss art, poetry, and music, have their portrait painted or sketched, gossip and be entertained by their "cultural heroine" at work and play. Sirani held court and amazed all with her erudition, sharp wit, poetry, musical accomplishments, and above all public displays of her virtuoso painting. Here "la maestra" also taught her approximately 20 female students, all of whom went on to become professional painters or printmakers, establishing one of the earliest art academies for women in Europe.

Malvasia is the first to give us an indication of the female pupils whom Elisabetta taught at her "Scuola":[54] Ginevra Cantofoli,[55] Veronica Franchi, Angela Teresa Muratore,[56] Elena Maria Panzacchi (1659–1737), Teresa Coriolano, Maria Oriana Galli Bibiena (1656–1749), Lucrezia Bianchi (active 1670), Lucrezia Scarfaglia,[57] Camilla Lauteri (1649–81),[58] Catterina Mongardi, and Veronica Fontana "famous already and the only female engraver in wood."[59] Malvasia also notes Elisabetta's two younger siblings, Barbara Sirani Borgognoni (1641–92) and Anna Maria Sirani Righi (1652–1715), who were taught by their father and elder sister. However, Antonio Masini[60] provides fuller information on the work of most of these and other professional women artists working in Bologna in the seventeenth century. He introduces us to Vincenza Fabri, another of Elisabetta's pupils, Anna Teresa Messieri (born 1669 and active by 1684, pupil of Cesare Gennari), and Angela Cantelli Cavazza (active 1676), "paintress of certain fame"[61] also believed to have been "student of the said Sirani."[62]

The artist's published work diary (*Nota delle pitture fatte da me Elisabetta Sirani*), supported by a range of archival evidence and inventories and civic chronicles, enables us to explore this entrepreneurial woman's female networks. Elisabetta's intriguing web of relationships extended out from family and friends, pupils and assistants, to patrons and supporters – local and international. People from all social levels and classes intersected within the confines of Elisabetta's family studio-salon: a microcosm of Bolognese (and European) Baroque culture and sociability.

Bologna Dotta: The Setting

Elisabetta Sirani was fortunate enough to have been born in Bologna, the most important city in the Papal States after Rome. Bologna was remarkable in its promotion of female education. Patrician women were active agents in its public life and civic rituals, and their intellectual and creative attributes were publicly celebrated. Bolognese chronicles and *ricordi* are replete with references to women's visibility in the public sphere; hardly any important social, civic, or religious event passed without mention of their presence. They actively organized as well as fully participated in the city's festivities and banquets, public debates, and local religious processions.

As Caroline Murphy has shown, Bolognese noblewomen's collective social identity was extremely marked and especially important for the city's image of political unity.[63] The wives of the city's political leaders, for instance, formed part of the official welcoming parties for important female visitors to Bologna, accompanying their ceremonial entry into the center, just as their consorts, the *Senatori, Anziani,* and *Gonfaloni,* did for visiting male dignitaries. These guests were lavishly and generously entertained with dinners and parties organized by the women at their *palazzi,* and were shown Bologna's most honored cultural attractions, amongst which was Elisabetta Sirani painting in her studio at Casa Sirani.

Sirani's VIP Visitors

When the Duke and Duchess of Brunswick visited Bologna on their way to Venice in early January 1665 "with a retinue of 70 people,"[64] the entire entourage was lodged at great personal expense in Senator Ercole Marescotti's palace, and before leaving "many Balls were held, that is in Casa Tanara, Fibbia and Caprara."[65] According to Conte Annibale Ranuzzi, during this sojourn "The Signora Duchess of Brunswick … made it quite clear to the Ladies who accompanied her [that she wished] to appreciate everything"[66] that the city of Bologna had to offer.[67] The Duchess, Elisabetta Giuliana of Holstein-Norburg, was indeed accompanied by the Senator's wife and Sirani patron, Contessa Laura Angelelli Marescotti, and the city's noblewomen not only to the Church of "La Santa" (Corpus Domini) to see Caterina Vigri's preserved body (the local patron saint of painters), but also to Elisabetta Sirani's nearby studio just around the corner in Via Larga. The artist duly sketched her visitor's portrait in one sitting, which Marchese Ferdinando Cospi – one of Elisabetta's many illustrious patrons and her personal agent – immediately sent as a gift to Prince Leopoldo de' Medici of Tuscany.[68] The Duchess must have made quite an impression, for Elisabetta herself noted the visit in her diary: "(1665) On the 3rd January, the signora Duchess of Brunswick was in our house, to see me paint, where in her presence I produced a Cupid of one year of age, signifying *Amore proprio (Self-love or Love Unmasked),* showing him wishing to wound himself with an arrow, and admiring himself in the mirror. Understand me those who can, for I understand myself etc."[69] Elisabetta's final reference was a subtle pun alluding to the vanity of her northern visitor.

Elisabetta Sirani's studio had by this (relatively) late stage in her career become a cultural institution. The artist was herself acting in a diplomatic capacity, attracting dignitaries from all over Italy and the courts of Europe who would take home a work she had quickly sketched for them on the spot. Like Giovanni Andrea's *maestro,* Guido Reni, the Sirani appear to have had a number of sketched-in canvases of favorite subjects already prepared as part of their studio's general stock. These were stored in the workshop *stanze*

to show prospective clients. These *bozze* could then be quickly finished as required.[70] Elisabetta's work thus assisted in the international circulation of Bologna's cultural identity. The artist herself records that in early 1665 alone, every important visitor to Bologna had come to see her work:

On the occasion that the signor Duke of Mirandola passed this way, he came to see my work, and watch me work, and all the Princes and princesses, like those of Messerano, and others, and thus all the Noblemen and grand Personages that this Spring passed through Bologna.[71]

This was to be her final diary entry before she died in August 1665. The della Mirandola referred to by Elisabetta was Duke Alessandro Pico II of Mirandola. The Duke and his consort, Princess Anna Beatrice d'Este, had stayed in Bologna for two spring days in May that year as the guests of Senator Conte Odoardo Pepoli, as Marchese Fava reveals in his civic chronicle.[72] They took the opportunity to see the artist in her studio, perhaps wishing to order another painting from Elisabetta, as the Duke had done the year previously with an *Alessandro ed Efestione* (untraced), her last recorded work for 1664.[73] Earlier that year, the Crown Prince of Tuscany Cosimo III paid Elisabetta the honor of his visit, watching her work on an allegory for his uncle Leopoldo, and also ordering a *Madonna* for himself (she describes this visit in her workbook, under the date of 13 May 1664).[74]

Giovanni Luigi Picinardi's 1665 funeral oration, *Il pennello lagrimato* (literally the tearful paintbrush or the lamented paintbrush), confirms the presence in Bologna of not only these visiting luminaries to watch "Elisabetta working her canvases," but also Alfonso Gonzaga, the Duke of Brisach, and the sons of the Viceroy of Bohemia and the Duke of Lorraine "who admired the directness of her right [hand]."[75] Picinardi further refers to other influential patrons who appreciated Elisabetta's work. They include King John II Casimir Vasa of Poland; Henrietta Adelaide of Bavaria; Madama Reale di Savoia (Maria Giovanna Battista); Isabella Clara Duchess of Mantua, consort of Carlo II Gonzaga; Vittoria della Rovere, Grand Duchess of Tuscany (Cosimo III's mother); Empress Palatine Eleonora Gonzaga; Prince Leopoldo de'Medici; and Margherita dell'Arno, otherwise known as Margherita de' Medici Farnese, Leopoldo's sister and the Duchess of Parma and Piacenza, who had visited Elisabetta in 1661 on her way to her nephew Cosimo III's marriage to Principessa Margherita Luisa d'Orleans in Florence in June that year.[76]

A semi-public site where a cross-section of Bolognese society intersected, Elisabetta's painting studio was a cultural *salotto* according to contemporary accounts (including her own) of the *via vai* of people. These especially included the *dame* who flocked to this fashionable locale to have their portrait painted, discuss poetry, or simply to socialize with the artist of such renown. Elisabetta's maidservant Lucia Tolomelli stated that she was employed not only to cook and clean in the Sirani household, but also to receive the many visitors "because many people continually came to watch her paint."[77] Lucia added that she was restricted from leaving the house in case "some ladies

were to come to the home, as was usual."[78] Another such source is Count Annibale Ranuzzi, engaged by Leopoldo de' Medici to supervise Elisabetta's commissions for the Florentine court, and for whom she produced a number of works including his own (sketched) portrait and that of his sister *Anna Maria Ranuzzi Marsigli come Carità* (1665). Ranuzzi makes special reference to "the noblewomen who go to watch her paint"[79] in a letter to his Florentine patron.[80] Like Elisabetta's mentor Count Carlo Malvasia, Count Ranuzzi was a regular visitor to the Sirani casa-studio, as he wrote, "da lei" (at her place), almost daily. And whenever possible, such Bolognese nobility and intellectual elite would accompany important international visiting dignitaries to the Sirani studio-salon, both male and female, to witness the artist's *virtuoso* painting, poetic and musical talents as Elisabetta herself recorded in her diary entries, and confirmed by contemporary chronicles, archival documentation, and correspondence.[81]

Malvasia further states that in recompense for her bravura, Elisabetta was presented with "gifts" of "silver, gold, jewels and the like," which her parents proudly placed in a special display cabinet in the reception area of the house for all her visitors to admire.[82] An especially noteworthy example is the diamond-encrusted silver cross received for the above-mentioned *Allegory of Medici Good Government* painted for Leopoldo de' Medici in 1664, as Elisabetta proudly noted: "Having finished the painting ordered from me by signor Prince Leopold, in which I wanted to paint the already mentioned Charity, Justice and Prudence, and it being sent to him, he presented me with with a Cross with fifty-six diamonds."[83] Elisabetta's patron-agent Marchese Ferdinando Cospi also wrote to the Medici prince of the appreciative reaction this gift had elicited: "I felt great happiness for the applause received by the lovely gift Your Highness presented to la Sirana, liked by all."[84] Such honorific gifts in lieu of monetary payment for Elisabetta's paintings was a sign of honour paid to virtue, symbolic of their high value and of the artist's new-found noble status.

Conclusion

This brief introduction has aimed to shed some light on the shifting multiple functions of the professional artist domestic interior in early modern Italy, from home and work studio to reception space and cultural *salotto*; from a site of production and teaching to the celebration of artistic virtue and diplomatic exchanges. It has highlighted seventeenth-century artistic practices: studio organization, division of labour, teaching practices, apprenticeship and artistic training (especially of professional women painters and printmakers); and has explored some of the socio-political and cultural networks of Emilian society through the interchange of daily life in seicento Bologna. Blurring the boundaries between public and private space, between the domestic and the civic, the Sirani household and studio-cum-salon, with its constant

"via vai" of local artists and models, patrons and noblewomen, intellectuals and ecclesiastics – as well as the reception of important visiting dignitaries, "principi," and diplomats – serves as a microcosm of early modern European sociability, and points to the fluidity and permeability of gender and class distinctions.

Elisabetta's academy for professional women artists, the first of its kind in Europe, can thus be considered a female equivalent of the many artistic, literary, and scientific academies that had sprung up in the private palaces of humanist Bologna from the sixteenth century onward, in which women were also known to have participated. Her world of art, anchored at home but oriented to an increasingly public world of gendered virtuosity, connoisseurship and display, is also a forerunner of the sette and ottocento female cultural salons that were to appear around Europe at the dawn of the Enlightenment.[85]

Notes

1 Elisabetta Sirani, *Nota delle pitture fatta da me Elisabetta Sirani*, in Carlo Cesare Malvasia, *Felsina Pittrice*, Bologna, 1687 (Bologna: Tipografia Guidi all'Ancona, 1841), II: 394; Adelina Modesti, "Alcune riflessioni sulla opere grafiche della pittrice bolognese Elisabetta Sirani nell'Archiginnasio," *L'Archiginnasio* XCVI (2001): 155. For the Sirani family, see further Adelina Modesti, *Elisabetta Sirani: Una virtuosa del seicento bolognese* (Bologna: Editrice Compositori, 2004), 33–5, notes 30–34, 42.

2 Giuseppe Guidicini, *Alberi genealogici delle famiglie nobili bolognesi*, ASBo C19th ms., Vol. VII, 219; Francesco Alessio Dal Fiore, *Blasone bolognese* (Bologna: Floriano Canetoli, 1791–5) vol. I, 1792, Part II, *Paesane, famiglie cittadine*, 78, S, n. 1248. Reproduced in Modesti, *Elisabetta Sirani*, 12, fig. 1.

3 Archival material related to the Sirani include "assegnazione di beni," property divisions, marriage contracts, testaments, and legal inventories. Cf. Giuseppe Guidicini, *Cose notabili della città di Bologna* (Bologna: Tipografia delle Scienze di Giuseppe Vitali, 1868), II: 213; Carlo Cesare Malvasia, *Carlo Cesare Malvasia, Vita dei pittori bolognesi, appunti inediti*, edited by Adriana Arfelli (Bologna: Commissione per i Testi di Lingua, 1961), 109. The *casa di campagna* is mentioned in the 1672 Sirani estate division, and may be identifiable with the farmhouse and arable land in the Comune di Gaibola which formed part of the *dote* of Giovanni Andrea Sirani's youngest daughter, Anna Maria, stipulated in her marriage contract of 1689, c. 81v. *Assegnazione fatta da Antonio Maria Siranis a Margherita della Mano, Anna Maria Sirani et Jacoba Siranis*, 19 February 1672, ASBo Notarile Giovanni Battista Buldrini, Prot. BB, cc. 29v–30r; *Dote Anna Maria Sirani, moglie di Gio.Batt. Righi, 1689, 7 Feb.* Rogito Aurelio Mirandola. Prot D, Doc. 318 (ASBo Fondo Notarile).

4 The Sirani were still registered under the said parish when the youngest daughter Anna Maria was baptized on 16 January 1653; see Baldassare Carrati, *Libro dei battesimi donne 1650–1686*, ms. B 885, BCABo, under entry *Santo fonto di S. Pietro*, c. 7.

5 BCABo, Baldassare Carrati. *Stato delle anime* ms. B898 I, c.39, 1647, Stato Anime di S. Matteo Pescarie dall'Ospitale della Morte: "Sig.re Gio. And.a Sirani, Margaritta C[onsort]e di Gio. Sirani, Isotta Cognata, Isabetta, Barbara ed Angela figli." The youngest daughter Angela must have died soon after, as no record of her appears after this.

6 BCABo, Baldassare Carrati. *Stato delle anime* ms. B898 I, c.173, 1654, Stato Anime di S. Michele Arcangelo: "S.r Gio. Andrea Sirani, Marg[herit]a C[onsort]e, Gioac[om]a sorella, Isotta Cognata, S.a Isabetta, Barbara, Ant[oni]o M[ari]a e Anna M[ari]a suoi figli."

7 BCABo, B. Carrati. *Stato delle anime* ms. B898 I, c.82, 1630, Stato anime di S. Nicolò di S. Felice: "S.r Antonio Masini, Elena Madre, Margar[it]a figlia [casa di d.o Carlo Masini]." I am grateful to Domenico Medori for providing these last two references.

8 Baldassare Carrati, *Alberi genealogici di famiglie bolognesi* (mss. B 710, B 733, BCABo).

9 Michelangelo Gualandi, "Elisabetta Sirani, pittrice, intagliatrice, musicista bolognese," letter dated July, 1851, in *L'indicatore modenese* II (December 18, 1852): 1–2; Modesti, "Alcune riflessioni,"159.

10 See Antonio Manaresi, *Il processo di avvelenamento fatto 1665–66 in Bologna contro Lucia Tolomelli per la morte di Elisabetta Sirani* (Bologna: Zanichelli (Arnaldo Forni) 1904), and also discussion in Modesti, *Elisabetta Sirani*, Epilogue at notes 3–6.

11 Manaresi, *Il processo di avvelenamento fatto 1665–66*, 10: "nostra vicina e solita a praticare in casa nostra."

12 Ibid., 47.

13 "Andavano in qua e in là per Bologna a fare delli servitii d'ordine delli detti signori Sirani."

14 Manaresi, *Il processo di avvelenamento fatto 1665–66*, 13: "in casa del Signor Giovan Andrea Sirani, dove ero solita praticare."

15 Ibid., 18: "essendo falegname, facevo de'telari per li quadri della detta Signora Elisabetta, che era pittrice, cioè dipingeva."

16 "Genti di casa di esso Signor Sirani, le quali in quel tempo non erano in cucina."

17 Luigi Crespi, "Vita di Giovanni Andrea Sirani," in *Felsina pittrice. Vite de' pittori bolognesi tomo terzo* (Rome: Stamperia di Marco Pagliarini, 1769), republished as *Felsina pittrice. Vite de' pittori bolognesi tomo III che serve di supplemento all'opera del Malvasia* (Bologna: Arnaldo Forni Editore, 1980), 70. For an overview of Sirani's own artistic development, see Fiorella Frisoni, "Giovanni Andrea Sirani," in *La scuola di Guido Reni*, edited by Emilio Negro and Massimo Pirondini (Modena: Artioli, 1992), 365–81. For his place within the Reni entourage, see Armanda Pelliciari, "La bottega di Guido Reni," *Accademia Clementina. atti e memorie* 22 (1988): 119–41; Armanda Pelliciari, "L'eredità di Guido Reni," in *La pittura in Emilia e in Romagna. Il Seicento*, edited by Andrea Emiliani (Milan: Nuova Alfa-Elimond, 1992), I: 185–206; Richard Spear, *The "Divine" Guido. Religion, Sex, Money and Art in the World of Guido Reni* (New Haven: Yale University Press, 1997), 225–52; Babette Bohn, "The Construction of Artistic Reputation in Seicento Bologna: Guido Reni and the Sirani," *Renaissance Studies* 25(4) (2011): 511–37.

18 Malvasia, *Appunti inediti*, 89–90.

19 Modesti, "Alcune riflessioni," 214.

20 Modesti, *Elisabetta Sirani*, 132–4.

21 Adriana Arfelli in Malvasia, *Appunti inediti*, 100, note 42. For the Zani family, Bolognese nobles, see the anonymous article "Il palazzo e la famiglia Zani in Bologna," *Strenna storica bolognese* XV (1965): 231–44.

22 Malvasia, *Appunti inediti*, 125–6; Giampietro Zanotti, *Storia dell'Accademia Clementina* (Bologna: Lelio della Volpe, 1739), I: 422; Marcello Oretti, *Notizie de' professori del disegno, cioè pittori, scultori et architetti bolognesi e de' forestieri di sua scuola* (Bologna, 1760–1780), ms. B 129, BCABo, c. 118.

23 "Sacerdote e Dottore di Legge."

24 Malvasia, *Felsina pittrice*, II: 407: "grand'intelligente dilettante, (e) bravo disegnatore." Cf. Oretti, ms. B 129, c. 128; Adelina Modesti, "Patrons as Agents and Artists as Dealers in Seicento Bologna," in *The Art Market in Italy 15th—17th Centuries*, edited by M. Fantoni et al. (Modena: Franco Cosimo Panini Editore, 2003), note 28. Elisabetta was to paint Musotti's funerary portrait in 1663; see Modesti, *Elisabetta Sirani*, 341.

25 See Modesti, *Elisabetta Sirani*, 212, note 8.

26 Manaresi, *Il processo di avvelenamento fatto 1665–66*, 31: "I have known the signora Elisabetta Sirani, daughter of signor Giovanni Andrea Sirani of Bologna, very well now for six or seven years, on occasion that I went to learn painting from the said signor Giovanni Andrea, and where I still go now/Io ho conosciuto benissimo la signora Elisabetta Sirani, figlia del signor Giovanni Andrea Sirani di qui da Bologna, da sei o sette anni in qua, in occasione che andavo ad imparare di dipingere da detto signor Giovanni Andrea, e ci vado ancor adesso," cited in Modesti, *Elisabetta Sirani*, 212, note 10.

27 Canuti for three years, according to Malvasia, *Appunti inediti*, 114.

28 Manaresi, *Il processo di avvelenamento fatto 1665–66*, 64: "apartamento di sopra ... casa dei signori Sirani."

29 "Stanza dei padroni."

30 "Lucia haveva cura e faceva tutte le facende di casa."

31 "Apartamento in basso."

32 Manaresi, *Il processo di avvelenamento fatto 1665–66*, 49.

33 ASBo, Notarile, Silvestro Zucchini (1614–82), 6/11 Fori Civile, doc. dated 19 July 1629. With thanks to Rosaria Greco Grassilli and Vincenzo Lucchese Salati for reference to this document.

34 ASBo, Fondo Demaniale (Barnabiti), *Corporazioni religiose soppresse*, 87/4979, Campione di Piante.

35 As defined by John Florio, *Queen Anna's New World of Words, or Dictionarie of the Italian and English Tongues* (London, 1611), 460.

36 The new road, named after the reigning pontiff Urban VIII, was opened in 1629. See Mario Fanti, *Le Vie di Bologna. Saggio di toponomastica storica e di storia della toponomastica urbana* (Bologna: Istituto per la storia di Bologna, 1974), 706.

37 Manaresi, *Il processo di avvelenamento fatto 1665–66*, 15: "stanza da basso della casa."

38 Ibid., 20–22: "la condussi nella mia stanza e dispogliatala la misi nel mio letto ... e alla 23 hore incirca passò da questa all'altra vita."

39 Ibid., 25: "che calava giù per le scale per andare all'apartamento di basso." It is interesting to note that a self-portrait drawing by Elisabetta at the Ashmolean shows her dressed as a noble lady on the lower floor about to ascend the stairs of her family home.

40 Malvasia, *Appunti inediti*, 101–2: "Racconta l'istesso Signor Giovanni Andrea che, fanciulla ancora di diciotto mesi, stando in grembo in piedi e nuda di madonna ... che seco giocolava, entrando la madre la vide circondata da uno splendore grande, e n'avvisò il marito che, sgridandola e burlandola, fu cagione che più osservante ella tornasse dentro ad osservare ciò più che mai vero/ The same Signor Giovanni Andrea recounts how, as a little girl of only 18 months, [Elisabetta] was standing naked in the lap of a Madonna ... where she was dallying, her mother on entering saw her surrounded by a great light, and advised her husband of this, who yelling and scoffing at her, stated that it would be more observant if she returned inside to observe that which was more likely [to be] true."

41 ASBo, *Assegnazione*.

42 See John T. Spike, "L'inventario dello studio di Guido Reni (1 ottobre 1642)," *Accademia Clementina, atti e memorie* 22 (1988): 43–65.

43 Giovanni Andrea Sirani became an art merchant when he developed gout and could no longer paint. See Modesti, "Patrons as Agents and Artists as Dealers."

44 Modesti, *Elisabetta Sirani*, 163.

45 For the Sirani professional library, see Stefania Sabbatini, "Per una storia delle donne pittrici bolognesi: Anna Maria Sirani e Ginevra Cantofoli," *Schede umanistiche* 2 (1995): 83–101; Modesti, *Elisabetta Sirani*, 135–8.

46 It must be recalled that in Seicento Bologna, this *maestro*-apprentice model still operated, since the official artistic academy, the Accademia Clementina, was not instigated until 1706.

47 Crespi, "Vita di Giovanni Andrea Sirani," 73.

48 See discussion in Modesti, *Elisabetta Sirani*, 115.

49 Modesti, "Alcuni riflessioni," 180–97.

50 Modesti, "Alcuni riflessioni," 181, and note 123. Cf. Raffaella Morselli, "Guido Reni: i collezionisti, gli allievi, le copie," in *La Scuola di Guido Reni*, 19. See further Modesti, *Elisabetta Sirani*, 302–3.

51 "fu scolaro della famosa Elisabetta Sirani ... è riuscì buon disegnatore in figura"

52 Oretti, ms. B 129, cc. 122, 127: "famosa scuola di Elisabetta Sirani."

53 Carlo Cesare Malvasia, "Vita di Giovanni Andrea Sirani e di Elisabetta sua figliuola," in his *Felsina pittrice*, II: 407.

54 Marchese Ferdinando Cospi also referred to Elisabetta's teaching academy as "*la sua scuola*": letter to Leopold de' Medici, Bologna 27 January 1665, ASFi, MP, 5532, filza 35, c. 298, cited in Modesti, "Patrons as Agents," note 50.

55 Massimo Pulini, *Ginevra Cantofoli. La nuova nascita di una pittrice nella Bologna del Seicento* (Bologna: Editrice Compositori, 2006).

56 Enrico Noe, "Un'amicizia artistica: Teresa Muratori e G. Gioseffo del Sole," *Il Carrobbio* 2 (1976): 291–300; Stefania Biancani, "Angela Teresa Muratori. Uno studio attraverso le fonti," *Storia e Critica delle Arti. Annuario della Scuola di Specilizzazione in Storia dell'Arte dell'Università di Bologna* 3 (2002): 164–95.

57 For Scarfaglia, see her husband Dott. Carlo Forni Scarfaglia's legal inventory in Raffaella Morselli, *Collezioni e quadrerie nella Bologna del seicento: inventari 1640–1707*. Documents for the History of

Collecting. Italian Inventories: 3, edited by A. Cera Sones (Los Angeles: The Provenance Index of the Getty Information Institute, 1998), Doc. 42, 230–32.

58 Antonio Buitoni, "Un dipinto sconosciuto di Camilla Lauteri," *Notiziario del Comitato per Bologna Storica ed Artistica* 38(1) (2011): 1–3.

59 Malvasia, *Felsina pittrice*, II: 407: "fatta famosa ormai ed unica intagliatrice in legno"; see Modesti, *Elisabetta Sirani*, 143, note 37.

60 Antonio Masini, *Aggiunta alla tavola e catalogo de pittori*, unpublished ms. of 1690, in *Bologna perlustrata*, II, 57–61, 68–9, 73–4, 77, 82–3, 92–3, 115–17, 127–9; Adriana Arfelli, "'Bologna perlustrata' di Antonio di Paolo Masini e l'*Aggiunta*' del 1690," *L'Archiginnasio* LII (1957): 188–237.

61 "Pittrice di qualche grido."

62 "Scolara della Sirani." Cf. Gaetano Giordani, *Notizie delle donne pittrici di Bologna*, Almanacco statistico bolognese n. 3 (Bologna: Tipografia Nobili e Comp., 1832), 11; *Manuale pittorico felsineo, ovvero repertorio nominativo dei pittori bolognesi, data di loro nascita, scuole artistiche a cui appartennero, epoca di loro morte: desunta dalle opere del Malvasia, Crespi, Orlandi, Amorini, Vasari, Levati, Zani, Zanotti ecc.: utile ai pittori ed amatori di nelle arti e di cose patrie* (Bologna: Tip. delle muse, 1859), 19. For further documentation and discussion of Elisabetta's pupils, see Germaine Greer, *The Obstacle Race: The Fortunes of Women Painters and their Work* (New York: Farrar, Straus and Giroux, 1979), 219–25; Sabbatini, "Per una storia"; Modesti, "Alcuni riflessioni," 176–80, 184–5, note 102; Babette Bohn, "Female Self-portraiture in Early Modern Bologna," *Renaissance Studies* 18(2) (2004): 239–86; Modesti, *Elisabetta Sirani*, 107–15, 118–20; Irene Graziani, "Il cenacolo di Elisabetta Sirani," in *Elisabetta Sirani "pittrice eronia" 1638–1665*, edited by Jadranka Bentini and Vera Fortunati (Bologna: Editrice Compositori, 2004), 119–33.

63 See Caroline P. Murphy, *Lavinia Fontana: A Painter and Her Patrons in Sixteenth-Century Bologna* (Cambridge: Cambridge University Press, 2003), 86–7; Caroline P. Murphy, "In Praise of the Ladies of Bologna: The Image and Identity of the Sixteenth-Century Bolognese Female Patriciate," *Renaissance Studies* XXXI(4) (1999): 440–54; Caroline P. Murphy, "Lavinia Fontana and *Le Dame della Città*: Understanding Female Artistic Patronage in Late Sixteenth-Century Bologna," *Renaissance Studies* X(2) (1996): 190–208.

64 "Con un seguito di 70 persone."

65 Marchese Fava, *Diario delle cose piu notabili succedute nella città e territorio di Bologna principando dall'anno 1644 sino all'anno 1700*, BCABo ms. B 33, c. 53: "si sono fatte molte feste di Ballo, cioè in Casa Tanari, Fibbia e Caprara."

66 "La Sig.ra Duchessa di Bransuich … diede gran segni alle Dame che l'accompagnavano di apprezzare ogni cosa."

67 Letter to Leopoldo de' Medici dated Bologna 10 January 1665, ASFi, MM, v. XII, c. 100, cited in Riccardo Carapelli, "Il culto di San Catterina de' Vigri a Firenze," *Il Carrobbio* XXI (1995): 61. Ranuzzi's father-in-law, Marchese Ferdinando Cospi, further informed Leopoldo that the Duchess had just left Bologna for Venice. ASFi, MP 5532, c. 290, letter dated Bologna 10 January 1665.

68 See Cospi's letters to Leopoldo de'Medici, dated Bologna 27 January and 3 February 1665, ASFi, MP 5532, cc. 298, 299, cited in Modesti, "Patrons as Agents," note 50.

69 Sirani, *Nota delle pitture fatta*, 400: "Alli 3 Gennaro, fu in casa nostra la signora *Duchessa di Bransvich*, a vedermi dipingere, dove io in sua presenza feci un Amorino d'età d'un anno, significando l'*Amore proprio*, mostrando volersi ferrire da se co una saetta, rimirandosi nello specchio. Intendami chi può, che m'intend'io ec …" Cf. Modesti, "Patrons as Agents," 374. The painting has been traditionally identified with the *Amor desmasquè* in The Hermitage, St Petersburg, inv. 2584. However, not only is cupid not holding a mirror, this painting does not appear to be by Elisabetta's hand.

70 This working method coincides with Malvasia's description of Giovanni Andrea's practice of leaving the underpainting of his canvases to settle for quite a long period, which he would then rework a number of times before completing the finished painting "smaltato." See Malvasia, *Appunti inediti*, 98–100; Malvasia, *Felsina pittrice*, II: 401.

71 Sirani, *Nota delle pitture fatta*, 400: "Con occasione, che passò per costà il sig. Duca della Mirandola, venne a vedere le mie opere, e a vedermi operare, e tutti li Principi e principesse, come di Messerano, e altri, e così tutti li Signori, e Personaggi grandi che sono questa Primavera passati per Bologna."

72 Fava, *Diario delle cose piu notabili*, 54.

73 Sirani, *Nota delle pitture fatta*, 400.

74 Ibid., 399; Modesti, *Elisabetta Sirani*, 23.

75 Giovannni Luigi Picinardi, *Il Pennello Lagrimato. Orazione funebre del Signor Gio. Luigi Picinardi, Dignitissimo Priore de' Signori leggisti nello studio di Bologna, con varie poesia in morte della Signora Elisabetta Sirani pittrice famosissima* (Bologna: Giacomo Monti, 1665), republished in Malvasia, *Felsina pittrice*, II, 386–91: 389: "Elisabetta nel lavoro delle tele ... Lo affermarono di veduta un Cosimo de Medici, uno Alessandro Pico, Alfonso Gonzaga, il Duca di Brisach, il figliuolo del Vicerè di Boemia, quello del Duca di Lorena, la Principessa di Bransuik, e quella di Messerano, che ammirando la franchezza della sua destra."

76 Picinardi, *Il Pennello Lagrimato*, 390. For Margherita de' Medici's visit, see Modesti, "Patrons as Agents," note 69.

77 "Perchè venivano continuamente molte genti a vederla dipingere."

78 Manaresi, *Il processo di avvelenamento fatto 1665–66*, 43, 66: "dovesse venire a casa qualche dame, come era solito."

79 "Le gentildonne che vanno a vederla dipingere."

80 Edward Goldberg, *Patterns in Late Medici Patronage* (Princeton: Princeton University Press, 1983), Chapter 2, note 37.

81 Like that between the Cospi-Ranuzzi and the Medici. On such visits to Elisabetta's studio, see Modesti, "Patrons as Agents," 371, 374.

82 "Argenti, ori, gioie e simili, che andavano a titolo di regalo": Malvasia, "Vita di Elisabetta Sirani," *Felsina pittrice*, II: 400.

83 "Finito ch'ebbi il quadro ordinatomi dal sig. Principe Leopoldo, nel quale io volli farvi la già detta Carità, Giustizia e Prudenza, e inviatoglielo, mi regalò d'una Croce con cinquantasei diamanti": Sirani, *Nota delle pitture fatta*, 399.

84 "Ho sentito grande allegria per l'applauso che ha hauto il bel regalo fatto da VA alla Sirana piaciuto da tutti." Letter from Cospi to Leopoldo de' Medici, Bologna 21 October 1664, ASFi, MP, 5532, filza 35, c. 286, cited in Modesti, "Patrons as Agents," note 98.

85 For a discussion of the "The Female Salotto" in Bologna, see Modesti, *Elisabetta Sirani*, 120–125, with relevant bibliography.

This chapter began life as part of my PhD (Monash 2006) and monograph *Elisabetta Sirani: una virtuosa del seicento bolognese* (Bologna: Compositori, 2004) and has been reworked and developed for an English audience. A revised and updated English edition of the monograph is forthcoming *Elisabetta Sirani "Virtuosa". Women's Cultural Production in Early Modern Bologna* (Turnhout: Brepols, 2013), to which I refer the reader for a fuller discussion of the ideas put forward in this chapter. I would like to thank La Trobe University for a faculty travel grant which enabled me to present this paper at the Venice RSA Conference in April 2010, and also my colleague Adrian Jones for his meticulous editing. Special thanks go to Erin Campbell for inviting me to present my work. All translations are my own unless otherwise indicated.

ABBREVIATIONS:

ASBo: Archivio di Stato di Bologna

ASFi: Archivio di Stato di Firenze

BCABo: Biblioteca Comunale dell'Archiginnasio, Bologna

MM: Miscellanea Medicea

MP: Mediceo del Principato

Part II
People, Spaces, and Objects

Parenting in the Palazzo:
Images and Artifacts of Children in the
Italian Renaissance Home

Stephanie R. Miller

According to chroniclers, the most numerous victims of the epidemics following the Black Plague were children and young people; in fact, the 1363–4 epidemic was known as the "children's plague."[1] Eventually the wave of epidemics after the Black Plague subsided in the early fifteenth century, allowing for a population rebound, which skewed the age demographics in favor of the young.[2] Coinciding with this dramatic population shift is the emergence in fifteenth-century Florence of a new appreciation for children and childhood, evident in contemporary treatises and records and in images related to childhood that ornament the city and appear within the home in increasing numbers over the course of the century.

Images of children, alone or as the Christ Child with the Virgin, are among the most familiar images of the Italian Renaissance in the fifteenth century, especially the frequently replicated subject of the Madonna and Child which was used for domestic devotional purposes. Other depictions of children are found simply by walking through the streets and churches of Florence, such as the *bambini* roundels by Andrea della Robbia at the Ospedale degli Innocenti, or Ghirlandaio's frescoes of childbirth and child-resurrection that appear within Florentine churches, such as Santa Maria Novella and Santa Trinità. The abundant imagery of children suggests tender bonds between parents and their children, and attentiveness, in general, to children. Fifteenth-century treatises on the family, such as Leon Battista Alberti's *I libri della famiglia* or *On the Family* (1433–4), or Fra Giovanni Dominici's fourth book *On the Education of Children* from his *Regola del governo di cura familiare* (by 1405), reinforce the prevailing regard for childhood in the cultural imagination.

While art historians frequently interpret images and artifacts of childhood with an appreciation for gender and rank, a sensitivity to age distinctions in the Renaissance imagery of childhood is still emerging in modern art-historical scholarship, despite the fine distinctions observed between

the various stages of pre-adulthood in Renaissance texts.[3] Indeed, fifteenth-century authors emphasize that pre-adulthood unfolds in a series of distinct states, including the stages of infancy, childhood, adolescence, and youth. Significantly, humanist fathers and writers had a sophisticated view of the various stages of childhood, an appreciation evident in their writings on the subject of the family and society, their treatises on education, and in sermons to parents.

In these works, childhood emerges as a phase that is distinct from and occurring after infancy, which typically lasted until the child was seven.[4] Childhood, also referred to as *puerizia*, was thought to extend roughly from the ages of 7 to 14. The term *puerizia* signified attributes Renaissance adults associated with their children, such as the virtues of purity and innocence, though this stage was also associated with ignorance and a "lack of intellectual ability."[5] Infants were also perceived as having these qualities, which were further hindered by their lack of speech.

Adolescence was also a distinct phase, which, then as now, presented problems. Matteo Palmieri, in the *Vita civile* or the *Civil Life* (1431–8), described the transitional nature of adolescence as the juncture at the "fork in the road" on the letter Y, where infancy and childhood represent the "stem" of the "Y," a clear and virtuous path, and the split in the letter Y represents virtue and vice and the choice awaiting the adolescent.[6] Further, an adolescent's lack of experience, according to Palmieri, made him ill-equipped to make the choice alone.[7] Common to nearly all of fifteenth-century descriptions is the rather unflattering depiction of the nature of adolescence and the parents' need to control and direct their adolescents into virtuous, upstanding citizens.

This chapter explores children and their artifacts in their parents' home in fifteenth-century Florence. The home for children and their caregivers was used differently as the children grew, and thus this chapter considers the material culture and domestic space of childhood from their stages of life – from infancy, to childhood, to adolescence and older. The domestic space in this context connotes more than the shelter of a child's home; it also includes the family activities and the objects it deemed necessary to raise its children. It is a space to instruct and promote the family's next generation and future citizens of the Republic. From this perspective, the domestic activities are intended to have quite public results. The images and objects related to childhood, as well as the documentary data, reflect, confirm, and occasionally challenge, fifteenth-century observations on children and parenting. Relevant contemporary accounts on parenting and personal memoirs help contextualize kindred images and artifacts, including portraits, within the realm of the household. As this chapter demonstrates, the material culture of children and childhood informs us of how children at various points in their development were perceived, nurtured, and regarded within the home. Although the objects explored suggest parental attitudes, this analysis also demonstrates their various functions within the home, which range from commemorative and promotional, to prescriptive and educational.

Infancy

Social historians have described adult attitudes towards children and childhood in the Renaissance as fraught with "ambivalence."[8] Though child abandonment and oblation still occurred, greater emotional attachment to or interest in children appears in the Renaissance, especially when contrasted with the medieval era. But when compared to the greater wealth and diversity of imagery and artifacts related to childhood in the following century, the fifteenth century is arguably transitional. Nevertheless, fifteenth-century images and texts confirm that the importance of nurturing children entered the Renaissance social consciousness in full force, despite the persistence of some lingering parenting practices that might suggest otherwise. For instance, in the case of wet-nursing, several Renaissance authors urge mothers to nurse their newborns at home. Repeatedly, home and maternal care and nursing are advocated by individuals such as Leon Battista Alberti (1404–72), Matteo Palmieri (1406–75), and Giovanni Rucellai (1475–1525), yet in almost the same breath, the resistance to maternal nursing is equally evident, for wet-nursing was the preferred, social reality.[9] Alberti's writings on the family demonstrate this conflict: he encourages maternal nursing because the mother "is more modest and of better character than other nurses, [and] offers more suitable and much more practical nourishment to her own children"; however, this statement is actually the conclusion of a discussion on how to find an appropriate wet-nurse and what to do when one cannot be found.[10] Maternal, home-nursing was not a regular occurrence and, according to the data, live-in nurses were uncommon, though if there was a live-in nurse, the baby would stay with the nurse in her quarters near the top of the house and away from the family.[11] Ultimately, wet-nursing was a tradition associated with "gentle" and privileged society, and by extension privileged women also experienced greater fertility than non-nursing women.[12] While the infant survival rate was greater at home,[13] perhaps the overwhelming fear of their children's death and the fear of attachment in a culture still plagued by high infant mortality contributed to parental attitudes.[14]

 In families with even modest means, soon after birth and baptism, babies were immediately removed from their biological mothers and birth-homes and were transferred to the care and households of their *balie* or wet-nurses, to begin the two to five or more years of separation from their parents.[15] In this regard, the concept of home extends beyond the physical boundaries of the natal home to include that of the *balia*. The employment of a wet-nurse away from the home was so prevalent that Lloyd deMause provocatively referred to it as "institutional abandonment."[16] To assist the newborn's chances of survival, the baby's layette might include talismanic objects, such as branches of coral, special rings or crosses, or even a silver-bound wolf's tooth, which Christiane Klapsich-Zuber suggested could double as a "teething-toy."[17] Babies stayed with the wet-nurse at least until weaning was completed (on average two years), although there are records of the duration lasting up to

age seven (sometimes even longer) with "little evidence that parents visited their child."[18]

The near-instant transfer of baby from mother to midwife and wet-nurse in numerous depictions of biblical birth narratives during the Renaissance underscores the acceptability among Renaissance urban families that someone other than the mother would soon be caring for the newborn. Therefore, this study of the material lives of infants in the household is shaped by those children who were either kept by their parents or whose parents recorded the delivery of the baby to the wet-nurse. Fortunately, some *ricordanze* describe layettes with summaries of items that Renaissance parents deemed essential to their children's well-being when in the extended care of another woman and family.[19] Though the intention of the layette was ostensibly to provide material care for the infant, these objects in a temporary household, used by a surrogate mother, may have taken on other associations. It is interesting to speculate on the agency of these objects from one, presumably more elite household, transferred to the residence of a family that was likely from a lower social stratum. Together, the infant and his objects were a constant presence and extension of another family within this other home. For instance, in the *ricordanze* of the Florentine Antonio Rustichi, which includes the birthdates of his children between 1417 and 1436, he records the costs of the various nurses and lists the items to accompany the newborns to their new, provisional homes; in the case of his son Lionoardo, his layette contained approximately 32 items.[20] It is also clear from such descriptions that some things were noted as old or used, while others indicated that the entire layette was new. New or used, simple or extravagant, baby clothing accounted for the most numerous items in the layette, with pieces ranging from ornate lined cloaks to simple shirts with or without sleeves.

Babies spend much of their early months having their most basic needs attended to. Regardless of whether the infant went to a *balia* or stayed in the natal home with the mother, the baby would, by necessity, be physically close to the female caregiver. The objects associated with these small, portable children are naturally small, intimately connected with the immediate care of the child, and often portable too. The baby with his items, including cradles, could be moved around the home as needed by the *balia* or other caregiver as she went about her other responsibilities.

Ricordanze occasionally list coverlettes, pillows, and cradles, and sometimes even describe the form of the cradle that would accompany the infant to his interim home. In addition to these descriptions, there are painted depictions of cradles, as well as extant sixteenth-century examples. Cradles – which were used in both rural and noble households – were intended to calm infants and were typically equipped with a mechanism for rocking. This could take the form of a string attached to a less-portable hammock-like contraption, as seen in Simone Martini's *The Cradle Miracle* (1324, Siena, Pinacoteca Nazionale),[21] or the cradle could be designed as a basket or box on rockers, which could be rocked manually or prodded with a stick. Both plain wooden cradles and

the more elaborately carved ones used rockers oriented either head-to-toe or side-to-side.[22]

Infant suffocation by overlaid blankets or by being crushed in the wet-nurse's or mother's bed was a significant enough threat that it was addressed by Renaissance moralists and authors on the family, and was eventually deemed a crime by the church.[23] To avoid this tragedy, those families who sent cradles to the wet-nurses usually included a framework of arched ribs to keep blankets safely on top and to protect the infants from falling out in the event of "over-rocking" the cradles.[24] Nevertheless, unless this framework was brought into the adult's bed, it would not have prevented a sleeping adult from rolling on the infant, for in at least two of the cases where such an armature was brought to the wet-nurse, the child still died of suffocation. Other developments to avoid this misfortune included "little boxes to put in bed" or *cassette* to protect the child when in the adult's bed. Once the cradle became too small for the growing child, the child might sleep with his or her nurse or a couple of other siblings in the same bed. By this age, however, many babies returned home to this sleeping arrangement, and for many elite Florentine families, a nurse's room was on the floor over the *piano nobile*;[25] rarely would a child have his own bed and room, even after he returned home.

Andrea della Robbia's swaddled *bambini* roundels at the Ospedale degli Innocenti, Florence, with babies in various states of wrap, are among the best loved and well known of all Renaissance images. Linen and wool swaddling bands, like those rendered in the roundels, were the other frequent and numerous layette items; Rustichi's 1417 entry for his son Lionardo, in fact, specified six swaddling bands and six pieces of woolen cloth.[26] If the infant remained at his natal home, these items were doubtlessly found in the household, probably in the nurse's room away from the family's main living spaces. *Fascie* and *pezze*, long strips and pieces of cloth, bound babies aged anywhere from 6 to 12 months.[27] Though infants were swaddled to pacify and to protect them from scratching themselves, they were also tightly bound for long periods of time to suppress involuntary movements, because of the fear that infants could be on the "verge of turning into totally evil beings."[28] The extended practice of swaddling, in addition to mollifying babies, was also thought to delay independent walking.[29] Extreme swaddling creates "extremely passive" babies by slowing their heart rates, making them "cry less ... sleep far more," and, deMause asserts, makes them so docile that they could have been "hung on pegs on the wall" or just propped up somewhere.[30]

In Dominici's discussion on the domestic care of children, he counseled against showing affection to children, especially after the age of three, which, as we have seen, is near the average age of a child's return home. As Dominici counsels, after the age of three: "From then on let him be a stranger to being petted, embraced, and kissed by you." He further advised against even expressing pleasure towards children for fear of it being too sexual.[31]

The ubiquitous Madonna and Child domestic devotional objects typically depicted close, affectionate bonds between mother and child and were made to encourage personal reflection and identification with the holy image.[32] However, the child in the Marian images is usually an infant and is therefore at the age when an infant is typically not yet with his biological parents. Geraldine Johnson has convincingly described how these Marian images had "talismanic function[s] regarding fertility [and] the birth process" and, as such, these half-relief Marian images were often included in and around the bedroom, along with portrait busts and other valued items.[33] Some Marian images clearly show an intimate relationship between mother and child, but others reveal a curious distance, in which the child attempts to gain the mother's attention or affection, yet she remains rather impassive. While iconographic conventions might justify such maternal impassiveness, such a demonstrative lack of warmth would serve to underscore Dominici's advice against showing children too much affection.[34]

Despite the numerous Madonna and Child depictions frequenting Renaissance patrician homes in Florence, the absence of actual babies is notable. James Bruce Ross suggests that the ever-present domestic Marian images with well-fed, happy babies might be a form of "secular fantasy."[35] Ross interprets the images as representing a desire for "maternal intimacy" that the mother did not experience and wonders if the works offered "emotional compensation for their absent children?"[36] Similarly, if the new brides used talismanic images and holy dolls to inspire their procreative powers, these same women, as new mothers, might desire devotional images to stimulate their maternal powers even in the absence of their children.[37] While domestic devotional images were intended to encourage women and children to emulate the virtues of holy figures, they might also have fostered a form of wish fulfillment and provoked a mother's longing for her infant.[38]

Childhood

Less small, not as easily portable, the presence of children in the home is more obvious at this age, especially as they are reintegrated into their birth families. Though no single space seems to have been designated for their home care and moral and educational instruction, children were certainly sharing space, and occasionally objects, with others in the household. Where did children play and where did instruction occur? Alberti does not elaborate on a space for these sorts of activities, other than noting that such activities should not disturb the rest of the household. Care was taken so that children's activities, and those of the caregiver, did not intrude on other activities in the home, specifically those of the head of the family. As Alberti asserts: "The prattling and noisy hordes of children and housemaids should be kept well away from the men."[39]

In the quasi-public Florentine palazzo, private and public spaces fluctuated depending on who was present, in particular women.[40] Therefore, younger children would likely be on the *piano nobile*, but not exclusively in the parents' chambers, since those spaces were occasionally occupied with visitors and business associates. If there were female quarters, instruction and care conceivably occurred here, or in the kitchen, or even in the *sala*, where there was more room for play under the close supervision of the older females of the household. Suggestively, Piero di Messer Andrea Buondelemonti's 1497 *sala* inventory included not only chairs, tables, and trestles, but also four small desks, "*4 deschette*," and other furniture indicative of its "social function," and perhaps other educational purposes as well.[41] The courtyard, of course, is an ideal place for play and exercise, but in order to function this way, it too depends on how and who uses the space. However, adolescent boys, discussed later, have more freedom in this area of the home. Other segregation occurred during meals when parents likely dined separately from their children, who probably enjoyed their meals with servants and attendants.[42]

The return of the child to the biological parents invariably forced an adjustment for the entire family.[43] The wet-nurse was often the only mother a child knew for the first few years of his life. Then, at age two or three, upon his return to the biological family, he is separated once more, but this time from his surrogate family. Significant moments in the life of a family were often commemorated in art. Just as *deschi del parto* marked the birth of the child, perhaps portrait busts of young children, which emerge in the mid-fifteenth century in Florence, were also commissioned to commemorate a particular moment in the life of a family, including the return of the child to the natal home.

The new images of children in unprecedented quantities suggest that childhood was being observed and appreciated in new ways.[44] In general, Renaissance portraits commemorated an individual, often for civic accomplishments, virtuous character, or both. If adult male portraits embody the family's "lineal interests,"[45] portraits of male children similarly represent the family's "future promise."[46] Significantly, while painted portraits of older adolescents became popular in the fifteenth century, the rendering of children ranging from a few years to no older than 12 or 13 found realization in the sculpted form, not painting.[47] In sculpture, such portraits typically render the specific features of a family's young boy; however, occasionally the child's image is realized in the form of the Christ Child or the youthful St John the Baptist.[48] Thus, although Fra Giovanni Dominici encouraged parents to display in their home images of holy children to provide their children with moral exemplars and so that they might literally see themselves in those holy figures and emulate the holy virtues,[49] scholars from Wilhelm Bode to Victor Coonin have noted that the charming and innocent depictions of small children in marble do not always exclusively represent the Christ Child and often depict the household's smallest members.[50]

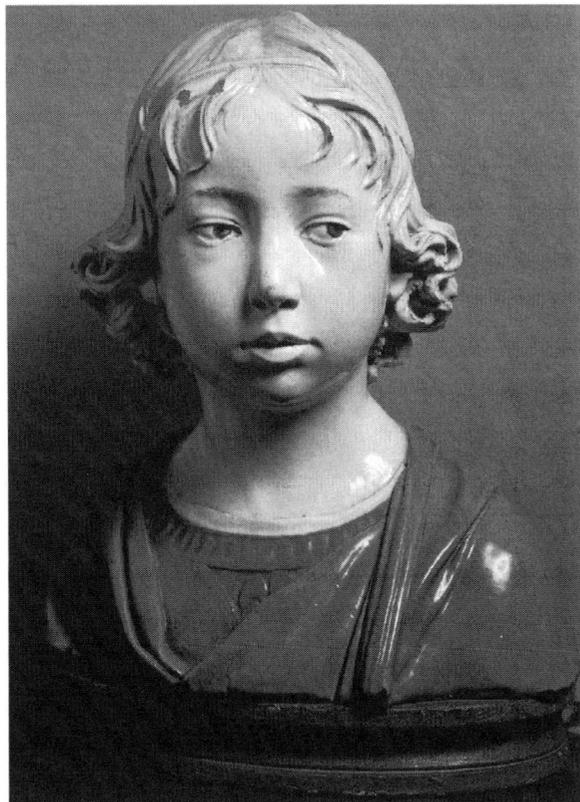

4.1 Andrea della Robbia, *Bust of A Young Boy*, 33 cm, c. 1475, glazed terracotta, Museo Nazionale del Bargello, Florence. Photo credit: Scala/Art Resource, NY

Andrea della Robbia's *Bust of a Young Boy* (c. 1475, Florence, Museo Nazionale del Bargello) appeals to family viewers, including the young three- or four-year-old boy himself and his parents, by permanently recording the features of the child at this young age (Figure 4.1). It should be noted that there were also busts of girls, although far fewer in number, including another notable example by Andrea della Robbia now in a private collection in Florence. The Bargello and private collection glazed terracotta busts by Andrea are secular portraits of children, perhaps a brother and sister from a noble Florentine family.[51] Portrait sculptures of this nature, usually commissioned by the father, may mark the child's return to the family while simultaneously recalling other portrait traditions and depictions of the Christ Child and the young John the Baptist, thus retaining the moral implications of those works, but without the iconography. Margaret Morse's chapter in this volume discusses the prescriptive value of religious paintings in the Venetian *portego*; the Florentine busts share this moral, didactic function, albeit not necessarily in the most central room of the Florentine palazzo.

Portraits within the home were most often located in or just outside the bed-chambers and of particular relevance to child portraiture are "two busts of children on the bed" in the antechamber from the Buonisegni house.[52] They are not identified by name, nor are they described as putti or biblical child representations. Other portrait busts of children or youthful representations of holy figures might be found on moldings within a room, over doorways and chimneys, or over *acquai*, wash basins.[53] Statuettes and figures of children, not necessarily portraits, could also be found in the chambers, such as the bronze child or the "statue of a child holding a fish" listed in the inventory of Jacopo Giucciardini.[54] Though its precise location in the home was unknown, a small decorative – and certainly morally instructive – della Robbia glazed terracotta statuette of *The Meeting Between the Children Christ and St John the Baptist* (c. 1510, Florence, Museo Nazionale del Bargello) perhaps typifies the types of domestic works featuring children. Unlike a heavier bronze statuette, something this small and lightweight, not to mention shiny, could easily be picked up, moved, and by necessity cleaned to retain its lustrous appearance,

suggesting greater intimacy with objects of this nature. The small size of this morally pedagogical object harmonizes with the prescriptive copper paintings described by Erin J. Campbell in this volume; curiously, the reflective surface of the glazed terracotta statuette corresponds to the polished, glossy effects of the Bolognese paintings on copper. In both instances, the virtuous messages of the objects are most likely intended for women and younger family members. Depictions of children were pervasive throughout the same rooms holding the majority of a Florentine home's images and objects. Though children were present in these rooms, so were visitors to the household and these instructive images reinforce the idea that the head of the household was a good parent intent on raising virtuous children and future citizens.

Depending on the age of the child when he or she returned home, weaning would have already occurred and the swaddling bands removed. To assist the child with independent walking potentially inhibited by the swaddling bands, a walker or *girello* at home was employed.[55] Sixteenth-century examples survive, and we know of its earlier use through a few fifteenth-century depictions, and through the recommendations of Francesco da Berberino in his *Reggimento e costumi di donna* (c. 1305).[56] *Girelli* could take a few different forms, but generally a circular or square wooden armature, with or without wheels, surrounded the child. Also assisting with walking, certain tunic dresses for toddler boys included straps sewn into them for adults to hold onto.[57] As toddlers, there was little distinction between boys and girls in terms of dress, maternal attention, and sleeping arrangements. Up to the age of three, boys and girls might share a bed, together with their nurse. However, soon after the age of three, gender segregation was deemed important for their well-being and in the ideal household girls would sleep in the mother's dressing room, with the nurse's room adjacent to it, and the boys would sleep in the "strong room."[58] Alberti urged that boys separate from girls in the household as early as possible so as not to be accustomed to their "activities and habits."[59] Lorenzo di Giovanni Tornabuoni's 1497 inventory of his palace, for example, lists two rooms associated with his son Giovanni, a room in which to sleep (*camera*) and a *saletta*, a small hall.[60] Elsewhere, Alberti acknowledged the need for some separate spaces for the maidens of the household and asserted that their space ought to be "treated as though dedicated to religion and chastity," but comfortably so due to the "tedium of confinement."[61] Inventories and records also note that children's rooms might be adorned with devotional imagery and objects, such as a painting of the Madonna and Child, a statuette of the Virgin, or even a small tabernacle.[62] Moral lessons in children's spaces were promoted by instructive room ornamentation, perhaps assisted with the guidance of a caregiver-interlocutor. Morse's and Campbell's chapters in this volume, which address these concerns in Venice and Bologna, highlight that pedagogical domestic imagery is not exclusively a local, Florentine phenomenon.

As the children grew, formal instruction was essential. Paternal instruction emerged more forcefully as the male child neared adolescence, but the mother

or other female caregivers in the home usually initiated the child's education. Infant cries were not universally experienced sounds in Florentine palazzi. More common sounds were the oral traditions of nursery rhymes, story-telling, and songs by the home's women to its young children to encourage language skills.[63] As mentioned above, instruction likely occurred in places occupied by women – thus, a variety of places could accommodate educational activities, including kitchens, women's chambers, rooms where children slept, and, not to be overlooked, *sale*. The *sala*, one of the largest rooms on the *piano nobile*, had adequate light and tables (or even desks), so, when not in use for formal functions, was a spacious room where children could learn the letters of the alphabet in portable children's books and hornbooks. In this regard, the *sala* might function similarly to the Venetian *portego* when this room was not used for receptions (see Morse's chapter in this volume). These parenting activities, regardless of where they occurred, stimulated early reading and inculcated proper morals and virtues.[64] Carved letters in fruit taught children their alphabet, with the fruit itself the reward for learning achievement – a messier lesson perhaps better suited for the kitchen.[65]

Other rewards or inducements, such as toys and new shoes, were given to boys and girls for completing chores and other tasks.[66] The types of toys one could expect to find in the household ranged from the toys Fra Dominici warns as eliciting only vanity, such as "little wooden horses, attractive cymbals, imitation birds, [and] gilded drums," to the types of miniature playthings he believes will secure the child's virtue, such as, "a little altar or two, … little vestments … little candles … [and] little bells," for the children to pretend they were sacristans, acolytes, and priests.[67] Though the difference in the types of playthings Dominici mentions is the ostensible difference between encouraging virtue and piety over vanity, he perceives the effects of imitative play through educational toys. This concept and value of educational toys is described in the next century by Lodovico Dolce (1508–68) in his treatise on female education in which he discusses the objects young girls require to raise them into proper wives and mothers to take care of a house and family.[68] Dolce argues, as Dominici had argued, in favor of toys that inspired virtue and practicality rather than toys that inspired vanity, such as dress-up dolls. He urges young girls to play with "all the tools concerning household activities, reduced in miniature, and made as we see them, of wood or various metals," with the belief that the girls will learn through imitative play the household responsibilities they will inherit when they grow up.[69] Marta Ajmar-Wollheim draws on Dolce's commentaries in her exploration of women's growing influence on the material culture of the domestic realm. Ajmar-Wollheim documents the increasing responsibilities of women within the home, including the education of young children in the household. She associates toys, like the ones recommended by Dolce, with the world of visual aids and "exemplary objects" within the home, such as *cassoni* or maiolica objects, which are decorated with didactic images intended to broadly instruct and convey "family memories."

As with the infant's layette, clothing for children was a major expense noted in the records, with shoes now among the expenses. Louis Haas noted that some of the most common purchases found in fourteenth- and fifteenth-century *ricordanze* included ribbons, hose, fine cloth, and numerous slippers, shoes, and clogs.[70] Dominici confirms this practice by criticizing parents who dress children in "fancy garments, stamped shoes, short waist-coats, tight and fine-knit hose," fearing children will incur poor habits and worthless vanities.[71] Despite Dominici's admonishments, parents endlessly combed their children's hair and dressed them in finery when they could, even though such attention could pose a detriment to the child's moral well-being.

Dominici's treatise on the education of children demonstrates a growing appreciation for the nature of childhood, an appreciation revealed time and again by other contemporaries. However, if we are to trust Dominici, his text reveals lingering opinions and practices regarding children and their care. Occasional phrasing implies that his ideas were familiar to the reader, such as "granted there will not take place any thought or natural movement before the age of five" and "because of the need to hold in check this age inclined to be evil and not good, often take occasion to discipline the babies, but not severely. Frequent, yet not severe whippings do them good."[72] Such "chastisement ... should continue not only while they are three, four, or five years old (the common ages of their return from the *balia*), but as long as they need it up to the age of twenty-five."[73]

Adolescents

Fra Dominici described early adolescence as a period when children "begin to throw off the maternal yoke and to go out among others, and they undo in three days all the hard work of ten years."[74] This phrase sums up one of the great distinctions between children and adolescents of the household: adolescents "go out" of the sheltering, nurturing, and educational environment of their parents into the external, public world where the lessons of the parental home are threatened. Generally, *puerizia* are children no older than 13 or 14.[75] *Fanciulli* typically implies younger adolescents, 14 or 15 to about 24. As the child enters adolescence, he is able to participate in more public activities, whether it be school or youth confraternities. *Giovani* also refers to male youths, but at the upper end of the spectrum, roughly from 24 to 30, when these males were excluded from youth confraternities and were not yet eligible for governmental activities.[76]

During the fifteenth-century population rebound in Florence, the age distributions of Florence's youthful population were not the same for all socio-economic classes; bluntly put, the rich were "considerably younger than the poor."[77] Fifty percent of males in wealthier households were less than 17 years of age and wealthier households were also statistically characterized by having more male children.[78] Within this demographic disparity, contemporaries perceived young males as privileged, spoiled, impatient, and disorderly.[79]

Most Renaissance authors on family and education agreed that paternal involvement was critical in raising a son into a useful member of society.[80] In fact, these commentators warn of the ill effects on the sons, and society, when the father is absent.[81] In reality, several factors worked against the ideal paternal involvement and fathers were indeed often absent.[82] Without the moderating, guiding, and even restraining hand of the father, Alberti explained that "changeable youth always follows its desires … The lusts of youth are infinite, most unstable" and that "[young men] full of vice, full of license, burdened with needs, give themselves to filthy activities, dangerous and disgraceful for them and for their family."[83]

Through empirical observations and by reading ancient texts,[84] Renaissance adults explored the conflicting and dual nature of this age. Leon Battista Alberti wrote at length on the father's role with regard to his sons, the emotions attached to parenting, and the mutual interests between the Florentine family and the Florentine Republic.[85] Giovanni Morelli echoes Alberti's claim on paternal duties and the need to raise sons into good citizens for the Republic.[86] Because having and raising children were family and state obligations, humanists insisted that fathers assume a greater responsibility in raising their sons. Accordingly, these texts describe the emotional component of parenting and their desire to guide their children with love and understanding rather than through fear and violence. Alberti associated this form of parenting with Republican values: parents, like good governments, lead with "authority," reason, and guidance, rather than with "*imperio*" or "absolute power," which was associated with tyranny.[87]

To achieve this, Renaissance parents sought to have their boys "accustomed to life among men."[88] Since adolescent males "go out" of the parental home with increasing regularity, their preferred location within the household has also changed to reflect their growing public persona. Ideally, young men no longer slept in the rooms near their parent's chambers, but found quarters on the ground floor, closer to visitors, associates, and the public world beyond the palace.

Guests should be accommodated in a section of the house adjoining the vestibule, where they are more accessible to visitors and less of a disturbance to the rest of the family. The young men of seventeen should be accommodated opposite the guests, or at least not far from them, to encourage them to form an acquaintance … Off the room for the young men should be the armory.[89]

The location on the ground floor of the palazzo contributed to the instruction and guidance of the home's *giovani* through conversation with elders and was a suitable place where the father of the house could direct his sons in memory training. In his treatise on the family, Alberti's son Lionardo describes how his own father would send him out of the palace on various errands to strengthen his memory.[90] The fifteenth-century palace with its courtyard and internal *loggia* was an ideal location for the coming and going of adolescent boys and their interactions with visitors, and also for physical play and

games. Even the stern Dominici recognized the need for fun and physical exertion, and similarly Alberti understood that the courtyard provided space for this behavior. Describing the ideal princely residence, Alberti refers to the ground floor vestibule and its adjacent spaces as an open, receptive space where "young men who are waiting for the elders to return from conversation with the prince may practice at jumping, playing ball, throwing quoits, and wrestling."[91] Maria DePrano's chapter in this volume describes various musical instruments, masks, and jousting equipment in the *camera terrena sul androne* (ground-floor chamber by the vestibule); were these objects and activities associated with the young men of the palace? Such proximity between this room and the younger gentlemen of the household now living in ground-floor quarters near this same room provocatively suggests that these young men used the instruments or jousting equipment. Elite male youths were expected to have musical literacy, which promoted their burgeoning sociability.[92]

The behavior of the adolescent males outside the protective and guiding environment of the home caused the most concern among fifteenth-century writers. To curb unwanted behavior, among other things, youth confraternities provided further physical outlets for young males by arranging for locations and times to play and exercise.[93] Certainly, the organized jousts alleviated some of the unstructured street violence while providing the added virtue of chivalry and fortitude to their participants.[94] Although the boys left the house and perhaps the moderating influence of their parents behind, they were still dressed in clothes purchased with their parents' money. Moralists such as St Bernardino of Siena (1380–1444), however, did not share this tacit acceptance of their sons' attire. For instance, he opposed the *giornea*, a rather short, belted outer garment worn by the males. Though not limited to youth, the *giornea* was primarily worn by them and St Bernardino regarded it as a blanket covering an animal.[95] Red tights also caused concern and by the end of the century, younger adolescents were prohibited from wearing them.[96] Typically, adolescent head coverings included the red *beretta* or cap, found in narrative frescoes by Benozzo Gozzoli and Domenico Ghirlandaio and in numerous adolescent painted portraits.

Portraits of male youths are often discussed together under the larger banner of male portraits, but are perhaps best considered as a distinct category of images – a category which emerged in the fifteenth century at the same time as the larger Florentine youth culture itself. Alison Wright has discussed how the development of independent painted portraiture in the Renaissance was related to the imagery of holy figures in their common quest to stimulate memory, to arouse devotion, and to emulate the virtues of the figures represented.[97] Thus, for example, Ghirlandaio's *Portrait of an Old Man with Child* (c. 1490, Paris, Louvre) depicts a generational relationship, one that is both commemorative of the individuals and, Wright would argue, devotional in its form and arrangement.[98] The devotional potential and the exemplary role of the elder individual extends to Botticelli's *Young Man with*

Medal of Cosimo de' Medici (c. 1474, Florence, Uffizi Gallery), which permits the unnamed sitter to hold "close to his heart" the relief image of the Pater Patriae.[99] The juxtaposition of youth and age elevates the status of the youthful sitter, his age also confirmed by his attire, and associates him with the civic, Republican values of a Medicean Florence. The medal and the youthful sitter are linked in the same generational way as Ghirlandaio's painting, creating a link between generations and providing both civic and familial role models for the younger generation.[100] Portraits like these literally depict the advice of Alberti, Morelli, and others who stress the need for elders to guide young men into adulthood and mold them into proper citizens. Like the portrait busts of children and portraits of older members of the family, domestic depictions of adolescent and youthful males shared the same physical spaces in the bed-chambers where inventories indicate the most treasured objects of the home were located. Additionally, Maria DePrano's chapter in this volume notes Tornabuoni portraits, along with other items denoting family rank and piety, in the ground-floor living chambers. The arrangement of objects from this family's domestic space may indicate how other leading Florentine families displayed portraits and holy images on the ground floor where the families' *giovani* were likely spending more of their days.

Desiderio da Settignano's portrait bust of an unnamed young adolescent, *A Young Boy* (1450–1455, Florence, Museo Nazionale del Bargello), was recently highlighted for its "exceptional character," which bears directly on its potential function in the domestic realm, as an exemplary figure for adolescents or other children in the home.[101] Having been brought up on a diet of images intended for moral instruction, members of the household who looked upon the numerous depictions of older, but still youthful holy figures in the domestic environment would consider such images similarly. Numerous domestic depictions of adolescent and youthful St John the Baptists, similar in appearance to Desiderio's *Young Boy*, with particular details and features encourage male adolescents and other children in the family, and even male servants, to mirror the adolescent St John the Baptist, as advocated by Dominici. These busts of children and adolescents (including those of holy figures) were a relatively brief flowering from the middle of the fifteenth century to about 1510, coinciding "with the fall of the Republic," thus relating these works not only to the home but also to the family's civic obligations and duties.[102] As the patron saint of Florence, the civic implications of St John the Baptist were exceptionally potent in exemplary figures in household imagery to instill children and adolescents with religious and civic values.[103] Small statuettes of Hercules are also found in Renaissance palazzo, connote strength and fortitude, and represent the Republic of Florence.[104] Richard Goldthwaite finds the "juvenescence of formerly venerable older men like King David … or like Saint John the Baptist, heretofore represented as a hairy semibarbarian" as evidence of the rising status of women in the palazzo and new concerns for children and their education.[105] With small, moveable objects, it is difficult to pinpoint fixed locations for statuettes of this size and type.

It seems likely that statuettes and busts were in *piano nobile* and ground-floor *camere*, and might have been placed over beds, doors, fireplaces, and even over *acquaii* (wall fountains).[106]

The prevalence of youthful David images in Florence in the fifteenth century is unique[107] and corresponds with the political message and situation of Florence, and to the general demographics of the city. With a city population skewed towards young, adolescent males, a young David reflected the city's youth and promoted its virtue and Republican patriotism. While most youthful David images became symbols of Florence appropriated by the Signoria, the handful of domestic versions point to this message in the home setting, for residents and guests. Donatello's bronze *David* (c. 1446–60?, Florence, Museo Nazionale del Bargello), ultimately for the Medici household, or the marble Casa Martelli *David* by Bernardo or Antonio Rossellino (c. 1461/79, Washington, DC, National Gallery of Art) are obvious examples. Their courtyard locations are particularly salient when considering the young men (and potential guests) residing in surrounding *camere*. Courtyard sculptures of David, roundels of generic Old Testament heroes, or other edifying medallions ornamenting a courtyard frieze reflect the taste and status of the patrician to a visitor, but may also have served as pedagogical reminders to the home's eldest children on their way in or out of the palace.[108]

However, small bronze and terracotta statuettes confirm the existence of iconic subjects within the home, such as a terracotta *David* statuette, which is just under 20 inches tall (Figure 4.2). Adrian Randolph's multi-valented reading of della Robbia domestic *dovizie* offers a relevant comparison for reading the Davidian subject in domestic spaces.[109] Regarding the glazed terracotta *dovizie*, Randolph effectively links the della Robbia works to Donatello's lost *Dovizia* from the Mercato Vecchio, in terms of the familiar thematic parallels of abundance and wealth, and specifically how this theme was read by women and men in the house through a domestic lens, thus literally bearing on the goals of the family. Further, these goals of wealth, fertility, and procreation were civic goals, opening the door for a more fluid exchange between Florentine domestic and civic culture. Therefore, as much as these domestic objects formed part of the family spaces of the home, the objects themselves elided the civic and the domestic. Considering the domestic Davids, one has to consider how these objects were read in the context of the spaces of the family, realizing that such works conditioned both creator and observer as they walked through the civic spaces of the Florentine Republic. Antonio Pollaiuolo's *David* (c. 1470, Berlin, Gemäldegalerie) is an illuminating example intended for a well-appointed home.[110] A young man, an older adolescent, with a confident, even militaristic stance, promotes the ideal of the readiness of well-trained and educated youth to defend the Republic and even the home. He wears not armor, but the elegant "patrician garb" of upper-class youth and even his hairstyle is typical of this age and class. Such idiosyncrasies suggest that this David represents a contemporary youth,

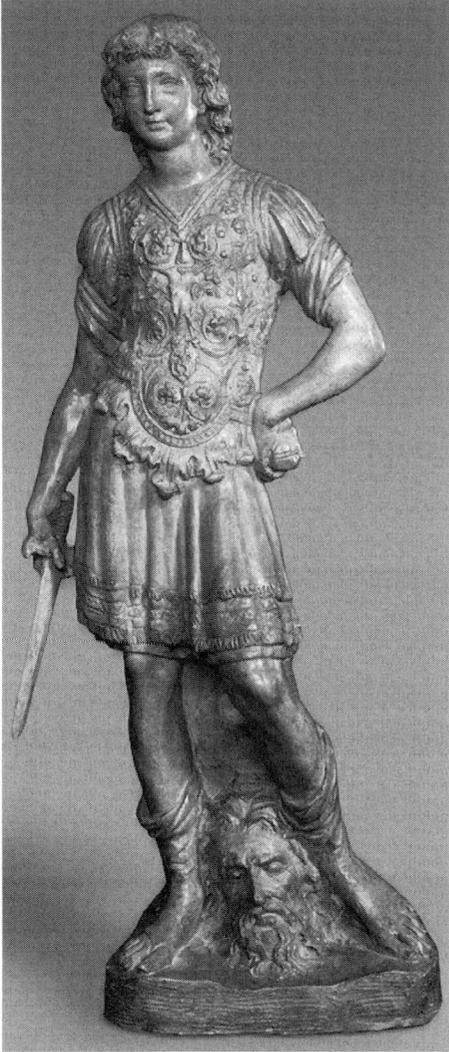

4.2 Master of the David and Saint John Statuettes, *David*, 50 x 17.4 cm, terracotta, late fifteenth to early sixteenth centuries, National Gallery of Art, Washington, DC. Photo credit: National Gallery of Art

though the painting lacks any firm documentary evidence to support such a view. Yet, with domestic images intended to instruct and educate, it is plausible that an adolescent resident might contemplate this David, who looks like himself or his friends, and thereby emulate the virtues that all contemporary authors insisted Florentine youth needed. Further, displaying the youthful David in the home or courtyard, as a symbol of the Republic, paralleled child-rearing practices advocated by humanists who urged fathers to raise their sons with guidance and authority, not with the fear and violence of tyranny. The male youths in fifteenth-century Renaissance portraits who had not yet reached political maturity were apparently causing nothing but social trouble, but parents, educators, and society in general were on their guard, looking for ways and techniques to guide these soon-to-be citizens. Treatises and youth confraternities participated on this front, and adolescent portraits and related adolescent imagery in the home promoted the desired expectations and outcomes of their efforts, while also providing mirrors of the adolescents' ideal selves.

The need to impress and always appear publicly appropriate, even when at home, is a recurrent theme in Alberti's *On the Family*; one's actions were always a public reflection of family honor. For example, noting the day and time of a child's birth was not strictly the joy of welcoming a new child into the family. Such notations demonstrated the "conscientiousness" of the father and one day, should the information be needed, asking others for it would be embarrassing.[111] The majority of exemplary images were in rooms typically populated by adults, usually the parents' chambers or perhaps in the *sale*, rather than exclusively in the children's rooms. The presence of adults in these rooms, conversing with the children, telling them stories, and directly referring to the images, augmented the images' instructive value. Significantly, the images communicated to visitors that the patriarch of the home fulfilled his civic and dynastic obligations not only by having children, but also by attempting to educate his children on behalf of his family and the Republic. The attentiveness Renaissance parents directed toward their children at every age, through formal portraits, devotional objects with child holy figures, toys, and fashionable attire reveals the public nature of child-rearing and care within the palazzo. Indeed, from his birth, the child's life oscillates between

the social norms, which abruptly take the newborn from his natal home, to his return to it and the spaces and things of the home used for the child's moral, physical, educational, and civic development. The child's growth also necessitates a transition to the public world, and the parents and spaces of the home adjust to new needs. As their son grows, the guiding hand of the mother and other household women on the *piano nobile* subsides when the son becomes an adolescent and when the father becomes a more active parent, preparing his son for life beyond the palace. However, from upper-level windows overlooking the courtyard, a mother could still keep an eye on her growing son as he leaves and returns to the palazzo.

Notes

1 David Herlihy and Christiane Klapisch-Zuber, *Tuscans and their Families* (New Haven: Yale University Press, 1978, 1985), 188–91.

2 Ibid., 195.

3 Philippe Ariès, *Centuries of Childhood: A Social History of Family Life*, translated by Robert Baldick (New York: Alfred A. Knopf, 1962) is a landmark study which paved the way for ensuing scholarship. The work of Christiane Klapisch-Zuber (see note 1 and *Women, Family, and Ritual in Renaissance Italy*, translated by Lydia Cochraine (Chicago: University of Chicago, 1985)) has contributed to our understanding of the role of women and also how children were perceived. See also Margaret King's "Concepts of Childhood: What We Know and Where We Might Go," *Renaissance Quarterly* 60(2) (2007): 371–407, which presents a sweeping review of the literature, the methodologies, and the under-explored areas of early modern childhood; Patricia Fortini Brown's "Children and Education," in *At Home in Renaissance Italy*, edited by Marta Ajmar-Wollheim and Flora Denis (London: V&A Publications, 2006), 136–43; and Jacqueline Marie Musacchio's *Art, Marriage, and Family in the Florentine Renaissance Palace* (New Haven: Yale University Press, 2008), especially 38–50, which also offer insightful considerations of children and childhood in Renaissance Italy.

4 Ilaria Taddei referencing Isidore of Seville's *Etymologiarium* in her "Puerizia, Adolescenza, and Giovanezza: Images and Conceptions of Youth in Florentine Society during the Renaissance," in *The Premodern Teenager: Youth in Society, 1150–1650*, edited and translated by Konrad Eisenbichler (Toronto: Centre for Reformation and Renaissance Studies, 2002), 15–26. Fifteenth-century authors who comment on life stages and characteristics often refer to Isidore of Seville (c. 560–636).

5 Ibid., 21.

6 Matteo Palmieri, *Vita civile*, edited by Gino Belloni (Florence: Sansoni Editore, 1982), 32: "poi nella giovaneza, quando già si conosce il bene dal male, dicono cominciare le dua vie del Y, cioè della nostra vita in nel quale tempo o gl'uomini seguitano la via più ritta, cioè delle virtù, o veramente se ne vanno per la via pianna et più bassa de' vitii."

7 Taddei, "Puerizia, Adolescenza, and Giovanezza," 20; ibid., 32.

8 Lloyd deMause, "The Evolution of Childhood," in *The History of Childhood*, edited by Lloyd deMause (New York: Psychohistory Press, 1974), 51. DeMause's view of this period as a transitional era offers a skewed perspective on infancy, since his discussion only considers children who were kept, who survived infancy away from their birth parents, and who were not left to charitable welfare at an orphanage.

9 See James Bruce Ross, "The Middle-Class Child in Urban Italy: Fourteenth to Early Sixteenth Century," in *The History of Childhood* (see note 8), 186 and 217 n. 11; Leon Battista Alberti, *I libri della famiglia* translated by R.N. Watkins as *The Family in Renaissance Florence* (Columbia, SC: University of South Carolina Press, 1969), 51–4; Palmieri, *Vita civile*, 18–23; Giovanni Rucellai, *Il Zibaldone Quaresimale*, edited by A. Perosa (London: The Warburg Institute, 1960), I, 13.

10 Alberti, *The Family*, 54. See also Giovanni Dominici, *Regola del governo di cura familiare, parte quarta: On the Education of Children*, translated by Arthur Basil Coté (Washington, DC: The Catholic University of America, 1927), 37 and 41; Ross, "The Middle-Class Child in Urban Italy," 186.

11 Ross, "The Middle-Class Child in Urban Italy," 187, n. 24, "in the servant women's room"; Klapisch-Zuber, *Women, Family, and Ritual in Renaissance Italy*, 143.

12 Ross, "The Middle-Class Child in Urban Italy," 217, n. 13, describing the life of Marsilio Ficino who must have "lived decently" because he was sent out and brought up by his *balia*, citing Reymond Marcel, *Marsile Ficin (1433–1499)* (Paris, 1958), Appendix II, 694. The modest contraceptive effects of nursing among women in lower social classes versus non-nursing, usually urban, upper-class women, contributed to the population and economic disparity between urban elites and rural communities. See Herlihy and Klapisch-Zuber, *Tuscans and their Families*, 198–201; Brown, "Children and Education," 140.

13 DeMause, "The Evolution of Childhood," 34. Richard Trexler, "The Foundlings of Florence: 1395–1455," in *Dependence in Context in Renaissance Florence* (Binghamton, NY: Medieval and Renaissance Texts and Studies, 1994).

14 DeMause, "The Evolution of Childhood," 30. Nevertheless, as will be shown, parental love and attention is noted repeatedly.

15 Ross, "The Middle-Class Child in Urban Italy," 184–5.

16 DeMause, "The Evolution of Childhood," 34.

17 Klapisch-Zuber, *Women, Family, and Ritual in Renaissance Italy*, 149, n. 64, citing trousseau records for Rossello Strozzi, Antonio Rustichi, Filippo di Neri Rinuccini, and Luca da Panzano.

18 Ross, "The Middle-Class Child in Urban Italy," 195. The father of Giovanni Morelli, for instance, was left with his wet-nurse until he was "ten or twelve." Despite the recommendations to keep children at home, the relinquishment of infants to the wet-nurses prevailed and was, seemingly, even celebrated in art in much the same way that maternal bonds are suggested or promoted by domestic Madonna and Child images. In a number of birth trays, or *deschi del parto*, as well as public representations of the birth of the Virgin or Christ Child, the birth and the relinquishment to the implied wet-nurse are depicted as nearly simultaneous events. For more information on these objects, see Jacqueline Musacchio, *The Art and Ritual of Childbirth in Renaissance Italy* (Princeton, NJ: Princeton University Press, 1999); and John Pope-Hennessy and Keith Christiansen, "Secular Painting in 15th Century Tuscany: Birth Trays, Cassone Panels, and Portraits," *Bulletin of the Metropolitan Museum of Art* 38(1) (1980): 4–64, especially 4–11.

19 Klapisch-Zuber, *Women, Family, and Ritual in Renaissance Italy*, 149, n. 60–64; Ross, "The Middle-Class Child in Urban Italy," 191.

20 Ross, "The Middle-Class Child in Urban Italy," 191, lists the items in the *ricordanze* of Antonio Rustichi (see n. 22 below); Mussacchio, *Art, Marriage, and Family*, 42 and 269, notes 238–40, also describes similar layette items for Antionio di Marchione Maleghonele's daughter, Lionarda. Klapisch-Zuber, *Women, Family, and Ritual in Renaissance Italy*, 149, also lists items from Rustichi and other families' journals.

21 Cathleen Hoeniger describes this cradle as in a well-to-do home. The painting's subtext also cautions guardians against overly vigorous rocking in "The Child Miracles in Simone Martini's Beato Agostino Novello Altarpiece," *Zeitschrift für Kunstgeschichte* 65 (2002): 320.

22 Brown, "Children and Education," 140. Extravagant and expensive cradles are found in the Este family records which describe some as lavishly carved, gilded, and ornamented with expensive cloths and paintings. See Thomas Jason Tuohy, "Studies in Domestic Expenditure at the Court of Ferrara, 1451–1505: Artistic Patronage and Princely Magnificence" (PhD dissertation, The Warburg Institute, University of London, 1982), 103–5. Musacchio, *Art, Marriage, and Family*, 43, provides other inventory descriptions for cribs, blankets, and pillows.

23 Kapisch-Zuber, *Women, Family, and Ritual in Renaissance Italy*, 148.

24 Klapisch-Zuber, *Women, Family, and Ritual in Renaissance Italy*, 148–9. Of the 25 *ricordanze* mentioned in her study, 13 included cradles, and of those 13, 10 also included the framework.

25 Brown, "Children and Education," 140. See also Brenda Preyer, "The Florentine Casa," in *At Home in Renaissance Italy* (see note 3), 34–49, on the layout of the palace.

26 Ross, "The Middle-Class Child in Urban Italy," 191, n. 47, citing the unpublished diary of Antonio di Bernardo Rustichi between the years 1412 and 1436, Florence, State Archives, Carte Strozziane, series II, vol. II, folios 8 recto to folio 71 verso.

27 Ross, "The Middle-Class Child in Urban Italy," 194.

28 DeMause, "The Evolution of Childhood," 11. Babies from birth to four months were likely completely swaddled, then their arms were released, but legs and bodies were bound to about six to nine months (ibid., 38). It could take as long as two hours to wrap a baby and caregivers were expected to change bands three times per day. See Ross, "The Middle-Class Child in Urban Italy," 194, citing "carnival songs."

29 Ross, "The Middle-Class Child in Urban Italy," 194.

30 DeMause, DeMause, "The Evolution of Childhood," 37. That the practice of swaddling was widespread in Renaissance Italy is certain; how long a child was swaddled is less so.

31 Dominici, *Regola del governo*, 41.

32 Ibid., 34. See also Geraldine Johnson, "Family Values: Sculpture and the Family," in *Art, Memory, and Family in Renaissance Florence*, edited by Giovanni Ciappelli and Patricia Rubin (Cambridge: Cambridge University Press, 2000), 219.

33 Geraldine Johnson, "Beautiful Brides and Model Mothers: The Devotional and Talismanic Functions of Early Modern Marian Reliefs," in *The Material Culture of Sex, Procreation, and Marriage*, edited by A. McClanan and K. Rosoff Encarnacion (New York: Palgrave, 2002), 146, 150.

34 See DeMause, "The Evolution of Childhood," 20–21, on this point.

35 Ross, "The Middle-Class Child in Urban Italy," 199.

36 Ibid.

37 See Klapisch-Zuber, "Holy Dolls: Play and Piety in Florence in the Quattrocento," note 3; and Geraldine Johnson, "Art or Artefact: Madonna and Child Reliefs in the Early Renaissance," in *The Sculpted Object: 1400–1700*, edited by Stuart Currie and Peta Motture (Aldershot: Scolar Press, 1997), 1–24.

38 Johnson, "Art or Artefact," 6, discusses Fra Dominici's influence on domestic arts. See Sigmund Freud, *Neurosis and Psychosis*, The Standard Edition of the Complete Psychological Works of Sigmund Freud, XIX, 1923, 151, which describes the concept of wish fulfillment.

39 Leon Battista Alberti, *On the Art of Building in Ten Books* (Cambridge, MA: MIT Press, 1988), 120.

40 On such spatial fluctuation, see Sandra Weddle, "Women's Place in the Family and the Convent: A Reconsideration of Public and Private in Renaissance Florence," *Journal of Architectural Education* (November, 2001): 64–72.

41 James R. Lindow, *The Renaissance Palace in Florence: Magnificence and Splendour in Fifteenth-Century Italy* (Burlington, VT: Ashgate, 2007), 124.

42 I would like to thank Katherine McIver for this information and the reference to unpublished inventories in Parma: Archivio di Stato Parma, Familia Sanvitale, Patrimonio familiare, b. 72, D II 861 and Famiglia Pallavicini, b. 5, 18 September 1522.

43 Ross, "The Middle-Class Child in Urban Italy," 196.

44 Arnold Victor Coonin, "Portrait Busts of Children in Quattrocento Florence," *Metropolitan Museum Journal* 30 (1995): 61–71.

45 Ibid., 65–6; Geraldine Johnson, "Family Values," 229.

46 Coonin, "Portrait Busts of Children in Quattrocento Florence," 61, 65, and 67. Just as portraiture assumed an important role in the humanist culture of Renaissance Florence, so too did portraits that documented the new youth culture. Although not as common as their adult male counterparts, portrait busts of children emerged as a sculptural genre in the 1450s and flourished for about 50 years. Perhaps the tangibility of sculpture, in contrast with painted child portraits, promoted touch, a form of socially acceptable physical affection between parents and children that was limited primarily to this age. Further, the durability of the sculpted medium may have offered parents hope that their children would survive childhood and endure to continue the family.

47 Ibid., 61. In the sixteenth century, painted portraits of babies, children, and older youths flourish. See the exhibition catalogue *I principi bambini: abbigliamento e infanzia nel seicento*, edited by Elena Pulcini (Florence: Centro Di, 1985).

48 Wilhelm Bode, *Florentine Sculptors of the Renaissance*, translated by Jessie Haynes, 2nd edn (New York: Hacker Art Books, 1969 reprint), 155–6.

49 "Have paintings in the house, of holy little boys or young virgins, in which your child still in swaddling clothes may delight, as being like himself … and as I say for paintings I say for sculptures … In the same way he may mirror himself in the holy Baptist, dressed in camel skin, a small boy entering the desert": Dominici, *Regola del governo*, 34. Debra Strom, "Desiderio and the Madonna Relief in Quattrocento Florence," *Pantheon* 40 (Spring 1982): 131; and Johnson, "Art or Artefact," 6, provide two brief summaries on how Fra Dominici affected the domestic arts; here Johnson noted the primary viewers of the devotional figures were "relatively uneducated … such as a child." See also Alison Luchs, "The Bambini," in *Desiderio da Settignano: Sculptor of Renaissance Florence*, Marc Bormand, Beatrice Paolozzi Strozzi, and Nicholas Penny (Washington, DC: National Gallery of Art, 2007), 160–75.

50 Bode, *Florentine Sculptors of the Renaissance*,155–6; and Coonin, "Portrait Busts of Children in Quattrocento Florence." For examples, see Desiderio da Settignano's *Christ Child (?)* and *Little Boy* (c. 1460 and c. 1455/60, Washington, DC: National Gallery of Art).

51 Giancarlo Gentilini, *I della Robbia: La scultura invetriata nel rinascimento*, vol. I (Florence: Cantini, 1992), 173. Fifteenth-century parents could associate the virtuous character connoted by the tin-glazed medium of the portraits with their children. See Stephanie R. Miller, "A Material Distinction: Tin-Glazed Terracotta Portraits in Fifteenth-Century Italy," *The Sculpture Journal* 22(1) (2013): 7–20.

52 Portrait busts or heads were often unidentified in inventories. See John Kent Lydecker, "The Domestic Setting of the Arts in Renaissance Florence" (PhD dissertation, The Johns Hopkins University, 1987), 66 and 69: "due teste di banboci in su le letiere."

53 Ibid., 72. See also Brenda Preyer, "The Florentine Casa" and "The *Acquaio* (Wall Fountain) and Fireplace in Florence," in *At Home in Renaissance Italy* (see note 3), 38–9 and 284–7; Musacchio, *Art, Family, and Marriage*, 208–9.

54 Lydecker, "The Domestic Setting of the Arts in Renaissance Florence," 127, n. 105 and 143. These objects are found in a variety of materials, bronze, terracotta, or the material is left unstated. See Musacchio, *Art, Marriage, and Family*, 233–4 for terracotta examples of domestic representations of playful children.

55 Brown, "Children and Education," 140.

56 Ross, "The Middle-Class Child in Urban Italy," 202, citing Barberino (1264–1348). Barberino also urges children to use little chairs with a hole for the purposes of toilet-training. Vincenzo Catena's now-destroyed Dresden *Holy Family* (c. 1495) depicted the square, wheel-less form of the walker.

57 Brown, "Children and Education," 140.

58 Alberti, *On the Art of Building*, 149.

59 Alberti, *The Family*, 63.

60 Lindow, *The Renaissance Palace in Florence*, 124, n. 34.

61 Alberti, *On the Art of Building*, 149.

62 Lydecker, "The Domestic Setting of the Arts in Renaissance Florence," 64, n. 84, citing the room of 10-year-old Giovannino (Giovanni di Francesco Tornabuoni's son) given in a 1497 inventory; Jacqueline Marie Musacchio, "The Madonna and Child, A Host of Saints, and Domestic Devotion in Renaissance Florence," in *Revaluing Renaissance Art*, edited by Gabriele Neher and Rupert Shepherd (Aldershot: Ashgate, 2000), 155, cites Bartolomeo Sassetti, who in 1471 outfitted his sons' room with a devotional Madonna and Child, and in 1476 a painting of the Virgin and Son with St John the Baptist for his son Priore's bedroom.

63 Margaret King, "The School of Infancy," in *The Renaissance in the Streets, Schools, and Studies: Essays in Honour of Paul F. Grendler*, edited by Konrad Eisenichler and Nicholas Terpstra (Toronto: Centre for Reformation and Renaissance Studies, 2008), 41–85, especially 54–7.

64 Brown, "Children and Education," 141; Musacchio, *Art, Marriage, and Family*, 45–6.

65 Louis Haas, *The Renaissance Man and His Children: Childbirth and Early Childhood in Florence, 1300–1600* (New York: St Martin's Press, 1998), 137. Haas comments on oral traditions in the home by citing fathers' interests in reading to their children.

66 Ibid., 142, referring to S. Bernardino's and Dominici's recommendations.

67 Dominici, *Regola del governo*, 42–5. Toys are seemingly a part of a household's ephemera, perhaps kept for as long as they were useful and then given away. Also not recorded is where these objects were kept when in use. Hypothetically, most toys were not kept out, but were stored in chests.

68 Marta Ajmar, "Toys for Girls: Objects, Women, and Memory in the Renaissance Household," in *Material Memories: Design and Evocation*, edited by Marius Kwint, Christopher Brenard, and Jeremy Aynsley (Oxford and New York: Berg Publishers, 1999), 75–89, especially 86–7.

69 Ibid., 87–9.

70 Louis Haas, *The Renaissance Man and His Children: Childbirth and Early Childhood in Florence, 1300–1600* (New York: St Martin's Press, 1998), 144–5. Particularly revealing are the details from Niccolò Strozzi's list of the numbers and varieties of shoes for all seasons.

71 Dominici, *Regola del governo*, 39.

72 Ibid., 48.

73 Ibid., 49.

74 Ibid., 44.

75 Konrad Eisenbichler, *The Boys of the Archangel Raphael: A Youth Confraternity in Florence, 1411–1785* (Toronto: University of Toronto, 1998), 18–19. See also See Richard Trexler, "Ritual in Florence: Adolescence and Salvation in the Renaissance," in Trexler, *Dependence in Context*, 260, n. 4.

76 Eisenbichler, *The Boys of the Archangel Raphael*, 19–20, supporting Trexler, "Ritual in Context."

77 Herlihy and Klapisch-Zuber, *Tuscans and their Families*, 195.

78 See ibid., especially 196, for the social and economic breakdown of these ages and its implications.

79 Ibid., 196. Marrying at a much earlier age than boys, girls were essentially immune to the social repercussions of adolescence and are therefore not a part of this discussion.

80 See Paola Tinagli, "Womanly Virtues in Quattrocento Florentine Marriage Furnishings," in *Women in Italian Renaissance Culture and Society*, edited by Letizia Panizza (Oxford: Oxford University Press, 2000), 268.

81 David Herlihy, "Some Psychological and Social Roots of Violence in the Tuscan Cities," in *Violence and Civil Disorder in Italian Cities, 1200–1500*, edited by Lauro Martines (Berkeley, CA: University of California Press, 1972), 143–4 and 147.

82 Ibid., especially 140, 146–7.

83 Taddei, Puerizia, Adolescenza, and Giovanezza," 23, and Herlihy, "Some Psychological and Social Roots of Violence in the Tuscan Cities," 135, both cite Alberti.

84 Juliann Vitullo, "Fatherhood, Citizenship, and Children's Games in 15th Century Florence," in *Framing the Family Narrative and Representation in the Medieval and Early Modern Periods*, edited by Rosalynn Voaden and Diane Wolfthal (Tempe, AZ: Center for Medieval and Renaissance Studies, 2005), 182.

85 Ibid., 182, citing Alberti, *The Family*, 56.

86 Ibid., 182–3, citing Vittore Branca (ed.), *Ricordi di Giovanni di Pagolo Morelli* (Florence: Le Monnier, 1956), 456–7 and Alberti, *The Family*, 56.

87 Ibid., 182.

88 Alberti, *The Family*, 62.

89 Alberti, *On the Art of Building*, 149.

90 Alberti, *The Family*, 66. Later, Lionardo discusses the potential need for quality tutors.

91 Alberti, *On the Art of Building*, 121.

92 Flora Dennis, "Music," in *At Home in Renaissance Italy* (see note 3), especially 235.

93 Eisenbichler, *The Boys of the Archangel Raphael*, Chapter 15, "Fun and Games," 191–7.

94 Alison Wright, *The Pollaiuolo Brothers: The Arts of Florence and Rome* (New Haven: Yale University Press, 2005), 148. Andrea del Verrocchio's *Bust of Giuliano de'Medici* (1475/78, Washington, DC: National Gallery of Art) and Antonio del Pollaiuolo's *Young Man in Pageant Armor* (1469–75, Florence, Museo Nazionale del Bargello) were probably created to celebrate such a tournament.

95 Ludovico Sebregondi, "Clothes and Teenagers: What Young Men Wore in Fifteenth-century Florence," in *The Premodern Teenager* (see note 4), 34, citing St Bernardino's *prediche volgari*, vol. 3, sermon 37, p. 189.

96 Ibid., 29, 30, and 35. Age-dress legislation could be suspended on "official occasions" with age-dress distinctions blurring among the upper classes.

97 Alison Wright, "The Memory of Faces: Representational Choices in Fifteenth-Century Florentine Portraiture," in *Art, Memory, and Family in Renaissance Florence* (see note 32), 86–113, but see especially 87–8.

98 Ibid., 101–2, which describes him as a grandfather, as do others, such as the contributing authors of the revised edition of Frederick Hartt's *History of Italian Renaissance Art* (Upper Saddle River, NJ: Prentice Hall, 2007), 362. Statistically speaking, there were few grandfathers in comparison to grandmothers in Florence; see Herlihy, "Some Psychological and Social Roots of Violence in the Tuscan Cities," 147. Given the late age at which many men began their families, identifying the "old man" as a grandfather might be a presumption.

99 Wright, "The Memory of Faces," 101.

100 David Alan Brown (ed.), *Virtue and Beauty: Leonardo's Ginevra de'Benci and Renaissance Portraits of Women* (Washington, DC, National Gallery of Art, 2001), 177–8, catalogue nos 26 and 27. Similarly, Botticelli's *Portrait of a Young Man Holding a Medallion* (c. 1485, Washington, DC, National Gallery of Art), implies comparable intentions, but with courtly or moral connotations.

101 Bormand, Strozzi, and Penny (eds), *Desiderio da Settignano*, 128.

102 See Coonin, "Portrait Busts of Children in Quattrocento Florence," 69; Luchs, "The Bambini," 161; and Beatrice Paolozzi Strozzi, "Saints and Infants," in *The Springtime of the Renaissance: Sculpture and the Arts in Florence 1400-60*, edited by Beatrice Paolozzi Strozzi and Marc Bormand (Florence: Mandragora, 2013), 119-29.

103 Tinagli, "Womanly Virtues," 268. Tinagli cites Dominici (1860), 177–8. Statuettes of the adolescent St John the Baptist might be found over *acquai*; see Lydecker, "The Domestic Setting of the Arts in Renaissance Florence," 72; and Preyer, "The *Acquaio*," 286.

104 Lydecker, "The Domestic Setting of the Arts in Renaissance Florence," 120–21, n. 86, a 1472 notation of a sale of a small gesso Hercules from the home of Lorenzo Morelli; its location in the home is not recorded. See also Maria Monica Donato, "Hercules and David in the Early Decoration of the Palazzo Vecchio: Manuscript Evidence," *Journal of the Warburg and Courtauld Institutes* 54 (1991): 83–98.

105 Richard Goldthwaite, "The Florentine Palace as Domestic Architecture," *American Historical Review* 77(4) (1972): 977–1012, 1009–10.

106 The elevated positions of the works may convey an elevated status. Peta Motture and Luke Syson, "Art in the Casa," and Preyer, "The *Acquaio*," in *At Home in Renaissance Italy* (see note 3), especially 278 and 284–7.

107 See Gary M. Radke, "Verrocchio and the Image of the Youthful David in Florentine Art," in Gary M. Radke (ed.), *Verrocchio's David Restored* (Atlanta, GA: The High Museum of Art, 2003), 35–54. See also Musacchio, *Art, Marriage, and Family*, 241–2, for other examples.

108 Several enamel terracotta roundels of unidentified Old Testament and ancient heroes by the della Robbia family were probably installed in exposed spaces, such as courtyards; no complete program, however, has as yet been determined. See Francesca Petrucci, "Andrea della Robbia," in *I Della Robbia e "l'arte nuova" della scultura invetriata*, edited by Giancarlo Gentilini (Florence: Giunti, 1998), 85.

109 Adrian W.B. Randolph, "Renaissance Household Goddesses: Fertility, Politics and the Gendering of the Spectatorship," in *The Material Culture of Sex, Procreation, and Marriage* (see note 33), 163–89. The civic and religious connotations of domestic statuettes modeled after large public sculpture is also noted by Motture and Syson, "Art in the Casa," 282.

110 Wright, *The Pollaiuolo Brothers*, 74.

111 Alberti, *The Family*, 123.

The Venetian *Portego*: Family Piety and Public Prestige

Margaret A. Morse

One of the most distinctive spaces of the Renaissance Venetian domestic interior was the *portego*, the long hall that spanned the central axis of the *piano nobile* of the palazzi of the city's wealthy and noble classes, as well as some of its more modest households (Figure 5.1).

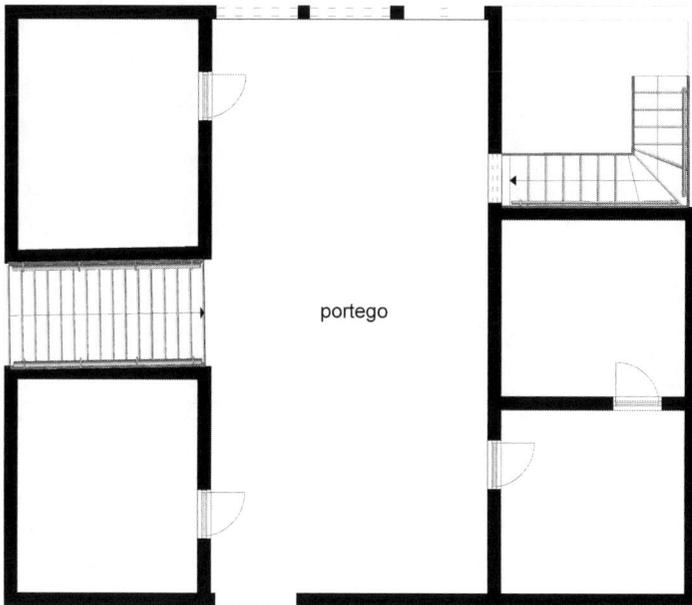

portego

5.1 Plan of a typical Venetian palazzo. Image drawn by author

In his treatise on domestic architecture, written in the 1540s, the theorist Sebastiano Serlio described the implementation of the *portego* plan in Venice as "the universal custom of the city."[1] A little less than a century later, in 1615, Vincenzo Scamozzi wrote in his treatise *L'idea dell'architettura universale*: "Of all the cities in Europe, Venice in particular can boast of many large halls. In fact, to create a fine hall Venetians are prepared to reconstruct most of the building."[2] Despite the fact that it became an almost standard feature of domiciles in the Republic, people did not normally perform the daily activities of the household in this space, and it was typically sparsely furnished as a result.[3] The *portego* was transformed, however, for the periodic banquets, receptions, and other social occasions that took place there, events that fused private family life with the public sphere. It was also an interior room that was visually and structurally more open than any other in the home, thereby always carrying the potential for encounters with visitors and business clients, amongst other company. The *portego* thus served as a kind of liminal space where the seemingly contrary ideas of internal and external, individual and communal, and, as I will demonstrate in this chapter, sacred and secular co-existed and merged.

Recent scholarship has examined the *portego* as an expression of nobility and a symbol of the virility of the Venetian Republic, thereby exploring the decoration and the social purposes of the space from a secular point of view.[4] I take a different approach here and argue that the space could additionally function as a spiritual environment. Religious paintings made such objectives possible. While pictures of various types were displayed in almost every room of the home, in the sixteenth century the *portego* increasingly became a site for the exhibition of paintings, and especially religious works. Household inventories reveal that holy images, from standard devotional forms to moralizing Biblical narratives, could be found in nearly all Venetian *porteghi*, and their consistency speaks of the critical role that they played in this setting. Elsewhere in this volume, Elizabeth Carroll Consavari has shown that paintings became the most highly collected item in Venetian households by the end of the sixteenth century. Monika Schmitter has also argued that the *quadro da portego* emerged in cinquecento Venice as a separate genre of painting; the scale and function of the room determined the particulars of these works, such as size, composition, and subject matter.[5] In this chapter, I concentrate on how religious paintings, in combination with the architectural features of the *portego* and its varying forms of decoration, helped to construct and govern the spiritual dimensions of the space, the activities that took place there, and, ultimately, identity. Religious paintings, along with other items of spiritual import, had the capacity both to shape the devotional behaviors of household members who encountered the space on a daily basis and to articulate the desired public persona of the family to frequent guests of the home.

The conventional characterization of the Renaissance home as secular space has meant that while scholars have acknowledged the presence of

sacred imagery, the role of religion and its related visual culture in this sphere remains one of the least examined aspects of an increasingly scrutinized area of early modern art, culture, and daily life. In the past couple of decades, focused studies on images of the Virgin and Child, particularly in the Florentine domestic interior, have emerged; scholars have concluded that in the palaces and households of Florence, religious pictures, primarily those of the Madonna, were mainly associated with the *camera*.[6] The maternal nature of Marian imagery and her primary location in an individual's chambers – along with the sometimes small scale of other objects associated with personal piety (Books of Hours, for instance) – and the behaviors associated with solitude, such as reading, ownership, and contemplation, have contributed to the frequent interpretation of domestic devotion as a private, confidential endeavor, and one geared towards women. As primary patrons and audiences for many domestic goods, women certainly did contribute a great deal to the shaping of the religious visual culture of the home, as well as the rituals and behaviors that they engendered. Yet, as Andrea Pearson has stressed in her book on Burgundian devotional art, we must be cautious not to seclude – both physically and mentally – household devotions because such perceptions threaten to make sacred domestic imagery "socially irrelevant" in our discussions of late medieval and early modern religion.[7] The marginalization of this subject in the art-historical literature of the early modern household also seems to be a result of this.

A study of Venetian homes shows that religion was central, literally and figuratively, to domestic life. Inventories, largely from the cinquecento, reveal that over 90 percent of Venetian households, from almost all social classes, owned at least one image or object of religious significance.[8] In fact, most homes had a wide range of holy goods, including paintings, sculpture, altars, and less conspicuous objects, such as rosary beads and devotional jewelry. Paintings were the most common of religious items acquired for the domestic environment, yet in Venice, they were not confined to the *camera*; instead, they permeated the household and could be found in nearly all rooms, including the *portego*. Given its large dimensions and central location in the house, the *portego* had been a place of work for many merchants and artisans, but during the course of the sixteenth century, it increasingly became a site for the assertion of social standing and success.[9] The presence of holy images in this most public of private spaces thus encourages us to reconsider its uses (and non-uses). It also demonstrates that religion was a fundamental aspect of domestic life and something individuals and families publicized as pivotal to their identity. The house physically and symbolically embodied those who dwelled there, and the practice of commissioning and collecting works of art for this sphere contributed to such concrete forms of expression. Moreover, in a period in which the laity assumed greater control over their spiritual lives, the home served as one of the most salient settings for religious activity and expression, made possible by the acquisition and display of devotional goods. With its substantial number and variety of religious paintings, the *portego* thus

makes a compelling case for the relevance of religion and its visual culture in our constructions of early modern domesticity.

During the late fifteenth and sixteenth centuries in Venice, where the sacred infiltrated all aspects of life, to be seen by one's peers as devout, moral, and favored in the eyes of God was of considerable importance for nearly all individuals and families, and the acquisition of pious works of art was thus a means by which to enhance one's public standing. This is not to say that the motivations that drove domestic devotion were spiritually insincere. Elsewhere I have examined the various functions successfully fulfilled by the images and objects associated with household religion – a testament to their critical role in shaping the home and the family that dwelled there. Sacred goods in the Renaissance Venetian household fostered devotion within the interior setting, and served additional roles as protective devices and educational aids that communicated the tenets of the faith and shaped a family's moral character.[10] It was because of their potential to define and articulate these particular circumstances that sacred articles became an authoritative vehicle for forming not only the personal spiritual lives of the individuals who experienced their power intimately on a daily basis, but also their social identity and reputation.[11]

The Appearance and Use of the *Portego*

The distinctive form and sizable dimensions of the *portego* were, to a large extent, dictated by the urban landscape. In a cramped city segmented by canals and a chaotic network of narrow streets, area for building was limited; palaces and houses often ran right into each other, decreasing the wall space available for windows. In response, architects developed a solution to bring large amounts of natural light into residential spaces, based on a design organized around four parallel load-bearing walls. These walls divided the ground plan into three axial spaces oriented perpendicular to the façade (Figure 5.1), with the *portego* normally occupying the entire inner axis and the smaller rooms of the house – the bed-chambers, sitting rooms, kitchen and occasional study – located in the two wings that flanked it. The design allowed architects to pierce liberally both the front and rear elevations with windows to provide the *portego* with abundant illumination.[12] A majority of the city's edifices have undergone centuries of remodeling, yet this original, tripartite arrangement – identifiable by the cluster of two to four glass openings at the midpoint of the façade – is still visible today on the fronts of Renaissance domiciles, even on the more modest homes that once belonged to the city's artisans and *popolani*.[13]

Despite its prominence in terms of size and appearance, inventories suggest that daily life of the *casa* principally unfolded not in the *portego* but in the *camere* located to either side. The relatively limited quantity and types of objects normally kept in the *portego* seem to reflect the lack of regular domestic activity in this central circulation space. In fact, when not in use, the room

occasionally functioned as additional storage space for essential household items; for example, the upstairs *portego* of a bricklayer named Lazzarini contained a cabinet full of glasses and *masserizie di casa* (household items), in addition to goods that would typically be used in the kitchen, such as various instruments for making bread and a container full of flour.[14] The chests kept in the *portego* regularly carried an assortment of objects, which ranged from silver and dishes that would be taken out and displayed during banquets and receptions to the necessities of the households, such as clothing and sheets.

Even if it was not an area for habitual domestic pursuits, the *portego* was a space continually accessed by both members of the household and its guests. The other rooms of the home flanked it on both sides, and stairs from the street, courtyard, or canal entrances all led into this large hall. The *portego* acted as a kind of receiving area and was often the only room of the house that a visitor would ever see, since not all guests would be invited into a family's personal chambers. Its considerable size made it the obvious choice for banquets, nuptial celebrations, and other social events, episodes that transformed the look and atmosphere of the room with objects, people, noise, and activity. As the most public of the interior spaces, there always existed the potential that the *portego* would be seen, and thus appearance mattered, regardless of the frequency of use.[15] The constant fluctuation between non-use and use added to the space's liminal status and its varying conditions of display.

The dimensions and design of the *portego* would have undoubtedly impressed the visitor to the home. The sets of large windows situated at either end of the long hall filled the room with light, producing a glittering and luminous effect that was only enhanced by the variety of reflective surfaces that imbued the space, most notably the highly polished and multi-colored *terrazzo* floors, and in some cases the mirrors, arms, and military trophies – a clear sign of the martial feats of certain family members and their loyalty to the Venetian Republic – that were exhibited here.[16] Wooden beams called *travi* typically ran across the ceiling perpendicular to the axis of the *portego*, creating a rhythmic pattern of light and dark down the length of the room. These were sometimes decoratively painted or even papered, and on rare occasions the highest portion of the walls, referred to as the *soffitto*, was ornamented with painted and sculpted friezes.[17] Gilded furniture, paintings, picture frames, and, from time to time, leather wall hangings collectively added to the space's pervasive visual brilliance.

The furnishings of the *portego* reflected the room's perpetual function as a site of hospitality. There was always an abundance of chairs and benches on which guests could sit, as well as tables, often mounted on trestles. Such furniture was relatively portable and could easily be moved about to suit the needs of the room at any given time.[18] A majority of *porteghi* contained at least one credenza, a piece of furniture much like the modern-day sideboard, to store and display the family's expensive tableware, often made of glass, silver, and maiolica.[19] Movable fountains and basins were also frequently found here, wrought in iron, bronze, and other metals.[20] Clocks became a

fairly standard object of the room, along with oil lamps and glittering glass chandeliers. On the walls hung a variety of tapestries and textiles made from luxurious fabrics, such as damask and brocade; they ranged from solid colors to floral patterns and elaborate landscapes. In addition to their placement on the partitions of houses, inventories regularly mention wall hangings stored in chests kept in both the *portego* and other rooms, which suggests that they were changed according to the social occasion or the time of year. As one of the costliest items a family could own, they would have certainly been taken out for special events, not just to enhance the beauty of the space but also to display a household's wealth and status. Coats of arms appeared on everything from chests and furniture to banners and picture frames; these markers personalized the *portego* and celebrated a family's cherished lineage.

Musical instruments contributed to the sounds and sights of the *portego*. Instruments, such as lutes and harpsichords, became increasingly popular items during the course of the sixteenth century, even in the homes of artisans. The highly decorative surfaces of many instruments – carved, painted, gilded or made from an inlay of precious materials such as ivory and ebony – enhanced the varied, and sometimes dense, visual splendor of the space, while the sounds they made undoubtedly resonated down the long walls. Music was not confined to the social spectacles that took place in the home, but was a regular activity of the family;[21] as the largest room of the house, the *portego* may have functioned as a place where family members of all ages could gather together for music lessons and concerts.[22]

The air and lighting that the *portego* received also probably made it a refreshing locale during the temperate months of the year for other kinds of domestic activity; thus, it may have been used more regularly depending on the seasons. Eating in the Renaissance home was not fixed to a single location. While the *portego* indeed served as the place where large banquets were held, family members may have dined here at other times as well, although we lack evidence to confirm if children and adults ate together.[23] A 1520 contract signed by six brothers who lived in the patrician palace of Ca' Foscarini described a *camera* as the room "where we are generally accustomed to eat in the winter," an indication that when the weather was warm, they likely dined in the *portego*.[24] Vincenzo Scamozzi encouraged the design of rooms with many windows because the fresh air and abundant light in such a space "raised one's spirits" and allowed for numerous activities to happen there all day long.[25]

Religious Paintings in the *Portego*: Between Interior and Exterior

Pictures added to both the attractiveness and the multi-faceted purposes of the *portego*. The two elongated walls of this room offered the ideal surface for their display. Indeed, paintings were perhaps the most regular element of Venetian *porteghi*; the number recorded in these spaces only increased during the course of the sixteenth century.[26] Inventories generally describe them as

large in scale, entirely appropriate for a room of such ample size. Some of the subjects displayed here were battles, allegories, and mythologies, such as the *Judgment of Paris* that hung in the *portego* of the Cavaliere Gerolamo Vignola or the *Four Seasons* painted on four separate canvases displayed in the lower *portego* of the ducal secretary, Simone Lando.[27] Portraits, usually of one's own family members, were also common. The artist and biographer Giorgio Vasari made a note of the Venetian tradition of portrait collections of one's kin. Praising Giovanni Bellini's initiation of the custom, Vasari wrote that "there are many portraits in all the houses of Venice, and in many gentlemen's homes one may see their fathers and grandfathers back to the fourth generation, and in some of the more noble houses back further still."[28] Like coats-of-arms and other heraldic signs, portraits functioned as another way of personalizing this most public space of the household while pronouncing the family's heritage to the outside world.

Religious subjects, however, outnumbered other kinds of themes in the *porteghi* throughout the Republic, and their sustained popularity across households and over time denotes their relevance and authority in this space. Venetians conceived of their dwellings as environments in which to pursue the sacred and better the soul, and religious objects and images were the primary means by which such goals were articulated and achieved. Benedetto Arborsani, a Venetian *cittadino* (a non-noble but elite citizen), described the ideal home as Christian and moral in his memoir of 1543 and even used the term *sagrestia*, or sacristy, as a metaphor for the *casa*.[29] Four decades later, Cardinal Silvio Antoniano conveyed a similar opinion in his extensive treatise on the Christian rearing of children published in Verona in 1584, as discussed by Erin Campbell in her chapter in this volume. He specifically encouraged fathers to hang religious paintings or prints around the domestic interior to incite reverence and devotion in those who dwelled there and to proclaim to those who visited that this was a Christian home.[30] The large numbers of religious paintings recorded in sixteenth-century Venetian household inventories suggest that Antoniano's instructions had already long been put into practice.

The Madonna and Child was the most common image exhibited in the *portego*, sometimes described in inventories as *alla grecha*, or in the Greek manner, denoting the Byzantine or Greek/Italian hybrid style that Venetians still favored long after it had fallen out of fashion elsewhere in Italy. Inhabitants of the Republic remained ardent consumers of the Greek manner throughout the sixteenth century and a large community of Cretan painters living in Venice meant that there was always a steady supply of Byzantine Madonnas. Venetians were attracted to this familiar style because they distinguished it as one of inherent value and sacredness.[31] Many of the miracle-producing Madonnas esteemed throughout the Republic, for example, were frequently copied for domestic consumption.[32] For several Italian cities, the Virgin performed as patron and protectress, but in the lagoon, she was synonymous with the Republic itself.[33] Legend claimed that Venice was founded on the

feast of the Annunciation in the year 421; thus, the Virgin's acceptance as the mother of God was seen as her consent to tend especially to this favored and sacral locale. Through acquisition and ownership of the image of the Madonna, and in a style deemed particularly holy and efficacious, Venetians could now bring this important civic cult into their personal sphere and express loyalty to the state.

At the same time that Venetians were avidly acquiring Greek images for their households, artists' workshops throughout the city and the Veneto region were creating increasingly naturalistic paintings of holy figures that quickly rivaled their Eastern counterparts in the context of domestic devotion. Artists began to represent the Madonna, Christ, and the saints as tangible, living beings, oftentimes set within landscapes or domestic locales that, while sometimes idyllic and imaginary, were convincing in their naturalism, and frequently even thematized the concept of a holy household. In pictures by Venetian artists such as Giovanni Bellini, Giorgione, Titian, and Jacopo Bassano, holy figures and the details of their surroundings were made all the more real not only to appeal to the aesthetic tastes of a sophisticated class of patrons, but also to meet their spiritual demands. Northern European paintings fulfilled similar objectives. Artists' names are almost never recorded in inventories, but many paintings are described as *alla fiandra*, or in the Flemish style. Inhabitants of the Republic admired paintings from Northern Europe – and Flanders, in particular – almost as much as those that came from the East.[34] Flemish artists often placed religious subjects in contemporary settings and cloaked the sacred message in visual narrative full of naturalistic detail. While artists from time to time may have swayed from the authenticity of the sacred texts, their pictorial strategies brought the biblical event into the present and the divine to the human level.

Other pictures that were displayed in the *portego* comprised themes such as: Christ and events from the Passion, *sacre conversazioni*, narratives from the Old and New Testaments, such as the Annunciation and the Nativity, scenes from apocrypha, and solitary images of a variety of saints. For example, Carlo da Fano, a physician, displayed paintings of Rachel, St Christopher, and the Annunciation in the *portego* of his home in the district of San Basilio,[35] while a man named Bernardo da Crema, from the parish of Santa Marina, had a framed painting of Christ on the cross, one of the Madonna, and a series of six paintings that told the story of Tobias.[36] Further examples include an old but large painting of the Visitation, a small wooden painting of the Madonna, and a canvas depicting the Old Testament heroine Judith, framed in walnut, listed in the *portego* of a Zuan Marco Trevisan, and paintings representing the Madonna with St Francis and the Conversion of Paul displayed on the *portego* walls of the home of Angelo Savina.[37]

Subjects such as the Madonna and Child and scenes from Christ's Passion could also be found in other rooms of the Venetian home, a testament to the ubiquity and power of such devotions. Certain figures and themes, however, appeared more commonly, and sometimes exclusively, in the *portego*, which

suggests that they played a particular role in this space. These include: St Christopher, the *Cena di Christo* – most likely images of the *Last Supper* or perhaps the *Supper at Emmaus* or *Wedding Feast at Cana* – and moralizing Biblical accounts, such as the *Prodigal Son*, *Christ and the Woman from Samaria*, and *Christ and the Adulteress*. For example, the 1566 inventory of a man named Francesco dall'Oca records a large painting of the *Prodigal Son*, framed in walnut, along with a canvas of Christ and the Four Evangelists, while Domenico de Gritti, a cloth dyer from the district of San Raffael whose inventory was registered in 1557, had a large painting of the Samaritan woman in his *portego*, worth four ducats.[38]

St Christopher's presence in the *portego* was largely talismanic. It was believed that looking upon the image of Christopher, the patron saint of travelers and merchants, would save the beholder from sudden death that day. Listed among the contents of possessions of the nobleman Giovanni Badoer (c. 1465–1535) is "uno San Christophalo in portego."[39] While the medium – painting, sculpture, print – of the image of the saint is not clear from the notation, its visible presence in Badoer's household likely had particular resonance for this Venetian diplomat, who traveled to countries such as Spain, France, England, and Hungary.[40] St Christopher's image was also quite appropriate for the *portego* given its function as a liminal space. Although the notaries are not specific with regard to the actual location of images of Christopher within the *portego*, it is highly probable that they were positioned next to or in close proximity to the doorway that led outside, in a manner similar to the placement of both painted and sculpted versions of this saint above or adjacent to the entrances of churches. Thresholds mark points of passage and transition, and thus the placement of pictures of St Christopher by doorways, ecclesiastical or domestic, operated as a metaphor for the saint himself; when transporting Christ across the river, he crossed the boundary from disbelief to true faith.[41]

While it is impossible to witness examples of gallery-type pictures of St Christopher *in situ* in a Renaissance residence, there are a few examples of domestic spaces in Italy in which mural paintings of the saint are preserved, and in each of these cases, his image appears directly by the threshold, thus strengthening the case for similar exhibition in the typical Venetian home. Christopher was not especially popular in Florentine households, but his image does survive there in the Palazzo Davanzati, as well as in the famous Trecento palazzo in nearby Prato that the merchant Marco Datini had constructed as his principal residence upon settling in the Tuscan city in 1383. In the former example, the habitat of a wealthy merchant family constructed in the late fourteenth century, a full-length figure of Christopher appears over the doorway that leads into the principal residential quarters, clearly visible as one ascends the staircase to the first floor. In the latter example, Marco Datini commissioned the Florentine artist Niccolò di Pietro Gerini to paint a fresco of the saint in the entrance hall of his residence, directly adjacent to the main doorway into his home.[42]

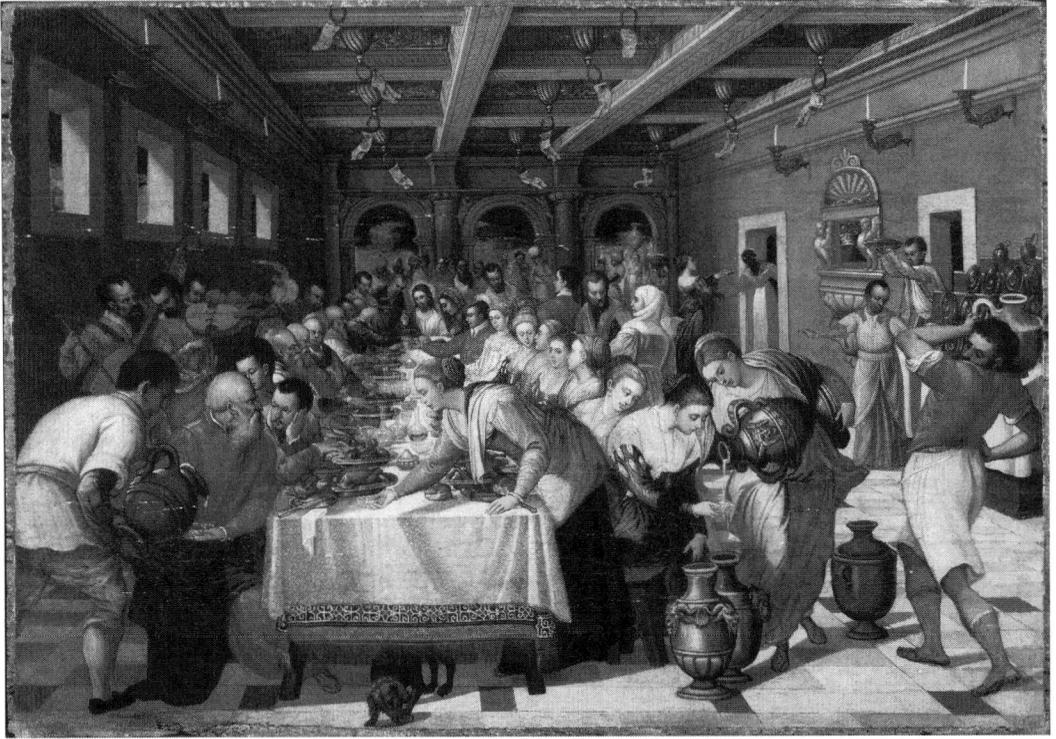

5.2 Anonymous after Tintoretto, *Marriage Feast at Cana*, 80 x 116 cm, oil on canvas, c. 1561–70. Museo Correr, Venice. Photo credit: Cameraphoto Arte, Venice/Art Resource, NY

Today, there is only one surviving image of St Christopher in a Venetian residential setting: Titian's version in the Ducal Palace. Painted in 1523 at the bequest of doge Andrea Gritti, it is situated directly over the doorway at the end of the stairwell that leads from the private apartments of the doge to the civic spaces of the palazzo; thus, every day, as the doge walked down the stairs to conduct the affairs of the state, he passed underneath this talisman and was assured the saint's protection. Christopher's location in a household so grand and symbolic for the city of Venice speaks of the eminent value that this holy figure held in an overwhelmingly mercantile society. By placing pictures of St Christopher adjacent to the entrance of the *portego*, he was one of the first and last images Venetian merchants saw when entering and leaving the home on their frequent voyages to and from distant lands. Through this manner of display, Venetians sought to secure the intercession of this holy protector to ensure the safe passage of travelers from their household, while providing those who stayed behind with a vision of comfort and reassurance.

Just as St Christopher was a fitting subject for the *portego* given its liminal nature, the sacred meals of Christ were also appropriate themes for a room where dining occasionally took place, similar to the display of the *Last Supper* in the refectories of monasteries throughout Italy.[43] The suppers of Christ painted in the Veneto around the mid- to late-sixteenth century were typically set in large, contemporary interiors, full of material splendor, people, and movement, and likely reflected in terms of setting and activity the actual

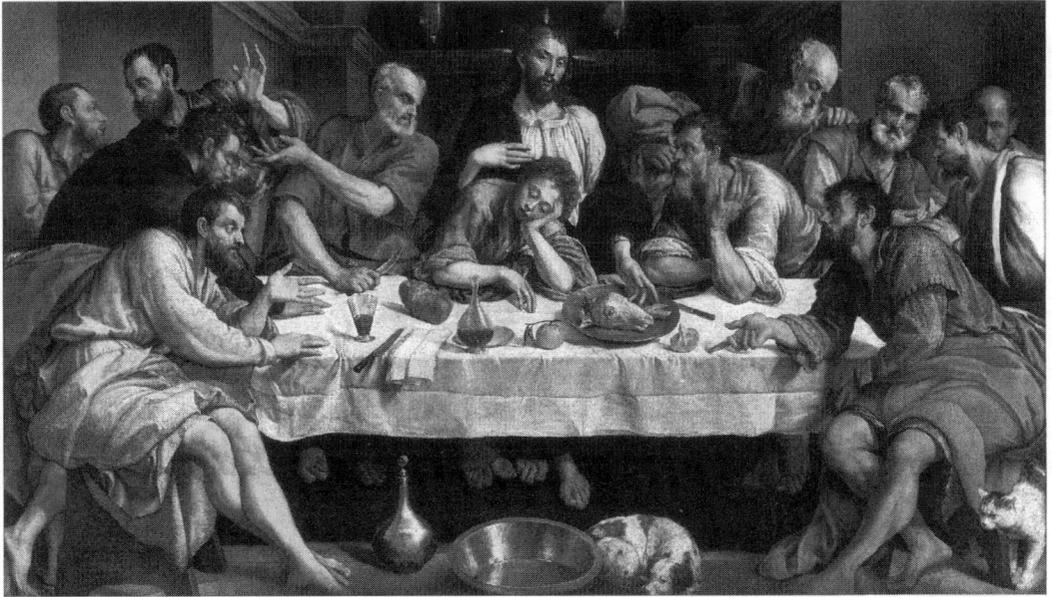

banquets that convened in *porteghi*. For example, a *Marriage Feast at Cana* painted by a Greek-Venetian artist in the 1560s (Figure 5.2) after Tintoretto's large-scale version in the church of Santa Maria della Salute and perhaps created for the domestic context appears to take place in a space very similar to Venetian halls. Beams run the length and width of the room and lead the eye back to the three large windows, whose arched forms reflect the growing classicizing taste in architecture in the lagoon city during the cinquecento. A credenza, full of silver or pewter vessels, occupies the right-hand wall, along with an elaborate wall fountain flanked by two griffins. Well-dressed guests in contemporary clothing gather around a long table and are entertained by a group of musicians to their left, while numerous servants move about the hall and replenish food and drink. Christ is almost entirely subsumed by the crowd, yet his faint halo and the lines of perspective draw the viewer's eye back to the far end of the table where he sits. His presence reminds the viewer not only of the miracle that took place amidst the bustling activity in the picture, but also where one should direct his or her attention when similar events took place in the actual *portego*. By presenting the holiest of meals, images like these offered audiences the paradigmatic feast for what were often non-pious celebrations, thereby merging the sacred with the secular.[44]

One surviving Venetian *Last Supper* that can be traced back to an original owner is the painting by Jacopo Bassano now in the Borghese Gallery in Rome (Figure 5.3); according to Bernard Aikema, it was ordered by the nobleman Battista Erizzo in 1546–7. In this version, Bassano slants the table in an unnatural manner to offer emphatically the wine and bread to the viewer, while Christ's fixed gaze on the beholder and his gesture – one hand on his chest and the other presenting the Paschal lamb – underscore

5.3 Jacopo Bassano, *The Last Supper*, 30 x 51 cm, oil on canvas, 1542, Galleria Borghese, Rome. Photo Credit: Alinari/ Art Resource, NY

the Eucharistic significance of the piece.[45] An individual or family's stance on questions of religious doctrine, such as the nature of sacraments, was an issue that became increasingly important amid the tumultuous religious climate of Venice during the second half of the sixteenth century, when many of the city's residents either fully embraced or were sympathetic to Lutheran and Evangelical teachings. Images of sacred meals may have thus been acquired and displayed in the *portego* to pronounce more publicly the beliefs of the patron.

As with images of sacred suppers, the decision to exhibit moralizing New Testament narratives in the *portego* aligned with the communal functions of the room, situating the space between interior family life and external affairs. The subject matter was also relevant to the social and economic circumstances of the Republic in the sixteenth century. Venice was a cosmopolitan city, and its residents, sometimes themselves foreigners, continuously received guests who hailed from distant lands. Accordingly, *Christ and the Samaritan Woman* would have resonated for both members of and visitors to the household as a tale of acceptance and charity, embodied in the woman from the land neighboring Jerusalem. Charity permeated Venetian life as the concept was built into the social institutions – *scuole*, hospitals, the Monti di Pietà – of the city for the peace and prosperity of the Republic.[46] The virtue of charity was thus synonymous with not only moral honor but also civic loyalty.[47]

Inventories are usually vague documents and unfortunately do not list a specific episode of *The Prodigal Son* story that Venetians owned. Two types are images are possible: a Merry Company-type scene that highlights the son's sinful nature drinking and cavorting in a tavern, or one that focuses on his return home and the father's forgiveness. The former could have served as a warning against the kind of bawdy behavior that could ensue in a room designed for hosting parties and banquets, while the latter may have imparted messages of welcome and goodwill to guests at the same time as it played upon familial relationships and, like St Christopher, offered a reassuring image for Venetian merchants frequently away from home. Even the subject of *Christ and the Adulteress*, which undoubtedly served as visual discouragement against the sin and crime of adultery to the women of the household, announced the ideals of tolerance and compassion.

The visual and physical juxtaposition of religious images and portraits in the *portego* further reinforced how the family wished to be seen. Sometimes this connection was made even more explicit through the presence of donor portraits within the paintings themselves. The pictorial cycle commissioned by the merchant Alvise Cuccina in around 1571 for the first-floor *portego* of his family's palace is an example of this practice on a grand scale. A member of the city's *cittadino* class, Alvise consciously sought out Paolo Veronese, a painter popular with the Venetian nobility, to execute the series, and through this act of patronage he made a claim for his own status as a wealthy and knowledgeable benefactor of the arts.[48] Alvise's aim in commissioning the paintings did not, however, end here. The cycle consists of four canvases:

The Adoration of the Magi, The Wedding Feast at Cana, The Road to Calvary, and the *Cuccina Family Presented to the Madonna and Child* (Gemäldegalerie Alte Meister, Dresden). The first three paintings listed each include at least one portrait of a key figure of the family, while the last features all of the members of the Cuccina household, including a posthumous portrait of Alvise's brother, Antonio.[49] Both individually and as a whole, these portraits/ devotional paintings thematize the subject of personal prayer and piety by making manifest the family's experience in the presence of the sacred, and visually profess their faith and orthodox beliefs.[50]

To Learn and to Pray

Images, of course, were also didactic. As the above examples demonstrate, the sacred stories of *portego* paintings were not only directed outward to the public sphere. The focus was also inward; pictures played an influential role in shaping the spiritual and moral fiber of family members, particularly children, who were believed to be highly impressionable beings, impacted by the food they consumed, the words they heard, and, most especially, the images they saw. Throughout the Renaissance, religious leaders who penned domestic treatises consistently stressed the importance of creating and raising a Christian family. An early surviving economy from the Renaissance, *De regimine rectoris*, composed by Venice's Fra Paolino the Minorite in the beginning of the fourteenth century, counseled fathers to instruct their children first in faith, then in good manners, and finally in knowledge.[51] Elsewhere in this volume, Stephanie Miller has elaborated upon Giovanni Dominici's *Regola del governo di cura familiare*, complete by 1405, and his advice on educating children. Dominici asserted that regardless of a woman's position in life, her primary responsibility was to instruct her child in faith, and he gave specific details and advice about how women should teach their children to be moral and devout Christians. He urged the display of pictures of Mary, Christ, and the saints around the house as exemplars for small children, and encouraged the creation and maintenance of domestic altars as a devotional exercise.[52]

Comparable guidance continued to be offered in the latter half of the sixteenth century and was largely influenced by reform efforts of the church. Cardinal Agostino Valier, for example, in his *Della istruzione delle donne maritate*, first published in Venice in 1575, stressed the importance of wives in maintaining moral households, which he saw as "truly houses of God, lodges of peace and concord."[53] He instructed women to attend to their husbands' needs, administer to the household, and read pious works and devotional literature in order to teach the fundamental aspects of the faith to their children and maidservants. In a similar manner, the theorist Francesco Tommasi, in his *Reggimento del padre di famiglia*, published in 1580, asserted that the principal care of parents towards their children must be that of faith, and encouraged religious education to be carried out as soon as possible after birth.[54]

The use of images as a pedagogical tool was established on the simple but efficacious principle of the gradual assimilation of the beholder to the depicted subject.[55] As Paolo Cortesi wrote, "pictures should be symbols of virtues so that … the soul will be excited to similar virtuous acts [throughout the day]."[56] Domestic religious images undoubtedly fulfilled such a task. Miller has shown that in Florence, the *sala*, with its larger size, could function as a site for domestic education. While specific evidence about children's time in the Venetian *portego* is lacking, similar activities may have occurred there as its scale and lack of dedicated function meant that children could likely gather in this space on an everyday basis, since the room was not normally in use. Along the long walls of the *portego*, pictures of saints and other holy figures could provide young family members with a visual paradigm of sanctity to which they should aspire, while the moralizing narratives simultaneously communicated edifying, Christian messages to members of the household and acted as emblems of the honorable and hospitable character of the family to those who called on the home from the outside world.

As mentioned above, devotional images, such as the Madonna and Child and scenes from Christ's Passion, were not restricted to bed-chambers, but instead permeated the family's living quarters, including the *portego*. Given the visual nature of belief and worship in the Renaissance, the display of such images makes it likely that devotional activity took place in this central *sala* in addition to the *camera*. There is even the suggestion of an altar in the *portego* of one household, which clearly brought religious observance into the space. The 1560 inventory of a spice merchant named Gerolamo, from the district of Santa Croce, does not record an actual altar, but it does list a cabinet "made for the altar" ("fatto per altar") in the *portego* of his home. The notation implies that the altar itself may have been a permanent fixture of the house, thereby passing the scrutiny of the notary whose task was to list movable goods. Noted right after this altar cabinet are several liturgical items that suggest a complete ritual environment ripe for the performance of mass: an old altar cloth with a deep blue cross, priestly vestments, two bronze bells, a small iron basin, a pair of iron candlesticks, and a chalice.[57] While the example of Gerolamo may be a rare exception, it does reinforce the hypothesis that the *portego* was a site for devotional activity. In addition to holy images, other objects not normally kept or displayed in the *portego* could travel into this space to assist spiritual pursuits. These include portable items such as prayer books, handheld crucifixes, rosary beads, and devotional jewelry, all of which are recorded in abundant quantities in the majority of Venetian households.

The *portego* may have provided an appropriate setting for family prayer and religious lessons, as its ample size, in addition to the light and air it received, made it a space conducive to large gatherings. The *portego*'s lack of regular use may also have made it a desirable location to carry out more solitary devotions, a welcomed retreat from sometimes cramped living quarters with little privacy. The size, axial dimensions and glittering surfaces of the *portego* – from the windows and polished floors to the mirrors, armor, and gilded

furniture – were also suggestive of ecclesiastical spaces, and gave the room an aura of sanctity and authority. In fact, the sixteenth-century scholar Francesco Sansovino asserted that the space was similar to a "very reverend and spotless church of nuns."[58]

Despite the sacred nature of the space, religious pictures hung alongside secular subjects, and in sometimes disquieting combinations, as exemplified in the 1545 inventory of the *portego* of Gerolamo Zon, where a *Last Supper* and a Greek Madonna and Child were displayed alongside a bathing scene painted on canvas from the Flemish school.[59] Inventories suggest, however, that sacred images were often set apart from the mundane through the addition of *fornimenti*, or furnishings, such as candles, oil lamps, and small containers for holy water that hung in front of or nearby the image, similar to the manner of exhibition of the half-length Madonna and Child in Vittore Carpaccio's *Dream of St Ursula* (Galleria dell'Accademia, Venice) from 1495. Such markers underscore the image's holy status and serve as votives to honor the divine figures represented. Furthermore, they verify that although they did not always adorn altars, pious pictures in the domestic context functioned as focal points for religious meditation.[60] Ordinary space could be converted into a site where interaction with the divine occurred through the presence of charged images and object. The advice of Cardinal Silvio Antoniano matches precisely the display practices in Venetian households. He argued that the environments for prayer in the household were just as influential as the pictures exhibited in them. In order to stimulate respect, direct one's attention and energies to the devotions performed in this space, and regenerate the soul, Antoniano urged parents to present holy images in a "non-confusing" manner with burning oil lamps and in dedicated locales throughout the house, like small oratories or other properly ornamented sites.[61]

Many Venetian families and individuals consciously converted the *portego*, a space associated with secular activities such as business and banquets, into a setting that was simultaneously sacred. The presence of ornamented religious images, and even an altar, in this room demonstrates that domestic devotion and its related visual and material culture were not always private and physically secluded affairs, and thus should not be thought of as the direct converse of more public expressions of faith and identity, such as the patronage of altarpieces and entire chapels in churches. In the Renaissance Venetian home, religious paintings were openly displayed in a highly accessible space for all family members and their guests to see and experience. The constancy of certain themes and styles tied individual households to a larger Christian and civic community, while the varied and sometimes idiosyncratic subjects were probably tailored to meet personal spiritual needs as well as to communicate more overtly particular characteristics of each family. Like religious images exhibited elsewhere in the *casa*, the divine figures and moralizing narratives hanging on the walls of the *portego* functioned internally as spiritual outlets for those residing there, yet the space itself could offer household members a different kind of devotional encounter: its size carried the potential for larger

religious gatherings full of light and music, while its general lack of use may have also made it a locale sought after for quiet reflective retreat. At the same time, the *portego* and its imagery were directed outside the *casa*, since it was in this space that the family received visitors to the home, whether for work or entertainment. The fact that patrons almost consistently adorned *porteghi* with pictures of sacred subjects, yet sometimes little else in terms of furnishings, speaks to the power of the combination of this impressive space and the images exhibited there in shaping a household's identity as noble, charitable, and, above all, holy. Just as the *portego* was central to the Venetian home, so too was religion to Renaissance conceptions of domesticity.

Notes

1 Sebastiano Serlio, *Il trattato di Architettura di Sebastiano Serlio. Sesto libro delle habitationi di tutti li gradi degli homeni*, with commentary by Marco Rosci (Milan: I.T.E.C. Editore, 1966), fol. 51v. See also Patricia Fortini Brown, *Private Lives in Renaissance Venice: Art, Architecture, and the Family* (New Haven: Yale University Press, 2004), 67.

2 Vincenzo Scamozzi, *L'Idea dell Architettura Universale*, translated and edited by Koen Ottenheym, Henk Scheepmaker, Patty Garvin, and Wolbert Vroom (Amsterdam: Architectura & Natura Press, 2003), 180.

3 Isabella Palumbo Fossati, "L'interno della casa dell'artigiano e dell'arte nella Venezia del Cinquecento," *Studi veneziani* 8 (1984): 139–40; and "La casa veneziana," in *Da Bellini a Veronese: temi di arte veneta*, edited by Gennaro Toscano and Francesco Valcanover (Venice: Istituto Veneto di scienze, lettere, ed arti, 2004), 474–5; Brown, *Private Lives*, 71; and "The Venetian *Casa*," in *At Home in Renaissance Italy*, edited by Marta Ajmar-Wollheim and Flora Dennis (London: V&A Publications, 2006), 55, 58.

4 Brown, *Private Lives*, 19–20, 71–5; and Monika Schmitter, "The *Quadro da Portego* in Sixteenth-Century Venetian Art," *Renaissance Quarterly* 64 (Fall 2011): 701–4. In her discussion of the *Cuccina Family Cycle* painted by Paolo Veronese in the 1570s, Blake de Maria does examine the merging of the sacred and the secular in this particular series of *portego* paintings made for Alvise Cuccina. See *Becoming Venetian: Immigrants and the Arts in Early Modern Venice* (New Haven: Yale University Press, 2010), 143–59.

5 Schmitter, "The *Quadro da Portego*," 693–701.

6 Christiane Klapisch-Zuber, *Women, Family, and Ritual in Renaissance Italy* (Chicago: University of Chicago Press, 1985), 320; Ronald G. Kecks, *Madonna und Kind: Das häusliche Andachtsbild im Florenz des 15. Jahrhunderts* (Berlin: Gebr. Mann, 1988), 24; Geraldine A. Johnson, "Art or Artifact? Madonna and Child Reliefs in the Early Renaissance," in *The Sculpted Object 1400–1700*, edited by Stuart Currie and Peta Motture (Aldershot: Ashgate, 1997), 7; and "Beautiful Brides and Model Mothers: The Devotional and Talismanic Functions of Early Modern Marian Reliefs," in *The Material Culture of Sex, Procreation, and Marriage in Premodern Europe*, edited by Anne L. McClanan and Karen Rosoff Encarnacíon (New York: Palgrave, 2002), 146–7; Kent Lydecker, "The Domestic Setting of the Arts in Renaissance Florence" (PhD dissertation, The Johns Hopkins University, 1987), 65–6; Jacqueline Marie Musacchio, "The Madonna and Child, a Host of Saints, and Domestic Devotion in Renaissance Florence," in *Revaluing Renaissance Art*, edited by Gabriele Neher and Rupert Shepherd (Aldershot: Ashgate, 2000), 154; and *Art, Marriage, and Family in the Florentine Renaissance Palace* (New Haven: Yale University Press, 2008), 198; Donal Cooper, "Devotion," in *At Home in Renaissance Italy* (see note 3), 192, 198; Megan Holmes, "Review of Roberta Olson, *The Florentine Tondo* and Christelle Baskins," *Art Bulletin* 83 (June, 2001): 351–4; and Peter Thornton, *The Italian Renaissance Interior 1400–1600* (New York: Harry N. Abrams, Inc., 1991), 264. Rhonda Kasl makes a similar claim for images of the Madonna in Venice in "Holy Households: Art and Devotion in Renaissance Venice," in *Giovanni Bellini and the Art of Devotion*, edited by Rhonda Kasl (Indianapolis: Indianapolis Museum of Art, 2004) 70, 72–3, 74.

7 Andrea Pearson, *Envisioning Gender in Burgundian Devotional Art, 1350–1530. Experience, Authority, Resistance* (Aldershot: Ashgate, 2005), 8–10.

8 Over 700 inventories from the cinquecento can be found in the Archivio di Stato di Venezia (hereafter ASV), Cancelleria Inferiore, Miscellanea Notai Diversi (hereafter Canc. Inf., Misc. Not. Div.).

9 Palumbo Fossati, "La casa veneziana," 474; Patricia Fortini Brown, "Behind the Walls: The Material Culture of Venetian Elites," in *Venice Reconsidered: The History and Civilization of an Italian City-State, 1297–1797*, edited by John Martin and Dennis Romano (Baltimore, MD: Johns Hopkins University Press, 2000), 307–8; Brown, *Private Lives*, 71–5; Brown, "The Venetian *Casa*," 51, 54-57; and Schmitter, "The *Quadro da Portego*," 694.

10 Margaret A. Morse, "Creating Sacred Space: The Religious Visual Culture of the Renaissance Venetian *Casa*," *Renaissance Studies* 21 (April, 2007): 152, 177–84.

11 Dale Kent, *Cosimo De' Medici and the Florentine Renaissance: The Patron's Oeuvre* (New Haven: Yale University Press, 2000, 6–7.

12 Deborah Howard, *An Architectural History of Venice*, revised edn (New Haven: Yale University Press, 2002), 36.

13 Richard J. Goy, *Venetian Vernacular Architecture: Traditional Housing in the Venetian Lagoon* (Cambridge: Cambridge University Press, 1989), 63.

14 Fossati, "La casa veneziana," 474.

15 Brown, *Private Lives*, 1, 71; Schmitter, "The *Quadro da Portego*," 695.

16 For more on the importance of arms in the space, see Schmitter, "The *Quadro da Portego*," 701–4.

17 Brown, "The Venetian *Casa*," 54–5.

18 Brown, *Private Lives*, 73. See also Fausto Caldieri and Simone Chiarugi, "Tables and Chairs," in *At Home in Renaissance Italy* (see note 3), 224–7.

19 Allen J. Grieco, "Meals," in *At Home in Renaissance Italy* (see note 3), 249–50. Elizabeth Currie, *Inside the Renaissance House* (London: V&A Publications, 2006), 34–5.

20 Currie, *Inside the Renaissance House*, 21 and 23.

21 Flora Dennis, "Music," in *At Home in Renaissance Italy* (see note 3), 228–43.

22 Currie, *Inside the Renaissance House*, 32. On the involvement of children and other family members in the household, see Dennis, "Music," 229, 235–7, and 239.

23 Elsewhere in this volume, Katherine McIver and Stephanie Miller have pointed out that children usually did not eat with their parents.

24 Brown, "The Venetian *Casa*," 58.

25 Scamozzi, *L'Idea*, 206.

26 Schmitter, "The *Quadro da Portego*," 706–7. A survey of the inventories also indicates this increase.

27 ASV, Canc. Inf., Misc. Not. Div., b. 43, n. 41 (Vignola inventory, October 30, 1585); and b. 43, n. 59 (Lando inventory, January 10, 1585, m.c.). For a more complete discussion of *portego* paintings and the variety of subjects, see Schmitter, "The *Quadro da Portego*," especially 707–18.

28 Translated quote from Brown, *Private Lives*, 16.

29 ASV, Scuola Grande di Santa Maria della Valverde o della Misericordia, b. 50, n. 2, fol. 2r.

30 Silvio Antoniano, *Dell'educazione cristiana e politica de'figliuoli* (Florence: Tipografia della casa di correzione, 1852), 150–51, 153–4.

31 Rona Goffen, "Icon and Vision: Giovanni Bellini's Half-Length Madonna," *Art Bulletin* 57 (December, 1975): 487–8; Patricia Fortini Brown, *Art and Life in Renaissance Venice, Perspectives* (New York: Harry N. Abrams, Inc., 1997). 128–9. On the influence of Byzantine piety in Venice, see Antonio Niero, "Influsso della pietà bizantina sulla pietà italiana," *Il Vetro* XXXVII (January–April, 1983): 155–69.

32 Goffen, "Icon and Vision," 487.

33 David Rosand, *Myths of Venice: The Figuration of a State* (Chapel Hill: University of North Carolina Press, 2001), 13.

34 On the popularity of Flemish paintings in domestic Venetian collections, see Bernard Aikema, "The Lure of the North: Netherlandish Art in Venetian Collections," in *Renaissance Venice and the North: Crosscurrents in the Time of Bellini, Dürer, and Titian*, edited by Bernard Aikema and Beverly Louise Brown (Milan: Rizzoli, 1999), 83–91.

35 ASV, Canc. Inf., Misc. Not. Div., b. 36, n. 29., October 19, 1535.

36 ASV, Canc. Inf., Misc. Not. Div., b. 40, n. 16., March 14–15, 1563. On the increasing popularity of painted series in the *portego*, see Schmitter, "The *Quadro da Portego*," 708.

37 ASV, Canc, Inf., Misc. Not. Div., b. 37, n. 10 (Trevisan inventory, February 14, 1537 m.c.); and b. 38, n. 40 (Savina inventory, November 30–December 22, 1550).

38 ASV. Canc. Inf., Misc. Not. Div., b. 40, n. 36 (dall'Oca inventory); and b. 39, n. 1 (de Gritti inventory).

39 ASV, PSM, Citra, b. 121–2.

40 *Dizionario biografico degli Italiani* 5 (Rome: Istituto della enciclopedia italiana, 1960–), 116–19.

41 Dominique Rigaux, "Une image pour la route: l'iconographie de saint Christophe dans le regions alpines: XIIe–XVe siècles," in *Voyage et voyageurs au Moyen Age: XXVIe Congrès de la S.H.M.E.S.: Limouges-Aubazine May 1995* (Paris: Publications de la Sorbonne, 1996), 247–8. On the symbolic connotations of thresholds, see Susan Kuretsky, "Rembrandt at the Threshold," in *Rembrandt, Rubens and the Art of their Time: Recent Perspectives*, edited by Roland E. Fleischer and Susan Clare Scott (University Park, PA: Pennsylvania State University Press, 1997), especially 63.

42 Bruce Cole, "The Interior Decoration of the Palazzo Datini in Prato," in *Studies in the History of Italian Art, 1250–1550* (London: Pindar Press, 1996), 12, 20. See also Anne Dunlop, *Painted Palaces: The Rise of Secular Art in Early Renaissance Italy* (University Park, PA: Pennsylvania University Press, 2009). I would like to thank Jacqueline Musacchio for sharing with me her knowledge of St Christopher in Tuscany.

43 On the popularity of sacred supper scenes in Venetian *porteghi*, see also Bernard Aikema, *Jacopo Bassano and His Public: Moralizing Pictures in an Age of Reform, c. 1535–1600*, translated by Andrew P. McCormick (Princeton, NJ: Princeton University Press, 1996), 70; and Schmitter, "The *Quadro da Portego*," 709–11. On the connection to *Last Supper* scenes in monasteries, see Morse, "Creating Sacred Space," 162 and Nicolas Penny, *The Sixteenth-Century Italian Paintings*, vol. 2, *Venice, 1540–1600* (London: National Gallery, 2008), 229.

44 Schmitter comes to a similar conclusion in her discussion of supper scenes in the *portego*. See "The *Quadro da Portego*," 711–13 and 727.

45 Aikema, *Jacopo Bassano*, 69–70.

46 Brian Pullan, *Rich and Poor in Renaissance Venice. The Social Institutions of a Catholic State, to 1620* (Cambridge, MA: Harvard University Press, 1971); and *Poverty and Charity: Europe, Italy, Venice, 1400–1700* (Aldershot: Variorum, 1994).

47 David Wilkins, "Donatello's Lost *Dovizia* for the Mercato Vecchio: Wealth and Charity as Florentine Civic Virtues," *Art Bulletin* 65 (September 1983): 419.

48 De Maria, *Becoming Venetian*, especially 81–5 108–13, and 143–59.

49 Ibid., 154.

50 Ibid., 144–5. On donor portraits, see also Kasl, "Holy Households," 81.

51 See Dennis Romano, *Housecraft and Statecraft: Domestic Service in Renaissance Venice, 1400–1600* (Baltimore, MD: Johns Hopkins University Press, 1996), 6.

52 A.B. Coté, "Blessed Giovanni Dominici. Regola del governo di cura familiare, parte Quarta. On the Education of Children" (PhD dissertation, The Catholic University of America, 1927), 34.

53 Translated quote from Romano, *Housecraft and Statecraft*, 48.

54 Francesco Tommasi, *Reggimento del padre di famiglia* (Florence: Giorgio Mariscotti, 1580), 138.

55 Dominique Rigaux, "Les couleurs de la prière à la fin du Moyen Age," in *Religione domestica (medioevo-età moderna)* (Caselle di Sommacampagna: Cierri Edizioni, 2001), 257.

56 Quote from Luke Syson and Dora Thornton, *Objects of Virtue: Art in Renaissance Italy* (London: British Museum Press, 2001), 21.

57 ASV, Canc. Inf., Misc. Not. Div., b. 40, n. 44.

58 Brown, *Private Lives*, 71.

59 ASV, Canc. Inf., Misc. Not. Div., b. 37, n. 49.

60 Lydecker, *The Domestic Setting*, 179.

61 Antoniano, *Dell'educazione cristiana*, 151 and 316.

Art and Family Viewers in the Seventeenth-Century Bolognese Domestic Interior

Erin J. Campbell

By approaching objects in the home as artifacts that reflect and shape social processes, recent studies have revealed the multi-layered relationships between people and things within the early modern domestic interior. Such research has demonstrated that domestic objects and furnishings, including *cassoni, deschi da parto*, ceramics, textiles, prints, sculptures, and paintings, fostered prescribed behaviors, assisted in the education of children, and mediated the rites of passage and life experiences of women, men, and children in the homes of the urban elite.[1] In the current volume, this approach is perhaps best exemplified in the chapters by Stephanie Miller and Margaret Morse, which approach religious paintings, terracotta portrait busts, and other artworks from a material cultural perspective.[2] While much of the research on the social roles of art objects within the home has focused on the Florentine and Venetian evidence from the fifteenth and sixteenth centuries, the goal of this chapter is to build on this foundational scholarship by moving into the seventeenth century and by focusing on the Bolognese interior, which has received far less attention in studies of the early modern domestic interior. Specifically, the present chapter offers new perspectives on family viewers in the Bolognese home by re-examining the evidence of the numerous anonymous paintings identified only by subject, size, frame type, shape, or medium that appear in published inventories of the homes of the urban elite in seventeenth-century Bologna.

Both Catherine Fletcher and Adelina Modesti's chapters in this volume contribute to our developing understanding of early modern Bolognese domesticities, establishing an impression of the relative prosperity of the urban propertied classes in Bologna, which included senatorial families, nobles, professionals such as university professors, doctors and notaries, as well as merchants, bankers, artists, successful artisans, and small business owners.[3] As residents of a city with a distinguished university community, a solid mercantile and agricultural base, and a stable oligarchical government,

Bologna's middle- and upper-class citizens enjoyed a comfortable standard of living by the mid-seventeenth century, after rebounding from the devastating plague in 1630 that reduced the city's population to around 47,000.[4] The domestic architecture of the wealthier Bolognese typically included an entrance hall leading to a porticoed courtyard with storerooms and offices for business on the ground floor, and gracious reception rooms and chambers on the first floor. On the exterior, spacious arcades and uniform earth-toned facades had a unifying effect on the fabric of the city, conveying the image of solidity and sobriety.[5] Augmenting this architectural image of conservatism and stability amongst the city's property owners were extensive and often luxurious interior furnishings, such as massive walnut cupboards, tables, benches, textiles, ceramics, sculptures and other domestic goods, including the numerous paintings that we find recorded in the inventories of the period.[6]

To support the widespread consumption of paintings by the city's wealthier citizens, Bologna had an exceptionally vital market for domestic pictures, with many active artists, collectors, dealers, middlemen, critics, and connoisseurs.[7] Yet, we still know relatively little about the domestic role of paintings within the seventeenth-century Bolognese interior. In part, this is due to the documentary record, which, while including inventories of household goods, records of financial transactions, and correspondence between buyers, agents, dealers, and artists, as well as contemporary writings about collections, says little about how people actually used paintings in their daily lives. While women occasionally appear in the historical record as people who owned[8] or inherited collections,[9] or whose dowries included art,[10] and we know several distinguished women outside Bologna who were patrons of Bolognese artists, children, servants, lodgers, guests, and other household viewers who interacted with imagery in the home are not present in the documentary record.[11] Moreover, compounding such perceived limitations of our documentary sources is the tendency of scholars to approach the early modern interior as "secular space," as Morse argues in her chapter on religious imagery in the sixteenth-century Venetian *portego*, which obscures the important devotional and social roles of religious imagery in the home. To create an interpretive framework that approaches pictures in the Bolognese home from the perspective of the domestic needs of family viewers, we thus need to ask different questions of traditional sources, such as household inventories, as well as to broaden the types of sources under our purview. This chapter will examine the evidence for family viewership in published household inventories, in contemporary art theory, sermons, and prescriptive writings, and in the physical evidence itself, including the content, size, style, medium, and production methods of paintings, to argue that art in the seventeenth-century Bolognese home continued to meet the domestic needs of family viewers, even as paintings moved from furniture onto the walls and into purpose-built domestic galleries.

Household Inventories and Family Viewers

The extensive notarial archive in the Archivio di Stato in Bologna (ASB) holds a veritable treasure trove of household inventories. The foundational work of Raffaella Morselli on a selected sample of the household inventories from 1640 to 1707 has revealed that the homes of the nobility, professional classes, merchants, artisans, and shopkeepers were filled with pictures.[12] Such an increase in the number of pictures in the home over the course of the early modern period is well documented in other urban centers in Italy, as Elizabeth Carroll Consavari's chapter in this volume demonstrates with respect to Venice.[13] In Bologna, independent easel paintings become the dominant form of painting in the home during the latter part of the sixteenth century; indeed, property inventories of Bologna's elite show that before the mid-sixteenth century, people owned few paintings, but had painted furniture such as *forzieri dipinti* (painted chests) and painted benches, but by the end of the sixteenth century and the beginning of the seventeenth century, the generation born in the 1540s and 1550s were collecting large quantities of pictures.[14]

To account for the emergence of independent easel paintings within the sixteenth-century Florentine domestic interior, John Lydecker argued that around the time of Giorgio Vasari (1511–74), we witness a shift from the use of art in a ritually meaningful way as an integral part of family life to what Lydecker refers to as a Vasarian world of artists and works, in which works of art within the home function much like they do within the modern museum.[15] Similarly, Peta Motture and Luke Syson point to the development of the domestic gallery, arguing "that during the course of the Cinquecento some Virgin and Child paintings were moved out of bedrooms into spaces that should be understood as proto-art galleries." While acknowledging that art can play multiple roles in the households of the sixteenth century, Motture and Syson suggest that:

we can trace a three-stage process during the course of the fifteenth and sixteenth centuries: firstly pictures were painted as intrinsic to items of furniture, secondly paintings that were no longer actually parts of utilitarian objects but that might pertain to them and imitate their shapes and, finally, these and other such works that were converted into or executed specially as gallery pictures. By this transformation, which would have rendered more visible some at least of the paintings and sculptures discussed above, we can trace the roots of what we see in so many public galleries today.[16]

Yet, the emergence in the sixteenth century of what Motture and Syson call "art for sake's sake" along with "proto-art galleries" for the display of paintings does not rule out other uses for art within the sixteenth-century home, as both Morse and Carroll Consavari's chapters in the present volume demonstrate.[17] Indeed, Motture and Syson, while pointing to the 1627 inventory of Andrea Vendramin's collection as evidence of the new collecting ethos, citing the fact that the main mode of classification is by artist, also acknowledge that the

compiler of the inventory "made a clear distinction between, on the one hand, Vendramin's collection depicted in the catalogue and, on the other, the older, smaller paintings that filled gaps in the studies and the 'diverse portraits that are for the adornment of the house.'"[18] Such inventory distinctions provide evidence that art that did not form part of a dedicated collecting ethos nevertheless continued to be displayed within the home.

To return to the Bolognese household inventories, Morselli's research demonstrates similar kinds of distinctions. While her work establishes that over the course of the seventeenth century, a sophisticated network of professionals emerged to support the rapid expansion of art collecting, so that, supported by the development of a class of expert evaluators (*periti*), inventories become more precise in listing authorship, as well as copies, schools, and styles, since these qualities contributed to the determination of economic value of the painting,[19] her studies also document that, alongside this developing apparatus of valuation based on authorship, many paintings in Bolognese inventories continue to be identified not by artist but by subject, size, shape, frame type, and medium.[20]

The evidence that many works of art listed in the inventories are not identified by artist must be interpreted with caution.[21] As Lena Orlin warns in her study of probate inventories in early modern England, inventories are like "puzzles with pieces missing" that must be interpreted along with other related documents.[22] In the case of seventeenth-century household inventories that appear in wills, there are a number of variables to be considered. The circumstances of inheritance, for example, could determine how household goods, including paintings, were listed. Morselli points out that in the instance of a single heir, the inventory may simply list the goods without recording their value.[23] Thus, one wonders, for example, if the majority of the 67 paintings listed by subject in the 1694 inventory of the *dottore in legge* (doctor in law) Ippolito Cucchi remained unattributed because Claudio Boschetti was the sole heir.[24]

In other cases, the individual circumstances of the owner, his or her social class, the expertise of the evaluator, and the status of the heir might also lead to sparser notations concerning works of art, such as omitting the names of artists. For example, in the case of the merchant Paolo Consoni, the inventory of 1693 records 39 paintings that were inherited by his wife Maria Dorotea.[25] While the valuation of Consoni's goods was overseen by the valuator Giulio Cenerini, Morselli notes that Consoni was not part of the richest class of merchants and he participated in the local art market according to his more modest means. She concludes that the listing of his paintings was not entrusted to an expert in painting, but was probably based on notes he had made during his life and on the memory of Maria Dorotea Consoni.[26] Although some of the works include a notation of authorship, most are listed by subject only.[27] Did Consoni never tell his wife the authorship of the others? Did she forget? Was it not deemed important since she was the sole heir? Interesting too is the fact that the painting assigned the most value is one without an identified

author.[28] Significantly, Morselli notes that the Consonis – who lived in a small house in the parish of Santa Marta in Bologna – are exactly the kind of family overlooked by Carlo Cesare Malvasia (1616–93) in his extensive writings on Bolognese art, since the Consonis' undistinguished social status meant the works they owned did not rate mention in *Felsina pittrice* (Bologna, 1678), nor did they possess a private chapel in a church in Bologna which might have been mentioned in *Le pitture di Bologna* (Bologna, 1686).[29]

The examples of the Cucchi and Consoni inventories show that it is difficult to speculate on the ubiquitous presence of unattributed paintings in Bolognese inventories. Nonetheless, the continuing presence over the century of so many unattributed works deserves a closer look. Even in instances in which one might expect authorship to be identified for more precise evaluation, such as in the case of several heirs, or the presence of expert evaluators, inventories contained in wills may list many paintings by subject, shape, size, medium, or frame type with no indication of authorship. One such example is the 1692 inventory of the household goods of the *pellicciao* (furrier) Giovanni Giacomo Alberti.[30] After his death, the heirs – his two sons – called in the two most distinguished experts at that time in Bologna, Francesco Andriani and Giacomo Bolognini, to evaluate the furnishings and the 48 paintings (including one drawing). Bolognini, who was a member of the Accademia Clementina and part of a family of painters (he was the son of Francesco Bolognini and the nephew of Giovan Battista Bolognini), evaluated the paintings.[31] Yet, the majority of paintings are unattributed,[32] such as the reference to "thirteen paintings of various sizes with standard frames, and without much value."[33]

Stewardship, Matronage, and Masserizia

While studies of household inventories reveal the sheer number of unattributed paintings in the homes of seventeenth-century Bolognese families, how do we interpret the significance of such evidence? Regarding the inventory in the will of the small merchant Paolo Aldrovandi,[34] who left his house to his five sons, Morselli concludes that all of the paintings on the upper floor were simply for "decoration," since there is no indication of authorship for any of the works.[35] Yet, the presence of so many unattributed works surely invites us to consider the possibility of more nuanced roles for art within the household beyond the merely decorative. At the very least, such evidence may signal that in addition to paintings that were valued as works by famed artists in a domestic gallery, artworks continued to perform a range of duties in the home, an idea that is supported by other sources of cultural information.

Although documented examples of specific, historical individuals in seventeenth-century Bologna interacting with art works in the home are rare, prescriptive texts written for a family audience provide evidence for the ideal relationships and attitudes towards pictures that family viewers were expected

to adopt.[36] In the first instance, these writings convey concepts of stewardship, which invite ideas of family and especially women's involvement with art in the home. Roger Crum, in his work on the domestic interior of fifteenth- and sixteenth-century Florentine palaces, has suggested that despite the paucity of women in the documentary record, the commissioning and purchasing of works for the home may have involved women to a considerable degree.[37] While Caroline Murphy and Adelina Modesti have both demonstrated that female patronage was essential to the careers of women artists in Bologna,[38] Crum's emphasis on women's custodial role with respect to household goods, and what he refers to as "matronage," invites us to look for evidence of women's involvement with art in the Bolognese home. Important to understanding the nature of women's stewardship of the material goods of the household is the term *masserizia*, a concept of wealth that is redefined in the fifteenth century to refer to objects and especially household furnishings.[39] As Richard Goldthwaite suggests: "The word came to signify wealth with two specific qualities: first, it is constituted by material possessions; and secondly, these possessions have a moral quality about them. Household goods, in short, were a form of capital that represented family solidarity and honor."[40] Such goods, according to Goldthwaite, were "the material core" of the family's "identity and existence" and "the foundation of the reputation of the family."[41] Thus, as Goldthwaite asserts, *masserizia* refers not to money but also to those "material goods that assure the solidarity of affection and the bonds of blood, honor, and virtue."[42] Within this new world of domestic goods, as Marta Ajmar-Wollheim has argued, drawing in part on the evidence of prescriptive writings and especially Giacomo Lanteri's 1560 treatise *Della economica*, women in particular were both key consumers and managers of household furnishings, roles which were strengthened over the course of the sixteenth century as women became increasingly more responsible for the decorous appearance of the home.[43]

Prescriptive writings on the family dating to the later sixteenth and early seventeenth centuries continue to emphasize the wife's crucial custodial role with respect to the *masserizia* of the family – a term for household goods that continues to appear in Bolognese property inventories to the end of the seventeenth century.[44] For example, Bernardo Trotto, in his book on marriage and widowhood, *Dialoghi del matrimonio e vita vedovile* (*Dialogues on Marriage and Widowhood*, 1583), has advice on how the wife must take care of her husband's "things" ("roba"),[45] as well as the "wealth" ("sostanze") of the family.[46] Similarly, Pietro Belmonte, in *Institutione della sposa* (*The Education of the Bride*, 1587), refers to the wife as "custodian" ("custodia") and charges her with the care of the "things" ("robbe") of the house.[47] Giuseppe Passi, in *Dello stato maritale* (*On the State of Marriage*, 1602), writes that, based on antique precedent, women have "the care of the things of the house," including furnishings ("il mobili") and household goods ("masseritie").[48] In Pompeo Vizani's *Breve trattato del governo famigliare*, published in Bologna in 1609, the chapter "On Wealth" ("Della sostanze") is followed by a chapter entitled

"On the Duty of the Consort in the Conservation of Wealth" ("Dell'officio della consorte nel conservar le sostanze").[49] Advising that it is necessary to have a home "well-furnished with household goods" ("ben fornita di massaritie"),[50] Vizani places the "massaritie" under the care of the wife.[51]

Family Viewers, Family Subjects

In addition to the evidence for women's stewardship of objects in the home into the seventeenth century, art theory, sermons, and other cultural texts show that the popularity of certain kinds of subjects can also be evidence of family audiences for art. With respect to subject matter, Crum views the moralizing themes of Renaissance art that were directed at female viewers as evidence for women playing a role in the patronage process, even if a man made the purchase.[52] As he argues, the themes of "humility, chastity, obedience, and dutiful motherhood" that is the message of many sixteenth-century domestic paintings would reinforce loyalty to the husband's lineage.[53] Crum's argument is supported by the research of other scholars, who have shown that subjects such as the Madonna and Child, the Holy Family, the Birth of St John, and the Birth of the Virgin mediated social processes within the home.[54] Diane Owen Hughes has also argued that the popularity of certain kinds of subject matter is evidence of family audiences, noting, for example, the rise in interest in the story of Lot and his daughters during the sixteenth and seventeenth centuries, at a time when the cost of dowries was increasing, marriage was becoming restricted, and the size of families was shrinking.[55] Hughes' study demonstrates that the specific social needs of families could have a decisive impact on the content of domestic paintings.

The themes identified by Crum and others as central to the production of domestic values continue to be identified as important for family viewers in the latter part of the sixteenth century and into the seventeenth century. In writings on art, for example, particular subjects are associated with family viewing, and especially with women and children. Thus, Giovanni Battista Armenini (1525–1609), in *De' veri precetti della pittura* (*On the True Precepts of Painting*, 1587), prescribes specific pictorial themes for women and girls: "But in the rooms where the matrons and the married women repose, examples of the histories and legends of illustrious women, Greek as well as Latin, are depicted, and the same is to be done in those rooms where the young girls live, depicting the women most famous for chastity, greatness of spirit, and faith."[56] Armenini also relates that in Lombardy, devotional works by Titian, Correggio, and Giulio Romano were owned by married women, and that the matrons cried when they were uncovered.[57] Such an association between women and devotional works in the home is suggested by Leandro Bassano's *Portrait of a Widow at her Devotions* (c. 1600), in which the sitter is placed in a domestic context, in front of a devotional image of the Birth of the Virgin.[58]

Sermons, devotional writings, and prescriptive texts inspired by the spirit of Catholic reform and aimed at the Christian household also single out specific subjects suitable for family audiences. Both Murphy and Modesti point to the impact of the sermons and writings of the Archbishop of Bologna, Gabriele Paleotti (1522–97) on the demand for art in seventeenth-century Bologna. Paleotti underscores the vital role of visual imagery in the moral and spiritual instruction of the family and especially children, and advises fathers and mothers to hang devotional images in every room to assist prayer.[59] Other spiritual advisors offered similar injunctions. For example, Silvio Antoniano (1540–1603), in *Tre libri dell'educatione christiana dei figliuoli* (*Three Books on the Christian Education of Children*, 1584), advises "the good father" to keep images of the crucifix and of the passion in the house to instruct his children,[60] and to keep images of "Our Lady" in the mother's room ("nella camera materna") for devotional purposes.[61] Antoniano emphasizes the value of pictures for instructing children, arguing that children's minds predispose them to learn better through images, which allow them to understand and more easily retain in the memory the articles of the Christian faith.[62] He includes instructions on where to place devotional images in the house, advising the reader that the father of the family will have "many paintings in the home" which encourage devotion and which will remind not just the children but everyone in the house to think about God. If it is not possible to have paintings that are artfully done, Antoniano tells us, then prints will suffice, which are inexpensive. Moreover, we are advised that images are to be arranged according to the scale of the house and should be placed in an orderly fashion in particular places.[63] Pietro Giussano, in *Instruttione a' padri per saper ben governare la famiglia loro* (*Instructions to Fathers on How to Govern Well their Families*, 1603), advises women to keep devotional images in their rooms, including those of Christ, the Madonna, and the saints.[64]

Equally valuable is the advice prescriptive writers offer on what kinds of art are not suitable for family consumption. These injunctions provide evidence of the co-existence of both "gallery"-style pictures aimed at the connoisseur (envisioned as male) and paintings deemed suitable for family viewing. Thus, many texts caution husbands and fathers to prevent wives and children from looking at morally questionable art.[65] Giussano, for example, advises fathers to throw dishonest images in the fire and instead display pictures and sacred images of Christ, the Virgin, her mother, and the saints, and especially saints which are "protectors" of the family.[66]

Such textual evidence for family subjects is supported by the many paintings relevant to women's life stages and domesticity listed in seventeenth-century Bolognese household inventories, such as the Madonna and Child, either alone or with other saints,[67] the Holy Family,[68] the Nativity,[69] the Birth of the Virgin,[70] the Birth of St John,[71] Anna teaching the Virgin to Read,[72] and Anna Selbdritt,[73] evidence which must surely imply the important role of family spectatorship in the choice of pictures for the home. Indeed, paintings of the Madonna and Child form one of the largest groups of unattributed works

(slightly more than half the works in this subject category are by anonymous artists). Moreover, although not subjects identified for family viewing by the moralists, the popularity of mythological subjects such as Venus, Bacchus, and Cupids could be framed by the familial concerns of marriage, fertility, and birth within the context of the domestic interior and especially in a post-plague society.[74] The many St Ursulas, St Catherines, Lucretias, Cleopatras, and Judiths listed in Bolognese inventories, most of them by unidentified artists, may speak to a specifically female audience as providing exemplars of virtue for virgins, matrons, and widows,[75] while saintly models of socially acceptable masculinity from childhood to youth, such as St John the Baptist, also appear in relatively large numbers.[76]

Domestic Paintings: Size, Media, and Style

In addition to subjects that imply a domestic audience, specific painting sizes, media, and styles may have been particularly associated with family viewers. Bolognese household inventories list many unattributed "quadretti" and "quadrettini" (small paintings), sometimes separately, sometimes in groups, which may document the existence in Bolognese homes of the small-format devotional images that were often created for women.[77] Murphy has noted that the bride's *corredo* or trousseau in late-sixteenth and early seventeenth-century Bologna included paintings.[78] In particular, Murphy identifies a type of picture that appears in Bolognese property inventories called the *quadro* or *quadrettino dal letto*, which was designed to hang over a bed or be attached to the bed-frame.[79] Examples of such works by the Bolognese artist Lavinia Fontana (1552–1614) include two small works on copper of the *Holy Family with Sleeping Christ Child*.[80] As Murphy argues, such pictures performed a number of functions within the family and "could be said to encompass magical, miraculous and pedagogical functions" for couples hoping to conceive, for expectant mothers, and for parents raising children.[81] Similarly, Modesti has argued that small devotional images by the Bolognese painter Elisabetta Sirani (1638–65) were designed to be placed above the bed to be used by women as instruments for meditation and prayer,[82] such as the small devotional image *Christ Child and Young Saint John the Baptist* (1661),[83] which is a subject that had been recommended since the fifteenth century as a role model for small children.[84]

In addition to small-scale works, the medium of copper is often associated with family audiences, and especially with female life passages and rituals. Denys Calvaert (1540–1619), Ludovico Carracci (1555–1619), and Lavinia Fontana all painted small devotional works on copper appropriate for wedding gifts.[85] Carlo Cesare Malvasia, our most important source for the Bolognese art world during the seventeenth century, notes that the Bolognese nobility frequently gave Calvaert's small paintings on copper to novices and brides.[86] References to works on copper are common in the household

inventories of seventeenth-century Bolognese homes. For example, the Landi family owned a small painting on copper with St Anne teaching the Virgin to read by Elisabetta Sirani,[87] a subject that Modesti argues attests to the increasing presence of women in the education of children, as well as the new emphasis on the education of girls in Bologna.[88] Elisabetta Sirani, as noted by Malvasia, was known for her works on copper.[89]

Clearly, works on copper were not made only for women. Men also purchased devotional works as well as works on copper, such as the musician recorded by Malvasia who owned an image of the Holy Family on copper by Sirani.[90] Nor were such works made only by women artists, since, as we have seen, Calvaert and Ludovico Carracci are both associated with the production of such works, as is Francesco Albani, as we shall see below. However, the medium of copper encouraged stylistic effects that were associated with feminine style and perhaps by extension domesticity and family audiences of women and children. The stylistic qualities associated with feminine style included miniature-like effects of polished surfaces, smooth brushstrokes, and the lack of bold contrasts of light and dark. The small scale of such works and their polished surfaces evoke the small lustrous glazed terracotta statuettes that Miller associates with family audiences in her chapter in this volume. As Philip Sohm has demonstrated, highly finished styles that lacked bold contrasts of light and shadow were typically criticized as "womanly" in seventeenth-century writings on art.[91] For example, Sohm notes the case of the artist Luca Mombello, who, according to his critics, changed his style to appeal to women and nuns – what they characterized as a "glossy," "polished," "delicate," and "sweet" style.[92] Malvasia referred to Denys Calvaert's style as "licked, flaccid, and womanly," characterizing it as a highly polished style.[93] Malvasia also reports the criticism of Reni's *seconda maniera*, which adopted a lighter and brighter palette without bold contrasts of light and dark, as "womanly, Flemish, washed out and without force."[94] Women painters themselves can also be associated with these stylistic characteristics. As Sohm notes, Giovanni Battista Manzini, in a letter published in 1646, writes about a fictional woman artist's style as having "that washed out, worn out, wan and cosmetically whitened tenderness that is more of a woman, than a man, painter."[95] Moreover, as Sohm agues, women were assigned smooth, polished styles and were associated with painting miniatures.[96]

Producing Family Pictures

Given that certain subjects, sizes, media, and styles of painting may provide evidence for family audiences, did art that was made for the domestic needs of conception, childbirth, religious and moral instruction, and devotion have specific production methods? In her study of half-length Marian reliefs created for Florentine homes during the fifteenth century, Geraldine Johnson demonstrates that new production techniques were developed to allow the

reliefs to be manufactured quickly and cheaply by "pressing gesso, clay, and stucco casts out of molds." Such "mass-produced" reliefs seem to be aimed at clients who could not afford the luxury reliefs produced to commission in marble, bronze, and gold.[97] Were such production techniques employed in the workshops of seventeenth-century Bolognese artists to serve the needs for paintings that met the devotional, instructional, or talismanic needs of family viewers?

While there is not the space here to fully develop this topic, the modes of production used by Francesco Albani (1578–1660) for his small easel paintings provide some tantalizing clues that deserve further development. Albani was a prolific Bolognese painter who devoted a significant amount of his artistic production to small easel paintings that were popular not only in Bologna but all over Europe.[98] Many of the themes of his small paintings seem especially attuned to domestic concerns, such as the *Holy Family* on copper (private collection, c. 1640),[99] in which the child Jesus lovingly helps his parents wash the family linens, or *Preaching of the Baptist* (Lyon, Musée des Beaux-Arts, c. 1640), which prominently displays mothers with their babies in the foreground of the image.[100] Albani trained in the studio of Denys Calvaert, who schooled him in the production of paintings on copper, which, as noted above, Calvaert sold to "novices and brides." As Catherine Puglisi argues, this training formed the basis for Albani's own, later production of small copper panels, "which show a miniaturist's finesse."[101] To meet the demand for his small paintings, Albani seems to have developed a form of assembly-line production.[102] Malvasia explains in his biography of the artist that Albani employed different artists to execute parts of his paintings, so that he had a "fountain-man" to paint "water, rivers, seas, fountains," painters to create the landscape and foliage, and an artist to paint the architectural elements.[103] Albani also seems to have increased his production capacity by reworking previous compositions[104] and by repeating figure types.[105] Such production techniques in the latter phase of his career have contributed to Albani's reputation as a "hack."[106] However, another way to look at Albani's production techniques is to view them as the inventions of a shrewd businessman who calibrated his production values to his varied audiences, realizing perhaps that for certain audiences, quality did not reside so much in the values of the collector's cabinet as on the ability to produce paintings that met the needs of family viewers.[107]

Conclusion

In conclusion, as this study of the anonymous works recorded in household inventories demonstrates, we must recognize that art objects in the home continued to provide families with multi-tasking tools for living, in times of crisis and repose, just as images had always done from the moment they entered the home as illustrations in manuscripts and books or as painted panels on *cassoni* and *lettuci*. Alongside the undeniable growth in purpose-

built art galleries in the home, the attendant demand for "name" artists, and the economic structures and experts to support the growth of a market for art based on authorship, the astonishing array of domestic paintings in the houses of the well-off Bolognese surely confirms the continuing social efficacy of the images of saints, martyrs, and heroes that populated the walls of the home in ever-increasing numbers over the course of the seventeenth century.

Notes

1 This chapter was originally presented as part of a 2009 CAA panel on cabinet pictures organized by Andreas Henning.
 For this approach to domestic objects, see, for example, Cristelle Baskins, *Cassone Painting, Humanism, and Gender in Early Modern Italy* (Cambridge: Cambridge University Press, 1998); Jacqueline Musacchio, *The Art and Ritual of Childbirth in Renaissance Italy* (New Haven: Yale University Press, 1999); Marta Ajmar, "Toys for Girls: Objects, Women and Memory in the Renaissance Household," in *Material Memories*, edited by Marius Kwint, Christopher Breward and Jeremy Aynsley (Oxford: Berg, 1999), 75–89; Paola Tinagli, "Womanly Virtues in Quattrocento Florentine Marriage Furnishings," in *Women in Italian Renaissance Culture and Society*, edited by Letizia Panizza (Oxford: Legenda, 2000), 265–84; Sara F. Matthews Grieco, "Persuasive Pictures: Didactic Prints and the Construction of the Social Identity of Women in Sixteenth-Century Italy," in *Women in Italian Renaissance Culture and Society*, 285–314; Geraldine A. Johnson, "Beautiful Brides and Model Mothers: The Devotional and Talismanic Functions of Early Modern Marian Reliefs," in *The Material Culture of Sex, Procreation, and Marriage in Premodern Europe*, edited by Anne L. McClanan and Karen Rosoff Encarnación (New York: Palgrave, 2002), 135–61. On the layering of meaning created by objects in the home, see Luke Syson's argument that, depending on the kind of images displayed within it, "the *camera* interior could declare all sorts of simultaneous, nuanced and overlapping meanings, secular and religious." Luke Syson, "Representing Domestic Interiors," in *At Home in Renaissance Italy*, edited by Marta Ajmar-Wollheim and Flora Dennis (London: V&A Publications: 2006), 98. See also Monika Schmitter's study of paintings on display within the Venetian *portego*. As Schmitter argues, "when a household had a number of paintings in the room, a distinctive set of concerns and values often emerged from the subjects chosen." To understand how such images would have been perceived by contemporaries, she maintains that "we need to consider the particularities, physical and anthropological, of the space for which they were originally made." Monika Schmitter, "The *Quadro da Portego* in Sixteenth-Century Venetian Art," *Renaissance Quarterly* 64(3) (2011): 693–743, quotations at 718 and 743.

2 See Ian Woodward's broad definition of Material Culture Studies as "studying culture as something created and lived through objects." Ian Woodward, *Understanding Material Culture* (Los Angeles: Sage Publications, 2007), 4. Daniel Miller and Christopher Tilley, in the inaugural edition of the *Journal of Material Culture*, define the study of material culture as an interdisciplinary "investigation of the relationship between people and things" that takes as its focus "the ways in which artifacts are implicated in the construction, maintenance, and transformation of social identities," studying "the material constitution of social relations." Daniel Miller and Christopher Tilley, "Editorial," *Journal of Material Culture* I(1) (1996): 5. Also relevant to this approach are anthropology's insights into how the social is constituted by objects. See Mariët Westermann, "Introduction," in *Anthropologies of Art*, edited by Mariët Westerman (New Haven: Yale University Press, 2005), xviii.

3 On the class structure in early modern Bologna, see Giancarlo Angelozzi, "Nobili, mercanti, dottori, cavalieri, artigiani: Stratificazione sociale e ideologia a Bologna nei secoli XVI e XVIII" in *Storia illustrata di Bologna*, edited by Walter Tega (Milan: Grafica Sipiel S.r.l.: 1989), V. II, 41–60. The diversity of people across the social spectrum who had art in their homes is well documented by Raffaella Morselli, *Repertorio per lo studio del collezionismo del Seicento* (Bologna: Pàtron Editore, 1997). For a summary of the classes of people who owned paintings, see pp. XVI–XXI.

4 These are the population numbers for 1631. In 1617 the population of Bologna was 67,871. On the population fluctuations and the effect of the plague of 1630, see Athos Bellettini, *La città e i gruppi sociali: Bologna fra gli anni cinquanta e settanta*, edited by Franco Tassinari (Bologna: CLUEB, 1984), 7–8.

5 Rolando Dondarini and Carlo De Angelis, "Da una crisi all'altra (secoli XIV–XVII)," in *Atlante storico delle città Italiane: Bologna*, edited by Francesca Bocchi (Bologna: Grafis Edizioni, 1997), 145–51. Dondarini and De Angelis describe the typical configuration of the early modern Bolognese palazzo, the urban renewal and renovation of Bologna's built environment, and the increasing homogeneity of the streetscape in Bologna during the sixteenth and seventeenth centuries as senatorial, noble, and merchant houses along the main streets were modernized through the addition of porticoes, stone or brick facades, and decorative elements carved in stone.

6 Lodovico Frati, *La vita privata di Bologna dal secolo XIII Al XVII* (Bologna: Ditta Nicola Zanichelli, 1900), 20–24. Frati documents the increasing enrichment of the home interior through the seventeenth century. For specific examples of Emilian furniture that might have graced these homes, see Renzo Grandi (ed.), *Museo civico d'arte industriale e Galleria Davia Bargellini* (Bologna: Comune, 1999); Graziano Manni, *Mille mobile emiliani: L'arredo domestico in Emilia Romagna dal sec. 16 al sec. 19* (Modena: Artioli, 1980); and the furniture collection at the Palazzina Marfisa D'Este in Ferrara published in Anna Maria Visser Travagli, *Palazzo Schifanoia e Palazzina Marfisa a Ferrara,* (Milan: Electa, 1991). The summaries of household inventories in Morselli's *Repertorio* also evoke the range of furnishings, including tapestries, sculptures, paintings, vases, and other objects.

7 Raffaella Morselli, *Collezioni e quadrerie nella Bologna del seicento: Inventari 1640–1707* (Los Angeles: The Provenance Index of the Getty Information Institute, 1998); Morselli, *Repertorio*. On the Bolognese art market, see also: Giovanna Perini, "La storiografia artistica a Bologna e il collezionismo privato," *Annali della Scuola Normale Superiore di Pisa* 22(3) (1981): 189–243; Olivier Bonfait, "Il pubblico del Guercino. Ricerche sul mercato dell'arte nel XVII secolo a Bologna," *Storia dell'arte* 68 (1990): 71–94; Richard Spear, "Guercino's 'prix-fixe': Observations on Studio Practices and Art Marketing in Emilia," *Burlington Magazine* 136(1098) (1994): 592–602; Caroline Murphy, "The Market for Pictures in Post-Tridentine Bologna," in *The Art Market in Italy: 15th–17th Centuries*, edited by Marcello Fantoni, Louisa C. Matthew, and Sara F. Matthews-Grieco (Modena: Franco Cosimo Panini: 2003), 41–53; Adelina Modesti, "Patrons as Agents and Artists as Dealers in Seicento Bologna," in *The Art Market in Italy*, 367–88.

8 See, for example, the inventory of goods for Giovanna Bolognini Malvezzi, which includes many works of art, which were inherited by her daughters Vittoria and Laura Bolognini. Morselli, *Repertorio*, 421–2. Morselli lists a number of inventories that record art owned by women, for example: Elisabetta Bolognetti Pattarazzi (308–9); Lucrezia Caprara (323); Lucrezia Canali (423); Elisabetta Coltellini Vittori (246); Anna Marchesini (224–5); and Paola Aldini Mosi (433), amongst others. However, the number of women's names that appear within Morselli's study of inventories is small in proportion to the number of men.

9 Maria Dorotea inherited the collection of her husband Paolo Consoni: Morselli, *Collezioni*, 174–5. Also notable is the case of the inventory of the *letterato* Angelo Fabbri, which was compiled by his wife Francesca Carracci and included more than seventy paintings, drawings, and prints: Morselli, *Collezioni*, 214–16.

10 See, for example, the inventory of paintings for the dowry of Maria Maddalena Negri (Morselli, *Collezioni*, 354, 361–3) and the inventory of the dowry of Ginevra Faloppia, which included devotional paintings (Morselli, *Repertorio*, 473–4). Morselli, *Repertorio*, records a number of dotal inventories that include pictures, for example: Artemisia Bianchi (615–16); Caterina Nuti (475–6); Giulia Cappellini (619–20); Isabella Pinchiorri (620); Valeria Dal Monte (474); Nicola Rabuìni (318); Anna Donesi (481); and Lucrezia Accorsi (483).

11 For example, the Grand Duchess Vittoria delle Rovere and Principessa Margherita Farnese of Parma: Modesti, "Patrons as Agents," 370, 372–3.

12 Morselli, *Collezioni*; Morselli, *Repertorio*.

13 For Florence see John Kent Lydecker, "The Domestic Setting of the Arts in Renaissance Florence" (unpublished PhD dissertation, The John Hopkins University, 1987), 260–61.

14 Murphy, "The Market for Pictures," 41–2, 45. See, however, Fletcher's study of the Casali residences in the present volume, which provides valuable evidence for the ownership of pictures and their placement in elite homes during the fifteenth century in Bologna.

15 Lydecker, 253–61.

16 Peta Motture and Luke Syson, "Art and Objects in the Casa," in *At Home in Renaissance Italy* (see note 1), 283.

17 See also Schmitter, "The *Quadro da Portego* in Sixteenth-Century Venetian Art," 693–751, which demonstrates the range of social roles played by various types of paintings in the Venetian *portego*.

18 Motture and Syson, "Art and Objects in the Casa," 283.

19 Morselli, *Collezioni*, 14.

20 See, for example, Morselli, *Collezioni*, 512–14, which lists images of the Madonna and Child by anonymous artists. In fact, in many of the subject categories listed by Morselli, there are listed anonymous works. More than half the numerous representations of St Jerome, for example, are listed as by anonymous artists (527–8).

21 For a good introduction to the interpretive issues involved in the study of household inventories, see Anton Schuurman, "Probate Inventories: Research Issues, Problems and Results," in *Probate Inventories: A New Source for the Historical Study of Wealth, Material Culture and Agricultural Development*, edited by Ad Van Der Woude and Anton Schuurman (Utrecht: Hes Publishers: 1980), 19–31.

22 Lena Cowen Orlin, "Fictions of the Early Modern English Probate Inventory," in *The Culture of Capital: Property, Cities, and Knowledge in Early Modern England*, edited by Harry S. Turner (New York and London: Routledge, 2002), 63, 76, quotation at 63.

23 Morselli, *Collezioni*, 11.

24 Morselli, *Collezioni*, 180–83.

25 Ibid., 174–5.

26 Ibid., 174.

27 Ibid., 175.

28 "Un Quadro Grande con espreso un asasinio o vero svalisio con cornice e Cassa dorata 300": ibid., 175.

29 Ibid., 174.

30 Ibid., 59–61.

31 Ibid., 59.

32 Ibid., 61. Morselli notes that the middle-class Alberti family were also never mentioned in the writings of Malvasia

33 "No. 13 quadri di pittura di varie grandezza con cornice ordinaria, e senza di poco valore ...": ibid., 61.

34 Ibid., 63–5. Aldrovandi was a "piccolo negoziante 'emballatore di seta.'"

35 Ibid., 63.

36 On the genre of conduct literature, see *Donna, disciplina, creanza cristiana dal XV al XVII secolo: Studi e testi a stampa*, edited by Gabriella Zarri (Rome: Edizioni di Storia e Letteratura, 1996).

37 Roger J. Crum, "Controlling Women or Women Controlled? Suggestions for Gender Roles and Visual Culture in the Italian Renaissance Palace," in *Beyond Isabella: Secular Women Patrons of Art in Renaissance Italy*, edited by Sheryl E. Reiss and David G. Wilkins (Kirksville, MI: Truman State University Press, 2001), 37–47.

38 Caroline Murphy, "In Praise of the Ladies of Bologna: The Image and Identity of the Sixteenth-Century Bolognese Female Patriciate," *Renaissance Studies* 31(4) (1999): 440–454. Adelina Modesti points out that women were involved in social philanthropy and activities linked to their own salvation and that of their families. See Adelina Modesti, *Elisabetta Sirani: Una virtuosa del seicento Bolognese* (Bologna: Editrice Compositori, 2004), 79. Modesti also points out that women were responsible for organizing and financing religious festivities and maintaining Marian sanctuaries and votive images (82). Modesti argues that the concept of matronage "flowers fully in the seicento" (79). In addition to the work by Murphy and Modesti, more archival research on individual Bolognese women patrons is necessary to create a wider understanding of their roles in the patronage process.

39 Crum, "Controlling Women or Women Controlled?," 43–5.

40 Richard A. Goldthwaite, *Wealth and the Demand for Art in Italy 1300–1600* (Baltimore: Johns Hopkins University Press, 1995), 211.

41 Ibid., 211.

42 Ibid.

43 Ajmar, "Toys for Girls," 84–5.

44 See, for example, the inventory of Paolo Aldrovandi (1693), which is entitled "Inventario generale di tutti li mobili e massaricie di casa ..." (Morselli, *Collezioni*, 64); inventory of Giovanni Andrea Sirani (1666): "Inventario delle robbe, beni mobili, biancherie e maseritie ..." (Morselli, *Collezioni*, 414).

45 Bernardo Trotto, *Dialoghi del matrimonio e vita vedovile* (Turin, 1583), 136.

46 Ibid., 133.

47 Pietro Belmonte, *Institutione della sposa* (Rome: Giovanni Osmarino Gigliotto, 1587), 40–41.

48 Giuseppe Passi, *Dello stato maritale* (Venice: Iacomo Antonio Somascho, 1602), 144.

49 Pompeo Vizani, *Breve trattato del governo famigliare* (Bologna: per gli heredi di Gio. Rossi, 1609): "Della sostanze," 41–6; "Dell'officio del consorte nel conservar le sostanze," 46–9.

50 Ibid., 41–6.

51 Ibid., 46–7.

52 Crum, "Controlling Women or Women Controlled?," 42–3.

53 Ibid., 45.

54 See, for example, Ajmar, "Toys for Girls," 75–89, who emphasizes the importance of visual aids for the instructing of women. With respect to specific subjects, see Johnson, "Beautiful Brides and Model Mothers," 135–61; Marta Ajmar, "Exemplary Women in Renaissance Italy: Ambivalent Models of Behaviour?" in *Women in Italian Renaissance Culture and Society*, edited by Letizia Panizza (Oxford: Legenda, 2000), 244–64; and Sara Matthews-Grieco, "Models of Female Sanctity in Renaissance and Counter-Reformation Italy," in *Women and Faith: Catholic Religious Life in Italy from Late Antiquity to the Present*, edited by Lucetta Scaraffia and Gabriella Zarri (Cambridge, MA: Harvard University Press, 1999), 160–75. While these studies tend to emphasize how women were acculturated to view their lives through a patriarchal lens, and the present chapter has similarly focused on the normative, it is important to ask to what degree did individual women conform to or resist the patriarchal prescriptions for behavior? To complement studies of the normative and prescriptive, more archival research is needed to identify and study specific seventeenth-century Bolognese women and the art they purchased. Studies of the patterns that emerge from the documentary record with respect to rooms in which particular subjects and ensembles of imagery were displayed are also needed. However, as Morselli's work demonstrates, Bolognese inventories do not necessarily list household contents by room. See Morselli, *Repertorio*, in which inventories that are organized room by room are identified.

55 Diane Owen Hughes, "Representing the Family: Portraits and Purposes in Early Modern Italy," *Journal of Interdisciplinary History* 17(1) (1986): 30.

56 Giovanni Battista Armenini, *De'veri precetti della pittura* (Ravenna: Francesco Tebaldini, 1587; reprint, Hildesheim and New York: Georg Olms Verlag, 1971), 187–8.

57 Ibid., 188–9.

58 Leandro Bassano, *Portrait of a Widow at her Devotions*, 1590–1600, 105 x 88.5 cm, in a private collection.

59 Murphy, "The Market for Pictures," 43; Modesti, *Elisabetta Sirani*, 86–7.

60 Silvia Antoniano, *Tre libri dell'educatione christiana dei figliuoli* (Verona: Apresso Sebastiano dalle Donne & Girolamo Stringari, Compagni: 1584), 37b.

61 Ibid., 52b.

62 Ibid., 53b–54b.

63 Ibid., 54b.

64 Pietro Giussano, *Instruttione a' padri per saper ben governare la famiglia loro* (Milan: Apresso la compagnia di Tini & 'Filippo Lomazzo, 1603), 239.

65 Passi, *Dello stato maritale*, 129; Antoniano, *Tre libri dell'educatione christiana dei figliuoli*, 55b–56a.

66 Giussano, *Instruttione a' padri*, 39–40.

67 Morselli, *Collezioni*, 512–20.

68 Ibid., 607–10.

69 Ibid., 605–6.

70 Ibid., 604.

71 Ibid., 603.

72 Ibid., 604.

73 Ibid., 603–4.

74 Ibid., 620–23.

75 Ibid., 539 (St Ursula); 534–5 (St Catherine); 628 (Lucretia); 627 (Cleopatra); 603 (Judith).

76 Ibid., 517, 519, 529–30. For the significance of saintly masculine role models for male adolescents, see Miller's chapter in this volume and Christopher Fulton, "The Boy Stripped Bare by His Elders: Art and Adolescence in Renaissance Florence," *Art Journal* 56(2) (1997): 31–40.

77 See, for example, "tre quadrettini dipinti senza Cornice": Morselli, *Collezioni*, 135; "Cinque quadretti ordinarijssimi di pochis.ma valuta"; "Una Madona piccola rotonda Cornice dorata ordinaria"; "Duoi quadrettini piccoli di un Christo in Croce et un S. Francesco corinisati": Morselli, *Collezioni*, 144. There are many more small paintings of religious and secular subjects recorded throughout the inventories published by Morselli.

78 Caroline Murphy, "Lavinia Fontana and the Female Life Cycle Experience in Late Sixteenth-Century Bologna," in *Picturing Women in Renaissance and Baroque Italy*, edited by Geraldine A. Johnson and Sara Matthews-Grieco (Cambridge: Cambridge University Press, 1997), 126–7. The trousseau also included linens, clothing, jewelry, and furnishings.

79 Caroline Murphy, *Lavinia Fontana: A Painter and her Patrons in Sixteenth-Century Bologna* (New Haven: Yale University Press, 2003), 166–71.

80 Lavinia Fontana, *Holy Family with Sleeping Child*, 1590s, oil on copper, 52 x 40 cm, Stockholm National Museum (Murphy, *Lavinia Fontana*, fig. 150); Lavinia Fontana, *Holy Family with Sleeping Christ Child*, 1591, oil on copper, 45 x 37 cm., Villa Borghese, Rome (Murphy, *Lavinia Fontana*, fig. 151).

81 Murphy, *Lavinia Fontana*, 170.

82 Modesti, *Elisabetta Sirani*, 88.

83 *Christ Child with the Young Saint John the Baptist*, 1661, oil on canvas, 32 x 25 cm, Daniele Lucchese-Salati Collection, Bologna. *Elisabetta Sirani: "pittrice eroina" 1638–1665*, edited by Jadranka Bentini and Vera Fortunati (Bologna: Editrice Compositori, 2004), 182–3.

84 Giovanni Dominici, *Regola del governo di cura familiare, parte quarta: On the Education of Children*, trans. A.B. Coté (Washington, DC: Catholic University of America, 1927), 34. As Dominici advises regarding pictures that are appropriate for children: "It will not be amiss if he should see Jesus and the Baptist, Jesus and the boy Evangelist pictured together …".

85 Murphy, *Lavinia Fontana*, 167.

86 Carlo Cesare Malvasia, *Felsina pittrice. Vite de' pittori bolognesi* (Bologna: 1678; ed. G. Zanotti, 1841; repr. Bologna: Forni, 1967), I: 197. Caroline Murphy notes that certain nuns in Bologna were expected to bring paintings when they entered the convent: Murphy, "The Market for Pictures," 44.

87 Morselli, *Collezioni*, 257. See also the small painting on copper by Elisabetta Sirani of the Holy Family recorded in the inventory of the fish merchant Giuseppe Comelli (1675): Morselli, *Collezioni*, p. 172, item 24.

88 Modesti, *Elisabetta Sirani*, 87.

89 Malvasia, *Felsina pittrice*, II:400. See also Modesti, "Patrons as Agents," 375.

90 Malvasia, *Felsina pittrice*, II:393.

91 Philip Sohm, "Gendered Style in Italian Art Criticism from Michelangelo to Malvasia," *Renaissance Quarterly* 48(4) (1995): 759–808.

92 Ibid., 792–3.

93 Ibid., 795.

94 The criticisms are those of Ferrante Carli, as recorded by Malvasia: ibid., 794.

95 Ibid., 802.

96 Ibid., 798–803.

97 Johnson, "Beautiful Brides and Model Mothers," 145–6.

98 For Albani's biography and for a catalogue of his works, see Catherine R. Puglisi, *Francesco Albani* (New Haven: Yale University Press, 1999). As Puglisi notes: "for more than a decade before 1651 he was devoting most of his time to inventing new themes and variations for cabinet pictures, which comprised his studio's principal production" (53). Albani's focus on small paintings was not without controversy in Albani's circle. Albani himself seems to have discounted his production of cabinet pieces according to Malvasia. As Malvasia recounts: "mi disse che si trovava di conto, aver fatto 45. Tavole per Altari, ed altrettante fatiche d'opere di quadroni in circa, senza gl'innumerabili quadri mezzani e piccoli di capricci di favole, e di composizioni, tutte tendenti a novità di pensieri concettosi ec. ma che di questi poco o nulla tenea conto …": Malvasia, *Felsina pittrice*, II:172. Albani's response to one of the earliest accounts of his career, published in Francesco Scannelli's *Il microcosmo della pittura* (Cesena: 1657; reprint Bologna: Nuova Alfa Editoriale, 1989), 364–6, demonstrates the artist's fear that Scannelli's description of him as a painter of small pictures would displace his achievements in history painting. According to Malvasia, Albani was extremely upset with Francesco Scannelli for praising his achievements as a painter of small pictures, even though Scannelli did not dispraise his larger pictures. As Malvasia writes: "Uscito fuore alle stampe l'ingegnoso e dotto Microcosmo della pittura del dottor Scanelli, non si può dire quanto sí turbasse e dolesse di esser stato anzi mal trattato da quell'autore, che nominato colla dovuta lode …". In addition to attributing Albani's works to others, Scannelli also "lodato solo in picciolo, nè magnificato in tante tavole grandi da Altare per tutta la città, e simili altre querele …". As a result,

Malvasia notes, Albani wrote his complaints in his own copy of the book: Malvasia, *Felsina pittrice*, II:186. Malvasia reproduces Scannelli's reply to Albani's complaints in a letter dated 10 May 1658, but Albani's own letter is lost. For Scannelli's letter, see Malvasia, *Felsina pittrice*, II:186–8. On Albani's response to Scannelli, see also Eric van Schaak, "Francesco Albani, 1578–1660," (PhD dissertation, Columbia University, 1969), 57–8, 148–50. Van Schaak transcribes the notations made by Albani in his copy of Scannelli's text: ibid., 380–86, Appendix C. See also Puglisi, *Francesco Albani*, 56, who notes: "Although he never stated that Albani did not succeed well on a large scale as on a small scale, that is exactly how Albani and Malvasia interpreted his attitude. Thus, Scannelli's short account already set down in Albani's lifetime the standard ingredients for later biographies and appraisals."

99 The painting measures 49.9 x 40.4 cm. For the painting, see Puglisi, *Francesco Albani*, pl. XXII, 64, 210, cat. 145.

100 Ibid., 188, cat. 106.

101 Ibid., 1.

102 These techniques are recounted by Malvasia, *Felsina pittrice*, II:179. See also Puglisi, *Francesco Albani*, 40.

103 Malvasia, *Felsina pittrice*, I:179.

104 Puglisi, *Francesco Albani*, 40.

105 See, for example, Roger De Piles, who criticizes Albani for repeating his figures, remarking "having admired one work by Albani, one would be able to say he had seen them all, given they were always the same." Quoted in ibid., 62.

106 Van Schaak dismissed the last 20 years of Albani's career. He writes: "Until the mid 1640s he [Albani] had been a vital force in Bolognese painting. After that date his work deteriorates rapidly and hardly merits serious art historical attention." Van Schaak, "Francesco Albani," 151.

107 For the idea that artists who served the market for domestic devotional images might calibrate their modes of production, style, and compositional features to the precise needs of their audiences, see Megan Holmes' study of the Florentine artist Neri di Bicci: "Neri di Bicci and the Commodification of Artistic Values in Florentine Painting (1450–1500)," in *The Art Market in Italy: 15th–17th Centuries* (see note 7), 213–23. Holmes argues that Neri's paintings appealed to clients from the "middle ranks of society" – especially artisans and "the *nouveau riche*" (218) – and that he calibrated his production methods to the needs of this market.

Part III
Domestic Objects and Sociability

Chi vuol esser lieto, sia: Objects of Entertainment in the Tornabuoni Palace in Florence[1]

Maria DePrano

Whether dancing with other aristocratic youths in front of the Mercato Nuovo[2] or reading a classical author by candlelight in one's study,[3] leisure in Renaissance Florence took many different forms, both in the public realm outside the walls of the *casa* or within the interior of the home. The semi-public revelries enjoyed at Italian Renaissance courts, and the public festivities celebrated on the streets of Florence, have been well investigated, as extensive documentation of these diversions exists.[4] Though not limited to Florence, Katherine McIver, for instance, considers courtly banquet seating in the city and the country in the cinquecento in this volume.[5] Domestic sociability and the objects related to those amusements remain under-explored facets of the domestic interior of the Florentine home, especially for the quattrocento. A few scholars have laid the foundations for further studies. Marta Ajmar-Wollheim has addressed sociability in the later decades of the cinquecento *casa*,[6] while Brenda Preyer has examined the manner in which the layout and the built-in decorations of the quattrocento Florentine palace facilitated social exchange.[7]

This chapter proceeds from the observation of a number of intriguing objects related to sociability and leisure, including jousting equipment, costumes, and musical instruments, listed in one room, *la chamera terrena in sul androne* (the ground-floor chamber by the vestibule), in the 1497 inventory of the Tornabuoni palace in Florence made near the close of the quattrocento by the Magistrato dei Pupilli.[8] This study investigates whether these objects were common in other Florentine homes by examining the inventories of the Medici and Inghirrami residences.[9] It explores who may have enjoyed these objects, and how they might have been employed in leisure activities outside the home and within this particular room, located near the nexus of the palace interior and exterior. Inventories provide scholars with tantalizing views of the domestic interior, but say nothing about how the inhabitants valued and interacted with the objects itemized in their home. The chapter concludes that

the Tornabuoni used the *chamera terrena in sul androne* for entertaining, and that correspondingly located rooms in other patrician Florentine homes may have been utilized in a comparable manner.

The Tornabuoni present a compelling subject for this exploration of patrician entertainment because of their service as hosts for visitors to the Florentine Republic, providing what one scholar has called the "Florentine state guest house."[10] According to the fifteenth-century Florentine *Libro Cerimoniale* (*Ceremonial Book*), Giovanni Tornabuoni, the Medici banker, papal treasurer, and art patron, received distinguished visitors to Florence, such as the Cardinal of Mantua.[11] The Tornabuoni family's socially prominent relations, through Giovanni's sister's marriage to Piero de' Medici, probably elicited the high level of entertaining evident in the *Libro Cerimoniale*, yet Giovanni Tornabuoni himself also came from a eminent family with an extensive history in Florence.

In exploring objects related to amusement in the chamber of an elite Florentine family, it is crucial to remember that not all entertainment is necessarily relaxing. Receiving the Cardinal of Mantua into one's home may have involved some enjoyable activities, while one also assured the dignitary's comfort and the visit's success. A similar complexity colors sociability. Hosting guests in one's home was not invariably a private activity, nor was it always a leisure-time endeavor. As Marta Ajmar-Wollheim indicates, socializing necessarily mixes public and private, and it may also have combined work and play.[12] By displaying and using armor, costumes, and musical instruments in the *chamera terrena in sul androne*, a room located at the critical juncture near the entrance to their home, the Tornabuoni presented their family as honorable, civic minded, and cultured to those who resided within the palace and to guests who visited.

In the Ground-Floor Chamber by the Vestibule

Large Renaissance homes in urban centers usually housed an extended family and were often called a *palazzo* (palace) or *casa grande* (large house), appropriate terms since they frequently were sizable block-like residences.[13] The Tornabuoni palace, located on Via dei Belli Sporti, now the eponymous and stylish Via Tornabuoni, was designed by Michelozzo.[14] The palace left Tornabuoni hands in the cinquecento and was subsequently renovated.[15] Because no ground plan of the fifteenth-century palace apparently survives, the layout remains obscure. The ground floor consisted of vaults for storing barrels; a few chambers and antechambers; a ground-floor *sala*; a chamber of the arms, with a smaller room for storing weapons, called *una timarta*; and the ground-floor chamber next to the vestibule (*chamera terrena in sul androne*) under examination here.[16] Located near the palace's large doors leading out into the urban fabric of Florence, the *chamera terrena in sul androne* was a more public chamber into which guests and visitors from the streets of the city could enter.

Renaissance Florentines elegantly appointed their *camere* (chambers) and *anticamere* (antechambers, following the chamber), supplying both categories of rooms with beds and benches, allowing them to function as sites for social gatherings.[17] The Tornabuoni suitably furnished their *chamera terrena in sul androne* with a suite of intarsiated walnut bed, trestle table, and bench with *spalliera*.[18] Ample additional seating was provided by low benches surrounding the central bed, another bed of diminutive size, probably with posts, and a daybed with a high back.[19] Two matching *cassoni*, a large armoire, and two leather-covered desks offered storage and surfaces for the display of significant possessions.[20] Textiles softened the chamber. As Allyson Burgess Williams argues in her chapter in this volume, expensive fabrics were an essential decorative element in Renaissance rooms.[21] A curtained canopy crowned the intarsiated bed, which was dressed with a quilt, as well as two pillows embellished with *reticella*, a kind of raised needlepoint.[22] A verdure tapestry of diminutive bunches of flowers hung on one wall, while a gilded gesso Virgin Mary in a tabernacle blessed the room from nearby.[23] Three Flemish paintings revealed the Tornabuoni family's fashionable interest in contemporaneous Northern art.[24] A portrait of Lucrezia Tornabuoni, Giovanni's sister, honored her memory and the distinction she brought to her natal family through her service to Florence, as well as her marriage to Piero de' Medici.[25] This last painting has been identified as the portrait of Lucrezia Tornabuoni, painted by Domenico Ghirlandaio, now in the collection of the National Gallery of Art, Washington, DC.[26] Seated among the refined intarsiated furniture and glancing at Flemish paintings on the walls, how did family members and guests to the Tornabuoni palace view and utilize the jousting equipment, costume accessories, and musical instruments in the *chamera terrena in sul androne*?

Arms and Armor

The Tornabuoni were an elite family of hallowed lineage in Florence who chose *popolo* rank in order to be eligible for elected office in the anti-aristocratic political milieu of the trecento.[27] They displayed their social distinction to their guests, and, like many elite in quattrocento Italy, emulated courtly culture[28] by exhibiting arms and armor in the *chamera terrena in sul androne*. A gilded *targietta* (small display shield) with the Tornabuoni family emblem and a jousting shield presented the family's honor and social prestige.[29] These were probably hung on the walls of the room, as they are listed immediately after the portrait of Lucrezia Tornabuoni, and inventory writers tended to note paintings and other objects on the walls before recording the room's furniture. The most spectacular item in this chamber must have been the helmet crest with pomegranates covered in fake gold or tinsel, which may also have been displayed on the wall.[30] Two sheathed swords with pommels worked in silver were the only weapons in the room.[31] These probably hung

over the fireplace, as they are recorded after the fire-irons and fire-dogs.[32] The parade shield and swords set the stage, indicating to guests that they should view the Tornabuoni as elite Florentines emulating courtly behavior.

Peter Thornton interprets the arms found in Renaissance houses as largely decorative items valued for their fine craftsmanship.[33] Shields with the family emblem, such as the three *targhoni* exhibited on the ground floor of the Inghirrami palace, certainly fit that characterization, as do the *targietta* and two beautifully crafted swords in the Tornabuoni *chamera terrena in sul androne*.[34] The Medici inventory for their Florentine palace lists pages of arms, jousting gear, and armor, much of it dispersed throughout the palace, although many weapons were stored in the rooms associated with Piero di Lorenzo de' Medici.[35] In a ground-floor *anticamera*, the Medici stowed a number of swords, daggers, and a half-head helmet.[36] Lorenzo il Magnifico deposited weapons, helmets, and under-armor garments (*pitocho*) in an armoire in his downstairs chamber.[37] Mario Scalini speculates that half-head helmets were worn as fashionable pieces rather than as a defensive helmet in war or jousting, as they did not protect the face.[38] Stylish men may also have worn one or two pieces of armor out on the town, even lightly armored doublets.

The armor in the *chamera terrena in sul androne* goes beyond the display of beautifully made objects and fashionable male dress. Crucial pieces of jousting armor were also stored or displayed in this room, including a buckler (a small round steel shield), two gauntlets of mail, an under-armor garment of red linen with mail sleeves, two armpieces, and two iron gauntlets.[39] These indicate Lorenzo Tornabuoni's participation in Florentine events that emulated knightly pastimes, such as *armeggerie* (parades of armed men) and jousts.[40] The helmet crest with tinsel pomegranates would have decorated a jousting helmet, two of which were stored in an antechamber on an upper floor of the palace.[41] A long outer garment, *sopravesta*, decorated with tinsel chimes and stored in an adjacent room, may have been worn with this helmet crest, over Lorenzo's jousting armor.[42] The Tornabuoni stowed 30 hollow lances for jousting in an upper-floor antechamber of their Florentine palace, with additional horse tack, weapons, and armor.[43] Luxurious equestrian equipment, including horse blankets, horse armor, and bridles stored in a nearby ground-floor room,[44] would have been used in pageants associated with jousts, as well as in civic processions leading foreign visitors through the city.

Patrician young men, like Lorenzo, participated in *armeggerie* to display their equestrian expertise through different events, which, although not competitive, surely led to bragging rights for the most successful contender.[45] Frequently used to welcome visiting dignitaries, *armeggerie* were also employed to impress young women. One famous *compagnia di armeggiattori*, all richly attired, conducted their exhibition at night before the houses of favored, attractive, well-born young women, finishing their amusement with a carnival float on the theme of the Triumph of Love.[46] An *armeggeria* celebrated the marriage of Nannina de' Medici to Bernardo Rucellai in 1466.[47]

Elite young men also partook in jousts, which were preceded by processions through the city on horseback in knightly gear and bearing banners. Jousts frequently occurred as part of carnival festivities, but were also performed throughout the year, during the celebrations for St John the Baptist's feast day, and to honor influential foreign guests. Unlike *armeggerie*, the men competed in jousts in which two individual men, always on horseback in Florence, confronted each other.[48] Lorenzo Tornabuoni jousted, as attested to by a letter from Poliziano to Pico della Mirandola, and he probably also belonged to a *compagnia di armeggiattori*.[49]

The Tornabuoni jousting equipment, used for public entertainment performed on the streets of Florence, but displayed in an interior room not far from the *portone* (main doors) of the palazzo, provided the opportunity for private conversations by young men of Lorenzo's *brigata* recounting their exploits for their own and others' enjoyment. By presenting the crest of a jousting helmet along with other jousting accoutrement in the *chamera terrena in sul androne*, the Tornabuoni portrayed themselves as honorable participants in important civil ceremonies that emulated aristocratic courtly culture, a message they surely hoped would be shared publicly outside their palace walls.

Masks

The most unusual items tucked among the luxury goods in this ground-floor chamber were 10 masks, nine wigs, and two beards "to make disguises."[50] By contrast, costumes do not appear in either the Medici inventory or that of the Inghirrami.[51] Wearing masks in the Renaissance was a charged activity, related to both death and the potential for inappropriate behavior.[52] The ancient Romans wore the death mask of ancestors in processions for newly deceased men, a fact well known in the Renaissance.[53] There was also a concern that those wearing masks might transgress the limits of accepted society.[54] Nonetheless, Florentines donned masks and costumes for various events, including public celebrations on the city streets and private parties.

The similar number of masks and wigs, 10 masks and nine wigs, gathered in the Tornabuoni *chamera terrena in sul androne* hints at a group attired in matching costumes, although the theme of the disguise, if there was one, has been lost to history. Florentines celebrated Carnevale and the Feast of St John the Baptist with thematic group masquerades and decorated carriages, sometimes referred to as triumphs.[55] Attired in a guise appropriate for the theme, individuals rode on the carriage, while others proceeded alongside. As they paraded through the city, the group sang songs written expressly for them by a poet assisted by a musical composer. William Prizer vividly portrayed the *carro carnascialesco* as "a miniature music drama moving through the streets of the city, mingling the arts of music, poetry, drama, choreography and costuming."[56] The concepts governing the *carri* varied

from a celebration of the Three Goddesses, which included Venus, Juno, and Minerva, to a Triumph of Apollo, Muses, and Poets presented for Carnevale in 1487 or 1488.[57] The *carri* themes were not limited to classicizing imagery. Some masquerades impersonated a trade, such as glove makers, that lent itself to the double entendres that peppered the songs performed by the *brigata*.

Lorenzo il Magnifico participated in the thematic design of a few *carri carnascialeschi*. He wrote the poetry of their songs, called *canti carnascialeschi*, such as the *Canzona de' setti pianeti* for a masquerade performed in the Carnevale of 1489/1490, and the *Canzona di Bacco*, a line of which is quoted in the title of this chapter.[58] Lorenzo's son Piero was also engaged in these projects. Piero is known, for instance, to have paid the composer Heinrich Isaac to set his father's poem *Alla battaglia* to music for presentation at Carnevale in 1488.[59] The members of Piero's *brigata*, such as his cousin and close friend, Lorenzo Tornabuoni, were probably also involved. Perhaps Lorenzo gathered the costume items in the *chamera terrena in sul androne* after their use on the streets of Florence. Their storage in a ground-floor room not far from the *portone* of the palazzo ties them to potential use outside the home. If these masks, wigs, and beards were used for a public masquerade, then, like the jousting accoutrement, the original participants and their viewers could have continued to enjoy these items of disguise long after the public spectacle, in conversations remembering their public performances.

Alternatively, the costume elements may have been employed in formal theatrical performances, which were staged in Florentine palaces in the late quattrocento and early cinquecento. A recitation of a comedy by Terence was performed at the Medici palace in 1476, and a presentation of a comedy by Plautus took place in 1488.[60] According to Marino Sanudo, on the last day of Carnevale 1513, a play was performed for Lorenzo II (also called Lorenzino or Lorenzo the Younger) in the Medici palace in Florence.[61] Niccolò Machiavelli's *La mandragola* may have been performed in a private home in 1518.[62] However, it is unknown whether masks were used in theatrical performances, whether domestic or public, in this time period.[63]

The masks, wigs, and fake beards may hint at other evening entertainments, such as improvisational theatrical amusements, costume parties, and dancing. The late cinquecento author on Sienese party games, Girolamo Bargagli, advocated improvised theatrical performances (*comedia all'improviso*) as suitable evening recreation.[64] Elite Florentines in the cinquecento also diverted themselves by attending masquerade parties. From October 1515 to May 1516, Duke Lorenzo de' Medici recorded special purchases in his financial account of disguises, including 13 masks purchased at the cost of four ducats.[65] The account also records a special outfit made for a masquerade at the Palazzo Salviati. Thus, improvisational theatrical performances and private masquerade parties were staged in the cinquecento domestic interior.

In the later decades of the quattrocento, Braccio Martelli, a friend of Lorenzo il Magnifico, recounted, in a letter written in code, a party celebrated

by Lorenzo's *brigata*, providing evidence that masquerades may have been part of evening amusements in that century as well. Martelli portrayed an evening of feasting, music, and singing. During the festivities, three male revelers exited from a neighboring room, "O strangely dressed up, and 2 with 5 dressed in the sky-blue, happy dress of Lucrezia."[66] In other words, O put on some form of disguise, with 2, who may not have been costumed, accompanied by 5, who wore a young woman's dress. Martelli also mentioned the men dancing the *moresca*, a dance popular across Europe. Because society viewed the vigorous movements involved in performing the *moresca* as indecent, it was often executed in a disguise, which frequently included a fake beard.[67] Unfortunately, Martelli did not divulge in his letter whether fake beards were worn by Lorenzo's carousing *brigata*.

The masks, wigs, and fake beards stored in the Tornabuoni *chamera terrena in sul androne* testify to theatrical or masquerade amusements enjoyed by the palace inhabitants and their guests. These may have been souvenirs of a public entertainment such as a thematic Carnevale carriage, remembered within the palace, or elements of informal masquerades and dances celebrated at home. Further research is required to determine whether patrician women donned disguises in domestic masquerade parties and informal theatrical entertainment in the quattrocento, despite the strict social control of women's behavior described in behavioral treatises.

Musical Instruments

Although the Tornabuoni possessed musical instruments, they did not own a great number of them.[68] The few that they enjoyed were gathered in the *chamera terrena in sul androne*, where they displayed a viola and bow, two *zufoli da suonare* (a wind instrument similar to a flute or a recorder), and a *chorno d'osso* (a horn of bone).[69] Upstairs, a grand harp beautified the chamber with the golden beams.[70] A second viola waited to be played in the *sala terrena* of their Villa Chiasso Macerelli.[71] The *viole* were probably *lire da braccio*, as both terms were utilized interchangeably in early modern documents.[72] This stringed instrument was valued for its presumed relationship to the lyre of antiquity.

According to the 1512 copy of the 1492 inventory of the Medici palace made upon the death of Lorenzo il Magnifico, the Medici similarly presented a number of different musical instruments in the "chamber of the two beds" in their Florentine palace.[73] This ground-floor chamber was located near the palace's large doors, as the next room recorded in the inventory is that of the *portinaio*, or doorman.[74] In this space, the Medici displayed five organs of various kinds, a keyboard (possibly a harpsichord), five other forms of harpsichords, two spinets, a viola with keys (most likely a hurdy-gurdy), a harp, a lute, three *viole*, and two sets of woodwind instruments along with other woodwinds.[75] With such a rich array of different musical instruments,

it seems safe to assert that this chamber may have functioned as a music room.[76] Its close proximity to the main doors of the palace meant that guests could easily arrive from outside the palace for musical entertainments.

Francesco Inghirrami also kept musical instruments and books of music in his homes. A *monochordo* (monochord, a musical and scientific instrument of one string) with its case, and a pair of small organs were displayed in an antechamber of his small house.[77] A pair of grand organs was kept in an antechamber to a finely furnished chamber attached to the *sala terrena*, or ground-floor *sala* of the home described as his residence.[78] A book of music and a second book, perhaps of song, were stored near Inghirrami's *scrittoio*, or desk, in his chamber in the *casa grande*.[79]

With the exception of the music enjoyed at Lorenzo de' Medici's palace, lyric entertainment in the fifteenth-century Italian home has been little studied. Lorenzo and his sons, Piero and Giovanni, were well-trained musicians, as were his sisters and his mother, Lucrezia Tornabuoni. Both Lorenzo and his son Piero played the *lira da braccio*, and delighted in the company of others who were likewise poet-improvisers.[80] Angelo Poliziano mentioned Piero's flair as an improviser in a letter to his father, Lorenzo il Magnifico.[81] Lorenzo's younger son, Giovanni, the future Pope Leo X, would become an important musical patron in Rome.[82] Lorenzo's sisters, Bianca and Nannina, at the ages of 14 and 11, respectively, performed for the papal retinue of Pope Pius II in 1460.[83] In a 1445 letter, Ugo della Stufa praised Il Magnifico's mother, Lucrezia, for learning to sing a new piece.[84] The Medici household, then, exhibited a high level of musical expertise, thereby setting an example for other Florentine families of the importance of musical knowledge as a social grace. The musical proficiency of two generations of Medici women demonstrates that musical accomplishment was a necessary refinement for elite women.[85]

The role of music in other patrician households in quattrocento Florence awaits further study. Some information can be inferred from analyses of families in the early sixteenth century, which have been generously researched because of scholarly interest in the madrigal. Musical instruction and performance must have been valued in the *palazzi* of the Rucellai and Strozzi families in the late fifteenth century, given the sophisticated musical patronage of their offspring in the early cinquecento. Giovanni Rucellai surely stressed the musical education of his son, Bernardo (1448–1514), who in the early years of the cinquecento hosted an informal gathering of humanists and musicians at his Orto Orucellai just west of Santa Maria Novella, a social forum that has recently been identified as one of the sources for the development of the madrigal.[86] Two of Filippo Strozzi's sons, Lorenzo (1482–1551) and Filippo (1488–1538), were similarly prominent patrons of the early madrigal in the opening decades of the sixteenth century.[87]

Few references regarding the musical instruction of the Tornabuoni have been found. However, Ugo della Stufa's April 1445 letter, mentioned above, details Lucrezia Tornabuoni's musical sophistication. If Lucrezia, Giovanni's

sister, had the musical talent and the training to learn new music, then her proficiency implies that her brother, Giovanni, may also have enjoyed some musical training, and possibly arranged for his own children to receive music lessons. Based on a letter written by Angelo Poliziano to Pico della Mirandola, Lorenzo Tornabuoni, Giovanni's son, was a poet-improviser, performing on the *lira da braccio* while he sang his own lyric inventions.[88] The women in the family probably also had received a musical education. Alessandra Macinghi Strozzi wrote to her son, regarding a potential bride, that she "knows how to dance and sing," indicating the importance of a musical training as a social refinement for women in Renaissance culture.[89] It might be expected, then, that Giovanni Tornabuoni's daughter, Ludovica, and his daughters-in-law, the deceased Giovanna degli Albizzi, and Ginevra Gianfigliazzi, also knew how to dance and sing, like the potential Strozzi bride.

The instruments owned by the Tornabuoni – a harp, two *zufoli*, and two *lire da braccio*, or *viole* – were used as instrumental accompaniment for vocal music. The *laudesi* Company of San Piero Martire, for example, hired musicians who played harp and *zufoli* for their feast-day celebrations.[90] Women in courtly settings sang to harp and *zufoli* accompaniment.[91] Of the instruments in the Tornabuoni *chamera terrena in sul androne*, the two *zufoli* would have been appropriate instruments for a well-born young woman to play. *Viole* and *lire da braccio* also accompanied singers, as mentioned above, as both were the preferred instruments for poet-improvisers in quattrocento Florence.[92] Lorenzo Tornabuoni's poetic talent and his extensive knowledge of ancient Greek poetry must have assisted him in his improvised compositions and performances.[93] That the Tornabuoni inventory lists two *viole*, one in each of their two principal homes, reveals the importance of the instrument to Lorenzo.

Dora Thornton discusses musical instruments as suitable accessories for the courtly study.[94] In fifteenth-century Florence, by contrast, the Tornabuoni, the Medici, and, to some extent, the Inghirrami kept their musical instruments in refined *camere* or *sale* on the ground floor of their homes. No musical instruments appear in any of the *scrittoio* of the three families.[95] Portable instruments certainly may have been carried to a *scrittoio* to be played, but why bother, if the chamber was comfortably furnished, as they were in both the Medici and Tornabuoni palaces? An account of a banquet given by the Florentine Salutati family for Neapolitan guests related that after the evening meal they moved to the palace's *camera* to make music, suggesting that this may have been standard practice in Florence.[96]

Given the importance of musical proficiency as a social grace and the presence of instruments in the home, it may be safely assumed that some of the residents of the Tornabuoni palazzo played these instruments, and entertained friends and notable guests as amateur musicians in the *chamera terrena in sul androne*. Contemporaneous letters give evidence that women performed at home for mixed audiences, including high-status male guests.

While they may not have contributed to conversations about jousting or Carnevale processions, they may have enjoyed listening to them and probably contributed to musical entertainment. The proximity of this room to the great doors of the palace suggests an ephemeral layer of permeability between the palace's interior and its exterior; music played within the home may have been enjoyed by passers-by on the streets bordering the palace walls.[97]

Conclusion

A number of authors have considered the function of ground-floor chambers. In the fifteenth century, Leon Battista Alberti recommended in his *De Re Aedificatoria* that guests sleep in a ground-floor chamber near the entrance to avoid bothering the host family.[98] Brenda Preyer argued that Lorenzo il Magnifico's *camera terrena* served as a location for meeting clients and guests.[99] James Lindow recently summarized the various uses of the *camera terrena* as a meeting place, a guest room for distinguished visitors, and a bedroom for use in the hot Florentine summer.[100] This chapter suggests an additional use, on the basis of evidence from the Tornabuoni inventory, that the *chamera terrena in sul androne* in the family's Florentine palace served as a chamber for entertaining small groups of friends and guests. The ground-floor chambers in other Florentine palaces may have functioned in a similar manner. The *chamera delle dua letta* in the Medici palace resembles the Tornabuoni *chamera terrena in sul androne*. Both elegantly furnished rooms displayed items related to entertainment and leisure. In the *chamera delle dua letta*, the Medici exhibited not only an extensive collection of musical instruments, but also a chess set, and art objects suitable for inspiring learned conversation, such as marble heads and several tapestries.[101]

These ground-floor *camere* could have been used in different ways in various seasons, as a bedroom for the family patriarch in the summer and a chamber for entertainment in the winter. In this volume, Catherine Fletcher observes that items of leisure such as musical instruments and a table for playing cards were noted in the inventory of the Casali villa outside Bologna, and suggests that the family may have taken these objects to the villa when they retreated from the summer heat of urban Bologna.[102] In the Tornabuoni *chamera terrena in sul androne*, elegant matching intarsiated furniture would have provided a comfortable, refined space in which to socialize. The luxurious jousting accoutrement, costumes, and musical instruments not only gave the room an honorable appearance, but also furthered social connections with family, friends, and distinguished visitors through learned and reminiscent conversation, informal theatrical interludes or dances, and musical performances. The location of the *chamera terrena in sul androne* near the palace's threshold argues for an appreciation of these objects of entertainment by both family members and guests to the palace, thereby publicly promoting the Tornabuoni as gracious, civic-minded, and cultured hosts.

Notes

1 "Let who wishes be happy …" The next line is *di doman non c'è certezza* (of tomorrow there is no certainty). Lorenzo de' Medici, "Canzona di Bacco," in *Canti carnascialeschi*, edited by Paolo Orvieto (Rome: Salerno Editrice, 1991), 80–81, lines 11–12. I wish to thank Erin Campbell for organizing, and Stephanie Miller and Catherine Harding for chairing, the "At Home in Early Modern Italy" sessions on the domestic interior at the 2010 annual meeting of the Renaissance Society of America. I am also greatly indebted to the intrepid Interlibrary Loan staff at Washington State University for their efforts on behalf of this chapter.

2 Bartolomeo di Michele del Corazza, "Diario Fiorentino di Bartolommeo di Michele del Corazza, anni 1405–1438," edited by Giuseppe Odoardo Corazzini, *Archivio storico italiano* V(XIV) (1894): 233–98, especially 277.

3 Niccolò Machiavelli, The *Literary Works of Machiavelli*, edited and translated by John R. Hale (Oxford: Oxford University Press, 1961), 139; Niccolò Machiavelli, *Opere*, edited by Mario Bonfantini (Milan: Riccardo Ricciardi Editore, 1963), 1111.

4 Giancarlo Malacarne, *Le feste del principe: Giochi, divertimenti, spettacoli a corte* (Modena: Il Bulino Edizioni d'Arte, 2002); Iain Fenlon, "Music and Festival," in *Europa Triumphans: Court and Civic Festivals in Early Modern Europe*, edited by J.R. Mulryne, Helen Watanabe-O'Kelly, Margaret Shewring, Elizabeth Goldring, and Sarah Knight, vol. 1 (Burlington, VT: Ashgate, 2004), 47–55; J.R. Mulryne and Elizabeth Goldring (eds), *Court Festivals of the European Renaissance: Art, Politics and Performance* (Burlington, VT: Ashgate, 2002); Helen Watanabe-O'Kelly and Anne Simon, *Festivals and Ceremonies: A Bibliography of Works Relating to Court, Civic and Religious Festivals in Europe 1500–1800* (London: Manell, 2000); Luciano Artusi and Silvano Gabbrielli, *Le feste di Firenze* (Rome: Newton Compton Editori, 1991). For additional references to public Florentine festivals, please see notes 55–8.

5 Katherine A. McIver, Chapter 9 in this volume.

6 Marta Ajmar-Wollheim, "Sociability," in *At Home in Renaissance Italy*, edited by Marta Ajmar-Wollheim and Flora Dennis (London: V&A Publications, 2006), 206–21.

7 Brenda Preyer, "Planning for Visitors at Florentine Palaces," *Renaissance Studies* 12(3) (1998): 357–74.

8 Florence, Archivio di Stato, Magistrato dei Pupilli avanti il Principato (hereafter cited as ASF, MPAP) 181, fol. 141r–50r. Scholars have employed the Tornabuoni inventory in their work, including Jean Cadogan, Patricia Simons, James Lindow, Susanne Kress, and Gert Jan van der Sman, although the inventory has not been analyzed as a means to better understand patrician sociability: Jean K. Cadogan, *Domenico Ghirlandaio: Artist and Artisan* (New Haven: Yale University Press, 2000), 258; Patricia Simons, "Portraiture and Patronage in Quattrocento Florence with Special Reference to the Tornaquinci and their Chapel in Santa Maria Novella" (PhD dissertation, University of Melbourne, 1985), I.162, 171–4, 179–83, 186–7 passim, II.132, 136–7, 140, 146, 150, 152 passim. Simons was the first to recognize these objects in the inventory (I.162). See also James R. Lindow, *The Renaissance Palace in Florence: Magnificence and Splendour in Fifteenth-Century Italy* (Burlington, VT: Ashgate, 2007), 119–84; Susanne Kress, "Die *camera di Lorenzo, bella* im Palazzo Tornabuoni: Rekonstruktion und künstlerische Ausstattung eines Florentiner Hochzeitszimmers des späten Quattrocento," in *Domenico Ghirlandaio: Künstlerische Konstruktion von Identität im Florenz der Renaissance*, edited by Michael Rohlmann (Weimar: Verlag und Datenbank für Geisteswissenschaften, 2003), 245–85; Gert Jan van der Sman, *Lorenzo and Giovanna: Timeless Art and Fleeting Lives in Renaissance Florence*, translated by Diane Webb (Florence: Mandragora, 2010), 48, 66–9, 176 n. 63, 179, nn. 83–6.

9 The Medici were selected because they represent the pinnacle of Florentine social hierarchy and consumerism, whereas the Inghirrami illustrate a family of learning and sophistication but more limited wealth. See Marco Spallanzani and Giovanna Gaeta Bertelà, *Libro d'inventario dei beni di Lorenzo il Magnifico* (Florence: L'Associazione "Amici del Bargello," 1992); ASF, MPAP 173, fol. 265r–74r; Jacqueline Marie Musacchio, "Appendix A: The Estate of Francesco Inghirrami," in *The Art and Ritual of Childbirth in Renaissance Italy* (New Haven: Yale University Press, 1999), 158–73.

10 Michael Mallett's comment cited by Preyer, "Planning for Visitors," 357–74, especially 373, n. 57.

11 Francesco Filarete and Angelo Manfidi, *The Libro Cerimoniale of the Florentine Republic*, edited and introduced by Richard C. Trexler (Geneva: Librairie Droz S.A., 1978), 95.

12 Marta Ajmar-Wollheim, "Sociability," in *At Home in Renaissance Italy* (see note 6), 206–7.

13 Leon Battista Alberti, *On the Art of Building in Ten Books*, translated by Joseph Rykwert, Neil Leach, and Robert Tavernor (Cambridge, MA: MIT Press, 1988), V.17; F.W. Kent, "Palaces, Politics and Society in Fifteenth-Century Florence," *I Tatti Studies* 2 (1987): 41–70, especially 45–9, 54, 58–9; Charles Burroughs, "Florentine Palaces: Cubes and Context," *Art History* 6 (1983): 359–63, 361;

Richard A. Goldthwaite, *The Building of Renaissance Florence* (Baltimore: Johns Hopkins University Press, 1980). For Leon Battista Alberti's recommendations for purchasing a family home, see Leon Battista Alberti, *The Albertis of Florence: Leon Battista Alberti's Della Famiglia*, translated by Guido A. Guarino (Lewisburg, PA: Bucknell University Press, 1971), 190–93; Leon Battista Alberti, *I primi tre libri Della Famiglia*, edited by F.C. Pellegrini and R. Spongano (Florence: Sansoni, 1946), 288–93.

14 Giorgio Vasari, *Le vite de' più eccellenti architetti, pittori, et scultori italiani*, edited by Luciano Bellosi and Aldo Rossi, vol. 1 (Turin: Giulio Einaudi, 1986), 329.

15 Francesco Gurrieri, *Il Palazzo Tornabuoni Corsi: sede a Firenze della Banca Commerciale Italiana* (Florence: Edizioni Medicea, 1992), 11–16. Simons, "Portraiture and Patronage in Quattrocento Florence," I.158–69.

16 ASF, MPAP, 181, fol. 146v–7v. The *chamera terrena dell'arme* was followed by an antechamber, which was itself followed by *timarta di detta*. *Timarta* does not appear in Battaglia's *Grande dizionario*. But words with the root *timar* all have to do with knights, and the items stored in this particular room are knightly, including a helmet of worked copper for a horse (*una testiera di rame lavorata da chavagli*). See Salvatore Battaglia, *Grande dizionario della lingua Italiana* (Turin: Unione Tipografico-Editrice Torinese, 2004), XX.1035.

17 Brenda Preyer, "The Florentine *Casa*," in *At Home in Renaissance Italy* (see note 6), 34–49; Peter Thornton, *The Italian Renaissance Interior: 1400–1600* (New York: Harry N. Abrams, 1991), 285–95.

18 *1ᵃ lettiera choperta di nocie e tarsia di braccia 5 e channaio e trespolo panchette basse intorno, 1ᵃ tavola di nocie di braccia 4 ½ con trespoli e lavori a tarsia, 1ᵃ pancha e spalliera di nocie di braccia 4 ½ chon tarisa*, ASF, MPAP, 181, fol. 147v.

19 *Panchette basse intorno, 1ᵃ chuccietta di braccia 4 incircha, 1° lettuccio e chappellinaio choperto di nocie a chassa di braccia 5*, ASF, MPAP, 181, fol. 147v.

20 *2 chassoni grandi a sepoltura choperti di nocie di braccia 3 ½ l'uno, 1° armario grande choperto di nocie a 2 serami, 2 deschetti choperti di quoio*, ASF, MPAP, 181, fol. 147v.

21 Allyson Burgess Williams, Chapter 10 in this volume.

22 *1° cortinagio con sopracielo cho pendenti da 2 lati, 1ᵃ coltricie chon federa verghata forestiera amezata con pieno di piuma, 2 ghuanciali da letto chon federe a reticielle*, ASF, MPAP, 181, fol. 147v. For *reticella*, see Thornton, *The Italian Renaissance Interior*, 74, 161, 381 n. 11.

23 *1° panchale a verzura di braccia 10 incircha doppio, Una vergine maria di giesso d'orata in 1° tabernacolo*, ASF, MPAP, 181, fol. 147v. For images of the Virgin Mary in the domestic interior, see Geraldine A. Johnson, "Art or Artefact? Madonna and Child Reliefs in the Early Renaissance," in *The Sculpted Object, 1400–1700*, edited by Stuart Currie and Peta Motture (Aldershot: Scolar Press, 1997), 1–17.

24 *3 telai con piu fighure fiandresche di tela lina*, ASF, MPAP, 181, fol. 147v. For Flemish paintings as popular items with the elite in Florence, see Paula Nuttall, *From Flanders to Florence: The Impact of Netherlandish Painting, 1400–1500* (New Haven: Yale University Press, 2004), 105–30.

25 *1° quadretto d'una testa e busto di mona Luchrezia de Medici*, ASF, MPAP, 181, fol. 147v.

26 Eleonora Luciano, "Lucrezia Tornabuoni," in *Italian Paintings of the Fifteenth Century*, edited by Miklós Boskovits and David Alan Brown (Washington, DC: National Gallery of Art, 2003), 303–7; Maria DePrano, "At Home with the Dead: The Posthumous Remembrance of Women in the Domestic Interior in Renaissance Florence," *Source* 29(4) (2010): 21–8.

27 Simons, "Portraiture and Patronage in Quattrocento Florence," I.108–18. The ancient lineage of the family is most evident from their long patronage at Santa Maria Novella; see Patricia Simons, "Patronage in the Tornaquinci Chapel, Santa Maria Novella, Florence," in *Patronage, Art, and Society in Renaissance Italy*, edited by F.W. Kent and Patricia Simons (Oxford: Clarendon Press, 1987), 221–50, especially 222–4.

28 Iain Fenlon, "The Status of Music and Musicians in the Early Italian Renaissance," in *Le Concert des voix et des instruments à la Renaissance, Actes du XXXIVᵉ Colloque International d' Études Humanistes Tours, Centre d'Études Supérieures de la Renaissance, 1–11 juillet 1991*, edited by Jean-Michel Vaccaro (Paris: CNRS Éditions, 1995), 66.

29 *1ᵃ targietta d'orata chol'arme di chasa, 1° scudo da giostra*, ASF, MPAP, 181, fol. 147v; Helmut Nickel, Stuart W. Pyhrr, and Leonid Tarassuk, "Circular Parade Shield (Target)," in *The Art of Chivalry: European Arms and Armor from The Metropolitan Museum of Art* (New York: Metropolitan Museum of Art, 1982), 49–50; Thornton, *The Italian Renaissance Interior*, 269; Mario Scalini, "Il 'ludus' equestre nell'età laurenziana," in *Le tems revient: 'l tempo si rinuova: Feste e spettacoli nella Firenze di Lorenzo il Magnifico*, edited by Paola Ventrone (Milan: Silvana Editoriale, 1992), 76.

30 *1° cimiere da elmetto chon melagrane d'orpello*, ASF, MPAP, 181, fol. 147v.

31 *2 spade chon pomi lavorati d'argiento in ghuaine*, ASF, MPAP, 181, fol. 147v.

32 *1ᵃ paletta e 1ᵃ forchetta e 1° paio di molle, 1° paio d'alari*, ASF, MPAP, 181, fol. 147v.

33 Thornton, *The Italian Renaissance Interior*, 269.

34 *3 targhoni cho l'arme sua nel terreno della chasa grande*, that is, three large shields with the arms of the house. ASF, MPAP, 173, fol. 265r. Musacchio, "Appendix A," 158.

35 Spallanzani and Bertelà, *Libro d'inventario*, 10, 88–92, 126–9; Mario Scalini, "The Weapons of Lorenzo de' Medici," *Art, Arms and Armour* 1 (1979): 12–20, especially 13. One jousting helmet in the Medici inventory is described as bearing the arms of the Medici and Tornabuoni: Spallanzani and Bertelà, *Libro d'inventario*, 90.

36 Spallanzani and Bertelà, *Libro d'inventario*, 10.

37 Ibid., 12–13.

38 Scalini, "The Weapons of Lorenzo de' Medici," especially 18–19.

39 *1° brocchiere soppannato di v° b° rosso, 2 ghuanti di maglia, 1ª pitochetto di tela rossa, 2 bracciali e 2 ghuanti di ferro*, ASF, MPAP, 181, fol. 147v.

40 Richard Barber and Juliet Barker, *Tournaments: Jousts, Chivalry and Pageants in the Middle Ages* (Woodbridge: Boydell Press, 1989), 150–162, especially 161; Giovanni Ciappelli, *Carnevale e quaresima: Comportamenti sociali e cultura a Firenze nel Rinascimento* (Rome: Edizioni di Storia e Letteratura, 1997), 137–47.

41 *2 elmi da giostra cho loro fornimenti*, ASF, MPAP, 181, fol. 150r.

42 *1ª sopravesta piena di sonagli d'orpello*, ASF, MPAP, 181, fol. 147r. In addition to the under-armor garments with sleeves of mail, called *pitoccho* or *pitochetto*, stored in the Florentine palace, another form of armor used to protect the torso, *chorazzina*, similar to brigantines, was kept in the Villa Chiasso Macerelli: *3 chorazzine choperte di tela azura*, ASF, MPAP, 181, fol. 141v; Mario Scalini, *A Bon Droyt: Spade di uomini liberi, cavalieri e santi* (Milan: Silvana Editoriale Spa, 2007), 202–3.

43 *30 lancie buse da giostra*, ASF, MPAP, 181, fol. 150r.

44 ASF, MPAP, 181, fol. 147v.

45 Ciappelli, *Carnevale e quaresima*, 137–47.

46 Pietro Gori, *Le feste fiorentine attraverso i secoli: Le feste per San Giovanni* (Florence: R. Bemporad & Figlio, 1926), 39–44.

47 Giovanni Rucellai, *Giovanni Rucellai ed il suo zibaldone*, edited by Alessandro Perosa, vol. 1 (London: Warburg Institute, 1960), 29; Claudio Benporat, "Documenti: Firenze, giugno 1466: Feste per le nozzi di Bernardo Rucellai e Nannina de' Medici," in *Feste e banchetti: Convivialità italiana fra tre e quattrocento* (Florence: Leo S. Olschki Editore, 2001), 148–51.

48 Ciappelli, *Carnevale e quaresima*, 139–47.

49 This letter is discussed in Giovanni di Napoli, *Giovanni Pico della Mirandola e la problematica dottrinale del suo tempo* (Rome: Desclee & Co., 1965), 226.

50 *9 chapelliere e 2 barbe da fare maschere, 10 maschere*, ASF, MPAP, 181, fol. 147v.

51 Spallanzani and Bertelà, *Libro d'inventario*, 268. The only reference to *una maschera* in the 1492 Medici inventory is to *uno anello d'oro, entrovi legato uno chammeo in su che è intagliato di rilievo una maschera anticha in profilo*, that is, a gold ring set with a cameo carved with the relief of an antique mask: Spallanzani and Bertelà, *Libro d'inventario*, 41. There is similarly no mention of a mask or fake beards in the Inghirrami inventory. ASF, MPAP 173, fol. 265r-274r; Musacchio, "Appendix A," 158–73.

52 Ciappelli, *Carnevale e quaresima*, 248–9.

53 Pliny, *Natural History*, translated by H. Rackham (Cambridge, MA: Harvard University Press, 1995), XXXV.5–6.

54 Ciappelli, *Carnevale e quaresima*, 248–9.

55 The two main references for Carnevale in Florence are the following: Ciappelli, *Carnevale e quaresima*; and Nicole Carew-Reid, *Les fêtes florentines au temps de Lorenzo il Magnifico* (Florence: Leo S. Olschki Editore, 1995). See also Charles Dempsey, "Portraits and Masks in the Art of Lorenzo de' Medici, Botticelli, and Politian's *Stanze per la Giostra*," *Renaissance Quarterly* 52(1) (1999): 1–42; and Antonio Pinelli, "Gli apparati festivi di Lorenzo il Magnifico," in *La Toscana al tempo di Lorenzo il Magnifico: Politica, Economia, Cultura, Arte, Convegno di Studi promosso dalle Università di Firenze, Pisa e Siena 5–8 novembre 1992* (Pisa: Pacini Editore, 1996), 219–32.

56 William F. Prizer, "Reading Carnival: The Creation of a Florentine Carnival Song," *Early Music History* 23 (2004): 185–252, especially 188.

57 Ibid., 189, 191–2; Charles S. Singleton (ed.), *Canti carnascialeschi del Rinascimento* (Bari: Gius. Laterza & Figli, 1936), 253. The date of the Three Goddesses carriage is unknown.

58 Ciappelli, *Carnevale e quaresima*, 195–211; Carew-Reid, *Les fêtes Florentines*, 112–14; see also Richard C. Trexler, *Public Life in Renaissance Florence* (Ithaca, NY: Cornell University Press, 1980), 414–15. Note that carnival celebrations were significantly curtailed from 1478 to 1488 in response to the Pazzi conspiracy and other exterior threats.

59 Blake Wilson, "Heinrich Isaac among the Florentines," *Journal of Musicology* 23 (2006): 97–152.

60 Mario Fabbri, Elvira Garbero Zorzi, and Anna Maria Petrioli Tofani (eds), *Il luogo teatrale a Firenze* (Milan: Electa Editrice 1975), 72.

61 Marino Sanudo, *I diarii*, edited by Rinaldo Fulin, Federico Stefani, Nicolò Barozzi, Guglielmo Berchet, and Marco Allegri, 59 vols (Venice: F. Visentini, 1879–1903), vol. 15, col. 572. See also Anthony M. Cummings, *The Politicized Muse: Music for Medici Festivals, 1512–1537* (Princeton: Princeton University Press, 1992), 30–34.

62 Richard Andrews, *Scripts and Scenarios: The Performance of Comedy in Renaissance Italy* (Cambridge: Cambridge University Press, 1993), 51.

63 Ibid., 35.

64 Girolamo Bargagli, *Dialogo de' Giuochi che nelle vegghie sansei si usano di fare*, edited by Patrizia D'Incalci Ermini (Siena: Accademia senese degli Intronati, 1982), 113.

65 Carole Collier Frick, *Dressing Renaissance Florence: Families, Fortunes, and Fine Clothing* (Baltimore: Johns Hopkins University Press, 2002), 106–7.

66 *Uscì .O. stranamente aconcio e . 2 . appresso . 5 . vestito della felice vesta di ÷ cilestra*. Isidoro del Lungo, *Gli amori del Magnifico Lorenzo* (Bologna: Nicola Zanichelli Editore, 1923), 32–42, especially 39. English translation, with a few changes, from Charles Dempsey, *The Portrayal of Love: Botticelli's Primavera and the Humanist Culture at the Time of Lorenzo the Magnificent* (Princeton: Princeton University Press, 1992), 89.

67 Paula Nuttall, "Dancing, Love and the 'Beautiful Game': A New Interpretation of a Group of Fifteenth-Century 'Gaming' Boxes," *Renaissance Studies* 24(1) (2010): 119–41, especially 123–9; Ingrid Brainard, "An Exotic Court Dance and Dance Spectacle of the Renaissance: *La Moresca*," in *The Report of the Twelfth Congress of the International Musicological Society, Berkeley 1977*, edited by D. Hertz and B.C. Wade (Kassel: Bärenreiter, 1981), 715–29.

68 Ownership of musical instruments increased dramatically from 1400 to 1600, especially after 1520. See Flora Dennis, "Music," in *At Home in Renaissance Italy* (see note 6), 230–33.

69 *1ᵃ viuola con l'archetto, 2 zufoli da suonare, 1° chorno d'osso con lavori*, ASF, MPAP, 181, fol. 147v. Two additional bone horns were put away in a storeroom on an upper floor of the palace. *2 chorni d'osso*, ASF, MPAP, 181, fol. 148v. *Corni d'osso* tended to be used as hunting horns. "Corno," *Grande enciclopedia antiquariato e arredamento*, edited by Vittorio Del Gaizo (Rome: Editalia, 1968), 223, and figure on 231.

70 *1ᵃ Arpa grande da sonare*, ASF, MPAP, 181, fol. 148v.

71 *1ᵃ viuola da sonare*, ASF, MPAP, 181, fol. 142r.

72 Emanuel Winternitz, *Leonardo da Vinci as a Musician* (New Haven: Yale University Press, 1982), 25–7; Sterling Scott Jones, *The Lira da Braccio* (Bloomington: Indiana University Press, 1995), 1–56.

73 *Chamera delle dua letta*, Spallanzani and Bertelà, *Libro d'inventario*, 18–22.

74 Spallanzani and Bertelà, *Libro d'inventario*, 22. Wolfger A. Bulst, "Uso e trasformazione del palazzo mediceo fino ai Riccardi," in *Il Palazzo Medici Riccardi di Firenze*, edited by Giovanni Cherubini and Giovanni Fanelli (Florence: Giunti Gruppo Editoriale, 1990), 98–129, especially 108, 125; Amanda Lillie, *Florentine Villas in the Fifteenth Century: An Architectural and Social History* (Cambridge: Cambridge University Press, 2005), 224, fig. 179.

75 Spallanzani and Bertelà, *Libro d'inventario*, 20–21. See also Timothy J. McGee, *The Ceremonial Musicians of Late Medieval Florence* (Bloomington: Indiana University Press, 2009), Table 5.3, 182–3.

76 The earliest reference to a "music room" was made by Paolo Cortesi in his *De Cardinalatu* in 1510. See Fenlon, "The Status of Music and Musicians in the Early Italian Renaissance," 65; Kathleen Weil-Garris and John F. D'Amico, "The Renaissance Cardinal's Ideal Palace: A Chapter from Cortesi's 'De Cardinalatu,'" *Memoirs of the American Academy in Rome* 35 (1980): 45–119, 121–3, especially 78–9, 105 n. 45; Nino Pirotta, "Musical and Cultural Tendencies in Fifteenth-Century Italy," *Journal of the American Musicological Society* 19 (1966): 152–3.

77 *1° monachordo cho' la chassa, un paio d'orghanetti cho la chassa*. These were stored *nel'antichamera dela chasa picchola*. ASF, MPAP, 173, fol. 268v; Musacchio, "Appendix A," 165. Another *monochordo* was

stored in a trunk in a large chamber in a different home. *1° monachordo dipinto bello cholla chassa*, was kept *nel forzeretto da soma* in the room described as *in chamera grande di sopra in sula sala a man' ritta*. ASF, MPAP, 173, fol. 273r; Musacchio, "Appendix A," 172.

78 *Chasa dela sua abitazione. 1° paio d'orghani grandi di braccia 2 in chirca sciolti* in the *antichamera dela detta chamera*. ASF, MPAP, fol. 272v; Musacchio, "Appendix A," 171.

79 *1° libro di musicha. 1° libro di chanto fighurato*. The *libro di chanto fighurato* could be a book of song, or a book of chant. It is impossible to say without the actual book. ASF, MPAP, 173, fol. 267v; Musacchio, "Appendix A," 162.

80 Cummings, *The Politicized Muse*, 37–9.

81 Angelo Poliziano, *Prose vogari inedite e poesie Latine e Greche edite e inedite*, edited by Isidoro del Lungo (Florence: G. Barbèra Editore, 1867), 76–8.

82 D'Accone describes Pope Leo X as "perhaps the most knowledgeable musical patron ever to occupy the chair of St. Peter." Frank A. D'Accone, "Lorenzo the Magnificent and Music," in *Music in Renaissance Florence: Studies and Documents* (Variorum Collected Studies Series) (Burlington, VT: Ashgate, 2006), V.259–90, especially 279; André Pirro and Gustave Reese, "Leo X and Music," *Musical Quarterly* 21(1) (1935): 1–16.

83 This was recounted in a report sent to the Gonzaga court. William F. Prizer, "Games of Venus: Secular Vocal Music in the Late Quattrocento and Early Cinquecento," *Journal of Musicology* 9(1) (1991): 3–56, especially 3–5, 53–4.

84 This letter was written to Lucrezia's brother-in-law, Giovanni di Cosimo de' Medici. Vittorio Rossi, "L'indole e gli studi di Giovanni di Cosimo de' Medici: Notizie e documenti," *Rendiconti della Reale Accademia dei Lincei: Classe di scienze morali, storiche e filologiche* 5(2) (1893): 38–60, 129–50, especially 45–6, 45 n. 3; Fulvio Pezzarossa, *I poemetti sacri di Lucrezia Tornabuoni* (Florence: Leo S. Olschki Editore, 1978) 14;. D'Accone, "Lorenzo the Magnificent and Music," 259–90, especially 268–9 and 268 n. 24.

85 Prizer, "Games of Venus," 4–5, 7–8. For trecento recommendations that elite women learn music, see Eleonora M. Beck, "Women and Trecento Music," in *Women Composers: Music through the Ages*, vol. 1, *Composers Born before 1599*, edited by Martha Furman Schleifer and Sylvia Glickman (London: Prentice Hall, 1996), 73–7.

86 Anthony M. Cummings, *The Maecenas and the Madrigalist: Patrons, Patronage, and the Origins of the Italian Madrigal* (Philadelphia: American Philosophical Society, 2004), 15–78.

87 Frank D'Accone, "Transitional Text Forms and Settings in an Early 16th-Century Florentine Manuscript," *Words and Music—The Scholar's View: A Medley of Problems and Solutions Compiled in Honor of A. Tillman Merritt by Sundry Hands*, edited by Laurence Berman (Cambridge, MA: Harvard University Press, 1972), 29–58; Howard Mayer Brown, "The Music of the Strozzi Chansonnier (Florence, Biblioteca del Conservatorio di Musica, MS Basevi 2442)," *Acta Musicologica* 40 (1968): 115–29; Richard J. Agee, "Filippo Strozzi and the Early Madrigal," *Journal of the American Musicological Society* 38(2) (1985): 227–37.

88 Nino Pirrotta, "Orpheus, Singer of *Strambotti*," in *Music and Theater from Poliziano to Monteverdi*, edited by Nino Pirrotta and Elena Povoledo, translated by Karen Eales (Cambridge: Cambridge University Press, 1982), 23–4, note 54.

89 Alessandra Strozzi, *Lettere di una gentildonna fiorentina del secolo XVI ai figliuoli esuli*, edited by Cesare Guasti (Florence: G.C. Sansoni, Editore, 1877), 464. Flora Dennis discusses Renaissance concern for the potentially immoral influence of music on women; see Flora Dennis, "Unlocking the Gates of Chastity: Music and the Erotic in the Domestic Sphere in Fifteenth and Sixteenth-Century Italy," in *Erotic Cultures in Renaissance Italy*, edited by Sara F. Matthews-Grieco (Burlington, VT: Ashgate, 2010), 223–45, especially 233–5. For a discussion of music instruction for women, see Judith Bryce, "Performing for Strangers: Women, Dance, and Music in Quattrocento Florence," *Renaissance Quarterly* 54(4) (2001): 1074–107, especially 1098–9.

90 Blake Wilson, *Music and Merchants: The Laudesi Companies of Republican Florence* (Oxford: Clarendon Press, 1992), 116–17.

91 Howard Mayer Brown, "Women Singers and Women's Song in Fifteenth-Century Italy," in *Women Making Music: The Western Art Tradition 1150–1950*, edited by Jane Bowers and Judith Tick (Urbana: University of Illinois Press, 1986), 62–89, especially 65–7, 74.

92 Timothy J. McGee, "*Cantare all'improvviso*: Improvising to Poetry in Late Medieval Italy," in *Improvisation in the Arts of the Middle Ages and Renaissance*, edited by Timothy J. McGee (Kalamazoo, MI: Medieval Institute Publications, 2003), 31–70.

93 Poliziano dedicated his poem *Ambra* to Lorenzo, complimenting his knowledge of Greek letters. Angelo Poliziano, "Ambra," in *Silvae*, edited and translated by Charles Fantazzi (Cambridge, MA: Harvard University Press, 2004), 68–9.

94 Dora Thornton, *The Scholar in His Study* (New Haven: Yale University Press, 1997), 120–23. Flora Dennis indicates the presence of musical instruments in the *camere* and *anticamere* in Florence, and the *portego* in Venice in "Music," in *At Home in Renaissance Italy* (see note 6), 233.

95 Francesco Inghirrami kept books of music near his desk in his chamber. See note 79.

96 Benporat, "Documenti: Firenze, 16 febbraio 1476: Convito organizzato da Benedetto Salutati e altri mercanti fiorentini per i figli del re di Napoli," in *Feste e banchetti*, 237–40.

97 Many thanks to Stephanie Miller for this observation. For a consideration of the transience of music, see Flora Dennis, "Resurrecting Forgotten Sound: Fans and Handbells in Early Modern Italy," in *Everyday Objects: Medieval and Early Modern Material Culture and its Meanings*, edited by Tara Hamling and Catherine Richardson (Burlington, VT: Ashgate, 2010), 191–209, especially 191–4. Flora Dennis also reflects upon the ability of music to traverse domestic borders, especially music played on the streets overheard in the domestic interior; see Dennis, "Unlocking the Gates of Chastity," in *Erotic Cultures* (see note 89), 235–7.

98 Alberti, *On the Art of Building in Ten Books*, 149.

99 Preyer, "The Florentine Casa," in *At Home in Renaissance Italy* (see note 6), 36. For the possessions in Lorenzo il Magnifico's *camera terrena*, see Spallanzani and Bertelà, *Libro d'inventario*, 11–16.

100 Lindow, *The Renaissance Palace in Florence*, 123–4.

101 Spallanzani and Bertelà, *Libro d'inventario*, 18–22. For a discussion of the earliest reference to a music room, see note 76 above. The music room in the seventeenth-century Palazzo Barberini in Rome was also on the ground floor. See Patricia Waddy, *Seventeenth-Century Roman Palaces: Use and the Art of the Plan* (New York: Architectural History Foundation, and Cambridge, MA: MIT Press, 1990), 54, 182, 245.

102 Catherine Fletcher, Chapter 1 in this volume.

Il mare di pittura:
Domestic Pictures and Sociability in the
Late Sixteenth-Century Venetian Interior

Elizabeth Carroll Consavari

The growing demand for household goods in Renaissance Italy, as documented by Richard Goldthwaite and others, was the driving force behind the painted picture becoming the most popular household object within the homes of the urban elite.[1] In cinquecento Venice, which is the focus of this chapter, paintings become the most frequently listed object in inventories, overtaking and surpassing the presence of antiquities in Venetian households by the end of the sixteenth century. While the relationship between domestic art collecting and consumption is complex, the degree to which art collections contributed to Venetian domestic sociability – those social rituals that connected the family both to each other and to the wider society beyond the walls of the palazzo – deserves a closer look.

With respect to the social roles of art objects in the Venetian interior, several recent studies have demonstrated the contribution of paintings to the creation of domestic values. For example, Margaret Morse has argued that paintings, along with other objects in the Venetian *portego* (*portico*), a longitudinal, centralized space, were used promote the family's lineage and religious values.[2] While the *portego* was used for social gatherings of various types, according to Morse, it was the constant presence of religious paintings in particular that communicated individual family values.[3] Mauro Lucco has similarly interpreted the display of paintings in the *portego*, the so-called *quadri da portego*, as a "method for semipublic self-aggrandizement" in the private Venetian palace.[4] Most recently, Monika Schmitter has explored the social function as well as the artistic choices made by both artist and patron for Venetian *portego* paintings.[5]

The present chapter builds on this research to further examine the role of paintings as objects that contribute to domestic sociability in the homes of the urban elite in Venice. In the context of the increasingly sophisticated domestic rituals of sociability that developed in the homes of the urban elite over the

course of the sixteenth century, as documented by Marta Ajmar-Wollheim and others,[6] paintings had an almost unlimited potential to act as resonant and sophisticated social connectors. From the perspective of domestic sociability, the numerous paintings which appear with increasing frequency in the inventories of Venetian patrician families may be viewed as akin to the musical instruments, intellectual, card or board games that have been shown to support a new climate of sociability in the domestic interior. In this context, paintings become "objects of entertainment" in the home, which relate to family identity and form part of domestic social rituals, comparable to the objects used in family entertainments addressed in Maria DePrano's chapter on the Tornabuoni palace.[7]

In particular, through an examination of the cultural values that contributed to the emergence of paintings as objects of domestic sociability, and through selected case studies of Venetian households, including the households of Antonio Pasqualigo, Andrea Odoni, Gianantonio Venier, Michiel Contarini, Andrea Vendramin, and generations of the Grimani, I argue that the increasing presence of pictures in Venetian households over the course of the sixteenth century re-created a "Golden Age" at home. As I will demonstrate, such domestic ideations of the Golden Age in a specific context, within the confines of the home, allowed Republican values to shape Venetian domesticity. One very specific context is the heavy presence of nymphs, gods, landscapes, and male and female nudes ornamenting the walls of patrician homes. Paintings could reflect the values of the Venetian Republic and the currently fashionable pastoral literature. One famous and controversial example is Giorgione's *Tempest* commissioned for Venetian patrician Gabriele Vendramin in c. 1508.[8] Numerous scholars have analyzed Giorgione's possible evocation of a precarious moment in Venetian history and his reliance on literary sources. These pictures, alluding to Arcadian themes of an ideal past, reference the same sources of pastoral literature and classical mythology as the pictures in Venetian State interiors such as the Doge's Palace, the Palazzo dei Camerlenghi or the Dieci Savi,[9] which served to forge social relationships both inside and outside the home, contributing to the interpenetration of the public and the domestic sphere.

This chapter furthermore explores the increasing presence of pictures in Venetian households over the course of the sixteenth century as a particular kind of domestic practice related to the articulation of taste and learned entertainment. The sixteenth-century idea of "home" in Venice thus becomes a hybrid space of exchange and plays a role in the formation of the domestic or private "salon." The Venetian *portego* was utilized for decorative display of the family's lineage and religious pictures, and, as Morse has shown, it was the constant presence of religious paintings that communicated individual family values. This cultural practice of display shows the pragmatic use of religious pictures in the Venetian interior, an issue also addressed in Campbell's chapter with respect to Bologna.[10] However, the vigorous domestic accumulation of the same objects signifies a departure from the practical usage, making us

further contemplate pictures and the many roles that pictures play within the home. However, the aforementioned essays by Lucco, Schmitter, and Morse do not address this aspect of sociability and paintings in the interior, and how as objects they participate in this nascent idea of home as "salon," or as a space of exchange.

A crucial factor in the development of the display of paintings as a distinct form of domestic sociability, which resulted in the flourishing of purchasing and commissioning of pictures for the home in the sixteenth century (at the expense of other objects to display), is the set of specific cultural values, desires, and beliefs articulated by both Venetian writers and foreign commentators associated specifically with the knowledge and display of painting within the domestic interior. Thus, the present chapter approaches Venetian domestic collecting practices as forming part of the set of domestic values that Patricia Fortini Brown has referred to as "what it meant to live *nobile*, expressing status in a manner legible to all."[11] It is at this juncture that sixteenth-century domestic collecting intersects with the pursuit of living nobly in Venice. There is extensive literature on collecting practices in Venice that has significantly advanced our understanding of the range of subject or artist, the volume of collecting, and the individual families.[12] Despite the flourishing of literature on collections, there is relatively little scholarship that examines domestic collecting practices from the perspective of their role within the development of the early modern Italian domestic interior, or the interpretation of their role in social interactions taking place in these newly redefined domestic spaces.[13] Looking from the framework of domesticity, Peta Motture and Luke Syson have analyzed how paintings moved from being displayed in the bedroom to more public rooms in the house in their assessment of the burgeoning household gallery.[14] This modification in choice of space signals a change in the sixteenth century. Paintings began to function as a sociable art, like music or masquerades in the interior, communicating values of a particular identity in a "public" space.

Ultimately, this chapter will argue that as sixteenth-century Venetian household collections evolved to show a greater interest in paintings, the practices of display that developed within the domestic interiors of individuals like Antonio Pasqualigo, Andrea Odoni, Gianantonio Venier, Michiel Contarini, Andrea Vendramin, and generations of the Grimani transformed their interior spaces into domestic art galleries, creating an emblematic Golden Age at home. To develop this argument, the study falls into two distinct parts. The first part of the chapter establishes the cultural values that set the stage for domestic collecting practices through an analysis of contemporary commentary on art and on the home interior itself. The second part of the chapter details the nature of domestic art collecting as it evolves over the sixteenth century through an examination of noted Venetian households before the sixteenth century, and considers several later sixteenth-century Venetian household collections as case studies. This perspective of domestic collecting not only elucidates the idea of cultural refinement and

home entertainment, but most importantly also suggests the active domestic enjoyment of paintings in the Venetian interior.

Problematizing Paintings in the Venetian Interior: The Merging of Domestic and Civic Values

The cultural values, desires, and beliefs expressed by Venetian writers and foreign commentators were associated specifically with the knowledge and display of painting within the domestic interior. These included: first, the recognition that painting is an honorable and ethical pursuit; second, a desire to return to the Golden Age; and, third, the notion that the ownership of paintings conferred a measure of social status. All three aspects were central to the sociability of the display of paintings as a domestic practice which connected the world of the family to the wider ethical field outside the home and brought the revered cultural past into the present life of the family, creating a social process that facilitated the bringing together of inside/outside, familial/civic, through conversations and interactions in the home with painted images.

An Honorable and Ethical Object of Entertainment

The new emphasis of paintings in the interior is evident in the observations of Count Jacopo di Porzia, who reinforces the idea of civic and domestic interpenetration in the Venetian interior in his text *De Reipubblicae Venetae administratione* (1492). Di Porzia admired the beauty of Venetian homes because in his opinion it granted one the privilege of observing Venetian taste and all that embellished the residences of patricians (*patriziati*) and merchants (*cittadini*).[15] His commentary likewise suggests that this privileged view of Venetian interiors allowed a window into understanding more about Venetian personal values, from the two upper classes of Venetian society: nobles and merchants. Because paintings were clearly an item admired amidst the Venetian interior, it becomes apparent in later sources that the mention of pictures was viewed as an honorable and high-minded pastime by the end of the fifteenth century. In his *De moderanda Venetorum aristocratia o Periarchon*, dedicated to Doge Leonardo Loredan,[16] the Venetian humanist Francesco Negri remarked that the act of painting should be considered a moral pursuit, even fundamental to a sense of Venetian good government; similarly, painting and its moral capacity could be cultivated at home.[17] Both Negri and Di Porzia suggest indirectly that the display of pictures and the act of viewing the, have become not only a pastime resonant with Venetian civic values, but also a feature of domestic sociability.

The Symbolic Return to the Golden Age

Gabriele Vendramin's painting of *The Tempest* by Giorgione is the prototypical example whereby a painting can subsume Venetian Republican values to

shape Venetian domesticity. In addition to paintings, the great scholar-printer Aldo Manuzio (c. 1450–1515) produced volumes of material to be consumed alongside paintings: printed books in Venice. Manuzio published pastoral literature (in Latin and the vernacular) for the first time in portable bound handbooks beginning in the late fifteenth century.[18] The cultural interest in a return to the Golden Age in Venice is marked by the publication of two key texts by Manuzio: Francesco Colonna's *Hypnerotomachia Poliphili* in 1499 and Jacopo Sannazaro's *Arcadia* in 1504. The rise of pastoral culture is especially evident in the case of Colonna's illustrated and highly debated Aldine publication.[19] The publication of *Poliphilo* in Venice, with its descriptions and woodcut images of Venus pastorals, ancient triumphal processions, and other ancient deities, is contemporaneous to pastoral-themed paintings by Giovanni Bellini, Palma Vecchio, Sebastiano del Piombo, and Giorgione. *Poliphilo* served as an important resource for these artists and for families interested in Arcadian themes.[20] Generally, the family (of patrician or *cittadino* class) in Venice would have possessed a certain sophisticated knowledge of humanist culture and would have been conditioned to appreciate and acquire such images as Venus reclining or sleeping on artfully positioned drapery. The pastoral in its various forms is a subject listed frequently in the inventories of sixteenth-century collections, the most famous examples being the inventories of the aforementioned Gabriele Vendramin's collection. Vendramin owned Giorgione's *Tempest*, while the nobleman Girolamo Marcello owned Giorgione and Titian's *Sleeping Venus*.[21] As Deborah Howard suggested long ago, the *Tempest* has garnered more attention than any other painting belonging to this genre. In her analysis of the image, Howard underscored the connection between Republican values and Arcadian themes, drawing attention to how the Venetian nobility was not only involved in political events based on the Republic's constitution (patrician males over the age of 26 could attend Great Council Hall meetings), but also that most nobility felt a strong commitment to participate in government, a feature unique to Venice compared to elsewhere.[22] Hence, there is reason to believe that there was a strong connection between the popular pastoral subjects allegorizing Venice and the Venetian patrons who probably commissioned them. Thus, the shaping of Venetian domesticity in paintings springs from this pastoral genre, which was viewed and perhaps even discussed at home. Venice, a city without any archeological or genealogical ties to a Roman past, would have been anxious to forge connections to Antiquity.[23] Embracing the pastoral in poetry, printing, and painting was the Venetian way to connect to its imagined ancient past. It is precisely these Arcadian themes which loaded the walls of Venetian homes, transforming the activity of display into a domestic sociable art likened to other leisurely diversions such as board games or the intellectual/conversational parlor games known as the *veglie*,[24] which required an awareness of literature on comportment as well as social morality.

SOCIAL STATUS

The courtier and writer Baldassare Castiglione between the years of 1518 and 1527 subtly promoted another cultural value in his prescriptive and influential dialogue on comportment which likely impacted the interior. In *The Book of the Courtier*, Castiglione promoted the idea that familiarity with both drawing and painting were worthy of the gentleman's pursuit of knowledge.[25] Effectively, Castiglione advanced the notion that a family's ownership of paintings merited social status. Similarly, Giacomo Lanteri's 1560 treatise, *Della economica trattato di M. Giacomo Lanteri gentiluomo*, on the order and management of the house is a manual written for the family interested in maintaining social status. Lanteri wrote "Fa stima che questa nostra casa ad ambidue noi et alla nostra famiglia commune, stia una picciola città," suggesting that the family home symbolized a small city, which deserved the same honor.[26] Lanteri also enumerated the wifely duties, which include specific instruction on interior decoration. Interior design was considered the most important provision and that the wife select linens, drapes, upholstery, and objects.[27] Following Castiglione and Lanteri, numerous pronouncements on painting as an established discipline, a liberal art, and as an object to be displayed in the domestic interior emerge in Venice in the form of treatises, guidebooks, and dialogues in the sixteenth century.[28] While Stefano Guazzo does not address painting or objects in the domestic interior, his dialogue *La Civil Conversazione* (1579) prescribes domestic conversation, that is, discussion among family members within the home, as a way of teaching civility and values of citizenship to the children.[29] Guazzo was concerned that modern life had altered the sense of a "true friendship" between members of society. To remedy this, he advises that the precepts of civility should be taught in a domestic environment.[30] Elizabeth Horodowich has identified the objective of Guazzo's dialogue that: "Spoken language functioned like clothes, a changeable system of signs and signifiers which communicated rank, status, mood, purpose, and occasion."[31] Much like the display of objects, the demonstration of words employed in conversation was paramount for Guazzo. These examples reaffirm the fact that the activity of display and prescribed conversation in the interior is a form of domestic sociability.

The Standard for Venetian Domestic Collecting Practices: Prefacing the Sixteenth-Century Cultural Recollection

As we have seen, literary culture, as well as historical and theoretical writings on art, helped to articulate a set of values that contributed to the sociability of paintings and subsequently the growth of domestic collections in sixteenth-century Venice. The earliest documented studio or *studio d'anticaglie* in the Veneto dates back to the fourteenth century.[32] There are notable differences in the consumption habits of this era versus the latter part of the sixteenth century in Italy.[33] Patricia Fortini Brown's work on the Venetian "sense of past" led her

to conclude that the reason for this difference was because the motivations of later fifteenth-century Venetian families were conditioned by their developed mercantile interests.[34] However, the literature has not addressed when and how Venetian domestic collecting practices changed and evolved within the physical space of the home to reflect its function of enjoyment and sociability. The first part of the question is less complicated to answer. By the beginning of the sixteenth century, there is evidence of numerous objects present in interiors which demonstrate the desire to display paintings, prints, and books in the Venetian home. We can begin to answer the second part of the question by looking at specific examples of the Venetian interior, such as the homes of Giovanni Grimani or Elisabetta Condulmer. In general, the manifestation of private cabinet pictures sustained by learned families' interest in pastoral culture such as Gabriele Vendramin, Girolamo Marcello, or Giovanni Grimani suggests a significant change in the display of paintings as a sociable art. It is at this juncture where the sixteenth-century Venetian family appears to have a newly defined role in the flourishing production of paintings both as patron and consumer, thus having a great impact on Renaissance domesticity.

The Grimani Family Collection
Patricia Fortini Brown has observed that Giovanni Grimani's massive household art collection revolutionized the entire structure of the palazzo. Not only do we see a change in the usage of domestic space, but also how sociability, or the enjoyment of art at home, now altered architectural design. Instead of displaying the objects in the *portego*, as was the Venetian tendency, the house was "refashioned to frame the art," with the addition of the tribunal.[35] The following analysis of four prominent Venetian collections reveals which sociable and domestic interests prevailed and those which evolved. We begin with Domenico, Marino, Marco, Vettore, and Giovanni Grimani, who were the most passionate about art during the earliest part of the century. The Grimani family was extraordinary because of their continued and multi-generational fascination with antiquity.[36] Cardinal Domenico Grimani, son of Doge Antonio Grimani, became the Cardinal of Aquileia in 1497. He was a theologian and humanist, who maintained relations with Erasmus of Rotterdam among other famous scholars. He established a library, which was one of the largest in Europe by the time of his death in 1523.[37] An inventory from 1528 belonging to him shows that the majority of objects were comprised of ancient Greek and Roman sculptures, medals, and manuscripts.[38] According to his 1523 will, he was in possession of the now famous Grimani Breviary, produced in Ghent and Bruges, Greek and Hebrew manuscripts, as well as innumerable antique marble busts and statues which he bequeathed to the Venetian Republic. Grimani's collection is what became *Lo Statuario Pubblico*, the first civic collection of archeological objects, now the *Museo Archeologico Nazionale di Venezia*. Gems, engraved medals, and paintings were displayed with sculptures in the *Sala delle Teste*, including paintings by Il Riccio, Titian, Tintoretto, and Veronese.[39] Domenico left not only the

Bishopric of Aquileia to his nephew Marino but also his collected statues, medals, marbles, bronzes, engravings by Battista Franco, and antique cameos. Marino's brother, Marco, was an elected procurator who became bishop in 1529. He, in turn, passed the bishopric on to Giovanni, his younger brother. Inheriting the family's "infallible taste," Giovanni[40] transformed the family collection, once dominated by ancient Greek sculptures,[41] to include drawings and paintings by Bonifacio de'Pitati, Titian and Giorgione.[42] Vettore, along with his brother Giovanni, the last of their generation, inherited and managed the family holdings. Vettore died in 1558.[43]

The most passionate family member, Giovanni, inherited Palazzo Grimani near the Church of Santa Maria Formosa. Patricia Fortini Brown has analyzed Giovanni's classical reconstruction and decoration of Palazzo Grimani, which included the addition of two wings in an attempt to create a larger courtyard, producing a more "Roman" plan.[44] The extraordinary collection was so vast that it was displayed in a space called the *tribuna*, once referred to in inventories as the studio or *studio delle anticaglie*; Grimani's objects displayed could not be contained in a single space, so it spilled into other rooms in the house, as observed by Sansovino in 1581.[45] The Grimani were clerics by profession, yet the diverse contents from antiquities to contemporary devotional images, which were not restricted to display in the *portego*, seems to suggest a departure from the pragmatic use of devotional objects evoking their personal religiosity to becoming objects of learned entertainment. The display of the Grimani holdings, both public and private, introduced the energetic accumulation of objects associated with humanist, theological, and social pursuits in Venice, yet their taste for antiquities would not thrive among later sixteenth-century families.

Interior Decorations to Learned Entertainment: Elisabetta Condulmer, Marcantonio Michiel, and Andrea Vendramin

Elisabetta Condulmer (c. 1490–1538) was a Venetian courtesan of noble lineage and, as her professional association would suggest, entertaining guests would have been a priority for her.[46] The domestic art gallery at her home would have functioned as sociable objects or part of the learned entertainment as conversational pieces, thus moving as objects from the private to public realm.[47] Her death on September 13, 1538 prompted an inventory which revealed room by room just how well she lived. While her noteworthy household art collection has not received as much attention in the literature as others, Brown has discussed the furnishings of the San Felice palace.[48] Condulmer's notary, Angelo da Canal, records that outside the *portego* there was a Flemish painting on canvas, while inside the *portego* da Canal records numerous paintings and drawings,[49] as well as gilded furniture and lamps displaying the Condulmer coat of arms, which is an indication that entertaining guests was a priority for Elisabetta. In some instances, da Canal identifies the subject of the

mythological paintings, such as Pyramis and Thisbe, while in other cases he describes the subject as simply a nude man or nude woman.[50] Da Canal also lists religious paintings, such as several depictions of Mary Magdalene and an Adoration of the Magi. He also notes a number of portraits painted in the Flemish style or *alla forestiera*, or "in the foreign manner."[51] In the *camera granda da madona* we find a space that Elisabetta decorated with religious paintings. In da Canal's description of this room, he records a painting of the Virgin and Saints John the Baptist and Jerome, as well as gilded chests, a walnut bed with gilded columns, and several sizable collections of maiolica and glass.[52] Unlike the Grimani collection, which was displayed in specific rooms dedicated for that purpose, Elisabetta's collection seems to be spread throughout the house, performing the function of interior decoration. Significantly, in spite of her "tarnished birthright," her taste did not deviate much from fellow patricians, and, like others of her class, the display of her objects and paintings throughout her home contributed to the perception of her wealth, elite social status, and perhaps her personal piety. At the same time, her collection was exceptional for its extensive range of paintings and embellished furnishings. The once sought-after marble figures, statues, medals, and coins popular among Venetians like Grimani, Pasqualigo, Odoni, or Venier were not items listed in her posthumous inventoried collection.

The most famous sixteenth-century Venetian household collections are known almost exclusively through the notes of Marcantonio Michiel, which were gathered between 1521 and 1543.[53] Ironically, his dilettantish interest in private art collections has a significant impact on our understanding of sixteenth-century domestic interiors, even if his diary-like notes were never intended to be published. Michiel wrote detailed descriptions of art in interior spaces, which often belonged to friends and acquaintances such as Pietro Bembo – humanist, intellect and soon-to-be cardinal – Cardinal Giovanni Grimani, and urban elites like Taddeo Contarini, Girolamo Marcello, Gianantonio Venier, Giovanni Ram, Antonio Pasqualigo, Andrea Odoni, Michele Contarini, Antonio Foscarini, Francesco Zio, and Gabriele Vendramin.[54] Michiel's entries vary, with the homes of Antonio Pasqualigo, Andrea Odoni, Gianantonio Venier, Michiel Contarini, and the Grimani receiving rich descriptions in comparison to the other six households. His notation of paintings is a crucial feature of the domesticity and plays a role in the learned entertainment of all the aforementioned households. Paintings on canvas are itemized first by Michiel among the inventories without exception, and are followed by those on panel, and then by carved-marble figures, busts and works on paper.[55] Even if his notes are regarded as one of the best sources for Venetian paintings in the interior, Jennifer Fletcher's research led her to conclude that Michiel's knowledge and consistent mention of antiquities indicate that he was probably a better source for ancient material than first perceived. Taking into account his interest in the antique, it appears unlikely that the primary position of paintings in his entries indicates a hierarchy of taste, but instead underscores a quantitative presence in each home. Surprisingly, his annotations furnish

details about objects ranging from sculpted busts, profile portrait paintings on panel, paintings on canvas, drawings, ancient marble fragments to crystal chalices, and in some cases he provides the object's location, which suggests certain objects were arranged in dedicated spaces.[56] One such example would be his description of Venetian merchant Andrea Odoni's sprawling collection, which was displayed "in la corte da basso," "nel studiolo de sopra," or "in portico."[57] From his notes, which suggest a dispersed display of objects, one perceives that the pragmatic use of devotional art, or as part of the decorative furnishings throughout the home – as was the custom – is in transition from devotional purpose (in a private room or altar) to representing family honor and cultural prestige in a more public room.[58] While Michiel is informative, it remains unclear how the objects functioned in rooms as part of the sociable interactions at home. Paintings and/or interiors alone do not have overt features that suggest their use as objects of entertainment. However, the sociable function of paintings is suggested by their placement in "public" spaces and in the company of furniture designed for sitting. The consistent arrangement of art objects near armchairs, stools, tables, and desks seems to suggest the function of entertainment or a communicating of identity to those sitting and observing these pictures in the *portego* or the smaller *mezzado*, where the studio or *studiolo* was sometimes located.[59] Just as Stefano Guazzo prescribed in *La Civil Conversazione*, one imagines the activity of displaying pictures, furniture, and prescribed conversation in these interiors as a form of Venetian domestic sociability. And having observed Grimani's massive accumulation of antiquities in addition to that of Michiel's circle of Venetian nobles and merchants and beyond, Andrea Vendramin's amassing of pictures will offer insight as an example from the following generation.

Andrea Vendramin (1565–1629), who was probably a relative of the famous Venetian Gabriele Vendramin,[60] formed a massive collection of domestic art, which contained hundreds of paintings by famous fifteenth- and sixteenth-century Italian masters. Most notably, Vendramin illustrated, in a first-of-its-kind 18-volume catalog, a registry of works organized according to genre in 1627.[61] The catalog section, entitled *De Picturis*, illustrated only half of Vendramin's entire paintings collection, which comprised roughly 300 pictures.[62] Among the works recorded were paintings by Titian, Raphael, Giorgione, Giovanni Cariani, Andrea Schiavone, Jacopo Tintoretto, and Giovanni Bellini.[63] Beyond the displayed paintings, the Vicentine-born architect and heir to Andrea Palladio, Vincenzo Scamozzi, noted that Vendramin's spectacular and diverse collection contained antique sculpture, paintings, vases, gems, and medals displayed in two unspecified rooms at the San Vio palace.[64] Vendramin's collection was decidedly encyclopedic in scope and marked a shift in collecting tastes from the medieval "cabinet of curiosities," to include paintings, vases and medals.[65] The Vendramin collection remained intact until it was acquired by the Dutch merchant Jan Reijnst in 1639.[66] In consideration of Giovanni Grimani's display of paintings and objects that overflowed from the metamorphosed *studiolo* to the new dedicated display

space, the *tribuna*, to many other rooms throughout the house, Condulmer's *camera granda da madona* and *portego*, or Andrea Odoni's sprawling display *in la corte da basso*, *studiolo*, and *portego*, the shift and spillage in display from private to public rooms within the house becomes transparent. Because Vendramin regularly received distinguished guests to his home, one suspects that his pictures displayed in the "unspecified rooms" were plausibly public spaces. Because of the changing needs of the family, by means of new display strategies, paintings evolve from their former pragmatic use to one of social practice. Paintings now displayed in the aforementioned rooms were part of the social rituals performed in these rooms, including informal gatherings, festive dinners, and daily business transactions.

In conclusion, I suggest that the presence of pictures in sixteenth-century Venetian households, as a particular kind of domestic practice related to the articulation of taste, family identity, sociability, and learned entertainment, articulates a Venetian "brand" of domesticity to be fully exploited in the seventeenth and eighteenth centuries. Venetian household collections not only evolved to show a greater interest in paintings, but also displayed practices, amidst the domestic interiors of Antonio Pasqualigo, Andrea Odoni, Gianantonio Venier, Michiel Contarini, Andrea Vendramin, and generations of the Grimani family. Venetians transformed the interior spaces into household proto-art galleries, which had implications for the idea of what it meant to live nobly. Paintings, as discussed by Di Porzia, Negri, Castiglione, and Pino, when displayed within the home, could elevate the moral and aesthetic values of "home." By bringing the two areas of collecting and the domestic interior together, we are able to add to the dialogue begun by Brown. The nature of living nobly at home in Venice quickly established one's family connection to the past, to a set of social ideals, to the Golden Age, to one's learning and accomplishments. Morse has convincingly argued in her chapter in this volume that the pragmatic use of religious pictures in the *portego* (a room typically used for social gatherings) provided a stage to making public[67] a new association of the individual family values, as has Erin Campbell in her chapter in this volume on devotional *quadrattini* for Bolognese families in the early seventeenth century. It has been my objective in this chapter to complicate the interior and explore the variable roles that the objects perform within the home. From this new perspective, the masses of paintings displayed in the *studio* to the *portego* suggest that they functioned as a sociable art, like music or masquerades, communicating values of identity in a "public" space. Paintings could declare the family associations with the public, learnedness, Venetianness, as well as status. Moreover, the modified choice of display space signals a change in the sixteenth century. Paintings began to function as a sociable art and could also communicate the values of the Venetian Republic and the currently fashionable humanist pastoral literature, thus elevating their association with "home." Ultimately, this new perspective on the Venetian interior shows that paintings, as they forge domestic social relationships both inside and outside the home, contribute to the interpenetration of the public

and the domestic spheres. Paintings, held as a form of learned entertainment in the Venetian domestic interior, fashion a continued role in the private "salon," which would eventually become the *casinò* or *ridotto*, a dedicated space within the palace[68] for playing games, business exchanges, or intimate social interactions. Thus, paintings and painted decoration would continue as a feature in this somewhat "anonymous class" of Venetian domestic spaces into the seventeenth and eighteenth centuries.

Appendix I

See Cristina de Benedictis, *Marco Antonio Michiel e il collezionismo veneto* (Florence: Edifir, 2000), 51. Antonio Pasqualigo's collection is described in the most exhaustive detail, as follows:

In casa de M. Antonio Pasqualino 1532, 5 Zener.

El quadro grande della cena de Christo fu de man de Stephano, discipolo de Titiano, et in parte finita da esso Titiano, a oglio.

La testa del gargione che tiene in mano la frezza, fu de man de Zorzi da Castelfrancho, hauuta da M. Zuan Ram, della quale esso M. Zuane ne ha un ritratto, benche egli creda che sii el proprio.

La testa per al naturale ritratta da vn huomo grosser, cun un capuzzo in capo et mantello nero, in profilo, cun una corda da 7 paternostri in mano, grossi, negri delli quali el più basso et più grande è di stucho dorato rileuato, fu de man de Gentil da Fabriano, portata ad esso M. Antonio Pasqualino da Fabriano insieme cun la infrascritta testa; zoè un ritratto d'uno giuine in habito da chierico cun li capelli corti sopra, le orechie, cun el busto fin al cinto, uestito di vesta chiusa, poco faldata, di color quasi biggio, cun un panno a uso di stola negra, frappata sopa el collo, che descende giuso, cun le maniche larghissime alle spalle et strettissime alle mani, di mano dellinstesso Gentile.

Ambedoi questi ritratti hanno li campi neri, et sono in profilo et si giudicano padre et figlio, et si, guardano l'un contra laltro, ma in due però tauole perchè par che si simigijno in le tinte delle carni. Ma al mio giudicio questa conuenienza delle tinte prouiene dalla maniera del maestro che facea tutte le carni simili tra loro et che tirauano al color pallido. Sono però ditti ritratti molto viuaci, et sopra tutto finiti et hanno vn lustro come se fussino a oglio, et sono opere lodeuoli.

La testa del S. Jacomo cun el bordon, fu de man de Zorzi da Castelfrancho, ouer de qualche suo discipolo, ritratto dal Christo de S. Rocho.

La meza figura de nostra donna, molto menor del naturale, a guazzo, che tiene el puttino in brazzo, fu de man de Zuan Bellino, riconzata da Vicenzo Cadena el qual in loco de vno zambellotto steso da diretto, li fece vno aere azurino. Sono molti anni che la fece et è contornata aparentemente cun li reflexi fieri mal uniti cun le meze tente; è però opera laudabile per la gratia delli aeri, per li panni, et altre parti.

Le due teste in do tauolette minori del naturale deli ritratti, luna de M. Aluixe Pasqualino padre de M. Antonio, senza capuzzo in testa, ma cun quello negro sopra la spalla, et la uesta di scarlatto; laltro de M. Michiel Vianello vestito de rosato cun el capuzzo negro in testa, furono di man [de] Antonello da Messina, fatti ambedoi l'anno 1475, come appar er la sottoscriptione. Sono oglio in uno ochio e mezo, molto finidi, et hanno gran forza et gran vivacità, et maxime in li occhii.

La testa marmorea de donna che tien la bocha aperta, fu de mano de ... data ad esso M. Antonio da M. Chabriel Vendramin per el torso marmoreo anticho.

Li molti dissegni furono de man de Jacometto.

The remaining six collectors are Taddeo Contarini, Girolamo Marcello, Antonio Foscarini, Francesco Zio, Giovanni Ram, and Gabriele Vendramin.

Notes

1 See Richard S. Goldthwaite, *Wealth and the Demand for Art in Italy 1300–1600* (Baltimore: Johns Hopkins University Press, 1993), 243. See also Peta Motture and Luke Syson, "Art in the Casa," in *At Home in Renaissance Italy*, edited by Marta Ajmar-Wollheim and Flora Dennis (London: V&A Publications, 2006), 268–83.

2 Margaret A. Morse, "Creating Sacred Space: The Religious Visual Culture of the Renaissance Venetian Casa," in *Approaching the Italian Renaissance Interior: Sources, Methodologies, Debates*, edited by Marta Ajmar, Wollheim, Flora Dennis, and Anne Matchette (Oxford: Wiley-Blackwell, 2007), 95–128; and Morse's chapter in this volume.

3 Patricia Fortini Brown, *Private Lives in Renaissance Venice: Art, Architecture and the Family* (New Haven: Yale University Press, 2004), 63–85.

4 Mauro Lucco, "Sacred Stories," in *Bellini, Giorgione, Titian and the Renaissance of Venetian Painting*, edited by David Alan Brown and Sylvia Ferino-Pagden (New Haven: Yale University Press, 2006), 106.

5 Monika Schmitter, "The Quadro da Portego in Sixteenth-Century Venetian Art," *Renaissance Quarterly* 64(3) (2011): 693–751.

6 See Marta Ajmar-Wollheim, "Sociability," in *At Home in Renaissance Italy* (see note 1), 207.

7 See Maria DePrano's chapter in this volume.

8 See Deborah Howard, "Giorgione's Tempesta and Titian's Assunta in the Context of the Cambrai Wars," *Art History* 8 (1985): 271–8; and Stephen J. Campbell, "Giorgione's 'Tempest,' 'Studiolo' Culture, and the Renaissance Lucretius," *Renaissance Quarterly* 56(2) (2003): 299–332; David Wilkins, *Why are Pictures Puzzles? On the Modern Origins of Pictoral Complexity* (New York: Routledge, 1999), 130–38, 150–53.

9 See David Rosand, *Myths of Venice: The Figuration of a State* (Chapel Hill: University of North Carolina Press, 2001).

10 Sandra Cavallo and Silvia Evangelisti have confronted the issue of circulation and transformation of institutional sacred spaces and religious art into the domestic sphere. See the "Introduction," in *Domestic Institutional Interiors in Early Modern Europe*, edited by Sandra Cavallo and Silvia Evangelisti (Burlington, VT: Ashgate, 2009), 1–11.

11 Brown, *Private Lives in Renaissance Venice*, 53. For Brown, moral values were coupled with aesthetic values and such family ideals were expressed in a number of ways throughout the Venetian interior domestic space, including the treasured Venetian *portego*. Essentially, living nobly at home required visual representations of family members as well as devotional images to elevate the idea of "home." Brown explores the issue of identity as related to aesthetic objects and palace decoration in Chapter 3, "To Live *Nobile*."

12 The bibliography on collecting in Italy is vast and regionally specific. For a sense of the issues motivating recent scholarship on Venetian collecting and for bibliography, see Michel Hochmann, Rosella Lauber, and Stefania Mason (eds), *Il collezionismo d'arte a Venezia: Dalle origini al cinquecento* (Venice: Marsilio, 2008); Richard Spear (ed.), *Painting for Profit* (New Haven: Yale University Press, 2010).

13 Motture and Syson, "Art in the Casa," 268–83. Motture and Syson note the practice of art collecting in their chapter; however, they do not develop a specific discussion relative to the domestic interior. Schmitter is the first to address the relationship between painters, patrons, and social space in the Venetian portego: see Schmitter, "The Quadro da Portego in Sixteenth-Century Venetian Art," 701–4.

14 See Motture and Syson, "Art in the Casa," 268–83.

15 See Marcantonio Michiel, *Notizia d'opere del disegno*, edited by Gustavo Frizzoni; illustrated by D. Jacopo Morelli (Bologna: Zanichelli, 1884), vol. 34; and Simona Savini Branca, *Il collezionismo veneziano nel seicento* (Padua: University of Padua, Facoltà di Lettere e Filosofie, 1965), 15: "Quid multa et varia domestica ornamenta proferam? Quid pretiosam illam argenti er auri supellectilem. Quid aulaea et omnia stragulorum genera, quibus domus vestrae penitus residenti? In quibus adeo modum excedetis, ut cuiuslibet Veneti privati supellax amplissimam, domum regiam exornare posset?"

16 This unpublished manuscript by Francesco Negri (Niger) is undated, yet G. Mercati suggests it was presented in 1510–12 based on his reading of the manuscript. The written dedication, located on the first page, is to Doge Loredan and was inscribed on November 20, 1523, two years after the Doge's death in 1521. Thus, 1523 is a reasonable *post quem* date. For further discussion of Negro's work, see Giovanni Mercati, *Ultimi contributi alla storia degli umanisti* (Vatican City: Biblioteca Apostolica Vaticana, 1939), vols 90, 96, 109.

17 Marcantonio Michiel, *Notizia d'opere del disegno*, edited by D. Jacopo Morelli (Bassano, 1800), 98–9: "Trattando egli di ogni istituto che al buon governo di uno Stato è richiesto, ove della pittura fa parola dice così: Veneti patres, quibus omnia sunt adesta virtutum ornamenta, Bellinos habent fraters natura ministros, quorum alter theoricem alter pictura praxim professus, non regiam eorum solum pulcherrimis tabulis in dies illustrant, sed totam poene civitatem decorant." On Negri, see also Jennifer Fletcher, "Marcantonio Michiel: His Friends and Collection," *Burlington Magazine* 123(941) (August 1981): 452–67.

18 See Horatio F. Brown, *The Venetian Printing Press, 1469–1800: An Historical Study Based upon Documents for the Most Part Hitherto Unpublished* (Whitefish, MT: Kessinger, 2008).

19 See Helena K. Szepe, "Artistic Identity in the *Poliphilo*," *Papers of the Bibliographical Society of Canada* 35(1) (1997): 39–73.

20 See Francesco Colonna, *Hypnerotomachia Poliphili*, translated by Jocelyn Godwin (New York: Thames & Hudson, 1999), 70–74.

21 See H. Posse, "Die Rekonstruktion der Venus mit dem Cupido von Giorgione," *Jahrbuch der Preussischen Kunstsammlungen* 52 (1931): 29–35; Jaynie Anderson, "A Further Inventory of Gabriel Vendramin's Collection," *Burlington Magazine* 121 (1979): 639–48; Stefania Mason, "Di mano di questo maestro pochissime sono le cose che si vedono," in *Giorgione 'Le maraviglie dell'arte*, edited by Giovanna Nepi Scire and Sandra Rossi (Venice: Marsilio, 2003), 64–71; and Donata Battilotti, "Gabriele Vendramin," in *I tempi di Giorgione*, edited by Ruggiero Maschio (Rome: Gangemi, 1994), 226–7.

22 Howard, "Giorgione's Tempesta and Titian's Assunta in the Context of the Cambrai Wars," 275.

23 See discussion in Patricia Fortini Brown, *Venice and Antiquity: The Venetian Sense of the Past* (New Haven: Yale University Press, 1997), in particular Chapter 12, 263–84.

24 Ajmar-Wollheim, "Sociability," 215–16.

25 See Patricia A. Emison, *Creating the "Divine" Artist: From Dante to Michelangelo* (Leiden: Brill Publishers, 2004), 92.

26 Giacomo Lanteri, *Della economica trattato di M. Giacomo Lanteri gentiluomo* (Venice: Vincenzo Valgrissi, 1560), 159: "Consider that this house is for both of us, together, for our collective family, is a little city."

27 Ibid., 167–70.

28 See the following discussion of the writers Marcantonio Michiel and Francesco Sansovino.

29 Daniela Frigo, "Civil conversatione e pratica del mondo: Le relazioni domestiche," in *Stefano Guazzo e La Civil Conversazione*, edited by Giorgio Patrizi (Rome: Bulzoni, 1990), 125. Frigo suggests that "Il Guazzo assume anche la conversazione domestica come duplice articolazione di lingua e costume … il linguaggio della domesticità struttura attorno alle sue regole di funzionamento l'intero universo relazionale della casa."

30 See discussion of Stefano Guazzo in Elizabeth Horodowich, *Language and Statecraft in Early Modern Venice* (New York: Cambridge University Press, 2008), especially 47–9, 52–5. The basic benefits of conversation are suggested by Guazzo's interlocutor Annibale in Book One. Horodowich suggests that Annibale prescribed conversation to the sickly Cavaliere Gugliemo as a "healthy act," with the idea in mind that sociability should function as a curative to the effects of his isolation and effectively, melancholia. See also Peter N. Miller, "Friendship and Conversation in Seventeenth-Century Venice," *Journal of Modern History* 73(1) (2001): 4.

31 Horodowich, *Language and Statecraft in Early Modern Venice*, 53. See also Stefano Guazzo, *La civil conversazione*, edited by Amedeo Quondam, vol. 1 (Modena: Franco Cosimo Panini, 1993), 72–3: "Anzi per trovar luogo di grazie nel conversare, bisogna quasi spogliarsi de'propri costumi e mostrar di vestire gli altrui, e imitarli in quanto sarà concesso dalla ragione."

32 Cesare Augusto Levi, *Le collezioni veneziane d'arte e d'antichità dal secolo XIV ai nostri giorni* (Venice: F. Ongania, 1900), vol. I, XXXIV–XLIV; Savini Branca, *Il collezionismo veneziano nel seicento*, 12; Lanfranco Franzoni, "Antiquari e collezionisti nel cinquecento," in *Storia della Culture Veneta: Dal Primo Quattrocento al Concilio di Trento 3/III* (Vicenza: Neri Pozza, 1981), especially 207–9; Krzysztof Pomian, *Collectors and Curiosities: Paris and Venice 1500–1800*, translated by Elizabeth Wiles-Portier (Cambridge: Polity Press, 1990); Paula Findlen, "Possessing the Past: The Material World of the

Italian Renaissance," *American Historical Review* 103(1) (1998): 89–92; Paula Findlen, *Possessing Nature: Museums, Collecting, and Scientific Culture in Early Modern Italy* (Berkeley: University of California Press, 1994), especially Chapter 7, "Inventing the Collector," 293–303.

33 See Goldthwaite's chapter on "Consumption and the Generation of Culture," in *Wealth and the Demand for Art in Italy 1300–1600*, 243–50.

34 Brown, *Venice and Antiquity*, 59–60.

35 Brown, *Private Lives in Renaissance Venice*, 234.

36 Irene Favaretto,"La memoria delle cose antiche … il gusto per l'antico e il collezionismo di antichità a Venezia dal XIV al XVI," in *Il collezionismo d'arte a Venezia* (see note 12), 98.

37 See discussion in Marino Zorzi, *Collezioni di antichità a Venezia nei secoli della Repubblica (dai libri e documenti della Biblioteca Marciana)* with essay by Irene Favaretto (Rome: Istituto Poligrafico e Zecca dello Stato, 1988), 25–40.

38 Hochmann, "La famiglia Grimani," in *Il collezionismo d'arte a Venezia* (see note 12), 214–18, and Zorzi, *Collezioni di antichità*, 26–33. See also P. Paschini, "Le collezioni archeologiche dei prelati Grimani nel cinquecento," *Rendiconti Pontificia Accademia Romana di Archeologia* V (1926–7): 157–9. Paschini published the 1528 inventory and estimated that Cardinal Marino Grimani inherited as many as 1,500 engraved gems and medals from his uncle. Regarding taste for the antique in Venice, including the Grimani family, see Favaretto, "La memoria delle cose antiche," 83–95.

39 Zorzi, *Collezioni di antichità*, 27.

40 Hochmann " La famiglia Grimani," in *Il collezionismo d'arte a Venezia* (see note 12), 207. In all probability, Giovanni Grimani was from the San Boldo branch of the family in Venice.

41 Ibid., 207.

42 Ibid.

43 Ibid.

44 Brown, *Private Lives in Renaissance Venice*, 230. See also Levi, who cites Muzio Sforza in *Le collezioni veneziane d'arte e d'antichità*, vol. 1, LVI.

45 Francesco Sansovino, *Venetia città nobilissima et singolare, descritta in XIIII libri* (Bergamo: Leading, 2002), 138.

46 See Brown, *Private Lives in Renaissance Venice*, 173–87. Brown suggests that Elisabetta was the illegitimate daughter of the Venetian noble Girolamo Condulmer.

47 Here again I refer to Marta Ajmar-Wollheim's ideas on sociability and the "bridging of these two spheres," public and private in the Renaissance casa.

48 Brown, *Private Lives in Renaissance Venice*, 175–81.

49 See Hochmann, Lauber and Mason (eds), *Il collezionismo d'arte a Venezia*, 56.

50 See Brown, *Private Lives in Renaissance Venice*, 177–9. Moreover, Brown suggests that perhaps some of the portraits of Elisabetta Condulmer and/or "nude woman" pictures portrayed Venus as the courtesan alongside Cupid as there is a corresponding painting by Parrasio Micheli dated to the mid-sixteenth century.

51 Brown, *Private Lives in Renaissance Venice*, 175.

52 Ibid., 176. Elisabetta's possessions also included birdcages, gems, rings, four books, and musical instruments.

53 Regarding Padua, see Monica Schmitter, "The Dating of Marcantonio Michiel's Notizia in the Works of Art in Padua," *Burlington Magazine* 145(1205) (2003): 564–71. For a study that details Michiel's notes and specifically his friends as collectors, see Fletcher, "Marcantonio Michiel: His Friends and Collection," 452–67.

54 For commentary on the Notizia d'opere del disegno as well as a complete reproduction of his notes, see Cristina de Benedictis, *Marco Antonio Michiel e il collezionismo Veneto* (Florence: Edifir, 2000). See also the discussion in Fletcher, "Marcantonio Michiel: His Friends and Collection," 465.

55 See Appendix I. This is also true for Pasqualigo's collection.

56 Patricia Fortini Brown, "Displaying Collections," in *At Home in Renaissance Italy* (see note 1), 63. The use of one room for exhibition space becomes a more current practice by "a few Venetians," into the sixteenth century.

57 See de Benedictis, *Marco Antonio Michiel e il collezionismo Veneto*, 51–3. *Studiolo, camera de sopra* or *portego* (portico) suggest a dedicated space located upstairs in a Venetian palace not to be confused with statuary collections, which were often housed downstairs in an open courtyard or atrium.

58 Motture and Syson, "Art in the Casa," 283. Motture and Syson proposed a three-stage process of metamorphosis during the fifteenth and sixteenth centuries whereby painted pictures, once an intrinsic part of the furniture, cease to be adopted as utilitarian objects and finally become gallery pictures. See also Morse's chapter in this volume.

59 Here I refer to inventories not described by Michiel, but those published by the Getty Provenance Index databases. J. Paul Getty Trust, "Ram, Alessandro, 10 November 1592, Odoni, Alvise, 1555, Grimani Calergi, Vettore, 25 October 1665–3 November 1685," Document Type: Inventory/ Valuation Date or range (sixteenth and seventeenth century) http://piweb.getty.edu/starweb/pi/ servlet.starweb (accessed July 30, 2012). These inventories show the coexistence of art objects and furniture intended to be adjacent or directly sat on, such as *poltroni* or *sgabelli*, as well as *tavolini*, or a *scrittoio* in rooms such as the *portego, mezzado,* and *mezzado sul Canal Grande.*

60 Gabriele Vendramin owned Giorgione's La Tempesta among other works by Titian and Giovanni Bellini.

61 See Hochmann, Lauber and Mason (eds), *Il collezionismo d'arte a Venezia*, 316.

62 See ibid.; and Mason, "Di mano di questo maestro pochissime sono le cose che si vedono," 64–71.

63 See Tancred Borenius, *The Picture Gallery of Andrea Vendramin* (London: Medici Society, 1923).

64 See Hochmann, Lauber and Mason (eds), *Il collezionismo d'arte a Venezia*, 316. Citing Vincenzo Scamozzi in 1615, Andrea Vendramin's collection is described as "ne ricorda l'importante raccolta di sculture, pitture, vasi, gemme, medaglie, disposta soprattutto in due stanze nel palazzo San Vio e secondo una precisa architettura, con triplicate ordine, già quasi prefigurando nell'elencazione una sorta di catalogazione: spiccavano inoltre sete statue di Alessandro Vittoria in un suo scrittoio d'olivo ed ebano, quindi plausibilmente sculture di piccole dimensioni."

65 Brown, *Private Lives in Renaissance Venice*, 236.

66 See Hochmann, Lauber and Mason (eds), *Il collezionismo d'arte a Venezia*, 316.

67 See the introduction in *Making Publics in Early Modern Europe: People, Things, Forms of Knowledge,* edited by Bronwen Wilson and Paul Yachnin (New York: Routledge, 2010), especially 1–5.

68 See discussion by Emanuela Zucchetta in *Antichi ridotti: Arte e societa dal Cinquecento al Settecento* (Rome: Frattelli Palombi, 1988), 8–42. For clarification, the Venetian *casinò* was first designed as a part of the home at its inception around the end of the sixteenth century. Yet the *casinò* was soon transferred outside the family residence and constructed as a small, separate but luxurious garden apartment outside of the walls of the home.

Let's Eat:
Kitchens and Dining in the
Renaissance Palazzo and Country Estate

Katherine A. McIver

The domestic interior in Renaissance Italy has been the subject of groundbreaking exhibitions, conference sessions, and publications in recent years.[1] Material culture is at the forefront of research, allowing us to better understand how and where people lived, what they collected and bought for their homes, and how and why they valued certain objects over others. We now have a much clearer picture of domestic life, but what about mundane issues like food preparation, eating, and the sociability of dining?

This chapter is drawn from a larger, ongoing project on the domestic interior and includes not only the city residence, but also the country estate,[2] its kitchens, and dining spaces. What I present here is an overview of my initial findings based on a series of inquiries that I considered as I sifted through a wide range of primary sources such as household inventories, detailing what was in the kitchens and related spaces; letters discussing the experience of dining; expense accounts, outlining expenditures for banquets and informal meals or for outfitting a kitchen; architectural treatises like those of Leon Battista Alberti (1404–72), Sebastiano Serlio (1475–1554), or Andrea Palladio (1508–80);[3] cooking manuals like those of Platina (1421–81), Bartolomeo Scappi (d. 1577), or Govanni Battista Rossetti;[4] and descriptions of celebrations like those of Cristoforo Messisbugo and Bartolomeo Scappi,[5] describing dining, food, and entertainment; and visual evidence such as paintings, prints, and architectural plans.

How was the Renaissance kitchen outfitted and where did people eat? Where were the kitchens and storage rooms located in relation to dining spaces within the Renaissance palazzo and at the country estate? What were kitchens and dining spaces like both in the palazzo and away from the city? Was food preparation simpler and dining more rustic, and where did it take place?

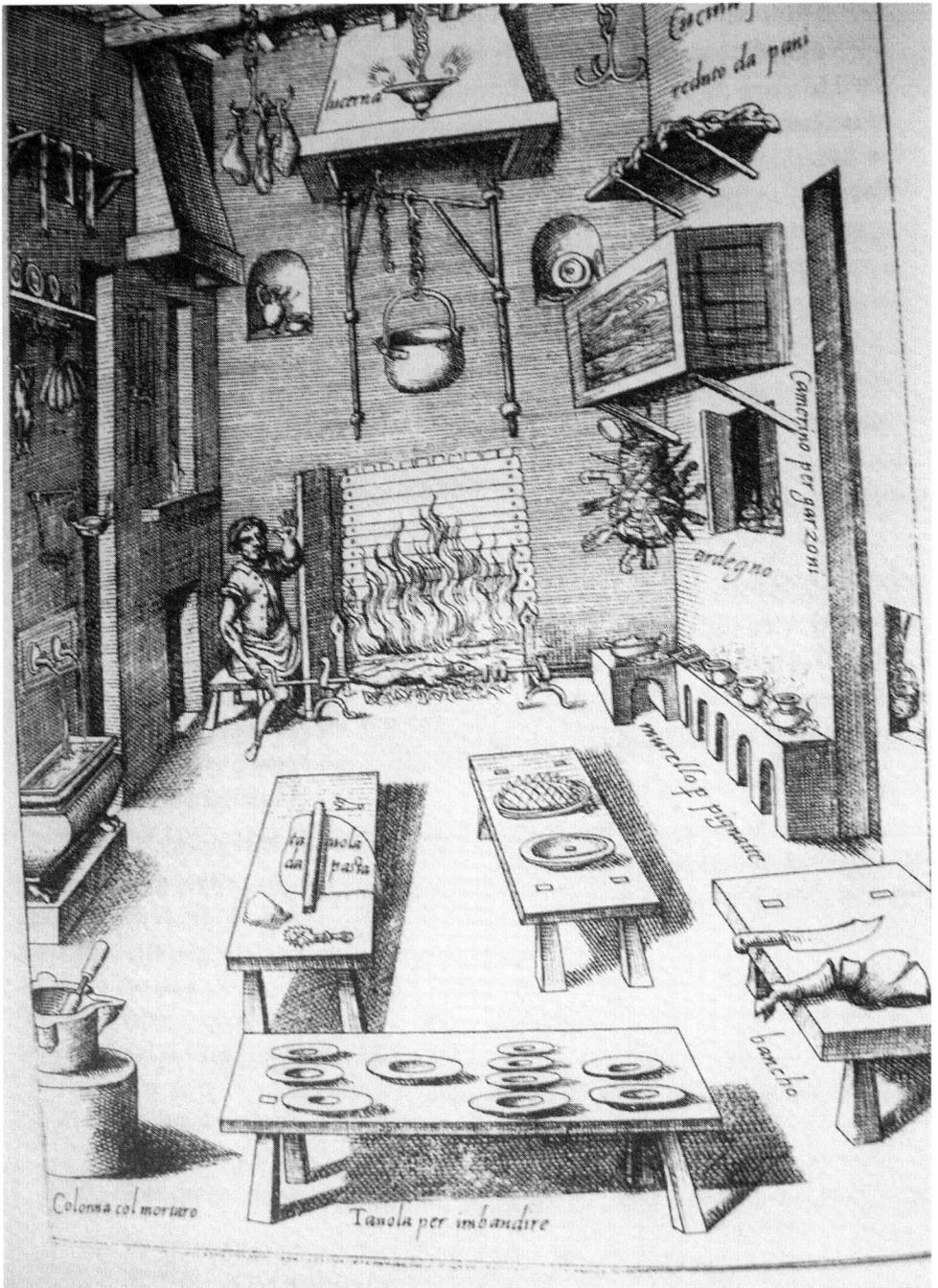

9.1 Bartolomeo Scappi, *The Main Kitchen* from
The Opera of Bartolomeo Scappi (1570), the Art and Craft of a Master Cook,
translated with commentary by Terrence Scully, Figure 1, p. 636. Photo credit: Author

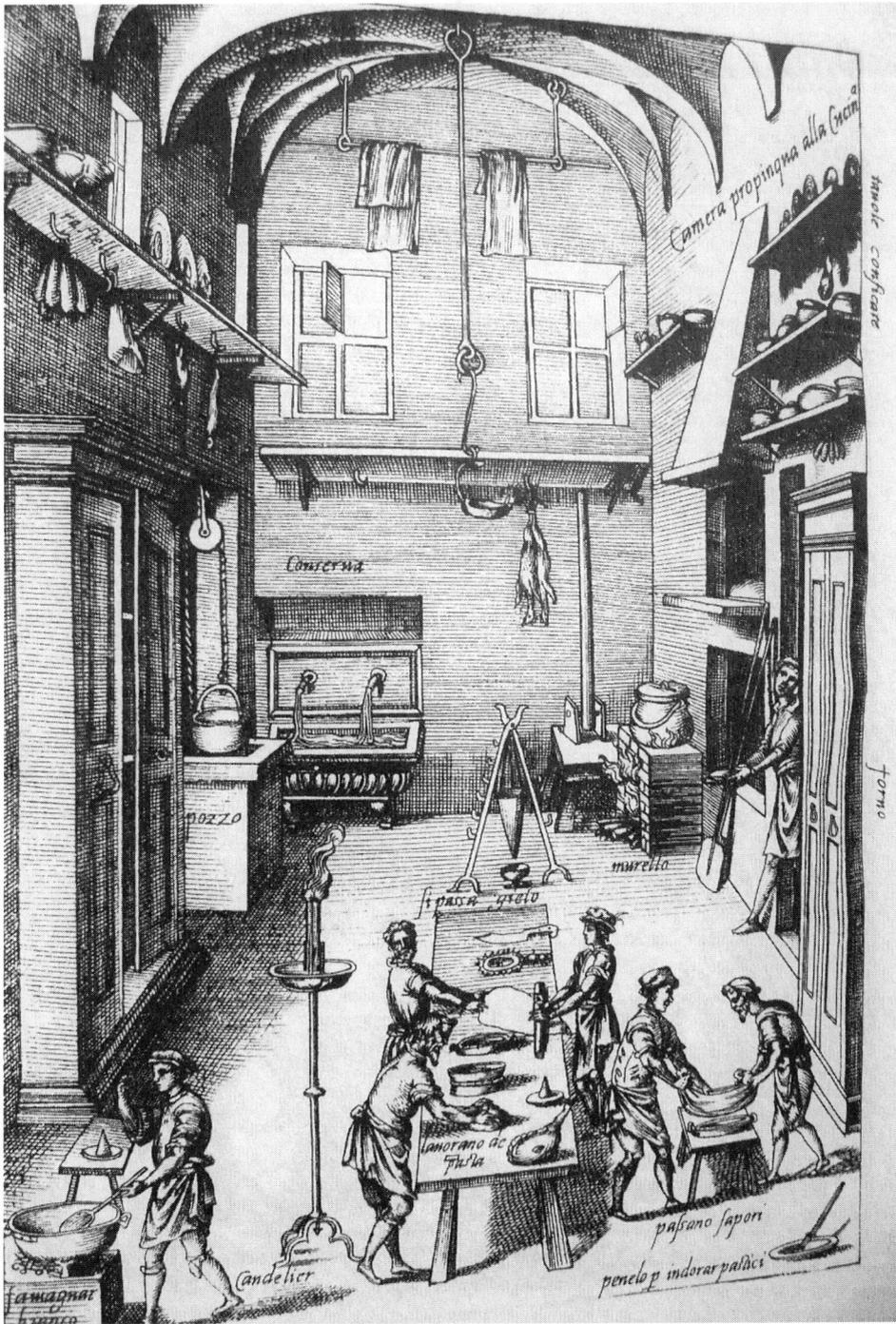

9.2 Bartolomeo Scappi, *The Room Next to the Kitchen* from
The Opera of Bartolomeo Scappi (1570), the Art and Craft of a Master Cook,
translated with commentary by Terrence Scully, Figure 2, p. 637. Photo credit: Author

Kitchens in the City and the Country

Kitchens were often some distance from where the food was to be served, sometimes down a narrow winding stair; however, ingenious devices were used to transport hot food to waiting diners. Both Leon Battista Alberti and Bartolomeo Scappi state that the kitchen should be in a remote place, yet close enough to the dining area so that food would not get cold in transit, but far enough away so that guests would not hear noise, smell noxious odors, and to prevent smoke from affecting the diners.[6] The kitchen should be bright, airy, and well-proportioned with a large, well-ventilated fireplace and windows. If we were to walk into an upscale Renaissance kitchen, we would find the work spaces located in the middle of the room, with separate areas for hot and cold food preparation, and fireplaces, stoves and sinks placed against the walls, some distance from food preparation. There would be a wide array of utensils, pots and pans of iron and copper, and other equipment.[7] We would notice the high ceilings, windows, stove vents, and chimneys.

At the heart of the kitchen, Scappi (Figure 9.1) shows an open fire, large enough to roast a pig, with mobile iron arms from which cauldrons could be suspended on chains; in front of it, spits revolve slowly, and to one side a screen shields the spit-turner from the blaze. Hot embers were regularly transferred to the row of five or six stone hobs set at ground level along the right wall, and pots bubble on grills placed over each hob.[8] Along the left wall, two ovens with iron doors are shown and further on cold water runs continuously into a stone trough, next to which is the entrance to a lockable larder. In the kitchen's coolest corner stands a solid stone base that comes just below waist height, with a mortar. We also see a bulky bench for chopping meat, three trestle tables in the center, and more tables could be added as needed for other tasks. No space was wasted: hams and dried fish hang on hooks from the ceiling and knives are ready to hand with their handles protruding from a stuffed bag.

A secondary kitchen (Figure 9.2) was located adjacent to the main one; it contains a well, another water trough, a hob much larger than the ones in the main kitchen, and two more ovens. To the left is a huge sideboard with a sturdy lock – precious items like spices and sugar were kept in it. A long smooth walnut table runs down the center of the room, with two men and a woman mixing, kneading, and rolling dough. To one side of them, two men sieve spices, and to the other, at a safe distance from any splashes or accidents, the blancmange-maker works at a large flat pan standing on its own hob. There are two further spaces associated with Scappi's model kitchen: a well-ventilated cool room for working with milk and fresh cheeses and an exterior loggia where fish are kept in open barrels of water, and where knives can be sharpened, pigs flayed, chickens plucked, and dishes washed.[9]

In contrast to Scappi's ideal kitchen, the Florentine accountant Michele del Giogante's kitchen was not so large and was without the additional rooms. It had windows opening onto the front street as well as onto the courtyard.

The main feature was a large fireplace with a hood located along the wall. Pots and pans hung on the wall and sausages from the ceiling; there was a sideboard and shelves for kitchen utensils, plates, and other equipment, as well as a sink for washing food. A pinewood staircase led up to the *sala* where he dined.[10]

In some instances, the kitchen was positioned close to the *sala* – a large hall, the favored place for dining, especially when a large number of guests were present. The number of kitchens depended on the number of *sale* and other rooms in the house that required servicing. When Bernardino Savelli and his wife Lucrezia Anguillara hosted a banquet for Pope Sixtus V (1525–90) in 1589, the Duke and Duchess of Castel Gandolfo had extensive planning to do.[11] The existing documents not only outline the menu for the evening, but also tell us how the staff planned the menu with elaborate lists of items to be purchased. In addition, the number of kitchens (three), how they were staffed, how the service rooms were set up to support the kitchen, and the table arrangement give us insight into just what happens behind the scenes for such occasions. The pope and his cardinals had a separate kitchen (*cucina segreta*) for the preparation of their meals, a separate dining area and rooms just off it for final preparations just before the meal was served.[12] And each kitchen, dining area, and service rooms became less elaborate as social status descended.

In a large palace, a separate room next to the *sala* was used by servants to apply finishing touches to the food, such as warming a sauce, adjusting elaborate decoration, setting dishes afire which had to be carried flaming into the *sala*, and dealing with wine service, the responsibility of the wine steward who mixed the wine with water and tasted it; he had to decide whether the wine should be diluted only slightly or whether water should predominate, depending on the state of the meal. Within the *sala* itself, a *credenza* or sideboard was used for the preparation of cold foods such as salads and it could also hold an impressive array of silver plate. *Credenze* were draped with snow-white cloths and became the epicenter of dining operations, and were always placed within sight of the host and guests.[13]

Larger palaces and villas often had separate kitchen wings connected to the main house by covered walkways. At Pope Pius II's residence in Siena (Palazzo Piccolomini), three kitchens were located on each of the three floors, but some distance from the *sale*. In the Casali residence in Bologna, on the other hand, there was a kitchen on the ground floor with a servant's room nearby and another kitchen on the second floor near the *sala* where the family dined.[14] For the sake of convenience, the kitchens, with their various supporting rooms, were connected to the main palace by porticos, although this was not always the case. While in Laura Pallavicina's house in Parma, a kitchen was located at the back of the house on the ground floor, food was also prepared and eaten in the *saletta* adjacent to her bedroom. The fireplace held a large copper pot that sat on an iron grate; nearby was a large, old walnut table with feet *all' antica* with *maiolica* ware laid out – so that Laura, elderly and ill, could

eat a simple meal that was prepared for her.[15] In his house in Rome, Jacopo Matteo had not only a main kitchen on the ground floor, but also a small kitchen (*cucinetta*) at the head of the stairs near his rooms and those of his wife.[16] In a smaller, middle-class house in Rome, the Sansonio family had only one kitchen located next to the *sala*, but in lower-class dwellings, the fireplace in the main room served as a kitchen or, if there was not a kitchen, the woman of the house purchased bread, prepared meat and other food items from an *osteria* – take out, if you will.[17] Amanda Lille notes that at Francesco Sassetti's country estate called La Pietra, the house had three large kitchens located on three different floors, close together in the north-west part of the house and probably shared a common chimney, and close by each kitchen was a large dining room (*sala*).[18] The Casali family estate outside of Bologna had two dwellings: one for the farm manager and the family's country house called Montevecchio.[19] Both residences had only one kitchen located just off the ground floor loggia; neither was particularly elaborate.

Moreover, there were a number of specialized processing rooms, a room for making bread, pasta, sausages, or cheese, as well as storage rooms for wine, vinegar, and spices – and of course, kitchen gardens. In addition to these rooms, there was also the *dispensa* or dispensing room, perhaps the most important space after the kitchen, which served the household staff. Supplies were bought by the purchasing agent (*spenditore*) according to the instructions of the steward (*scalco*); the porter (*sportarolo*) delivered them to the *dispensa*, where the quarter master (*dispensiere*) stored them, kept records, and dispensed provisions to the kitchen.[20] The *dispensa* was generally located close to the kitchen, usually on the ground floor.

Scappi notes that the kitchen should have adjoining rooms on the ground floor where pastry, sauces, and other preparations needing large spaces could be completed.[21] Like the kitchen, they should be bright and airy, with windows that opened and closed. The kitchen should be near the courtyard, where fowl could be plucked and animals skinned.[22] The courtyard should have a well to wash utensils and other items. Off the courtyard and near the kitchen should be a room for storing oil, rendered fat, butter, cheese, and other condiments;[23] it should be a cool place with windows. Household inventories suggest that some of the service areas were underground down a spiral staircase and hidden with their own entrances, passageways, and secret corridors; some storage rooms were stocked with non-perishable goods like cheese and salami, while others were meant solely for perishable items such as fowl or fish.

The household inventory of Laura Pallavicina's home follows closely Scappi's model. The kitchen, on the ground floor, was located at the back of the house adjacent to the courtyard which had a well and was near the kitchen garden; next to it was a room for making bread and another for making a variety of salami, several of which hung from the ceiling. A half-stair led down to the wine cellar, holding numerous bottles of red and white wine, as well as bottles of vinegar and olive oil, and then the stair led to several

small storage rooms. Near the kitchen were two storage rooms (*camerino* and *dispensa*) which contained a variety of kitchen supplies. In this medium-size palazzo, the kitchen was well equipped with a large fireplace, pine tables, a *credenza*, and more.

Several other inventories of houses in Rome follow a similar pattern to that of Laura Pallavicina's house by noting in detail the kitchens and supporting rooms. In Clarice Anguillara's home, for example, not only was there a kitchen on the ground floor with a *tinello* (staff dining room) next to it, but also two wine cellars, two storage rooms (*dispense*), and another called a "dispensa del orto," a *forno* (oven, in this case, a stone, outdoor wood burning oven; this term can also refer to a bakery), and other rooms off the courtyard.[24] And even more modest middle-class houses in Rome followed this layout of rooms. Jacopo Matteo's kitchen was located off the courtyard near the garden, but the *dispensa* was above; not far from the kitchen were two granaries, one below the other, then came a large wine cellar, a lower wine cellar, and a storage room ("una cantina da basso grande," "una cantina sotto," and "una dispensa dello cantina").[25] The Matteo inventory also noted a room for the cook near the kitchen, whereas such a room was more commonly referred to as a servant's room.[26] At the Villa La Pietra, in addition to the three kitchens already mentioned, there was a wine cellar, a room for making bread, a granary, and rooms for storing firewood and olive oil on the ground floor;[27] while not as elaborate an arrangement of rooms, it was an efficient set-up that would allow for both modest meals and some entertaining in a more leisure setting.

Dining in the City and the Country

Dining could happen in just about any room, and in the fifteenth and sixteenth centuries, this usually referred to a mid-day meal; as the centuries progressed, it was moved later and later, becoming the evening meal (*cena*). To confuse matters, most banquets were held in the evening, depending on whether or not it was a private, intimate banquet among friends or a grand, public banquet like the one held for Pope Sixtus V in 1589.[28] If people were away from home or did not have a kitchen or fireplace in which to cook, inns, wine shops, and street vendors provided food, and these were the common sources for a meal for the lower classes.[29]

Preparation for dining in the palazzo or country villa was flexible: trestle tables covered in a layer of fine linen were portable, as was the seating; walnut benches delicately patterned with ivory or other rare inlays or Roman-inspired x-form Savonarola chairs fitted with upholstered cushions were easily moved from room to room. However, a more public space like the *sala* (or *portego* in Venice) on the *piano nobile* remained the favored room for dining when guests were present or when a large space was needed for banqueting and entertaining during a meal – and a place for dancing afterwards.

This large hall was generally located at the head of the vaulted staircase leading up from the courtyard. An enormous fireplace and hooded chimneypiece of cool, gray stone, carved with the family coat of arms and decorated with candelabra-style arabesques, dominated the space. It had a timbered ceiling and tile floors, glistening with colorful geometric patterns; the interior walls were lined with Flemish *vedure* tapestries, whose foliate designs created the illusion of a garden. For a more intimate meal with the family or with a small group of friends, the smaller, more private *saletta* was used – and if the *saletta* was near the *sala*, the group could move there for dancing or musical entertainment. In Venice, the *camera* (off the *portego*) was used for small formal dinners and for everyday meals in cold weather.[30]

Outdoor dining was not uncommon; taking place in a partly covered loggia, it brought the outdoors conveniently within the building walls, and often facing the garden, it was the perfect space for grand banqueting and could be serviced by the ground-floor kitchen. This certainly could be the case at the Casali residence in Bologna, where the lower kitchen was just off the loggia, and their country estate had a similar arrangement, making dining outdoors easy.[31] It was common practice to eat out of doors in the country, whether at the villa or in the countryside; the advantage, in part, was the clean air, fresh produce, and the benefits of nature. Nearly every Roman owned at least one *vigna* (vineyard) either on the unpopulated hill area within the circumference of the Aurelian Walls or just outside them along the roads radiating out from the city.[32] If the property did not have a structure (for many *vigne* did not), they could simply pack up food, dishes, and whatever was needed to prepare a basic meal,[33] or if, like the Casali family, there was a family residence on the estate, family and friends could retire to the country for a few days of leisure. Isabella d'Este's agent in Rome wrote to her in June 1511 describing the life and entertainment offered by Pope Julius II to amuse her son Federico Gonzaga at the Villa Belevedere: "They ate in a very beautiful loggia looking out upon the whole plain ... in that loggia, the rooms and gardens of orange trees and pines, everyday is spent with greatest pleasure and entertainment ... singers, musicians and jugglers ... after this lovely diversion, they rose from the table and went out to enjoy those pleasant greenwards."[34]

Gender, too, played a role in the dining experience. Certainly, women were present during wedding banquets and similar celebrations, as we can see in Veronese's *Marriage at Cana* (Musée du Louvre, Paris)[35] or in descriptions like that of Ippolito d'Este's first banquet held at the Palazzo San Francesco in Ferrara in 1536. Held in honor of his aunt, the 61-year-old Isabella d'Este, other guests included his brothers Francesco and Ercole II, and the latter's wife, Renée of France.[36] They dined in the grand *sala*, which was lavishly decorated for the feast. While writers such as Cristoforo Messisbugo, an accomplished cook and steward who was employed at the Este court, give us a detailed description of everything needed for a grand banquet or a special occasion such as a wedding and list important guests including women, they do not tell us if the women sat with the men or what the actual dining arrangements were.

Letters provide us with some insight into just who was present at specific events and often discuss who sat where and with whom. Banquets at the Palazzo del Te in the 1560s, whether weddings or other special events, included both men and women; however, more often than not, the women sat separately from the men.[37] While she was in Rome in 1525, Isabella d'Este attended a dinner at Giovanni Antonio da Viterbo's house to celebrate a wedding.[38] It was a lavish banquet with five large tables well laid out; one table was only for women, while the others were for the men. Yet at a diplomatic dinner during the papal court's visit to Bologna in 1529–30 for Charles V's coronation as Holy Roman Emperor, women were seated in between the men.[39] While there does not seem to be any set protocol for setting arrangements at banquets in the city in the sixteenth century, the situations seems to be more relaxed at the country villa, with men and women intermingling.[40]

Evidence from household inventories suggests that many women had private dining areas and kitchens adjacent to their private apartments for their own use. The household inventory (1576) of Alfonso Sanvitale and Gerolama Farnese-Sanvitale's home in Parma, for example, noted such rooms. Between Gerolama's rooms and those of their daughter, Margarita, were "una camera delle donne" and a room where they ate ("una camera dovi si mangia") – the former had a fireplace and cooking equipment. Costanza Bentivoglio Savelli's private apartment on the *piano nobile* of the Palazzo Savelli in Rome was more elaborate and included "Sala della Illustrious Signora," "camera deli destri" (latrine), "una camera grande," "un studiolo" (study), and two more smaller rooms followed by a kitchen, next to which was a small *dispensa* near the upper loggia and the stair.[41] In her three-room apartment at Bracciano, Francesca Sforza's *anticamera* had a table for eating ("una tavola per mangiare"), as did her *camerino* – perhaps, one room for eating with guests and the other when she wished to dine alone. Allowing for more privacy, Eleonora Fieschi had, as part of her apartments, a *saletta* with a table for eating and a second table serving as a *credenza*.[42] Her female attendants ate in the *camera delle donne* next door. Bonamaria Pallavicina had not only "una saletta dove mangiava la Madonna" (where she ate) with two tables with folding legs and a *credenza* with a superb service of silver plate, but also a small kitchen next door.[43] Women may have eaten their everyday meals in these rooms, joining their husbands only for special banquets or when important guests were present. Young children also ate their meals in similar rooms away from adults.[44]

This is not to say that men did not dine in the *anticamera* of their apartments either alone, with their wife, or with guests; the evidence suggests, however, that this was common practice for women, but not necessarily so for men.[45] Upper-class women's daily lives were generally not involved with those of their husbands; rather, they were surrounded by women companions. They had their own servants and their own funds. Separate kitchens for women were maintained and separate accounts were kept for the provisioning of their tables.[46]

If actual dining spaces within the palazzo, especially the more intimate ones, are allusive, the actual sociability of dining, especially at grand and/or more formal banquets, is not; most of the literature of the period is about the organization and presentation of the food, which is tied to the sociability of dining, including the performance of serving a meal and the theatricality of presentation. We have an idea of what happened at the table, what was on the table, and what was expected of the guests, and while we do not know if men and women commonly ate together at such banquets, we do know that there were usually fewer women then men, and that women were often there as ornaments. Banqueting was about the audience, stage sets, props and interludes, and putting on a good show.[47] Platina noted that "we had a choice between eating, drinking, singing, or having a conversation. Now in itself none of these is better than any other: how it comes out depends on how it is performed."[48] Giovanni Pontano, writing in the 1490s, identified dining as one of the most important social activities. He used the term "conviviality" for the virtue of coming together in an atmosphere of familiarity to enjoy a meal. Dining was an expression of social aspirations, civility, and splendor (Jennifer Webb's chapter in this volume also attests to this characterization of dining at the court of Federico da Montefeltro). The banquet, which was a choreographed event, was a ritual of aristocratic hospitality communicating wealth and power. Thus, objects crafted in gold, silver, rock crystal, and hard stones contributed to the transformation of meals into extravaganzas.[49] Table settings, for example, not the food, impressed the guests at a dinner in Rome in 1580. Each guest was provided with his own napkin, along with a knife, fork, spoon, and silver or earthenware plates, which was often historiated *maiolica* ware. Meals, especially feasts, often began with expensive candied fruit. Food was presented in an alternating sequence of hot and cold courses. Hot food was delivered from the kitchen in carrying boxes. Courses of cold foods consisted of sliced meats, oysters, salads, and other foods that were prepared on serving tables adjacent to the *credenza*.

Both servers and diners were actors playing roles of varying importance in a spectacle that also included fine speeches, sets, and props.[50] The grace with which the diners used their hands, taking food from a plate and placing it in their mouths, was part of the performance. Drinking red wine from the shallow bowls that were in fashion in the sixteenth century required poise and elegance on the part of the guest. The finesse required to handle the wide range of fragile crystal and precious cutlery demonstrated one's mastery of courtly manners in the company of others. The talented carver (*trinciante*) had a special role, cutting the bread, fruit, meat, and fish at the *credenza* in full view of the diners. Performing a ritual gesture, he carved the roasted fowl with his knife, raising the meat in the air with a fork, and then arranging the slices in a circular pattern, or he was expected to carve the meat in mid-air so that it fell on the plate in a decorative pattern of slices, providing both entertainment and service to the guests. Vessels in motion or at rest were meant to be enjoyed against an array of eye-catching gastronomic delights.

Everything was conceived to overwhelm the senses in an ongoing show of colors punctuated by live performances and musical intermezzi. By stark contrast, the lower classes ate, not so much for sociability, but out of need – simple meals were made up of bread (bought at the local *forno*), a bit of meat (when they could afford it), and wine – most often purchased rather than cooked at home; their dwellings rarely had a fireplaces for cooking, let alone a kitchen and storage rooms.[51]

Putting the lower classes aside, what can be said about a simpler meal such as a small dinner in the more private *saletta* or even a more intimate space, like the *anticamera* of a private apartment in the city or even at the country villa? Gerolama Farnese-Sanvitale hosted an informal dinner for a small group of women friends in the rooms that adjoined her apartments and those of her daughter, Margarita, who sang for the guests. In her 1573 letter to Ottavio Farnese, Duke of Parma and Piacenza, Geroloma thanked Ottavio for lending her his musician, who trained Margarita, and also told him of the success of the event.[52] Although letters provide some insight into informal dining, the everyday meal, where it took place, what food was prepared and eaten, and the sociability of daily dining remain allusive – images, documents, and treatises tell us little and we are left to wonder about those daily meals.

The sociability of dining certainly carried over to the country estate, as we have already seen at the Villa Belvedere, where Pope Julius II offered a variety of entertainments to the young Federico Gonzaga; here, the meals echoed those in the city residences. But in less ostentatious country estates, the setting was more humble and the meals were simpler and more rustic, often based on what the farm produced and what had been put up in the various storage rooms. Most estates had a *forno* for baking bread and roasting meat, and reserves of salami and cheese. Fruit could be gathered from the orchard and vegetables from the garden, and if there was a pond, fresh fish could be caught or if there was a hunting park, fresh game killed for the evening meal – both activities served a dual purpose: hunting and fishing were entertainment, leisure time activities, and they both provided food for an upcoming meal. Farm animals such as pigs or sheep could be butchered and roasted on an open fire, and there was always an abundance of fowl.[53]

The main loggia of the villa usually looked out over the fields and gardens of the estate and would have been the setting for a banquet for a small group of friends or for the family's daily meal. Tables and benches could easily be set up; however, the elaborate table settings and the performance at the *credenza*, so typical of the city banquet, would not have been a part of the table service, in part because fewer staff came along to service the table and the kitchens were often smaller and less adequately equipped. It was informal in the country, relaxed, a time of leisure and enjoyment – it was a retreat from the cares and stresses of city life. And even the country peasant benefited to a certain extent; unlike his or her city counterpart, food was more abundant, yet farm work was more strenuous and more labor-intensive than work in the city.

Food preparation, eating, and the sociability of dining are the common
threads that run through this chapter. As our vision of private life in
sixteenth-century Italy becomes clearer, what had once been thought of
as more mundane parts of life, such as eating and food preparation, and
less significant spaces in the domestic interior, such as the kitchen and the
dispensa, will become part of the general discourse on life in the city and in
the country in the Renaissance. Kitchens (and food service) were fixed spaces
(and activities), but varied in size and location depending on the household.
Whereas there was a certain mobility or fluidity to dining within the
ever-changing landscape of the domestic interior, moving from the *sala* to the
anticamera to the loggia depending on the event or time of year. The sociability
of dining was part of the discourse on etiquette, display, and magnificence,
as codified by Pontano, Scappi, and others. Life in the kitchen was more than
food preparation and service; it could become a theatrical performance and
part of the fine art of dining.

Notes

1 For a comprehensive bibliography, see: Mara Ajmar-Wollheim and Flora Dennis (eds), *At Home
in Renaissance Italy* (London: V&A Publications, 2006); and Andrea Bayer (ed.), *Art and Love in
Renaissance Italy* (New Haven: Yale University Press, 2008). Fundamental to any research on the
domestic interior is Peter Thornton's *The Italian Renaissance Interior* (New York: Harry N. Abrams,
Inc., 1991).

2 Country estates or villas were working farms that also functioned as retreats from the city
for their owners. In this period, the term "villa" referred to a country estate encompassing
the landowner's house, any related farmhouses and outbuildings, together with gardens and
farmland; see Amanda Lillie, *Florentine Villas in the Fifteenth Century: An Architectural and Social
History* (Cambridge: Cambridge University Press, 2005), 2. The term "villa" could also mean the
countryside in general and was also applied to a hamlet, unfortified village, or small town in the
open country.

3 Leon Battista Alberti, *On the Art of Building in Ten Books*, translated by Joseph Rykwert, Neil Leach,
and Robert Travernor (Cambridge, MA: MIT Press, 1988); Sebastiano Serlio. *Architettura civile.
Libro sesto settimo e ottavo nel manoscritti di Monaco e Vienna*, edited by F.P. Fiore (Milan: Electa 1994),
Book 7; and Andrea Palladio, *I quattro libri dell' architettura* (Venice: np, 1570).

4 Bartolomeo Scappi, *The Opera of Bartolomeo Scappi (1570), The Art and Craft of a Master Cook*,
translated with commentary by Terence Scully (Toronto: University of Toronto Press, 2008);
Platina (Bartolomeo Sacchi), *On Right Pleasure and Good Eating*, edited by Mary Ella Milham
(Tempe, AZ: Medieval & Renaissance Texts and Studies, 1998); and Giovanni Battista Rosetti,
Dello Scalco (Ferrara, 1584; reprint: Bologna: Arnaldo Forni, 1991). Other treatises include: Cesare
Evitascandolo, *Dialogo del maestro di casa* (Rome: Carlo Vilietti, 1598); his *Dello Scalco* (Rome: Carlo
Vilietti, 1609); Vincenzo Cervio Fusoretto, *Il Trinciante … ampliato et a perfettione ridotto dal Cavaliere
Reale Fusoritto da Narni* (Rome: Carlo Vilietti, 1593); and Giovanni Roselli, *Epulario quale tratto
del modo de cucinare* (Venice: Zoppino, 1555). See also Deborah L. Krohn, "Picturing the Kitchen:
Renaissance Treatises and Period Room," *Studies in the Decorative Arts* 16(1) (Fall/Winter 2008):
20–31.

5 Cristoforo Messisbugo, *Banchetti composizioni di vivande e apparecchio generale*, edited by Fernando
Bandini (Ferrara, 1549; reprint: Vicenza: Neri Pozza, 1992).

6 Alberti, *On the Art of Building in Ten Books*, 148–9, 142 for kitchens and 150 for wine cellars; Scappi,
The Opera of Bartolomeo Scappi, 100–106.

7 Scappi, *The Opera of Bartolomeo Scappi*, 100–106; and Alberto Capatti and Massimo Montanari,
Italian Cuisine: A Cultural History (New York: Columbia University Press, 1999), 246–9.

8 Scappi, *The Opera of Bartolomeo Scappi*, 629–30; 636–9 for illustrations.

9 Ibid., illustrations 3 and 4.

10 Dale Kent, "'The Lodging House of all Memories,' an Accountant's Home in Renaissance Florence," *Journal of the Society of Architectural Historians* 66(4) (2007): 453–4.

11 ASR, Archivio Sforza-Cesarini, b. 22, fasc. 30a. I am currently writing an essay analyzing these documents in some detail.

12 In her chapter in this volume, Jennifer Webb discusses an anonymous manuscript (*Ordine et officii de casa*) written specifically for the Duke of Urbino, who was preoccupied with hygiene and cleanliness relating to food preparation and service. Like the pope at Castel Gandolfo, the Duke had his own private kitchen. What makes this manuscript most interesting is, unlike Scappi's, it is directed to a specific individual and his court, showing us the concerns of the Duke.

13 Valeri Taylor, "Banquet Plate and Renaissance Culture: A Day in the Life," *Renaissance Studies* 19(5) (2005): 621–33. See also Ken Albala, *The Banquet: Dining in the Great Courts of Late Renaissance Europe* (Chicago: University of Illinois Press, 2007), 1–26; Claudio Benporat, *Cucina e convivialita Italiano nel Cinquecento* (Florence: Leo S. Olschki, 2007); Pier Nicola Pagliara, "Destri e cucine nell' abitazione del XV e XVI secolo," in *Aspetti dell' abitare in Italia tra XV e XVI secolo*, edited by Aurora Scotti Tosini (Milan: Edizioni Unicopli, 2001), 42–61; and Allen J. Grieco, "Meals," in *At Home in Renaissance Italy* (see note 1), 244–55.

14 I wish to thank Catherine Fletcher for sharing this inventory with me; see her chapter in this volume.

15 Archivio di Stato, Parma (hereafter ASP), Famiglia Sanvitale, Patrimonio familiare, b. 28, DII 944. Laura's is not the only case where an ailing matron had meals prepared for her near where she slept. Eleonora Sansonio had meals prepared for her in the *anticamera* (antechamber, usually the room that preceded the bedroom) and then brought to her "nella camera dove dormira ce stava infirma detta donna" (Archivio di Stato, Roma (hereafter ASR), Collegio notai capitolino, b. 1548, ff. 444–5, 447, 18 November 1577.

16 ASR, Collegio notai capitolino, b. 312, ff. 326–31.

17 ASR, Collegio Notai capitolino, b. 1548, ff. 447–51. This was a two-storey structure with the bedrooms above. See Elizabeth S. Cohen and Thomas V. Cohen, *Daily Life in Renaissance Italy* (Westport, CT: Greenwood Press, 2001), 224.

18 Lillie considers the *sala* to be a dining space (*Florentine Villas in the Fifteenth Century*, 196), while 194–5 show plans of the Villa La Pietra with the kitchen areas designated.

19 See Catherine Fletcher's chapter in this volume for details concerning this inventory.

20 Patricia Waddy, *Seventeenth-Century Roman Palaces: Uses and the Art of the Plan* (Cambridge, MA: MIT Press, 1990), 38. The *dispensa* could be more than one room and could hold a variety of household goods in addition to items for the kitchen. Household inventories of the sixteenth century show the diversity of objects kept in the *dispensa*. Albala, *The Banquet*, 139–58; Rosetti demanded of each of his major officers that they keep a list or register exactly what came into the larder and exactly what went out. He also insisted that the buyer must list the quantities or weight of every item purchased and the stock-keeper must record everything he received and everything he handed over to the cook and *credenziero* (*Dello Scalco*, 143). For a more detailed discussion of the kitchen staff and the various rooms, see Scappi, *The Opera of Bartolomeo Scappi*, Book I; and Guido Guerzoni, "Servicing the Casa," in *At Home in Renaissance Italy* (see note 1), 146–51.

21 Scappi, *The Opera of Bartolomeo Scappi*, 103.

22 Ibid., 104. See also Jennifer Webb's chapter in this volume. Of particular interest here is her discussion of cleanliness in the kitchen and the awareness of health and hygiene issues relating to the preparation of certain foods and the impact this might have on the bodily humors.

23 Scappi, *The Opera of Bartolomeo Scappi*, 105.

24 ASR, Collegio notai capitolino, b. 1535, ff. 284–304. I have numerous other inventories of houses in Rome that show the same arrangement of rooms.

25 ASR, Collegio notai capitolino, b. 312, ff. 326–31.

26 Eleonora Sansonio's inventory also lists "una stantia del cocciero" and, like Jacopo's, her middle-class home had a similar set of rooms: ASR, Collegio notai capitolino, b. 1548, ff. 447–51. There are numerous other examples of inventories of middle-class houses in Rome with similar room arrangements.

27 Lillie, *Florentine Villas in the Fifteenth Century*, 197.

28 Albala, *The Banquet*, xi; in the Renaissance the evening meal, supper or *cena*, was a smaller, simpler meal. See earlier in this chapter for a brief discussion of Sixtus V and note 11. See also Thornton, *The Italian Renaissance Interior*, 347–9.

29 Cohen and Cohen, *Daily Life in Renaissance Italy*, 224.

30 Patricia Fortini Brown, "The Venetian *Casa*," in *At Home in Renaissance Italy* (see note 1), 58.

31 See Catherine Fletcher's chapter in this volume; Scappi, *The Opera of Bartolomeo Scappi* (illustrations 6 and 24), too, discusses the benefits of dining out of doors and presents ideas for an outdoor kitchen.

32 David R. Coffin, *The Villa in the Life of Renaissance Rome* (Princeton, NJ: Princeton University Press, 1979), 16. Agostino Gallo's *Le dieci giornate della vera agricoltura e piacere della villa* (Venice: Giovanni Bariletto, 1566) adds insight into our understanding of villa life and how it was better to reside in the country rather than in the city. See also James Ackerman, *The Villa, Form and Ideology of Country Houses* (Princeton, NJ: Princeton University Press, 1990), 108–23.

33 Scappi provides illustrations and instructions for setting up a traveling kitchen (*The Opera of Bartolomeo Scappi*, 630–34 and illustrations 6, 17, and 24). In addition, I have found numerous lists and inventories for food, equipment, and so on that was being packaged up to take to the country (Archivio Storico Capitolino, Rome, Archivio Orsini, serie I, bb. 412, 413, 414).

34 Alessandro Luzio, "Federico Gonzaga ostaggio alle corte di Giulio II," *Archivio della R. societa Romana di storia patria* 9 (1886): 513–14, 524.

35 For a discussion of the meal presented in this painting, see Katherine A. McIver, "Banqueting at the Lord's Table in Sixteenth Century Venice," *Gastronomica* 8(3) (Summer 2008): 8–12.

36 Mary Hollingsworth, *The Cardinal's Hat, Money, Ambition and Housekeeping in a Renaissance Court* (London: Profile Books, 2004), 60–61.

37 Strictly speaking, the Palazzo del Te was a suburban Villa, since it was outside the city of Mantua. Maria Mauer has kindly shared with me a number of documents relating to banquets and meals at the Palazzo; she is currently writing her dissertation of this subject.

38 Alessandro Luzio, "Isabella d'Este e il sacco di Roma," *Archivio Storico Lombardo* 4(10) (1908): 365; see also Catherine Fletcher, "'Furnished with Gentlemen': The Ambassador's House in Sixteenth-Century Italy," *Renaissance Studies* 24(4) (2010): 529, note 61.

39 Thomas Wall, *The Voyage of Nicholas Carewe to the Emperor Charles V in the Year 1529*, edited by R.J. Knecht (Cambridge: Cambridge University Press, 1959), 65. I wish to thank Catherine Fletcher for this reference.

40 Gallo (*Le dieci giornate*, day 8) noted that women sat alongside men while eating freshly caught fish that had been cooked for them.

41 ASR, Archivio Sforza-Cesarini, b. 19, fasc. 21. The inventory is dated 10 September 1563.

42 "Per la credenza," Antonio Manno, *Arredi et armi di Sinibaldo Fieschi, da un inventario del 1532* (Genoa: np, 1876) and Thornton, *The Italian Renaissance Interior*, 291.

43 ASP, Famiglia Pallavicini, b. 5, 18 September 1522.

44 ASP, Famiglia Sanvitale, Patrimonio familiare, b. 27, DII 861; Famiglia Pallavicin, b. 5, 18 September 1522.

45 Waddy (*Seventeenth-Century Roman Palaces*, 6) notes that the protocol of dining with the Cardinal involved eating in his *anticamera* with guests. See also Thornton, *The Italian Renaissance Interior*, 294–5, where he notes that informal meals could take place in the *anticamera*.

46 Waddy, *Seventeenth-Century Roman Palaces*, 26; the account books of Maddelena Strozzi Anguillara and Giacoma Pallavicina detail the expenditures for kitchen supplies, including food. See ASR, Congregazione religiose feminile, cistercensi, Sta Susanna, b. 4442; Busseto, Biblioteca, Archivio Pallavicino, bb. 39–43; and ASP, Notai, bb. 1989–92.

47 Capatti and Montanari, *Italian Cuisine*, 135.

48 Platina (*On Right Pleasure and Good Eating*, 119) is echoing the speech of Pausanias in Plato's *Symposium*, translation and introduction by Alexander Nehemas and Paul Woodruff (Indianapolis, IN: Hackett Publishing, 1989).

49 Taylor, "Banquet Plate and Renaissance Culture," 621.

50 Capatti and Montanari, *Italian Cuisine*, 137.

51 Cohen and Cohen, *Daily Life in Renaissance Italy*, 224. It is significant to note that the *osterie*, inns, and wine shops where the lower classes purchased food were owned by the upper classes, both men and women. Many of the inventories and notary documents (found in the ASR and the ASP) list *osterie, forni*, and inns as assets, often even noting the income derived from them.

52 ASP, Carteggio Farnesiano interno, b. 62, 15 July 1573.

53 This information is gathered from a wide range of inventories, letters and notary documents that I have collected. Gallo (*Le dieci giornate*, day 8) goes on at length about the plentifulness of veal, beef, chicken, doves, ducks, geese, and vegetables and fruits such as citrons, lemons, oranges, asparagus, and artichokes, and how he eats less expensive things like ricotta, farmer's cheese, and creams.

Silk-Clad Walls and Sleeping Cupids:
A Documentary Reconstruction of the Living Quarters of Lucrezia Borgia, Duchess of Ferrara

Allyson Burgess Williams

Much of the research on the furniture and objects of daily life that adorned palaces in Renaissance Italy is based on the examples of Florence and Venice.[1] In late fifteenth-century court studies, material goods are occasionally discussed, but the focus has been on projects such as identifying building programs and reconstructing lost painted decorations commissioned by noblemen such as Ercole I d'Este in Ferrara, Ludovico il Moro in Milan, and more recently Francesco II Gonzaga in Mantua. *Studioli*, such as those of Federico da Montefeltro in his palazzi in Urbino and Gubbio, have also been addressed.[2] In terms of early sixteenth-century courts, a great deal of research has been done on correctly situating and interpreting the famous painted and sculpted collections in the private quarters of Duke Alfonso I of Ferrara and of his sister Isabella d'Este in Mantua.[3]

The above-mentioned studies in courtly patronage are an important basis for new research with a slightly different emphasis. For example, the living spaces of Alfonso's wife, the Duchess Lucrezia Borgia (1480–1519), have not been carefully investigated, although she renovated and decorated two sets of rooms in the Estense castle and palace complex between 1505 and 1519.[4] Her quarters no longer exist in their original form and the documentation is fragmentary, but one of the main reasons for the lacuna is that the duchess commissioned relatively few paintings and sculptures as tangible reminders of her material world in comparison to her Este contemporaries. After creating a functional suite of *camere* with carved, gilded wooden ceilings and painted friezes, she draped her walls and beds with enormously expensive but more ephemeral silks and historiated tapestries. This study involves both identifying and reconstructing and the types of rooms the duchess occupied, and discussing the objects within them. Between the construction records of her first quarters, inventories of small artworks and objects, and epistolary descriptions of the sumptuous textiles adorning the apartments she occupied

after the birth of the ducal heir Ercole II, one can to some extent reconstruct the material world of Lucrezia Borgia. These primary sources have never been conjoined, and doing so provides new insight into the private life of a Renaissance duchess who consciously staged her environment both for her own pleasure and to appropriately impress the privileged few who were entertained in her rooms. This chapter is a preliminary investigation into the typology of an early sixteenth-century duchess' quarters, and also into how their lavish yet morally appropriate decorations could function as an effective form of self-fashioning.[5]

Initially one must ask whether the duchess' quarters could be deemed an entirely domestic space, and to what extent they were private. As Raffaella Sarti has pointed out regarding the palace at Urbino, boundaries between the private or domestic realm and the institutional were blurred in courtly settings.[6] As was customary, Lucrezia Borgia kept a separate court from her husband. Outside of festive and state occasions, or while staying in the Este villas where male and female members of the court relaxed together, she and her ladies-in-waiting primarily lived apart from the male-dominated public spaces of the ducal court, such as the audience halls, theater, courtyards, or business offices. And they almost certainly never went near the castle prisons or the armories. All those spaces could be deemed "institutional," rather than private or domestic. However, even Duke Alfonso's personal suite of rooms, decorated with antiquities and covered in paintings by Titian, Giovanni Bellini, and Dosso Dossi were shown to visitors upon occasion in order to honor and impress them. But what about the quarters of a duchess; how does one characterize the spaces of the female court? Lucrezia possessed and oversaw various properties and convents in addition to performing courtly duties that must have involved interactions with her own and her husband's staff. She also entertained official visitors from other courts whose descriptions of her lifestyle are most valuable. Would all the rooms in Lucrezia's quarters have been deemed domestic? Would the rooms in which she gave audiences have had an "official" ambience? It is possible that the private quarters of the Duchess of Ferrara, although they were primarily domestic spaces, could under some rare circumstances become more porous and serve a slightly more public function, albeit briefly?[7]

As duchess in one of the oldest ruling families in Italy, only queens and princesses outranked Lucrezia. Her status required a display of magnificence in personal appearance and in living quarters: gowns and jewels had to be stunning, and her rooms needed to be a luxurious and elegant counterpart to those of the duke, even if they were not often displayed. The decorations of one's personal spaces were and have always been an important extension of the self, and at court they were as vital for imparting an appropriate noble persona as dress, speech, and deportment.

Within the context of the sixteenth century, the opulent textiles and historiated tapestries gracing the Duchess of Ferrara's walls, beds, and tables would have been powerful signifiers of wealth, status, and *virtù*, perhaps

even more so than the paintings and sculptures commissioned by other Este family members. Since fabrics in personal dress were so carefully examined and commented upon (especially Lucrezia's or any other bride's wedding clothes) as markers of status and propriety, it is also possible that fabric draped on walls or furniture could have been viewed as extensions of their owner's bodies/selves.[8]

When Lucrezia came to Ferrara in 1502 as the twice-married illegitimate daughter of Pope Alexander VI, she received a somewhat cool reception from her new sister-in-law Isabella d'Este, who was used to being the *prima donna* in the world of the north central Italian courts. The *marchesa* was not keen on competition from the intelligent and charming future duchess, whose enormous dowry included a vast collection of fashionable and costly gowns, jewels, luxurious fabrics, and objects for daily use. A rivalry of sorts began, and Isabella's agents were instructed to send detailed descriptions of Lucrezia's living quarters whenever they visited Ferrara. Their rivalry reflected the politics of possession and display as well as strategies for social advancement that were inherent to the courtly world. Primarily, however, Isabella's thirst for information about her sister-in-law provides valuable insight into the lifestyle and material world of the sixteenth-century Italian courtly female.

Isabella's jealousy was understandable. The elegant, literate, and multi-lingual Lucrezia Borgia was the ideal wife for a duke. She had honed her diplomatic and administrative skills at the papal court, and had helped run the households of her two previous husbands, Giovanni Sforza, Lord of Pesaro and Alfonso of Aragon, Duke of Bisceglie. As the work of Diane Ghirardo has shown, her entrepreneurial skills allowed her to profit from innovative land reclamation projects, and she owned a separate palace in Ferrara that combined a religious order with warehouse space.[9] Her competence and business acumen was complemented by a graciousness that served the state well during the absences of her *condottiere* husband Alfonso, since she could rule in his stead. Unlike Isabella, Lucrezia was also known for her piety: in addition to endowing and building convents, she corresponded with famous clerics and commissioned devotional manuals.[10] In this aspect of her life, she was similar to Eleonora of Aragon (1450–1493), the previous Duchess of Ferrara, whose reign set Lucrezia a formidable example.

Research into the patronage patterns of the nobility in Renaissance Italy has made it clear that women were very often in charge of renovating and decorating their own living quarters.[11] Lucrezia followed the patterns set by her deceased mother-in-law Eleonora and her sister-in-law Isabella in making sure her rooms were appropriately elegant as well as functional. Before her death, Duchess Eleonora had occupied a portion of the medieval Este castle. Her rooms were mostly painted white to be covered by textiles and tapestries, but one of the rooms had imitation tapestries frescoed on the walls, and another had a frieze of vines and flowers. In 1484, she also had a balcony built over the moat towards the Torre dei Leoni (also known as the Torre San Micheli). It had a lead roof and was supported on marble brackets.

Its rear wall was frescoed with scenes of Eleonora's native city of Naples, including castles, animals such as giraffes, and roses and carnations along the borders.[12] Her suite also included a small chapel or oratory, and a study. The Duchess also built a garden and a second set of quarters on the north side of the *castello* that duplicated the functions of her rooms within the *castello*, but also included baths. The garden quarters must have been particularly inviting in hot weather and would have been much appreciated by Eleonora, her ladies, and her children. After Eleonora's death, Alfonso I's first wife Anna Sforza (1476–97), who lived in the Torre dei Leoni near Eleonora's balcony, used Eleonora's garden and baths, as did Alfonso himself.[13]

Upon her arrival in Ferrara in 1502, Lucrezia was given the rooms formerly decorated and inhabited by Eleonora near the Torre Marchesana. By the time she became Duchess of Ferrara in late January 1505, Lucrezia must have been anxious to create quarters that would reflect her tastes as well as her new status. She wasted no time in beginning the renovations which occurred concurrently in almost all of her chosen rooms. The principal spaces of Lucrezia's suite in the *castello* (Figure 10.1) included a *salotto* or large salon, a *camera* in the Marchesana tower and an adjoining *anticamera* running in the direction of the Torre di San Paolo. The *anticamera* had connecting doors and corridors allowing access to both the Torre Marchesana and the *salotto*. She also had work done on the adjacent hanging garden and its loggia to the north near the Torre dei Leoni. The area of the ravelin (passage over the moat) to the south contained two rooms of unknown function, a small chapel, Lucrezia's bedroom, and a bath and grotto directly below. The importance and scope of this project is indicated by the fact that of the 66 servants in her court in 1506, the third highest annual salary was paid to the court painter Michele Costa, who was in charge of the artists.[14] The young Ludovico Mazzolino did a great deal of the work, but other painters such as Tommaso da Carpi also appear frequently in the registers. Even though plague broke out in the city between June and October 1505, some work continued in the *castello*. Michele Costa and Mazzolino both agreed to be locked inside, painting friezes and gilding cornices in rooms that were already substantially complete. Needless to say, the Este family removed themselves to one of their country residences during this period.

Not much is known about the antechamber, but it would have been a necessary space for guards and waiting visitors. The *salotto* seems to have been the largest of Lucrezia's suite, measuring approximately 39 x 26 feet (12 x 8 m). It must have been used as a main reception and audience room, and was created by knocking down the walls between Eleonora's rooms behind the balcony. An impressively large space was essential so that Lucrezia could project the magnificence necessary to a ruler. While the private quarters of a duchess were normally far less permeable than were the more public, almost "institutional" audience halls and reception rooms used by Duke Alfonso, Lucrezia's salotto would have been entered by court officials on state business. When her *condottiere* husband was away, Lucrezia heard petitions and otherwise helped rule Ferrara, and thus she needed an official reception room.

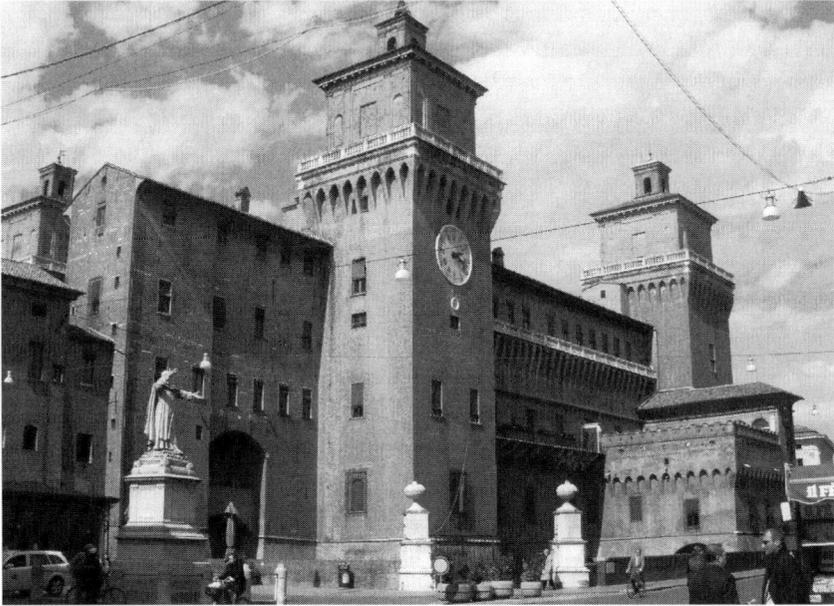

10.1 Castello Estense, Ferrara (late fourteenth century) showing left to right: the Via Coperta, ravelin, Torre Marchesana, hanging garden, and Torre dei Leoni. Photo credit: Author

The Duchess was also fond of music and dancing, and the *salotto* would have been an ideal space for such entertainments. As William Prizer has shown, Lucrezia employed a talented group of musicians, composers and singers, and her court (along with that of Isabella d'Este) was influential in developing new forms of music such as the *frottola*.[15] The Este were renowned for their musical patronage and, indeed, it was a significant pastime in upper-class households all over Italy. Maria DePrano's chapter in this volume discusses instruments present in the Tornabuoni palace in Florence and shows how musical skills were considered essential for ladies of the *signorile* classes.[16]

Lucrezia's *salotto* had what the Ferrarese termed vaulting *alla Fiorentina*, cross vaults ending part way down the room in corbels.[17] The flooring, as in all her rooms, was of *batudo*, or crushed stone applied in a liquid form, similar to Venetian *terrazzo*. Surrounding the room were 16 columns with bases and capitals each 6½ feet high, supporting a frieze, architrave, and cornices, the latter of which were gilded.[18] A new fireplace was constructed (heating such a big space must have been a challenge), and large *salvarobe* for storage were carved from walnut wood. Outside the room, Eleonora's balcony was rebuilt, widened, and elongated, complete with lead covering, to provide a sheltered place for Lucrezia and her ladies to sit and look out over the castle gardens and the city. It ran beyond the length of the room and also provided an external passageway between the *salotto* and the hanging garden near the Torre dei Leoni. Michele Costa painted the balcony, but the subject is unknown.[19] On December 6, 1505, the area was complete to the point that Isabella d'Este's agent Bernardo de' Prosperi could write and tell the *marchesa* that "Yesterday I saw the rooms that the Duchess is having built, and they

will be most beautiful; there is a large salon near the balcony."[20] Later in the building project, the hanging garden which projected over the moat was finished, and a loggia with marble columns was constructed, to provide even more space and fresh air for the Duchess and her court.

The square chamber in the Torre Marchesana adjacent to the *salotto* must have been one of the most striking of the suite, as it had the most complex decorative scheme. In addition to four new windows, a set of 12 distemper paintings was commissioned for the lunettes of the vaulted ceiling. Unfortunately, the documents do not state the subject of the images, referring to them only as "tele istoriate." It is possible that the subjects were worked out in cooperation with the poet and humanist Antonio Tebaldeo, who was on Lucrezia's staff at the time. The paintings were ordered from six different artists: Nicolo Pisano, Benvenuto Garofalo, Domenico Panetti, Ettore Buonacossi, Michellette, and Ludovico Mazzolino.[21] This is an impressive list of artists to coordinate, and they all seem to have delivered their paintings on time. In choosing a group of painters for the series, it is possible that Lucrezia was trying to imitate her sister-in-law, who had consciously set up a *paragone* between Mantegna, Perugino, and Costa in her famous *studiolo* in Mantua in the 1490s. Lucrezia's painters were less illustrious and were all from Emilia Romagna, so one remains uncertain about her artistic motives.

A great deal of new construction occurred in the castello ravelin. Rooms were carved out of its thick walls, the vaults below were shored up, glass windows were installed, and a service stairway was cut. Leading from the chamber in the Torre Marchesana to the south were two rooms, the functions of which are not clear. One room had a wooden ceiling of octagons surrounding a *tondo*, painted and gilded by Mazzolino. The other had oblongs surrounding another *tondo*, also painted and gilded. A small oratorio, probably vaulted, was also in this area possibly against the west side of the ravelin.[22]

Lucrezia's private bedroom must have been one of those at the southern end of the ravelin, perhaps the one closest to Alfonso's quarters under construction in the Via Coperta. It must have also been impressive, having an ornate compartmentalized ceiling with 12 large carved and gilded roses highlighted with blue, possibly on a blue ground, given that two grades of azure paint were ordered.[23] It might have resembled, in its luxury if not its decorative schema, the still-extant ceiling of Isabella d'Este's grotto from the Castello di San Giorgio in Mantua.[24] As in the other rooms, the cornices of Lucrezia's bedroom were also gilded. Its location in the ravelin is suggested by Bernado da Prospero's letter of December 6, 1505 partially cited above; he informed Isabella that her brother the duke and his duchess could enter each other's rooms "senza essere visto," without being seen, a subtle hint that the couple were on good, intimate terms in the third year of their marriage.[25] Leon Battista Alberti, who frequently moved in courtly circles, would have approved; he suggested in *De Re Aedificatoria* that the husband and wife should have adjoining rooms.[26]

In the summer of 1506, a bath and adjacent grotto were carved out of the heavy stonework of the ravelin below Lucrezia's room. Windows were put in, and copper baths and hot water heaters were ordered.[27] Bathing was very popular in the courtly culture of the fifteenth and early sixteenth centuries, and the ritual was particularly enjoyed by the Este (Lucrezia was known to spend an entire day washing her hair). Duke Ercole I (1431–1505) and Eleonora of Aragon (as already mentioned) both had baths near their quarters, and in the early sixteenth century Duke Alfonso I built a special bathing structure in the Castellina, a garden against the city walls which was a particular favorite of Lucrezia and her ladies-in-waiting.[28] As Jennifer Webb points out in her chapter in this volume, Duke Federigo da Montefeltro of Urbino especially valued the health benefits of cleanliness, and he had a bath installed below his private quarters so that he could ride into the castle and bathe before entering his rooms. While *bagni* often had tubs in which one could submerge oneself, we know from other sources that steam rooms and rooms for rest and conversation were also an important part of bathing rituals, which were a very social activity.[29]

In October 1506, after going through all the work of constructing and finishing her suite of rooms, Lucrezia suddenly moved into the Palazzo di Corte on the other side of the Via Coperta and began the whole renovation process anew. Something serious must have happened to precipitate this, since the documentary record suggests that her rooms were exquisite. Two reasons have been proposed for the shift. One is that Alfonso wanted to expand his quarters into the ravelin in which Lucrezia's rooms were located, and requested that she relocate. A second and more likely possibility is that her move was a result of the 1506 assassination attempt on Alfonso and his brother Cardinal Ippolito by their half-brother Don Giulio and brother Ferrante d'Este.[30] Alfonso promptly executed the non-noble accomplices, but as his brothers stepped up to the gallows, he commuted their sentences and imprisoned them for life. They were confined to specially constructed dungeons in the Torre dei Leoni directly below Lucrezia's newly completed hanging garden and loggia. Perhaps the constant proximity to the condemned men was unsettling to the Duchess and her ladies-in-waiting, one of whom had been in love with Giulio.[31]

Lucrezia moved into the former quarters of her father-in-law Ercole as well as co-opting his old music room. She created a two-storey suite in which her public reception and dining room, the *salotto*, as well as the *guardaroba* and the rooms where her ladies in waiting slept were directly below her two *camerini* and private *oratorio*. As before, vaults and staircases were created, friezes were painted and cornices were gilded.[32] Since Ercole had installed marble floor tiles, she might have been able to make use of these.[33] The rooms were comfortably heated, since documents refer to two *stue* or stoves in the downstairs *salotto* and its adjoining room.[34] She probably used her father-in-law's former baths on the ground floor of the palace.[35] There was no direct access into her bedroom from Alfonso's rooms, although she was still close to

the Via Coperta. In the move, Lucrezia lost her garden terrace, but she had a balcony overlooking the ducal garden and also a view of the kitchen courtyard. The latter might not have been lovely, but it would have been interesting. She might also have been able to look out onto the grand *cortile*.[36] In January 1508, a pregnant Lucrezia was said to sit all day long behind the windows with her *donzelle*, enjoying the activities below.[37] Views onto the outside world would have been psychologically important to the women of the court, as they could not often venture out in public.

For information about what might have been in Lucrezia's rooms, inventories list vast amounts of wall coverings, bed curtains, glass, silver and bronze cups and plates, as well as chapel decorations and liturgical equipment including relics, reliquaries, medals with images of Christ and the saints, carved and jeweled crosses, and devotional paintings.[38] Most of these items would have come with her from Rome on the 150 mules that carried her trousseau to Ferrara, but some she commissioned in Ferrara. Such objects contributed to the splendor of her environment, to use a term that the Neapolitan humanist Giovanni Pontano employed in his 1498 text *De Splendore* when differentiating between buildings, which were an expression of magnificence, and splendor, which best expressed luxurious clothes and interior decorations. As was traditional in Renaissance discourses concerning material culture, virtue was attached to personal and environmental elegance.[39]

In terms of paintings, Lucrezia's tastes ran very much to sacred art, although one cannot precisely match documents to known works. In 1507, she commissioned a half-length devotional image from the painter Bartolommeo Veneto, a Venetian from Cremona whose name appears in her books between 1505 and 1508. She requested an image of the Virgin Mary with Christ in her arms, surrounded by Saints Jerome and John.[40] Ludovico Mazzolino, so often mentioned in the Duchess' account books, is also likely to have painted devotional images for her. The Florentine painter Fra Bartolommeo painted a (now lost) head of Christ for the Duchess in 1517. Lucrezia's extraordinary religiosity must have impressed the artist, because he was concerned that it be emotionally compelling enough for her.[41] Such a work would have been perfect for Lucrezia's private chapel.[42]

One of the sacred objects that the duchess brought from Rome was a large silver *ancona* or altar, bearing Borgia arms, studded with jewels and with niches filled with carved figures that was displayed at the head of the bed.[43] As in other renaissance domestic spaces, the sacred and the secular comingled: apparently Lucrezia owned a modern copy of Isabella d'Este's much-prized Praxitilian sleeping cupid.[44] In 1508, the humanist and courtier Mario Equicola (1470–1525) wrote to Isabella in an outraged tone that he had discovered Latin epigrams by Ercole Strozzi (1473–1508), originally written for her cupid, that had been changed to praise Lucrezia's "inferior" modern sculpture.[45] Although Isabella owned many copies of ancient sculpture, here Equicola is praising the *marchesa*'s taste at the expense of Lucrezia's,

thus feeding the competition between the two women. In order to strengthen his own position at the court in Mantua, he cleverly used Isabella's self-identification as a connoisseur of the antique to his own advantage. One again wonders if Lucrezia felt she needed to own *all'antica* works of art to fit into the courtly world of the Este.

While the descriptions of the ornate ceilings and friezes in the upper parts of Lucrezia's *castello* suite are useful indicators of the beauty and degree of fine workmanship they contained, they were a framework, or a visual completion of luxurious decorative schemes that appeared on the walls and in the spaces below. For the sixteenth-century viewer, the most striking parts of Lucrezia's rooms would have been the costly fabric decorations adorning the beds, walls, and tables. As Peter Thornton has pointed out, one misses the whole effect of Renaissance spaces when seeing them now because the walls are most often completely barren; in the sixteenth century, decorations would have covered almost every square inch of the room. For example, I have already discussed the architectural components of Lucrezia's bedroom in the ravelin of the *castello*: the painted friezes, gilded cornices, and blue and gold roses on the ceiling. In addition to these, payments to Sigismondo de Paxino, professional embroiderer, reveal that in 1506 the room was also adorned with black silk panels with gold embroidery (her favorite color combination); thus we must adjust our mental picture of the room.[46] A few months later, de Paxino was again paid for gold thread, this time to embellish the crimson velvet wall hangings of Lucrezia's private chapel.[47] Crimson or *chermiso* was one of the most expensive dyes, making the wall hangings the height of luxury. For a duchess, this magnificence was not a mere indulgence; it would have been construed as a virtue.

Here again, one is grateful to Isabella d'Este's insatiable curiosity about the possessions and lifestyle of her female peers. Il Prete sent one of the first accounts of Lucrezia's living spaces in June 1502, a few months after her marriage to Alfonso. The first room had a bed curtained in fantastically expensive *alessandrino* blue silk, one tapestry-covered table, and another covered in green velvet. In a corner was a bench, the back of which was in blue velvet, with a silk seat upon which Lucrezia's devices were embroidered. The bed in the next room had a *sparaviero* (a bed hanging that pulled back like a bird's wings) of the most expensive cambric linen, appropriate for summer, silk *spalliere* (shoulder-height wall hangings) with gold fringes, and carpets everywhere.[48]

The most comprehensive description of the Lucrezia's use of luxury textiles was written in 1508, after the birth of her son and heir Ercole II. The courtier Bernardo da Prospero was clearly under orders to give the *marchesa* every detail of the lying-in chambers, which were in Lucrezia's newer rooms in the Palazzo di Corte.[49] The highlights of his accounts are as follows: the *salotto* was being used as a dining room (in accordance with the documents cited earlier) and it had a tapestry tablecloth on a table with a *spalliera* or back cloth and benches. As Katherine McIver notes in her chapter in this volume,

upper-class women often dined in their own quarters.[50] Prospero then entered an antechamber with a bed curtained in dark purple satin embroidered with vines and flowers that he recognized as having belonged to Isabella's mother. It is important to note here that Lucrezia's inventories list numerous satin bed curtains, overhead curtained pavilions, testers, and *sparavieri*. She also had countless chests full of uncut fabric that she could have had fashioned for the purpose. Lucrezia may have consciously chosen to display Eleonora's bed hangings in order to liken herself to her popular predecessor, who set an excellent example for the duchess in her magnificence, piety, ability to rule in her husband's absence, and of course fecundity. Ann Rosalind Jones and Peter Stallybrass have discussed how clothes given as gifts or bequests in the Renaissance were thought to bear the qualities, identity, and "social memory" of the original owner; one might say that Lucrezia successfully used bed hangings to conflate her "self" with that of the revered former duchess.[51] The expensively hand-embellished fabrics also honored the memory of her husband's mother and functioned as a significant marker of dynastic continuity. Like Eleonora, Lucrezia had at this point borne a healthy male heir for the Este, contributing to future political stability in Ferrara and its territories.

The walls of this room were curtained from the soffit to the floors with historiated silk and wool tapestries. Prospero notes that one of the tapestries displayed the scene from the Old Testament story of Susanna and the Elders, specifically the moment when Daniel separates the Elders and proves the innocence of Susanna. Lucrezia, who could have chosen from any number of historiated tapestries in her own or the Este collections, might have consciously selected this subject to speak to her own history. Prior to her new start in life as Alfonso d'Este's bride, her reputation had suffered from the connection with her licentious father Pope Alexander VI and her brother Cesare Borgia. Like Susanna, the honorable woman who was falsely accused of lechery, Lucrezia might have wanted to reassert her honor and virtue, and hence her suitability as an Este duchess and mother.

One of the smaller rooms had a pavilion-style bed canopy pulled back in a *sparaviero* which was made of gold and silver threaded lace lined with satin in the Estense colors of red and white. The lace would have been another subtle hint as to the Duchess' virtue. It was often associated with the work of women in convents, and was originally used in liturgical garments altar cloths and bridal veils.[52]

The Duchess' own room must have looked exceptionally elegant. Bernardo da Prospero discusses a *sparaviero* of silver cloth, fringed on top with silk and gold threads. Her sheets were of the finest striped cambric linen, and around the room were wall curtains of purple and crimson velvet and of gold cloth. One notes how for each bed and each set of wall hangings in Lucrezia's quarters, Prospero carefully lists the fabrics, their types, and their colors. Scholars of dress and textiles such as Carol Frick and Lisa Monnas have shown how luxury fabrics were an essential part of the material culture of

the Renaissance in terms of how one clothed oneself.[53] In the courtly world, where the sumptuary laws of cities such as Florence and Venice did not exist, both dress and room decorations could be as extravagant as income allowed. We know that silks, satins, and velvets were extremely expensive in general, taking months to hand loom, and the sheer quantities needed to surround beds and cover walls would have been far greater than those used in clothes. In addition to the obviously luxurious gold and silver fabrics, many of Lucrezia's *apparamenti* were dyed with the finest and most costly colors. As well as the crimson used in her *oratorio* and the enormously expensive blue called *alessandrino* bed hangings seen in 1502, the rare purplish *pavonazzo* also figures in the bolts of silk listed in her inventories. That Isabella d'Este, a woman for whom paintings and antiquities were a huge passion, was equally interested in the textiles adorning Lucrezia's chambers informs us of the significance of tapestries and luxury fabrics in courtly living spaces.[54]

After the tour through normally private rooms staged to define the duchess as a magnificent and virtuous mother, Bernardo da Prospero was allowed to see the infant Ercole II, who was ensconced in a cradle that was so elaborate that the courtier was not sure that he could describe it properly. It was the work of Bernardino da Venezia, the maker of the large roses for Lucrezia's bedroom and her elegant doorframes. At the time of his visit, the baby was in one of the Camerini Dorate, a suite of rooms that had been specially renovated and decorated by Ercole I in the Palazzo di Corte in 1479 for the use of visiting dignitaries. Clearly for the Este, the birth of the male heir was a state occasion warranting the use of these rooms, handily contiguous to Lucrezia's quarters. The cradle was under a tent-like apparatus with Moorish-style striped silk draperies in the Este colors. Here, one can tell that Bernardo da Prospero feared that his memory would not be precise enough for the *marchesa*, because he writes "the cradle was made in such a way that I don't know if I can describe it to your Excellency." It was on a platform encased in an enormous *all'antica* carved and gilded canopy "six feet long and five feet wide" complete with carved garlands on the architrave. It was canopied and curtained in white satin, and was suspended on poles inside a carved and gilded shell that made it look to Prospero like a "sacrificial altar." He also noted the gold cloth covering the baby, under which were striped and embroidered linens.[55]

This was not an isolated phenomenon; guests attending the festivities surrounding the birth of Beatrice d'Este and Ludovico Sforza's son Massimiliano in Milan in 1494 made a similar procession through fully adorned bedrooms. After seeing the Sforza heir, also in a four-poster cradle covered in white satin, the visitors were led out to the main audience hall to congratulate the Duke.[56] In a similar fashion, viewers passed through Lucrezia's chambers and were transitioned to the semi-public setting of the Camere Dorate for viewing the child, located right next to the palace audience hall. There was a distinctly gendered nature to this ritual, in that the procession through the lying-in spaces led the visitor from the feminine private to the stately public realm of the male ruler. The heir was placed

right at the nexus between the private and the public, between mother and father. It seems no accident that the white and gold fabrics surrounding him were the same colors used in ducal investiture ceremonies, thus affirming his legitimacy.

The document gives one a sense of the highly ceremonial nature of courtly birth celebrations and of the important role of magnificence expressed in opulent tapestries and sumptuous beds. While the *pièce de la resistance* was clearly the cradle, Lucrezia's own rooms were carefully staged to depict her as an ideal Este duchess. She displayed the much-revered former duchess' bed hangings alongside tapestries with stories of female virtue in order to assert a self-identity as an honorable woman.

More research needs to be done on the courtly living spaces and the objects used in the lives of Renaissance noblewomen. The building documents concerning Lucrezia Borgia's quarters show that she took as much care as did her husband and sister-in-law, two of the most famous patrons of art in the sixteenth century, in planning elegant yet functional quarters. She had the necessary antechambers for guards or waiting visitors, and there was always a *salotto* in which she received visitors and dined with her ladies-in-waiting. Other rooms for reading, needlework, music, or conversation were also included, with glass windows for adequate light. Below her private bedroom, baths and a relaxation area called a grotto were also created, for both health and comfort. Oratorios for private devotions were indispensable, and one was constructed in both sets of quarters, despite the existence of a nearby court chapel. Lucrezia oversaw a large group of artists in commissioning paintings for her room in the Marchesana Tower and planned extravagant architectural details for her other rooms, including painted friezes, gilded cornices, and intricately wrought wooden ceilings. Where her courtly counterparts Alfonso and Isabella commissioned cycles of oil paintings or frescoes, Lucrezia chose shimmering swaths of extremely costly fabrics and tapestries. When these were suspended from gilded cornices with painted friezes, an astounding effect must have been produced. Although most Renaissance textiles have not survived, they were an essential part of the visual experience of courtly interiors, as were the precious devotional objects such as paintings, altars, and liturgical instruments that she must have used and enjoyed on a daily basis. The splendor of Lucrezia's domestic decorations enhanced her virtue as a ruling female, thus inscribing her into Estense dynastic history while at the same time creating new histories for the family.

Notes

1 Marta Ajmar-Wollheim and Flora Dennis (eds), *At Home in Renaissance Italy* (London: V&A Publications, 2006); Patricia Fortini Brown, *Private Lives in Renaissance Venice* (New Haven: Yale University Press, 2004); James R. Lindow, *The Renaissance Palace in Florence: Magnificence and Splendour* (Burlington VT: Ashgate, 2007).

2 Luciano Cheles, *The Studiolo of Urbino: An Iconographic Investigation* (University Park: Penn State University Press, 1986); Thomas Tuohy, *Herculean Ferrara* (Cambridge: Cambridge University

Press, 1996), Evelyn Welch, *Art and Authority in Renaissance Milan* (New Haven: Yale University Press, 1996); Clifford M. Brown, *Isabella d'Este in the Ducal Palace in Mantua* (Rome: Bulzoni, 2005); Molly Bourne, *Francesco II Gonzaga: the Soldier-Prince as Patron* (Rome: Bulzoni, 2008); Charles Rosenberg (ed.), *The Court Cities of Northern Italy: Milan, Parma, Piacenza, Mantua, Ferrara, Bologna, Urbino, Pesaro, and Rimini* (Cambridge: Cambridge University Press, 2010). Two object-based studies in the Mantuan context are Lisa Boutin, "Displaying Identity in the Mantuan Court: The Maiolica of Isabella d'Este, Federico II Gonzaga, and Margherita Paleologa" (PhD dissertation, University of California, Los Angeles, 2011); Evelyn Welch, "The Art of Expenditure: The Court of Paola Malatesta Gonzaga in Fifteenth-Century Mantua," *Renaissance Studies* 16(3) (2002): 306–17. In covering the *marchesa*'s overall spending, Welch lists some of the luxurious objects that decorated her apartments, and they are similar to those listed in Lucrezia Borgia's inventories.

3 The literature on Alfonso d'Este's Camerini is vast: Alessandro Ballarin, *Il camerino delle pitture di Alfonso I d'Este* (Cittadella [Padua]): Bertoncello Artigrafiche, 2002–7); Antony Colantuono, *Titian, Colonna and the Renaissance Science of Procreation* (Burlington VT: Ashgate, 2010). On the decorations of Isabella d'Este's *studiolo*, see Stephen J. Campbell, *The Cabinet of Eros: Renaissance Mythological Painting and the Studiolo of Isabella d'Este* (New Haven: Yale University Press, 2004); for her antiquities collection, see the publications of Clifford M. Brown in the bibliography of Brown, *Isabella d'Este in the Ducal Palace in Mantua.*

4 A version of this chapter was given at the Renaissance Society of America Conference in April 2010. Part of the research for this chapter was conducted in the Archivio di Stato and the Biblioteca Estense in Modena. The staff of the library and archives were most helpful, especially Angelo Spaggiari and Giuseppe Trenti. The documentary record of Lucrezia Borgia's expenditures is not complete, covering mainly the first few years of her reign. Since my archival research was completed some of her account books have been published: Alessandro Ballarin and Maria Lucia Menegatti. *Il Camerino delle pitture di Alfonso I*, Vol. 4, *I Camerini di Alfonso I nella via coperta ed in castello* (Cittadella [Padua]: Bertoncello Artigrafiche, 2002), Chapter 3, "Il cantiere della duchessa in castello." I have followed their transcriptions when possible, but all translations are mine.

5 This is part of a larger study that I am preparing on the material culture of noblewomen's living spaces at Italian courts.

6 Raffaella Sarti, "Renaissance Graffiti: The Case of the Ducal Palace of Urbino," in *Domestic Institutional Interiors in Early Modern Europe*, edited by Sandra Cavallo and Silvia Evangelisti (Burlington, VT: Ashgate, 2009), 51–81.

7 More research is needed into the extent to which the lives of female noblewomen were lived in the "official" areas of courtly residences, and how closed their own quarters were to visitors.

8 On the importance of dress, see Carole Frick, *Dressing Renaissance Florence* (Baltimore: Johns Hopkins University Press, 2002). For descriptions of Lucrezia Borgia's clothes, see Polifilo [Luca Beltrami], *Inventario della guardaroba di Lucrezia Borgia* (Milan: U. Allegretti, 1903); and Rosita Levi-Pisetzky, *Storia della costume in Italia*, Vol. 3 (Milan: istituto editoriale italiano, 1966). For her wedding finery, see Michele Catalano, *Lucrezia Borgia* (Ferrara: A. Taddei, 1920), 13, 66–8.

9 On the duchess' land reclamation projects and construction of mercantile and convent spaces, see Diane Yvonne Ghirardo, "Lucrezia Borgia as Entrepreneur," *Renaissance Quarterly* 61 (2008): 53–91; and "Lucrezia Borgia's Palace in Renaissance Ferrara," *Journal of the Society of Architectural Historians* 64(4) (2005): 474–97.

10 Scholarly biographies of Lucrezia Borgia include: Ferdinand Gregorovius, *Lucrezia Borgia* (orig. 1874; New York: D. Appleton, 1904); Maria Bellonci, *Lucrezia Borgia, sua vita e suoi tempi*, revised edn (Milan: Mondadori, 1960); Nicolai Rubinstein, *Lucrezia Borgia* (Rome: DBI, 1971); Catalano, *Lucrezia Borgia*; Anna Maria Fioravanti Baraldi, *Lucrezia Borgia "la beltà, la virtù, la fama onesta"* (Ferrara: G. Corbo, 2002); L. Laureati, *Lucrezia Borgia [Ferrara, Palazzo Bonacossi, October 5–December 15, 2002]* (Ferrara: Ferrara arte, 2002).

11 Recent literature includes Katherine McIver, *Women, Art, and Architecture in Northern Italy 1520–1580* (Burlington, VT: Ashgate, 2006); Brown, *Isabella d'Este in the Ducal Palace in Mantua*; Tuohy, *Herculean Ferrara*, Chapter 3. For female patronage among the nobility in general, see Cheryl E. Reiss and David Wilkins (eds), *Beyond Isabella: Secular Women Patrons of Art in Renaissance Italy* (Kirksville, MO: Truman State University Press, 2001).

12 Tuohy, *Herculean Ferrara*, 100–101.

13 Ibid., 108–15. This portion of the Estense palace and castle complex is no longer in existence. Anna Sforza died in childbirth in 1497.

14 William Prizer, "Isabella d'Este and Lucrezia Borgia as Patrons of Music: The Frottola at Mantua and Ferrara," *Journal of the American Musicological Society* 38(1) (Spring 1985): 1–33 at 11–12. He was paid 372 lire a year, only slightly less than her favorite court musician, Tromboncino, and the poet Antonio Tebaldeo who functioned as her secretary.

15 Prizer, "Isabella d'Este and Lucrezia Borgia as Patrons of Music," 7–13.

16 Lewis Lockwood, *Music in Renaissance Ferrara 1400–1505* (Cambridge, MA: Harvard University Press, 1984). See also Maria DePrano's chapter in this volume.

17 Tuohy, *Herculean Ferrara*, 200; Chapter 7 has a most useful discussion of the terminology and types of architectural forms used in Ferrarese construction.

18 ASMo (Archivio di Stato, Modena) Memoriale, 1505, p. 95: "A mistro domenego dale nape per conto de la selega de batu(do) che lui fece in suso el saloto ap(pre)so el pesolo …; a paulo de bressa per resto de avere messo de oro le cornixe del saloto" (payment to Master Domenego de la Nape, for having made a floor of *batudo* on the large salon near the balcony …; to Paolo da Brescia for having put gold on the cornices of the large salon). On December 31, 1505, a summary of work done on the Duchess' room includes "It(em) p(er) ave(re) fato colone sedexe i(n) lo saloto de madama alte p. 5 (2m, 6.5') luna cornisade con (base?) e capitelj …; per avere fato el corniso(ne) sopto le dite colopne et friso et architravo longo p 90 (36 m, 118')". "Item, for having made 16 columns in the large salon of Madam, 5 feet high, finished with bases and capitals …; for having made the large cornice above the said columns and the 90 foot long frieze and architrave". Ballarin and Menegatti, *Il Camerino delle pitture di Alfonso I*, 131–2. See Tuohy, *Herculean Ferrara*, 205 regarding *batudo*.

19 A payment in the December 31, 1505 summary of work for having "smalta(to) i(n) suso el pesolo dove depi)n)xe m(aestro) michele" (varnishing in the balcony where Master Michele was painting). Ballarin and Menegatti, *Il Camerino delle pitture di Alfonso I*, 141.

20 "Heri vidi li camerini che fa fare la S(ignora) Duchessa, li quail serano belisimi, e cussì uno salotto dove è il pozolo." Catalano, *Lucrezia Borgia*, 81.

21 1506, August 5: "L. 14, m. a Mro. Benvegnudo da Garofalo depintore … per havere depinto a guazo doe telle istoriate che sono andate nel Cielo de la camara in Volta de la torre marchesana dove stantia Sua Sria" (14 lire to master Benvenuto da Garofalo, … for having painted in distemper two figured canvases that were placed in the ceiling vault of the Torre Marchesana where Her Highness lives). Archivio di Stato, Modena (ASMo), Camera Ducale, Amministrazione dei Principi, Lucrezia Borgia, Reg. 1133, Dare e Avere, 1506. The summary of the payments shows the various salaries of the artists according to rank and number of paintings completed:

"m Nicola pixano per doe tele depinte	L. 14
m Benvegnudo da garofalo per doe tele depinte	L. 14
domenego paneto per doe tele	L. 9
hectore depinctore per doe tele	L. 5
m. michelotto depintore per doe tele	L. 5
bigo manzolino per doe tele	L. 5"

ASMo, Camera Ducale, Amministrazione dei Principi, Lucrezia Borgia Reg. 1138 Inventari Guardaroba, 1506–8, p. 22.

22 Three payments within the long summary made on December 31, 1505: "Per avere facto uno solaro longo pedi 14 ½, largo pedi 14½ (5.8 x 5.8 m, 19'), de travi veronexi fato de sesti e de terzi, e sopra li diti la travatura de travi a quadrun de due televi fato a octo cantun, e quelo de mezzo è fato tondo con lo suo cornison e friso e architravo." "For having made a ceiling 14½ feet by 14½ feet of Veronese wood made in sixths and thirds, and above the abovementioned framework of the beams are two squares containing eight parts, in the middle of which was a tondo, with its cornice and frieze and architrave"; "Per avere fato uno sufita in lo camarin appresso de la Via Coperta longo piedi 15, largo 9-2/3 (6 x 3.86m) fato a q(ua)dri bislonghi e a tondi, religadi i(n)sieme co(n) lo friso, cornise e archi travo." "For having made a ceiling in the room near the Via Coperta 15½ feet long by 9-2/3 feet wide, made in oblong squares and with a tondo, confined within the frieze, cornice and architrave"; "per avere fato uno pezo de solaro ap(pre)sso lo oratorio dove era j(una?) fogara" (for having made a piece of a ceiling near the oratory were there was a hearth). Ballarin and Menegatti, *Il Camerino delle pitture di Alfonso I*, 132.

23 The roses were carved by Bernardino da Venezia (he also carved all the doors) and were gilded by Paolo da Brescia: "Paulo da Parma depintore per comprare peze cinquanta d'oro per compire de dorare tute le ruoxe del camarin de mezzo de Sua Signoria." "To Paolo of Parma (read Brescia) painter, for having purchased 50 pieces of gold for gilding all the roses in the room for her Ladyship". Ballarin and Menegatti, *Il Camerino delle pitture di Alfonso I*, 148. And on March 4, 1506 to Michele Costa, "depinctore per pagare onze 4 (115 gr) d'azuro fino … e onze 5 (143 gr) d'azuro grosso … per mettere ale roxe doro deli camarini de Sua Signoria." "Painter, payment for 4 ounces of fine azure and 5 ounces of rough azure … for painting on the gold roses in the little rooms of the duchess." Ballarin and Menegatti, *Il Camerino delle pitture di Alfonso I*, 150.

24 For excellent comparative material, see Brown, *Isabella d'Este in the Ducal Palace in Mantua*, ceiling of the *Grotta*, fig. 46.

25 "Et per li camerini del S(ignore), sua Ex. se poterà condure in camera de la p(or)ta Signora senza essere visto da persona e senza che veruno lo intenda, se non quanto a loro piacerà, per confinare le proprie stantie de l'uno cum l'altre." "And for the rooms of the Signore, his Excellency will be able to

go by the door into the rooms of the Lady without being seen by anyone whom they don't intend, and if they don't want to, they can each stay in their own rooms." Catalano, *Lucrezia Borgia*, 81.

26 Leon Battista Alberti, *On the Art of Building in Ten Books*, translated by Joseph Ryckwert, Neil Leach and Joseph Tavernor (Cambridge, MA: MIT Press, 1988), Book V, 149.

27 An analysis of the documentary record concerning Lucrezia's bath and grotto, which may not have been finished when she abandoned the rooms in 1506, can be found in Ballarin and Menegatti, *Il Camerino delle pitture di Alfonso I*, Vol. 4, Appendix 1, 184–9.

28 Alfonso d'Este's construction documents regarding the Castellina in the Archivio di Stato, Modena have yet to be published. For references, see Allyson Burgess Williams, *"Le donne, i cavalier, l'arme, gli amori*: Artistic Patronage at the Court of Alfonso I d'Este, Duke of Ferrara" (PhD dissertation, University of California, Los Angeles, 2005), 17, 18, and note 52.

29 On bathing in the Renaissance, see Stephanie Hanke, "Bathing all'antica: Bathrooms in Genoese Villas and Palaces in the Sixteenth Eentury," in *Approaching the Italian Renaissance Interior: Sources, Methodologies, Debates*, edited by Marta Ajmar-Wollheim, Flora Dennis and Ann Matchette (Oxford: Blackwell 2007), 674–700; Richard Palmer, "'In this our Lightey and Learned Time': Italian Baths in the Era of the Renaissance," *Medical History* 10 (1990): 14–22. For Ercole I's baths in the Palazzo di Corte in Ferrara, see Tuohy, *Herculean Ferrara*, 85.

30 On the plot to assassinate Alfonso and Cardinal Ippolito I, see Riccardo Bacchelli, *La congiura di Don Giulio d'Este* (Milan: Mondadori, 1983); Ballarin and Menegatti, *Il Camerino delle pitture di Alfonso I*, 162.

31 The payment registers of the Munizione e Fabbriche show that Alfonso took over Lucrezia's former spaces in the ravelin, and finished the bath and grotto.

32 Ballarin and Menegatti, *Il Camerino delle pitture di Alfonso I*, 173. One does not know if she transferred the ceiling paintings from the Camera Marchesana to her new quarters.

33 On the layout and design of Ercole I's rooms in the Palazzo di Corte, see Tuohy, *Herculean Ferrara*, Chapter 3 passim, but particularly 79–83.

34 Payments of November 16, 1506. Ballarian and Menegatti, *Il Camerino delle pitture di Alfonso I*, 168.

35 It would be interesting to know if Lucrezia had access to Leonello d'Este's famous intarsia *studiolo* which Ercole had installed above a loggia in the garden. On the location of Ercole's baths and the studiolo, see Tuohy, *Herculean Ferrara*, 81.

36 It is difficult to ascertain the scope of Lucrezia's suite, as it was dismantled and restructured shortly after her death to accommodate Alfonso's courtiers. The layout of the Palazzo di Corte has since been altered so drastically that one can only estimate exactly how far her suite extended and compare her construction documents with what is known about Ercole's rooms.

37 Bernardino Prospero to Isabella d'Este, January 8, 1508: "Madona e ne sta quasi tuto il giorno al fenestron de la Sala grande … e lì cum le sue done e cum le alter curiale pigliono piacere de vedere e de volere conoscere quante (maschere) ne vano intorno" ("My Lady sits almost all day at the big window of the large room … and there with her ladies and the other members of her court they take pleasure in seeing and wanting to know what is going on in the area"). Catalano, *Lucrezia Borgia*, 80.

38 Polifilo (Luca Beltrami), *La Guardaroba di Lucrezia Borgia* (Milan: Umberto Allegretti, 1903).

39 Lindow, *The Renaissance Palace in Florence*, Introduction and Chapter 1. For a Ferrarese humanist's views on magnificence, see Werner L. Gundersheimer, *Art and Life at the Court of Ercole I d'Este: The "De triumphis religionis" of Giovanni Sabadino degli Arienti* (Geneva: Libraire Droz, 1972).

40 March 16, 1507: "Spesa della Duchessa. – L. 20m. dovute – a Mro. Bartol.o da Vinegia depintore per il precio di un quadro di legname tuto dorato como le sue colone, como una meza figura di nostra dona, como el suo fiollo in braze et uno Sam Giroleno et san Zoanne, et uno specchio dj azale di bona grandeza" ("Accounts of the Duchess – 20 Lire owed to Master Bartolomeo da Venezia for the cost of a panel in wood all gilded with columns with a half-length figure of Our Lady, with her Son in her arms and a Saint Jerome and Saint John, and a good sized mirror"). ASMO Camera Ducale, Amministrazione dei Principi, Lucrezia Borgia, Busta 1131: Memoriale 1507–9, 14. I have not found a work by Bartolommeo Veneto matching this piece, but there is a *Holy Family with Saints Jerome and John* in the Galleria Sabauda, Turin, and possibly another in the Uffizi, Florence, which might have been commissioned by Lucrezia.

41 June 14, 1517, letter to Alfonso d'Este, for whom he was painting the *Festival of Venus*: "Con questa anchora mando una Testa del Salvatore alla Ill.ma S. della quale sendo io costi epsa fui richiesto. E se forse no sia depicta con qualla affectuosa devotione qual lei desiderava, attribuisca alla mia arida mente" ("With this I also am sending a head of the Savior to the Illustrious Lady which I am sending because she requested it. And if it is not depicted with the compelling devotion that she desired, attribute it to my arid mind"). Cited in Vincenzo Marchese, *Memorie dei più insigni pittori, scultori e architetti Domenicani*, 2 vols (Bologna: 1878), Vol. 2, 179.

42 Private chapels were common in princely palaces, where familial connections to cardinals and the papacy would make it easy to secure the necessary permissions, but they were only in the dwellings of the wealthiest families in cities such as Florence. On domestic devotional practices in Florence and Venice, see Philip Mattox, "Domestic Sacral Space in the Florentine Renaissance Palace," *Renaissance Studies* 20(5) (2006): 658–73; and Margaret Morse, "Creating Sacred Space: The Religious Visual Culture of the Renaissance Venetian Casa," *Renaissance Studies* 21(2) (2007): 151–84.

43 "Una ancona grande di argento adornata di petre molte cum le aperture sue inataliate di figure in fogliami et cum l'arma della S.a in cima et è cosi da tenire in capo al letto." 1516. Giuseppe Campori, *Raccolta di cataloghi inventarii inediti* (Modena: Carlo Vincenzi, 1870), 36.

44 By 1506, the Praxitilian cupid was on display in Isabella's rooms along with Michelangelo's version of the same subject.

45 "Vedendo l'altro heri le cose de m. Hercule Stroza f. r. trovai alcuni epygrammi il titolo de quali era *in Cupidinem marmoreum … Ill.mae et Ex. D. Lucretiae Borgia.* Posseno essere circa quindici, li quali tucti erano facti per il nostro della isabellica grypta, cosi haveria jurato, pur me dava admiratione che in le laude de Borgia se extendevano nominandola. Non era, como non so, per patere tale barraria et bestiale ambitione..adjungendome ira a mutare de titolo se tentava fare in lo libro Corezesco … Trovo la Duchessa havere uno Cupidine che dorme como quel de V.S.I et è cosa nova, et vogliono persuadere sia vecchia. Io ho deliberato scoprire tanta ambition er fare cognoscere che le scimmie (con reverentia de V.S.) quanto più se alzano più mostrano le parti pudibonde." Alessandro Luzio, "Isabella d'Este e i Borgia," *Archivio Storico Lombardo* 5(61/62) (1914–15): 736.

46 Ballarin and Menegatti, *Il Camerino delle pitture di Alfonso I*, 149.

47 Ibid., 155.

48 Letter of Il Prete to Isabella d'Este, June 4, 1502. Campori, *Raccolta di cataloghi inventarii inediti*, 81.

49 Letter of Bernardo Prospero to Isabella d'Este on April 27, 1508. Catalano, *Lucrezia Borgia*, 81–2.

50 See Katherine A. McIver's chapter in this volume.

51 Peter Stallybrass and Ann Rosalind Jones, *Renaissance Clothes and the Material of Memory* (Cambridge: Cambridge University Press, 2000), introduction, passim.

52 Lidia D. Sciama, "Lacemaking in Venetian Culture," in *Dress and Gender, Making and Meaning in Cultural Contexts*, edited by Ruth Barnes and Joane Bubolz Eicher (Oxford: Berg, 1992), 121–44.

53 Frick, *Dressing Renaissance Florence*, 2002; Lisa Monnas, *Merchants, Princes and Painters. Silk Fabrics in Italian and Northern Paintings, 1300–1550* (New Haven: Yale University Press, 2009).

54 In *Isabella d'Este in the Ducal Palace in Mantua*, 39, Brown notes how little is known about the textiles used by Isabella.

55 "In la camera dorata, contigua ali dicti camerini, sta il putino in una *camereta da campo de bachete* … É coperta tuta da raxo, listato ala moresca, biancho cremexin e altri colori. La camera apparata intorno de pani di raci; poi g'é la cuna, posta denanci al lecto d'epsa camera, che é facto in modo ch'io non sciò se poterò descriverla ala S.ria V. Prima é facto uno quadro longo circa sei piedi e larco circa cinque, cum uno montare di uno scalino, coperto il piano de pano biancho. Et per ogni cantone ge é una bassa quadra al antiqua, alta uno pede e mezzo, or circa, suso le quale surgon quatro colunne, che sustengono uno bellissimo architravo cum sue cornise, supra il quale architravo nasce uno fogliame intagliato che abraza da una colonna all'altra per ogni quadra. Questo tuto, ch'io ho dicto, é posto d'oro senza altri colori e é apparato de cortine de raxo biancho e cussì il capitello. In mezzo a questo quadro ge é una cuna in *nova fosa*, che dimonstra quasi uno sacrificio al antica, cioé uno *saxo*, quadro de sopra, ma concavo, che tiene la cuna in *polexi* e descende, sminuendosse cum certi ritorti, in modo che viene a riposare in uno pede, e é il tuto dorato come é il cesto. Supra la cuna é e uno conperturo de talla d'oro cum li suoi lenzolecti de cambraia listati e cum certo drapo de lino lavorato bellissimo." Campori, *Raccolta di cataloghi inventarii inediti*, 81–3.

56 Welch, *Art and Authority in Renaissance Milan*, 226.

"All that is Seen":
Ritual and Splendor at the Montefeltro Court in Urbino

Jennifer D. Webb

"The dignity of the signore[1] manifests itself in all that is seen" remarked the author of the *Ordine et officij de la casa de lo Illustrissimo Signor Duca de Urbino* (*The Rules and Offices of the Court of the Duke of Urbino*) (urb.lat.1248) (1482–9).[2] In this text, the author, likely the *maestro di casa* or head servant, provides a generic manual for running a Renaissance *casa* or household, modeled on the Montefeltro court during the reign of Federico da Montefeltro (1422–82). Renaissance courts were centers of learning and humanist discourse, and sites for entertainment and conviviality. Rituals perceived as methods of institutional display emerged out of domestic practices conceived largely to suit the needs of and please the signore. The interests and personal preoccupations of Federico da Montefeltro affected life at the court on every level. While his love of music, intellectual conversation, and study influenced the decoration of the palace, his personal preoccupations and needs guided all of the rituals of life. Together all of these elements of court life also displayed the dual Renaissance virtues of magnificence and splendor.

All of Federico's residences were to be seen and experienced, meaning that, as in many a Renaissance household (*casa*), all aspects of life were carefully choreographed. Food preparation and presentation is addressed in a number of the individual chapters of the *Ordine et officij*. Ritualized practice, which also included hand-washing, emerged in response to Federico's anxieties and then became just as integral a part of institutional practice as dining, gaming, dancing, or conversation.[3] This chapter weaves close analysis of the *Ordine et officij* and the physical fabric of the Palazzo Ducale in Urbino together with theoretical discussions of "home" and "place." All of these factors demonstrate that at the fifteenth-century Montefeltro court, domestic and institutional practices were indistinguishable and helped to fashion a very particular image of the signore, his family, and the *casa* as a whole. Such rituals made a space like the Palazzo Ducale a "home" rather than just an institution.

The preserved version of the *Ordine et officij* is a copy after the original dating between the death of Federico da Montefeltro in 1482 and his son's marriage in 1489.[4] Seventy-two pages in length and divided into 64 chapters, this document, along with the rest of the contents of Federico's private library, was moved to the Vatican Collection from the Palazzo Ducale in Urbino in 1657.[5] The majority of the chapters are structured in the same way: the author provides a general overview of the household position named in the title, discusses that individual's desired character traits, and then outlines his responsibilities in detail. While the *maestro di casa* writes the text with practical application of greatest concern, in the opening and closing pages he adopts a nostalgic tone which suggests that a shift in the management structure at the court had recently occurred. The author's preference for past modes of operation is evident in his decision to record an idealized version of the *casa* during Federico's reign rather than discuss that of the Montefeltro heir, Guidobaldo, who ruled at the time of the text's completion.[6]

The author of the *Ordine et officij* certainly had, according to John Easton Law, the concerns of Federico da Montefeltro and the city of Urbino "very much in mind" as he wrote.[7] While the *maestro di casa* treats each service position with a striking level of detail, he is vague about the spaces in which various tasks would be performed. This silence, for the Renaissance architectural historian, is lamentable but understandable for several reasons. First, the *maestro di casa* wrote this text at a time when the numbers of *oeconomica* grew rapidly; the sudden popularity of such household management texts parallels the contemporary desire for etiquette manuals.[8] The interest in such manuals made writing in generic spatial terms appealing because the guidelines had more universal applicability. Second, the question of applicability was a particular concern for the *maestro di casa*. In his description of positions and their associated tasks, he needed to offer sufficient flexibility for the roles to be adapted to a newly renovated or constructed physical location. The Palazzo Ducale in Urbino was built and renovated during Federico's four-decade-long reign, requiring that the *maestro di casa* and the rest of the staff continuously rework domestic and institutional rituals to suite newly completed spaces.[9] Finally, the positions outlined in the *Ordine et officij* were not only for administration of the Palazzo Ducale in Urbino. The Montefeltro region includes a large number of different-sized residences, all of which relied on the architecture and rituals of life to display the same level of magnificence and splendor, and to provide the same quality of service to the family and their guests. Smaller palaces like those in Fossombrone and Cagli, as well as the Rocca of San Leo, housed the duke and his entourage, while the ducal palaces in Urbino and Gubbio were seen as the institutional hearts of the Montefeltro. The latter two palaces were the largest in the region and hosted not only Federico and his family but also large numbers of important guests and their households. The spaces in which the tasks outlined in the *Ordine et officij* took place varied widely, but the concerns and the practices did not.

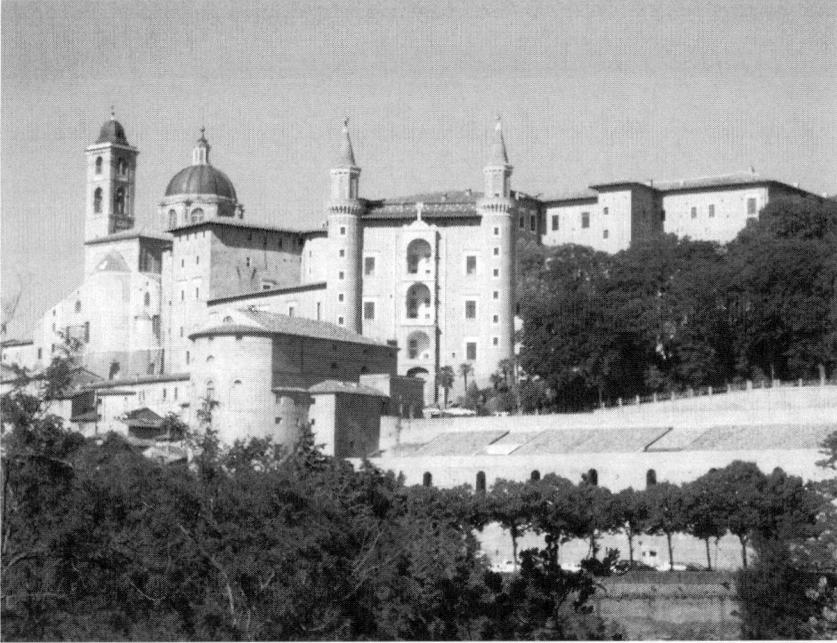

Although the *maestro di casa* was deliberately vague about where particular tasks were performed, he was clearly picturing the spatial layout of the Palazzo Ducale in Urbino as he wrote.[10] A closer examination of the palace's fabric helps to situate the imagined servants in that physical space. The largest of the buildings commissioned by Federico, the Palazzo Ducale, also shares features with many of the other buildings throughout the Montefeltro region and with Renaissance palaces in general. The main reception rooms as well as clearly defined apartments comprise the *piano nobile* and the basement includes areas for stabling horses, storage, and food preparation.[11] Access to the basement is usually by way of ramps from inner courtyards; these features appear in the Barco Ducale, Federico's hunting lodge outside of present-day Urbania, as well as in the Rocca in Sassocorvaro.[12] The elegant north-west façade with its pair of small thin towers (*torricini*) and the building's scale distinguish the Palazzo Ducale from all of Federico's other palaces and castles. For Federico, these monuments offered physical evidence of his regional domination and of the glory of the Montefeltro dynasty; thus, the Palazzo Ducale in Urbino as well as many of the other buildings executed during his rule dominate the landscape both physically and metaphorically.

The Palazzo Ducale was built beginning soon after Federico came to power in 1444 after the assassination of his legitimate half-brother, Oddantonio.[13] By 1444, Federico had already earned his reputation as a fearsome mercenary warrior and chose to build a new palace that he felt better reflected the glory of the dynasty and celebrated his personal achievements. The palace is organized around three courtyards, includes numerous apartment suites, and

very sophisticated "service" areas. One such apartment suite runs along the southern side of the *piano nobile*, while the rooms completed for Federico fill the space between the two *torricini* and include his famous *studiolo*. Raffaella Sarti considers how the study of "exposed writings" – inscriptions and graffiti – on the walls of the palace redefine divisions between institutional and domestic spaces.[14] Particular areas of the palace are often defined as purely public-institutional or purely private. The situation is much more complicated, as demonstrated in the kitchen, a space frequently seen as more private because of its domestic function. The inclusion of inscriptions and Federico's initials on the fireplace lintels assumes an audience not that distinct from that of the honorary inscription running around the Cortile d'Onore, the "public" heart of the palace.[15] Sarti concludes that the distribution of "exposed writing" proves that that there was no clear demarcation of space as public/ institutional or private/domestic in the Palazzo Ducale at the time that the *Ordine et officij* was written.

Certain spaces can be identified as more public or more private, but almost all also serve both domestic and institutional purposes. Many are intended for Federico's personal use and as a place to display his magnificence and splendor to privileged guests. The ground floor of the Palazzo Ducale is characterized by just such hybrid spaces, including reception halls, two chapels and the library suite that opens off the Cortile d'Onore. Filled with beautifully illuminated manuscripts produced in the workshop of Florentine, Vespasiano da Bisticci, and displayed on bookcases inspired by classical building façades, the library evidences Federico's exemplary humanist training, interest in antiquity, and concern with architectural design.[16] The Montefeltro eagle and golden flames that fill the vault of the suite's main room celebrate the magnificence of the dynasty as a whole. Both the design and decoration of the library identify the space as one of privilege and its holdings as personally significant to Federico. In Chapter 53 of the *Ordine et officij*, the author is primarily concerned with outlining the character of the librarian and his tasks rather than discussing specific features of the space.[17] The *maestro di casa* explains that the librarian, who also might serve as an intellectual adviser to the signore, must be of good nature, skilled in the acquisition of languages, and familiar with each of the books in the collection.[18] As in other chapters, the *maestro di casa* noted that the librarian's responsibilities included monitoring humidity to protect the books and determining whether the quality of new acquisitions met the signore's high expectations. The *maestro di casa* describes a formidable librarian whose greatest concern was the manuscripts; none could leave the building without the signore's permission; if that permission were granted, the librarian required the signature of the borrower or his agent. This position is typical of many discussed. Some of the tasks are clearly more domestic as they involved care for objects and service to the signore; other responsibilities suggest institutional concerns. The librarian served the needs and wants of the signore first and foremost, but also played an important institutional role in his negotiations with craftspeople and those visiting the collection.

Indeed, the space of the library, its contents, and the domestic concerns surrounding its maintenance, like so many other spaces within the palace, were part of a complex pageantry intended to convey magnificence and splendor.

The *maestro di casa*'s understanding of magnificence and splendor depended less on the definitions found in architectural treatises, court texts, or classical-inspired eulogies than on the idea of household efficiency and domestic practice. A *casa* that anticipated the needs of the signore and his guests and wasted neither time nor money was, in the opinion of the *maestro di casa*, the best reflection of the signore's success, his magnificence, his authority, and the sophistication of his court. The *maestro di casa* makes the significance of all this clear when, in Chapter 15 (on the items around the signore), he remarks that "the dignity of the signore manifests itself in all that is seen."[19] All of the objects should be clean, splendid, and presented with a "certain authority."[20] Thus, not just the act of patronage but also the objects and the court ritual must be understood as expressions of princely magnificence and splendor.

While much scholarly attention has been paid to the buildings and works of art commissioned by the Montefeltro, less has been said about how aspects of daily life were just as persuasive expressions of courtly splendor.[21] James Lindow's thorough discussion of magnificence and splendor opens his *The Renaissance Palace in Florence: Magnificence and Splendour in Fifteenth-Century Italy*.[22] In an effort to paint a more complete picture of how patrons communicated power in Renaissance society, Lindow turns to Renaissance texts in order to demonstrate that the conveyance of magnificence comprised just one part of a system that also focused on the display of splendor. The distinction between these two Renaissance virtues is crucial for understanding the very significant role domestic practice and objects played. Architectural patronage displays magnificence, while splendor is suggested by the objects that fill and animate the building. For this reason, magnificence involved a greater investment of resources, while splendor is associated with smaller projects or interior decoration.

Lindow's discussion helps better contextualize the concerns articulated in the *Ordine et officij*. Lindow demonstrates convincingly that Renaissance theorists and patrons understood magnificence and splendor as inextricably linked, particularly in secular palaces where the interior provided a "series of spaces where virtuous 'splendid' expenditure could and should be displayed."[23] First characterized by Cicero and Aristotle, the definitions of these virtues were reimagined by Leonardo Bruni and Leon Battista Alberti. Renaissance people understood magnificence as a responsibility of wealthy men and leaders. Lindow also cites a text nearly contemporary with the *Ordine et officij*, Giovanni Pontano's 1498 text *De splendore*, which clearly articulates the late-fifteenth-century definitions of the terms.[24] Pontano wrote "but magnificence derives its name from the concept of grandeur and concerns building, spectacle and gifts while splendor is primarily concerned with the

ornament of the household, the care of the person, and with furnishings and in the display of different things."[25] He expanded upon earlier concepts when he emphasized spectacle and gift-giving in his discussion of magnificence; in a similar manner, for splendor, he speaks not of objects alone, but specifically makes mention of the "care of the person." Like the author of the *Ordine et officij*, Pontano sees physical spaces, their decoration, and the ritual practiced within them as equally significant.

The *maestro di casa*'s vision of the perfect household seamlessly unifies domestic and institutional concerns. Each of the Montefeltro residences was a "home" for Federico and his family as well as a seat of rule. This spatial duality makes distinguishing the "domestic" from the "public" deeply problematic and of great concern in a volume that addresses "domesticities." Raffaella Sarti questions the value of scholarly binaries that see public/ institutional and private/domestic spaces as clearly bound and which often underlie the demotion of the "domestic" in studies of Renaissance culture.[26] Such binaries assume clear demarcations of space and practice that did not exist in Renaissance Italy and tend to privilege the institutional or public over practices and spaces perceived as private and/or domestic.[27] Even more problematic for understanding the "domestic" in Renaissance society is the assumption that private spaces are women's spaces.[28] Instead, the hybridity of these Renaissance court spaces must be embraced and considered in terms of notions of "place" and "home" as defined by O.F. Bollnow, Edward S. Casey, and J.E. Malpas.[29] These scholars demonstrate that an individual's identity and his or her needs help to create and define "place."[30] For Federico, the fabric of the Palazzo Ducale, the rituals referred to in the *Ordine et officij*, and the objects used all demonstrate how domestic practices help to define his "home."

Bollnow's *Human Space* emphasizes an individual's connections to place and reinforces the idea that what he calls "experienced space" depends upon a person's center, usually the home, which offers the individual shelter and differs from other places in clearly discernible ways that are usually controlled by the inhabitant.[31] Based on Gaston Bachelard's *Poetics of Space*, Bollnow explains that the house or home must offer shelter and protection, and that the interior definition of the space must meet the needs of the dwellers.[32] "Man (*mensch*)," he concludes, "needs such a sphere of security in order to live at all."[33] Not only does Bollnow emphasize the importance of the home as a fortress against the chaos of the natural world, he also reminds us that each individual makes or defines his or her home by way of objects and rituals: "the concrete space of human life is organized by purposeful activity in such a way that everything has its assigned place."[34]

The way that the home relates to and reveals the interests of an individual, family, or household helps to distinguish that place from other more generic structures offering protection from the world outside, like a hotel. Mary Douglas makes this distinction even more clear when she claims that scholars must consider the home as an "embryonic community."[35]

"Home," she concludes, is not fixed in time or space, but rather is a "realization of ideas" that reflects those that inhabitants are "carrying around inside their heads."[36] The organization of the home often exhibits the "infrastructure" of community, thereby making the home, according to Bollnow, an *imago mundo*.[37] He continues by explaining that the city is "nothing other than a house on a large scale."[38] The language that Bollnow used is striking because it reverses one of the most famous descriptions of the Palazzo Ducale in Urbino. In the *Book of the Courtier* (published 1528), Baldassare Castiglione called the building a "city in the form of a palace."[39] Comparing the Renaissance *casa* with the Renaissance city not only gives a sense of the scale of the household but also evokes another hybrid and changing space. Rituals often temporarily redefine urban spaces, making private ones public and public ones private.

Castiglione's narrative complements that of the *Ordine et Officij* in that both authors also associate the glory of the Montefeltro dynasty with the richness and sophistication of objects. Of the objects decorating and used within the vast fabric of the Palazzo Ducale, Castiglione makes mention of "silver vases, wall hangings of the riches cloth of gold, silk, and other like things."[40] Castiglione does not discuss functional objects or their usage, the two topics of greatest concern to the *maestro di casa*, a man partially responsible for running a palace on the scale of a city. Looking more closely not only at the language of the *Ordine et officij* but also at particular spaces of the Palazzo Ducale helps to illustrate the relationship between domestic ritual, architectural space, and Federico's own concerns.

The *maestro di casa* pays particular attention to food preparation and service, thus demonstrating just how complicated it was to run such a large institution.[41] Twenty-three of the 64 chapters of the *Ordine et officj* are devoted to these subjects.[42] Chapter 3 addresses the position of *scalcho* whose responsibilities included the management of table service. The *scalcho* should be intelligent, as well as practical, plain, eloquent, with good habits, and untouched by the petty jealousies that filled a court household; he had a number of management responsibilities, which included the admonishment of staff working below him.[43] The meal service for the signore was the *scalcho*'s primary concern and his position required that he stay in the kitchen night and morning so that the signore was served according to his taste and with the appropriate level of splendor and cleanliness.[44]

In Chapter 35, the *maestro di casa* takes the reader into the kitchen, a space designed for some of the most mundane of roles, but which was also one of the most significant for institutional practice and display. The position discussed is that of the head cook who works in a grand kitchen area, almost free of humidity, with smaller spaces for the preparation of meat and fish, others for washing and polishing of silver, and for storing the service utensils.[45] One smaller kitchenette existed solely for the preparation of the signore's meal, while other areas serviced the wider household and guests. The priority of the head cook was to keep every part of the kitchen clean and make abundant amounts of water available at all times. The division of meat preparation areas

in addition to the emphasis placed on the cleanliness of all items suggest that Federico's personal belief was that illness could come from the air or from an imbalance of humors.[46] Again, while the description is deliberately general and sounds much like the spaces described by Katherine McIver in her chapter in this volume, the imagined kitchen shares actual physical features with that in the basement of the Palazzo Ducale.[47] Accessible from outside the fabric of the palace, from inside, this area was reached by way of a sloped ramp out of the Cortile d'Onore. The basement is divided by an access corridor that runs from the bottom of the ramp and lines up with the base of the most northern of the two *torricini*. On the west side of the building is the kitchen, annexes, a storage room and the bath complex; to the east are store-rooms, the icehouse, the laundry, and two large vaulted rooms for stabling horses.[48] Several of the store-rooms house large sinks, while the kitchen and breakfast rooms include marble fireplaces. The spaces are well-lit, have a sophisticated system of draining, and allow air to circulate in a manner that controls humidity and encourages the level of hygiene that Federico required.

Federico took just as many health-related precautions in his personal life as he expected his *casa* to consider in the running of his home. This planning protected him from a number of the physical dangers that befell soldiers in the fifteenth century. Like his peers, Federico believed that attention to cleanliness protected him from further injury and death.[49] He, along with his contemporaries, Pope Nicholas V and Pope Pius II, traveled to hot springs around Siena and elsewhere throughout the Italian peninsula where they bathed and conversed with their peers. These spas were also famed for their healing powers and were believed to speed recovery from all kinds of physical ailments.[50] Such attention to physical cleansing and healing was linked with moral cleanliness. Douglas Biow explains that the term *pulito* is adopted by Renaissance scholars in reference to purity of character as well.[51] Federico felt, then, that both physical and spiritual cleanliness aided his recovery from serious wounds and illnesses.

For Federico, his personal preoccupations with hygiene, health, and devotion were intertwined with and central to the way in which behavior at the court was defined. Practices that belonged to the more private realm of the domestic became central to the very public display of splendor at the court. Indeed, Federico's concern with cleanliness affected the very fabric of the Palazzo Ducale in Urbino. Nestled between the kitchen and the base of the northern *torricini* – directly below the chapels on the ground floor and the *studiolo* on the *piano nobile* – is a bath complex likely executed by Francesco di Giorgio Martini.[52] Comprised of three small rooms, one is filled almost entirely by a tub and another includes a richly carved basin sink. Two characteristic Francesco di Giorgio dolphins serve as the faucets that feed water directly into a wide basin decorated with bands of classicizing ornamentation and a large lion's head at the base. This complex is not unusual; several of his peers had bathing areas built in or near their palaces and villas.[53] In her chapter in this volume, Allyson Burgess Williams explains that Lucrezia Borgia favored

the complex built by her husband, Duke Alfonso I of Ferrara.[54] According to Williams, bathing suites often included areas for both "rest and conversation" as well as tubs for submergence and steam rooms, which made them important social destinations. Like the kitchen, spaces for bathing were not private, but rather were seen as public areas integral to the social life of the court.

Two specific traumatic health-related incidents dramatically colored Federico's personal opinions about cleanliness and changed the nature of life at the Montefeltro court.[55] Although the second incident, the jousting accident that resulted in the loss of his right eye, is the most famous, it was a childhood experience that prompted the highest level of emphasis on rituals associated with cleanliness in his *casa*. At the age of 11, when Federico lived with the Brancaleoni family in the far north-western corner of the Montefeltro, a tumor, triggered by an infection from contact with local farm animals, grew on his cheek.[56] Although seemingly insignificant at first, Federico continued to sicken and only after the treatment of a local female healer was he miraculously cured.[57] Because he associated the infection with animals, he became more self-conscious about hygiene and human contact with animals in his own homes. Chapter 23 of the *Ordine et officij* outlines the responsibilities of the master groom; this man cared for the signore's horses as well as those of his guests. The *maestro di casa* emphasizes that the "diligent" groom was also responsible for maintaining the cleanliness of the stabling area and for keeping it well lit.[58] In the Palazzo Ducale, the two large vaulted stables are across the main access corridor from Federico's bath complex and the large kitchen. This spatial arrangement allowed Federico to ride on horseback directly into the basement of the palace and bathe, as necessary, before entering the more public areas of the palace.[59] Physically cleansed, he then climbed, on foot, up one of the spiral staircases in the *torricini* to the chapel where spiritual cleansing occurred.

Other texts from the late fourteenth and fifteenth centuries describe the importance of hygienic practices within the context of court etiquette manuals. In his *De civilitate morum puerilium* (*On the Civility of Children*) (1530), Erasmus of Rotterdam speaks out against certain uncouth practices that were also met with equal levels of dismay and disgust at the Montefeltro court. For example, Erasmus praises the upper-class practice of hand-washing and use of utensils; he comments that "some people put their hands in the dishes the moment they have sat down. Wolves do that."[60] In the thirteenth century, Tannhaüser highlighted, in *Die Hofzucht*, that one is forbidden from scratching oneself with a bare hand, especially if eating.[61] A fifteenth-century French author demanded similarly that one should "take care to cut and clean your nails; dirt under the nails is dangerous when scratching."[62] By prohibiting or advising against certain practices like scratching or eating with dirty hands, the authors distinguish between proper upper-class behavior and that of the uncouth. These guidelines also revitalize expected modes of behavior, which date to a time in the past when people dined with their hands and shared food, by reinventing them for an early modern context. The correspondence

between notions of civilization and manners that Norbert Elias identifies is closely attuned to the author of the *Ordine et officij*'s belief that magnificence and splendor are evident in all aspects of court life. The *maestro di casa* emphasizes the way that court ritual, cleanliness, and household efficiency are the true reflections of the signore's glory.

The *Ordine et officij* serves as a nice counterpoint to those treatises that describe appropriate behavior for courtiers, for it dictates modes of behavior and emphasizes the service rituals that complement these guidelines. However, some of the habits described in detail by the author of this text are deemed even more important in the hygiene-conscious atmosphere of the Montefeltro court. Courtiers knew of Federico's strong aversion to behaviors he believed jeopardized his health. Any courtier who scratched himself or cleaned his nails at the table attracted the wrath of the signore and, as a result, he would be asked to leave the hall.[63] Federico's paranoia about the spread of illness affected his altruism as well. Although the spirit of magnanimity motivated his lifestyle and he sought to make himself as available as possible to all of his subjects and members of his household, he feared any contact with beggars because he believed they would make him sick.[64] In spite of these worries, he understood that one of his responsibilities as ruler was to give alms to the needy. Rather than endanger the signore, however, household members distributed food in an area of the palace he never visited. Chapter 31 of the *Ordine et officij* addresses the position of almsgiver and states specifically that completion of this task should occur in remote areas of the palace; the author adds that individuals receiving alms should not appear with open wounds, be filthy, or visit other rooms out of respect for the signore.[65]

Concerns with etiquette are also evident in the chapters of the *Ordine et officij* devoted to food service. As Katherine McIver demonstrates in her chapter in this volume, food service was conceived as a performance that reinforced the "sociability of dining."[66] She explains that "banqueting was about the audience, stage sets, props and interludes and putting on a good show"; the table settings, the food and the eating were all part of this elaborate performance. All of the Montefeltro *casa* understood this well because, as we know, the "magnificence of the signore manifests itself in all that is seen." One servant's position consisted only of washing the signore's hands before and after the meal, while others carried the water and wine, and still others tasted the food.[67]

Like Pontano, the author of the *Ordine et officij* makes no reference to the kinds of courtly activities, like dancing, gaming, or conversation, that were central to life at the court in Urbino and are the focus of scholars of court culture. Such courtly frolicking, however, is described beautifully by Castiglione and inspired the architectural ornament throughout the Palazzo Ducale. Together, the imagery decorating the palace itself, Castiglione's account, and that of the *Ordine et officij* paint a picture of a court with many layers of ritual practice, all of which reflected the glory of the Montefeltro family. More widely discussed rituals performed by courtiers were facilitated and complemented by the

practical patterns of life at the court, like hand-washing or the unlocking of doors. The latter reflects the efficiency of the household and the management skills of the signore and his staff, while the music, dance, and conversation convey his intellectual prowess and cultural sophistication. The rituals recoded in the *Ordine et officij* relate to Lindow's understanding of the display of splendor. In Chapter 8, which addresses those in charge of table service, or the *credenzieri*, the *maestro di casa* explains that the post requires three individuals to clean silver that is presented on fine, white linens.[68] In addition to caring for vessels and utensils belonging to the signore, the *credenzieri* also prepared foods, including the *insalata*, which required handling fruit and salt; thus, hygiene was of particular concern for this position.[69] Indeed, the main courses of each meal catered to the signore's personal food preferences and were served with abundant amounts of bread, wine, and water. Such a plentiful display at his table signaled his ability to provide for the people and would have impressed even the poorest members of the court.[70] All of these elements were embraced so that the meal "lacked not in magnificence" and would be recognized by the savvy courtier as making a reference to abundance and plenty, themes central to Roman imperial iconography.[71]

Through his discussion in the *Ordine et officij*, the *maestro di casa* instills the domestic sphere with a powerful representational function that was meant to be experienced by a wide audience. Imagine the nervous guest, who was careful not to scratch himself or do anything to betray the fact that he forgot to wash himself before coming to visit the signore; he sits in one of the reception rooms, surrounded by works of art and architectural ornamentation decorated with motifs and *imprese* celebrating both Federico and the Montefeltro dynasty. This guest would then witness the many complicated daily rituals of life in the palace that involved a large number of devoted and capable servants wearing Montefeltro livery who carried opulent objects encircled by seasonal flowers and filled with everything that catered to the signore's taste. The *maestro di casa* continuously and effortlessly links the idea of cleanliness and other domestic practice with more traditional reflections of magnificence and splendor. More public social and cultural practices were complemented by smaller, domestic rituals like hand-washing, table service, and food preparation. Together, these rituals displayed the efficiency of the household and catered to Federico's every whim and obsession. This ordering of a partially institutional space by way of domestic practice made the palace a home.

Notes

1 A version of this chapter was presented at the session, "*Magnificentia et sapientia*: The Interior of the Italian Renaissance Court" at the Annual Meeting of the Renaissance Society of America in 2007. I would like to thank the editors for their assistance throughout the process, as well as Rima Girnius, Kristen Hylenski, and Jenny Bird for their suggestions.
 Throughout the text, I will be using the term "signore" to refer to Federico or any person in charge of a court. This term is more suitable to the situation in Urbino because of Federico's shift in status from count to duke. Also, I have adopted this term because the author of the text I will be referring to throughout also uses the term "signore."

2 "Perciò la dignità de li signori manifesta per quelli a chi li vede …": *Ordine et officij de casa de lo Illustrissimo Signor Duca de Urbino*, edited by Sabine Eiche (Urbino: Quattroventi, 1999), 102. The text will be referred to throughout by its abbreviated title of the *Ordine et officij*. For more information, see Piergiorgio Peruzzi, "Lavorare a Corte 'ordine et officij' Domestici, familiari, cortigiani e funzioni al servizio del Duca d'Urbino," in *Federico di Montefeltro: Lo Stato, Le Arti, La Cultura*, edited by Giorgio Cerboni Baiardi, Giorgio Chittonni and Piero Floriani, 3 vols (Rome: Bulzoni Editore, 1986), I: 225–96.

3 This builds on Maria Grazia Pernis and Laurie Schneider Adams's discussion of Federico's obsession with hygiene and its influence on court life. See *Federico da Montefeltro and Sigismondo Malatesta: The Eagle and the Elephant* (New York and Washington, DC: Peter Lang, 1996), especially 17–19.

4 John Easton Law, "The *Ordine et officij*: Aspects of Context and Content," in *Ordine et officij* (see note 2), 17–18. The manuscript includes many errors and has sustained some damage.

5 Sabine Eiche, "Note al Testo," in *Ordine et officij* (see note 2), 85.

6 Law, "The *Ordine et officij*," 17–19. Law also speaks of the nostalgic tone adopted by the author at 19–20 and 34.

7 Ibid., 19.

8 Guido Guerzoni, "Servicing the *casa*," in *At Home in Renaissance Italy*, edited by Marta Ajmar-Wollheim and Flora Dennis (London: V&A Publications, 2006), 151; Allen J. Grieco, "Conviviality in a Renaissance Court: The *Ordine et officij* and the Court in Urbino," in *Ordine et officij* (see note 2), 37–8.

9 For a complete history of the Palazzo Ducale, see Janez Höfler, *Il Palazzo Ducale di Urbino sotto I Montefeltro (1376–1508)*, translated by Franco Bevilacqua (Urbino: Accademia Raffaello, 2006).

10 Law, "The *Ordine et officij*," 19.

11 Brenda Preyer, "The Florentine *Casa*," in *At Home in Renaissance Italy* (see note 8), 35–7; Luisa Fontebuoni, "Destinazioni d'uso dal sec. XV al XX," in *Il Palazzo di Federico da Montefeltro*, edited by Maria Luisa Polichetti (Urbino: Quattroventi, 1985), 185–302.

12 Both *castello* and *rocca* can each be translated into "castle," but the distinction is more subtle in Italian. *Rocche* included some kind of residence and had a military purpose, while *castelli* served a specific strategic military purpose. The definition of *rocca* is "fortezza costruita in luogo elevato – in partic: la fortificazione più protteta più elevata del sistema difensivo di un castello o di una città medievale: mastio, cittadella; nel Rinascimento costruzione fortificata nella quale trovavano sede l'abitazione del signore o del capitano." See Salvatore Battaglia, *Grande dizionario della lingua italiana*, 10 vols (Turin: Unione tipografico-editrice torinese, 1961–).

13 See Pernis and Adams, *Federico da Montefeltro and Sigismondo Malatesta*, 25.

14 Raffaella Sarti, "Renaissance Graffiti: The Case of the Ducal Palace of Urbino," in *Domestic Institutional Interiors in Early Modern Europe*, edited by Sandro Cavallo and Siliva Evangelisti (Farnham, Surrey: Ashgate, 2009), 51–81; Andreas Tönnesmann discusses the ceremonial organization of the space in "Le palais ducal d'Urbino: humanisme et réalité sociale," in *Architecture et vie Sociale* (Paris: Picard editeur, 1994), 137–53.

15 Sarti, "Renaissance Graffiti," 56–7.

16 Cecil H. Clough, "The Library of the Dukes of Urbino," in *The Duchy of Urbino in the Renaissance* (London: Variorum Reprints, 1981), 101–2; Marcella Peruzzi (ed.), *Ornatissimo Codice: La biblioteca di Federico di Montefeltro* (Milan: Skira, 2008); Marcello Simonetta (ed.), *Federico da Montefeltro and His Library* (Milan: Y. Press SRL, 2007).

17 *Ordine et officij*, 131–2.

18 Ibid.

19 Ibid., 102.

20 Ibid.

21 Pasquale Rotondi, *Il Palazzo Ducale di Urbino*, 2 vols (Urbino: L'Institute Statale d'Arte, 1950); Grieco, "Conviviality in a Renaissance Court," 37–8.

22 James Lindow, *The Renaissance Palace in Florence: Magnificence and Splendour in Fifteenth-Century Italy* (Aldershot: Ashgate, 2007).

23 Ibid., 4–5.

24 Ibid., 1; Grieco, "Conviviality in a Renaissance Court," 38–40.

25 Lindow, *The Renaissance Palace in Florence*, 1.

26 Sarti, "Renaissance Graffiti," 51–81.

27 Ibid., 53.

28 See Marta Ajmar-Wollheim and Flora Dennis, "Introduction," in *At Home in Renaissance Italy* (see note 8), 12.

29 Edward S. Casey, "Body, Self and Landscape: A Geophilosophical Inquiry into the Place-World," in *Textures of Place: Exploring Humanist Geographies*, edited by Paul C. Adams, Steven Hoelscher, and Karen E. Till (Minneapolis: University of Minnesota Press, 2001), 403–25; J.E. Malpas, *Place and Experience: A Philosophical Topography* (Cambridge: Cambridge University Press, 1999). These scholars base their conclusions on the work of Georges Poulet, Martin Heidegger, Gaston Bachelard, and Marcel Proust.

30 See previous note and Martin Heidegger, "Building, Dwelling, Thinking," in *Rethinking Architecture: A Reader in Cultural Theory*, edited by Neil Leach (New York: Routledge, 1997), 100–109.

31 Bollnow uses the term "experienced space" to distinguish between more theoretical perceptions of "space" and "occupied space" which is bounded by individual perception. See O.F. Bollnow, *Human Space*, translated by Christine Shuttleworth and edited by Joseph Kohlmaier (London: Hyphen Press, 2011), 17–19.

32 Ibid., 124–7.

33 Ibid., 126.

34 Ibid., 127, 197.

35 Mary Douglas, "The Idea of a Home: A Kind of Space," *Social Research* 58(1) (Spring 1991): 287–307 at 290.

36 Ibid., 290.

37 Ibid., 299–300; Bollnow, *Human Space*, 138.

38 Bollnow, *Human Space*, 138–9.

39 "… ma una città in forma de palazzo": Castiglione, *The Book of the Courtier*, edited by Daniel Javitch (New York: W.W. Norton & Company, 2002), 11; *Il Libro del Cortegiano*, 9th edn (Milan: Garzanti, 2000), 18.

40 "… come vasi d'argento, apparamenti di camere ricchissimi drappi d'oro di seta e d'altre cose simili …" Castiglione, *Il Libro del Cortegiano*, 18; Castiglione, *The Book of the Courtier*, 11.

41 Grieco, "Conviviality in a Renaissance Court," 37–44.

42 Ibid., 40.

43 *Ordine et officij*, 90–92.

44 "Suo officio è de provedere ala tavola del signore principalmente et ala cucina sera e matina che'l singore sia servitor secundo el suo gusto e splendidamente et sopra tucto polita …": ibid.

45 Ibid., 118–19.

46 "… e tucta senza uno minimo suspecto de immunditia": ibid., 119.

47 Katherine A. McIver, Chapter 9 in this volume.

48 Fontebuoni, "Destinazioni d'uso dal sec. XV al XX," 185–302.

49 Baths were believed to cure battle wounds as well as infertility as they compensated for an imbalance of humors. See D. Chambers, "Spas in the Italian Renaissance," in *Reconsidering the Renaissance: Papers from the Twenty-First Annual Conference*, edited by Mario A. Di Cesare (Binghamton, NY: Medieval and Renaissance Texts and Studies, 1992), 9, 22; Pernis and Adams, *Federico da Montefeltro and Sigismondo Malatesta*, 17–19.

50 One spa close to the city of Pienza, in Viterbo, was famous for curing gout, a hereditary condition from which both Federico and his son, Guidobaldo, suffered. See Chambers, "Spas in the Italian Renaissance," 22–3; G.V. Pescolini, "I bagni senesi di Petriolo nel medievo," *Diana* 6 (1931): 110–28, 123. Robert Tavernor speaks about bath culture as well as a possible design, by Leon Battista Alberti, for an even more elaborate bath complex in the Palazzo Ducale in Urbino. See *On Alberti and the Art of Building* (New Haven: Yale University Press, 1998), 192–200.

51 Douglas Biow, *The Culture of Cleanliness in Renaissance Italy* (Ithaca: Cornell University Press, 2006), 2.

52 Pasquale Rotondi, *Francesco di Giorgio Martini nel Palazzo Ducale in Urbino* (Milan: Provinciali Spotorno, 1970), 33; Francesco Paolo Fiore and Manfredi Tafuri, *Francesco di Giorgio architetto* (Milan: Electra, 1993).

53 For Ercole d'Este's bathing complexes, see Thomas Tuohy, *Herculean Ferrara: Ercole d'Este, 1471–1505, and the Invention of the Ducal Capital* (Cambridge: Cambridge University Press, 1996), 83–7; Tavernor, *On Alberti and the Art of Building*, 193.

54 Allyson Burgess Williams, Chapter 10 in this volume.

55 Pernis and Adams, *Federico da Montefeltro and Sigismondo Malatesta*, 17–19.

56 Ibid., 17.

57 Ibid.; Bernardino Baldi, *Vita e Fatti di Federigo di Montefeltro Duca di Urbino* (Rome: Alessandra Ceracchi, 1824), vol. 1, 11.

58 *Ordine et officij*, 111–12.

59 Rotondi, *Francesco di Giorgio Martini nel Palazzo Ducale in Urbino*, 33.

60 Norbert Elias, *The Civilizing Process* (Cambridge, MA: Blackwell, 1994), 73.

61 For hand-washing, see ibid., 45–6; for scratching oneself, see Tannhäuser, "Do not scratch your throat with your bare hand while eating; but if you have to, do it politely with your coat," quoted in ibid., 51.

62 Quotation from *S'ensuivent les contenances de la table* (*These are Good Table Manners*). Ibid., 71.

63 Pernis and Adams, *Federico da Montefeltro and Sigismondo Malatesta*, 17–18.

64 Ibid., 18.

65 "… et Ordine che vadino a torla in uno loche de casa remoto et non siano veduti andare per casa cum boccali e cose immundi, et cusì che non vadino né a tinelli né a camera né in niuno altro loche de casa per dicto respecto": *Ordine et officij*, 115; Pernis and Adams, *Federico da Montefeltro and Sigismondo Malutesta*, 18.

66 For more on the ritual of food service, see Grieco, "Conviviality in a Renaissance Court," 37, 42–4.

67 Ibid., 43–4.

68 "E faccia mantenere li argenti nepitissimi et aparechiare et servire cum panni bianchi fini et ornate, et tucto preservare cum optima cura et fede …": *Ordine et officij*, 95.

69 "… et omne cosa che li havessino a manegiare commo insalata, fructi et sale, et simile cose tocchando cum mano mancho che se pò et cum summa puliteza": ibid.

70 Ibid., 97; Grieco, "Conviviality in a Renaissance Court," 39, 41–4.

71 See texts on the Emperor Augustus, who commissioned pieces, like the Ara Pacis, which celebrate the peace and resulting stability and fecundity associated with his reign. Paul Zanker, *The Power of Images in the Age of Augustus*, translated by Alan Shapiro (Ann Arbor: University of Michigan Press, 1990).

**Part IV
Objectifying the Domestic Interior**

Objectifying the Domestic Interior:
Domestic Furnishings and the Historical Interpretation of
the Italian Renaissance Interior

Adriana Turpin

This chapter places the study of early modern domestic furniture within
the historical, developmental process of the nineteenth-century Renaissance
revival and argues that by studying different approaches to the collecting
and display of Renaissance and Renaissance-styled furniture during the
nineteenth century, we reach a new understanding of the interpretation
and significance of the historic domestic interior. A result of this inquiry
is understanding the degree to which contemporary scholarship, museum
collections, and period rooms are informed by the nineteenth-century
European revival of all facets of the Italian Renaissance. While Susan
Wegner's chapter in this volume investigates the example of a modified
"period room" in the *Beauty and Duty* exhibition (Bowdoin College Museum
of Art, Brunswick, Maine, March 27–July 27, 2008), analyzing the imaginative
transformations in standard exhibition and installation practices, this chapter
examines the nineteenth-century practices, interpretations, and critical
legacies that have shaped our perception of the Italian Renaissance domestic
interior. As this study shows, the historicism that shaped the nineteenth-
century Renaissance revivalist collections in England, the restoration of
the interiors of Italian Renaissance *palazzi* by nineteenth-century owners
and collectors, and the subsequent effects of both these developments on
twentieth-century collections in America have all played a determining
role in recent interpretations of the Renaissance domestic interior.[1] These
findings support the conclusions of Susan Wegner's chapter, which show
that a comprehensive inquiry into Renaissance interiors benefits greatly
from the investigation into nineteenth-century period rooms, houses, and
museum installations. In the end, reappraisals of the period room reveal and
underscore how much room settings were altered to fit both aesthetic and
functional criteria.

Interpretations of Historicism

Nineteenth-century approaches to the interior, which continue to shape current understanding, directly reflect the attitudes of the period to the concept of history, both in general and specific terms. Among various trends in early nineteenth-century collecting, two stand out in forming later nineteenth-century and twentieth-century responses to Renaissance furnishings in public and private collections. One approach concerns the authenticity or purity of the object and the other seeks to address the historical recreation of the Renaissance through an imaginative experience of that era, sometimes at the expense of material authenticity. As Francis Haskell has argued, a new perception of the past evolved in the nineteenth century, one that concentrated on the historical sequence of events by which human actions could be understood.[2] Jules Michelet in the 1840s and again in 1855 promoted the term "Renaissance" to create a historical divide between this period and its precursor.[3] Parallel with the emergence of the notion of historical period came the need to present these concepts in visual forms. Two different but overlapping approaches emerged in museum display history, exemplified by two collections formed in the early nineteenth century in Paris: the Musée des monuments historiques in 1796 by Alexandre Lenoir (1761–1839) and the Musée de Cluny in 1842, with its collection formed by Alexandre du Sommerard. Lenoir created period rooms in which copies of original pieces were included to provide overall authenticity. Lenoir's illustrated displays depicted chronological time periods showing the process of historical evolution through works of art. Illustrations of these rooms in the museum demonstrate how famous historic monuments were collected together and combined to create an overall impression of a particular period, thus lending authenticity to the objects.[4] In contrast, Du Sommerard at the Musée de Cluny gathered medieval and Renaissance objects into an interior in order to "transport" people to bygone days. Du Sommerard's displays were intended to draw attention to the authenticity of historical objects. Thus, he created a homogeneous ensemble of Renaissance objects which became "Francis I's bedroom." The accumulation of authentic period objects thus aimed at abrogating the contemporary experience of time. As underlined by Stephen Bann, both ways of collecting still inform many museum displays today.[5]

The experiential approach to museum displays created in Paris had its roots in, but equally had an influence on, the decoration and furnishing of the domestic interior in both Britain and later in the United States. Termed the "romantic interior" by Clive Wainwright, patrons moved from design drawn from the universal language of the classical to specific historic recreations.[6] However, the English collector eschewed referencing a particular historic period in favor of interiors in which the role of the object was to create an illusion of a past time, rather than to present a specific

period or style. William Beckford, one of the earliest collectors in Britain to assemble European furnishings from different historical periods, created two very different architectural settings for his collections, which reflect the process of historicist interpretations first at Fonthill Abbey in Wiltshire and second in Bath. At Fonthill Abbey, begun in 1796, he placed furnishings of, or inspired by, the sixteenth and even seventeenth centuries into a Gothic architectural setting.[7] His approach, similar to Lenoir's Musée des monuments historiques, owed much to two predecessors: Horace Walpole, who furnished his Gothic villa at Strawberry Hill with both modern and historicist furnishings; and, perhaps more importantly, Sir John Soane at 11 Lincoln's Inn Fields. Soane arranged his collections with an emphasis on dramatic visual effects achieved through the juxtaposition of the objects with dramatic lighting that heightened the visitors' sensibilities and response to the collections. Soane sought a period atmosphere in which authenticity was secondary. For example, in Soane's Monk's Parlour, an eighteenth-century table designed by William Kent was happily placed among medieval relics. Like Soane, Beckford created dramatic effects in his furnishing of Fonthill Abbey with a wide range of objects. Thus, Beckford placed English "medieval" furnishings with seventeenth-century ebony cabinets, Portuguese and Indo-Portuguese cabinets, and Italian sixteenth-century *pietra dura*. These provided the setting for his equally eclectic collection of works of art that formed a veritable *kunstkammer*, with sixteenth-century and seventeenth-century hardstone vases and ivories, enamels, oriental works of art, and porcelains, but also modern versions of the same.[8] Beckford's interior was not authentic in detail, but gave the impression of authenticity through its combination of antique objects and its dramatic medieval architecture. History played its role: certain pieces were given an illustrious provenance, for instance, his "Wolsey" chairs, the "Bernini" cabinet, or the "Holbein" cabinet.[9] In Beckford's Lancaster Room, he created an assemblage based on a misunderstanding of fifteenth-century furniture, but which was, nonetheless, an attempt at a period room.

This raises a second question: did collectors necessarily recognize genuine works from the past at this time and did this matter? This was equally a problem within the market in general, as seen in the variety of furnishings illustrated in Henry Shaw's *Specimens of Ancient Furniture*, published in 1836.[10] One of the most striking examples among the variety of approaches taken by Beckford was his recreation of a great cabinet based on his own design. Beckford combined the original doors from a seventeenth-century ebony cabinet and with modern elements to fashion a cabinet that he saw as magnificent and superb.[11] Other historicist pieces in Beckford's collection were occasionally described, sometimes accurately as "in the style of," but on other occasions as "genuine." Thus, a fine "robe chest" described as dating from the time of James I was also a modern pastiche.[12]

The Revival of the Italian Renaissance in England

When William Beckford moved to Bath, he created a very different building from the immense Gothic cathedral of Fonthill Abbey that in its architecture and furnishing was perhaps one of the first examples of the Renaissance revival in England. The architect Henry Goodridge described Lansdowne Tower, begun c. 1826, as "Greco-Italian," a style chosen because "he considered therein the purity of the Greek and the freedom of the Romanesque were best described."[13] This Italianate, classical villa was based on early Italian architectural forms in England and is important in particular for its emphasis on the simplicity and grandeur found in Byzantine or Romanesque architecture. There is a close parallel to the design of Lansdowne Terrace in the illustration of Fiesole by James Duffield Harding in T. Roscoe's *The Tourist in Italy*, published in London in 1832.[14]

The interior spaces of Lansdowne and the furniture created for them also emphasized the simplicity of early Renaissance forms. The furniture was made in oak with the emphasis on solid forms, employing round arches and columns. For example, a pair of coffers designed with barrel-vaulted lids had decoration quoting the pierced arch of the internal façade of Santa Maria della Grazie, Milan, designed by Bramante.[15] By the 1840s, Beckford's rooms at Lansdowne were furnished in a more unified style, which was more closely based on Renaissance architecture and rooms, than his previous interiors. Furthermore, contemporary descriptions of both the Tower and 19 Lansdowne Crescent interiors drew parallels with sixteenth-century Italian art. Edmund English described the Crimson Drawing Room in 1844, saying that it had "a similarity closely in tone to that deep mellow richness remarkable in a fine picture by Titian … [and] is alike indescribable in language, while the former [room] in contradiction would remind us of a daylight work by Veronese more decisive in color."[16] Color and light, which Beckford always emphasized in order to create mood and atmosphere, were at Lansdowne specifically inspired by the colours of sixteenth-century paintings. Indeed, Beckford treated his interiors as a canvas in which all the elements contributed to the whole and in which atmosphere rather than authenticity was the main purpose. In addition to establishing mood and sensibility, Renaissance paintings could also provide a collector with information on the rooms and the objects themselves. Though problematic, historians today also rely on early modern paintings to determine the appearance of a room setting. Yet, it is too simplistic to say that because the object is seen in a painting, it therefore must be original. The interior spaces at Lansdowne demonstrate a critical aspect of nineteenth-century taste and the Renaissance revival: in all probability, late fifteenth-century architecture and sixteenth-century paintings guided the structure and character of these spaces.

Beckford's new home in the Italianate taste reflects England's interest in Italian Renaissance history.[17] The publication on Lorenzo de Medici in the

1790s by William Roscoe, Liverpool merchant and collector, was probably the first to place fifteenth-century Florence and the patronage of a great prince as the seminal point in the flourishing of humanism and the arts.[18] The germinal idea that the early Medici were benevolent princes and patrons is credited to Cosimo I and Giorgio Vasari. However, it was Roscoe who brought it back into the center of nineteenth-century interest in Italy and in particular promoted the notion of Florence as the cradle of the arts, and Lorenzo as the exemplar of artistic patronage.[19]

An alternative perception of Italy, taken up by writers during the French Empire, was that Italy was the center of the civic freedom. Simonde de Sismondi's *Histoire des républiques italiennes du moyen age* (published 1807–18), which Roscoe attacked for its unflattering view on the role of the princes, was enormously influential in promoting the greatness of the republic and the link between the city-state and democracy.[20] As Fantoni argues, the melding of these two opposite interpretations made Florence the emblem of the rebirth of civilization after the "slavery of feudal society."[21] Jacob Burckhardt, a generation later, furthered the idealized view of the Renaissance and argued that the Italian Renaissance contained all the elements of modern society, thus differentiating the fifteenth century from its medieval predecessor. Burckhardt gave the historic period a particular character, describing it as individual, imaginative, passionate, or of genius.[22] For J.B. Bullen, this definition of self is crucial in the nineteenth-century interpretation of the Renaissance.[23] Writers such as John Addison Symonds, Walter Pater, and Vernon Lee brought the concept of Italy as the cradle of modern civilization to the British understanding of the past.[24] J.J. Jarves made this explicit when he wrote that Americans "are made in the same manner as were the Florentines. We are travelling the same road, socially, mercantiley, [*sic*] and artistically, if not yet politically."[25] Thus, by the end of the nineteenth century, Renaissance Florentines were the models for the new rich of both Victorian England and the United States, while its art and architecture provided the basis of their representation. For collectors such as Frederick Leyland from Liverpool or John Pierpont Morgan from Hartford, Connecticut, who saw themselves as both merchant princes and the products of republican virtues, a Renaissance setting was an appropriate expression of their beliefs and ambitions.

To art critics, the Renaissance was synonymous with beauty, elegance, harmony, and dignity. Starting with the writings of Jacob van Falke (1825–97) a Viennese museum curator and writer, the Renaissance offered an alternative system of values to the Greek and the classical. Moreover, as he argued, the Renaissance style had an additional advantage to the classical, in that it could provide the nineteenth-century collectors with a theoretical framework for luxury and comfort.[26] Thus, the recreation of the Renaissance interior became an appropriate inspiration for any person who wished to show good taste.[27] In addition to the assertion that the style contained all the elements suitable for present use (idealism, perfection, modernity, and individualism),

there was thus the added benefit that the Renaissance interior provided appropriate luxury. In terms of furnishing the interior, as the German critic Wilhelm Lübke said: "It was the final period of the Renaissance that … was best able to meet every requirement of comfort and luxury in the field of furniture."[28]

The revival of the Renaissance style was importantly associated with the revival of craftsmanship.[29] The correlation between modernity and technical skill or finish was an important factor in determining the approach of collector, whether for objects fashioned in the Renaissance style or their originals. The objects chosen for the Victoria and Albert Museum by J.C. Robinson and successive curators were often examples of the highest finish and quality, commensurate with the technical perfection required by nineteenth-century collectors and dealers.[30]

Leyland and Approaches to Collecting in Mid-Victorian England

Beckford's choice of Greco-Italian architecture for his house in Bath may have expressed or reflected Roscoe's discovery of Lorenzo de Medici and Medici patronage. However, the revival of Italian Renaissance forms in architecture or decoration held less sway in Britain than the other historic revivals, particularly the Gothic or Elizabethan revivals. Where classical principles were followed, it was generally along Neo-Grecian lines, with the possible exceptions of the great clubs in London along Pall Mall.[31] Towards the end of the century, the Florentine *palazzo* appeared occasionally, either in a pure revival or emerging out of a generic classical idiom. For example, at 47 Berkeley Square, Ernest George and Peto built a Renaissance palace for Edward Stekinkopf, However, in general the new rich industrialists preferred classical exteriors and French *ancien-regime* interiors for their London houses.[32] It is thus particularly interesting to examine the furnishing of 49 Princes Gate, bought by Frederick Leyland, a wealthy shipping magnate from Liverpool, in 1874.[33] In common with many of his fellow industrialists and merchants, Leyland was interested in contemporary artists, and became an important patron of Rosetti and Whistler. However, he also amassed a significant collection of Old Master paintings, including a number by quattrocento artists, which were displayed together in his Botticelli room (Figure 12.1).[34] The fact that Leyland was not specifically interested in the quattrocento itself makes the furnishing and decoration of his domestic spaces all the more interesting. The task of acquiring the collection to furnish the so-called "palace of art"[35] was given to the dealer Murray Marks, whom Leyland called "a man of exquisite taste" and "who trafficked in virtually everything an aesthete might require."[36]

The paintings in Leyland's Princes Gate drawing rooms, in their quattrocento frames, provide the Renaissance theme even if they visually compete with the elaborate, eclectic furnishing of the rooms.

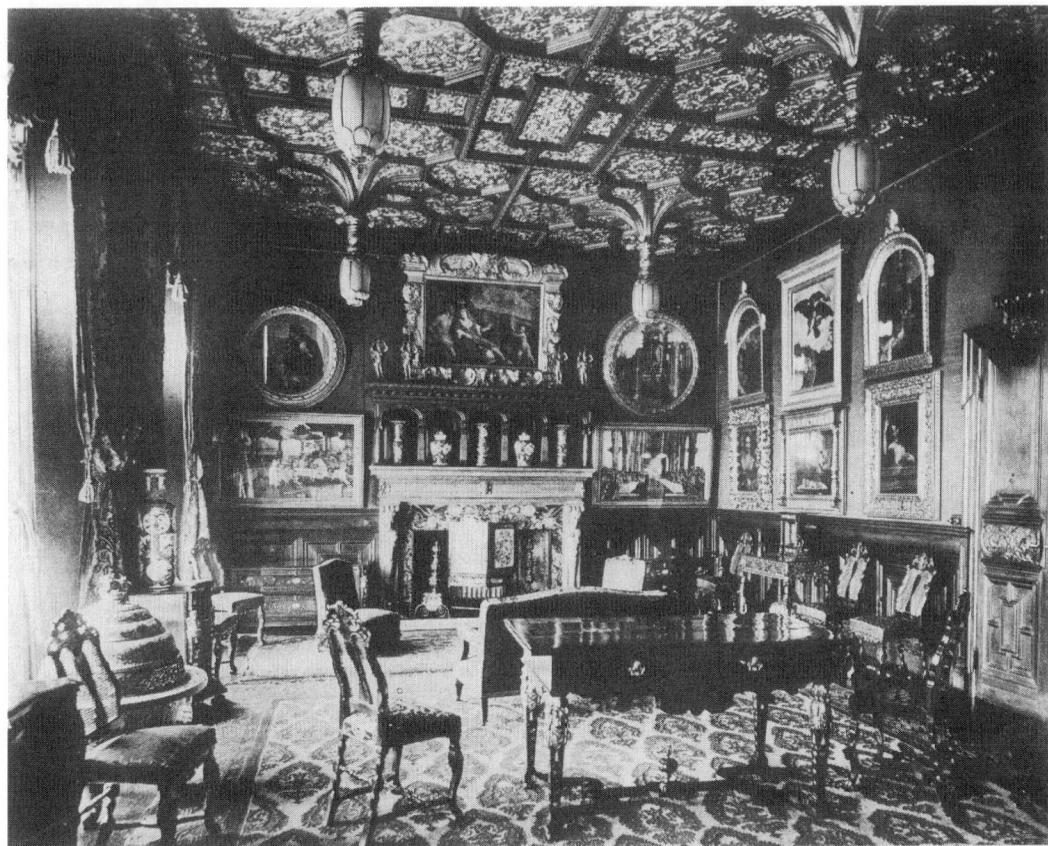

THE WEST SALON

For instance, part of the decoration included a copy of the Flemish rood screen from s'Hertogenbosch, which was acquired by Marks in 1866 and was placed between the three interconnecting drawing rooms.[37] The diverse collection of furniture from the sixteenth century to the eighteenth century that appears in the illustrations of the rooms at Princes Gate is described in the sale catalog of 1892.[38] Much of the "old" furniture is described as eighteenth-century Italian. However, the nineteenth-century appraisals assessed the chairs as early eighteenth-century Portuguese or Italian, and out of the 40 lots in the Italian section of the nineteenth-century sale, only nine were probably Italian. Of these, only two were Renaissance and they were two chests or *cassoni*, which by this time had become collectors' items, primarily for their painted panels and later for their use as furniture.[39] The others, although described as being Italian and even Renaissance, were certainly not Renaissance. Furthermore, the cassoni were combined with a number of French seventeenth- and eighteenth-century furniture, including some very expensive Boulle and contemporary English furniture. It was still desirable to evoke the Renaissance of Lorenzo de Medici within an

12.1 "The West Room," Osborn and Mercer, Catalog of No. 49 Princes Gate, S.W. (repair and decoration carried out under the superintendence and assistance of Norman Shaw and James McNeill Whistler). Photo credit: © Victoria and Albert Museum, London

atmosphere of opulence and taste, but as far as furnishings were concerned, there was little understanding of contextual historical style.[40]

Thus, in 1862, when the South Kensington Museum held an exhibition of the finest examples of British collections, only four out of some 50 pieces of furniture on loan were Renaissance works.[41] These four evidenced a taste for elaborately worked objects: three were small cabinets in damascened metal decorated with arabesque ornament, while the fourth object was a sixteenth-century Venetian throne chair, described as coming from the monastery of San Giorgio, Venice.[42] The change towards a more authentic understanding of Renaissance furniture was the work of museum curators such as J.C. Robinson of the South Kensington Museum, who began to bring works of art from Italy to Britain.[43] However, whereas museums might search for authentic objects to furnish their galleries, the integrated spaces of the Renaissance interior remained relatively unexplored. Instead, it was the British who settled in Italy who revived the concept of the Renaissance interior.

Furnishing the Renaissance Palace

If Italy was the nineteenth-century stomping ground for British curators and dealers searching for genuine Renaissance works of art and objects, it was also the place where many chose to settle, particularly in Florence. English visitors to Italy, and more specifically to Florence, were among the first to seek Italian palaces and restore them to their original appearance. John Temple Leader pioneered this approach to authentic restoration, gathering architectural fragments from the correct period to furnish his castle at Vincigliata, which he bought in 1855. His restoration of the castle influenced both the Anglo-American community in Florence and Italian collectors and museum curators.[44] Among the Italians were the Bagatti Valsecchi brothers, who visited Temple Leader to see his work at Vincigliata.[45] In turn, numerous English and Americans visited the brothers' magnificent palace in Milan, which was seen as a model of good taste. Among the visitors was Frederick Stibbert, who amassed an enormously varied collection of armour, paintings, and works of art from Europe and the East in his Renaissance-inspired house, the Villa of Montughi. The direct connections and interchanges between the Anglo-American community and Italian collectors, such as the Bagatti Valsecchi, underpin the similarities of approach as seen in these communities' interpretation of the Renaissance. Thus, even though the Bagatti Valsecchi or Frederick Stibbert built modern, Renaissance-styled homes and others such as Herbert Horne or Elia Volpi restored original Renaissance palaces, their approaches to the recreation or restoration of the domestic interiors and the types of furniture placed within them have much in common.

The Bagatti Valsecchi palace was begun in the 1880s in Milan by two brothers, Fausto and Giuseppe Bagatti Valsecchi. Its Neo-Renaissance style of the fifteenth and sixteenth centuries was much acclaimed by art critics as a model because it harmonized the decoration of the rooms with their furnishings. Thus, as was quoted in *Italian Art and Milanese Collections*, the architecture brought together the best of Renaissance design: "In design, proportion, and even execution, they leave little to be desired, and their interiors, furnished with beautiful ancient pieces and few of old pictures [*sic*] are models of good taste."[46] According to Pavoni, among the sources the brothers researched for their house were the most important Italian *palazzi* of the Renaissance, which were then synthesized into one ideal form. The theatrical purpose and effect is evidenced in the publication *La Casa Bagatti Valsecchi in Milano*, commissioned in 1919 by Giuseppe Bagatti Valsecchi in memory of his brother, where the editor presented the collection as an inspiration to contemporary architects, designers, interior decorators and stage designers, or movie directors. As far as furniture was concerned, the brothers searched for the best authentic examples they could find. Where this was not possible, either because Renaissance Italy had not known the particular types of furniture needed for modern living or because an original example was not available, they had pieces made up.[47] The taste that was promulgated by the collections and commissions thereby valued both the original and the new recreation in the search for a style that validated luxury and the skill of the craftsman. Moreover, as the aim was to live with the domestic objects and furnishings, there was again a dichotomy of interest between the decorative and museum values. Although the differences between copy and original were recognized, they were less important than the whole effect in the interior. Equally, the furniture, whether modern or old, was elaborate, highly finished, and as perfect as possible.

By recontextualizing the nineteenth-century revival of the Renaissance interior, it becomes apparent that much of the furniture comes from the sixteenth century or even later. Among the possible examples is a very fine walnut table carved in the manner of a sixteenth-century Italian model, with lion's paw feet and the sides based on Roman altar frontals, as was common in Roman tables of the period.[48] This faithful copy of an original design is indicative of nineteenth-century craftsmen's accuracy. The Mora family supplied furniture of all types of carved work to the Bagatti Valsecchi brothers. Huge numbers of chairs were supplied, of similar designs, based on seventeenth-century prototypes, but often embellished or given Neo-Renaissance decoration. Chiarugi divides the collection into those pieces that are primarily from the Renaissance or with modest restoration.[49] What emerges from this summary is that while there was great attention paid to collecting original pieces, it was equally acceptable to have new furniture crafted in the Renaissance style. The bills quoted by Chiarugi support the enormous quantity of seat furniture constructed and the high prices paid for these pieces. For example,

one piece of Renaissance furniture in walnut (*mobile*) cost 2,000 lire, as did the bed for Don Fausto, while two walnut night tables cost 240 lire. Some of the chair-recreations were called "rafa" or "raffaella," which Chiarugi thinks might be the type now known as Savonarola chairs. Certainly not made to deceive, it becomes difficult when these pieces appear on the market to be authentic. Therefore, new furniture in the Renaissance style was recognized as improving contemporary taste and skill. Such an appreciation for the Renaissance style, albeit not necessarily genuine Renaissance artefacts, provides an historical precedent to support some contemporary museum practices described by Susan Wegner in her chapter in this volume, whereby authentic, historical objects are placed side-by-side with modern recreations to both elevate the understanding of the object itself and its original, contextual environment. However, significantly, the copies in nineteenth-century rooms make the rooms appear "authentic," but equally, the copies in some senses deceive, rather than exclusively illuminate the historical. Additionally, nineteenth-century collectors felt that by imitating Renaissance craftsmanship, they were adding to the present.

The Palazzo Davanzati and its Influence

A second, very different approach was taken at the Casa Davanzati in Florence, where the Renaissance palace was furnished with period furniture to create a museum of the Renaissance domestic interior. Elia Volpi purchased the Palazzo in 1904, after a long battle to save the area and the palace from destruction.[50] Volpi had been a partner of Stefano Bardini, who, by that time, had supplied many of the most important collectors of Renaissance art such as Isabella Stewart Gardner, Nelie Jacquemart-André, and the head of the Berlin museums, Wilhelm Bode, with paintings and sculptures for their collections.[51] Bardini, as can be seen today in the museum that contains his collection, by the time of his death in 1923 created interiors by moving architectural features from all over Italy, ceilings, fireplaces, and doors. He also bought works of art and furniture, particularly *cassoni*, for which there was by 1900 an enormous market.[52] Certainly, Bardini's influence in creating the nineteenth-century Renaissance collection cannot be underestimated and his ideas of display influenced the representation of the collections of both Isabella Stewart Gardner and Nelie Jacquemart André. For example, the display of paintings set above Renaissance *cassoni*, a striking feature found in all these collections, is based on objects sold to them by Bardini. The Palazzo Davanzati is equally significant in its influence, despite differing slightly. Volpi intended to "restore" a genuine Renaissance interior and to create authentic domestic spaces within it. Moreover, his palace was not so obviously a show room for sale.

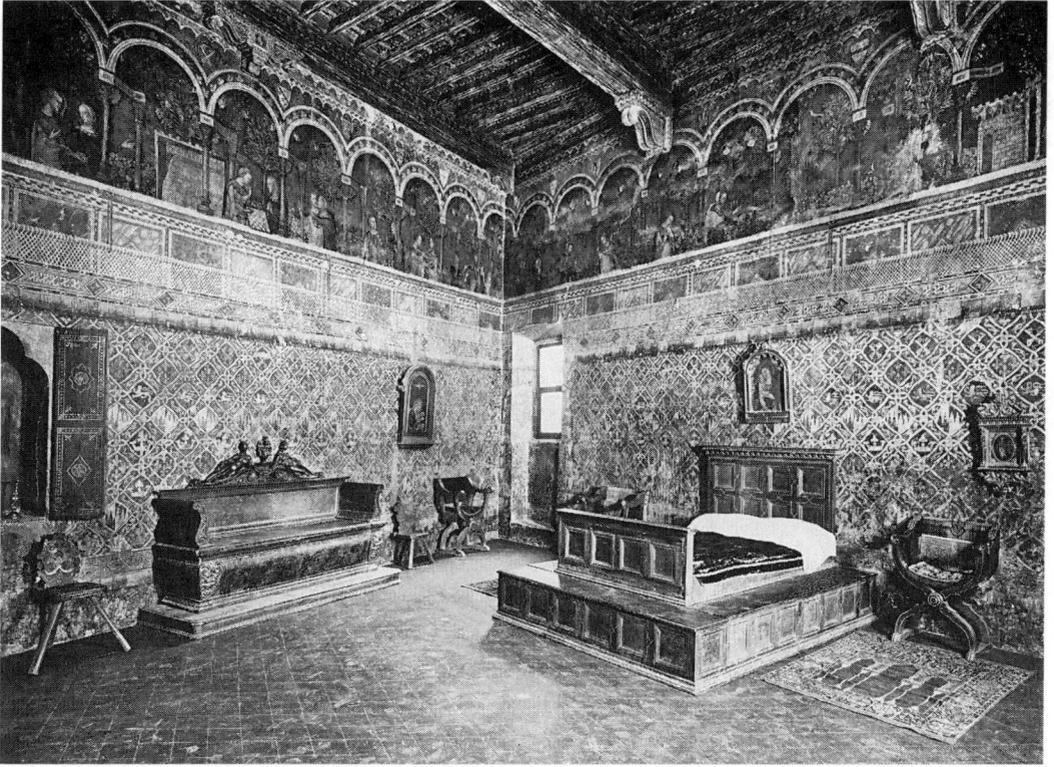

12.2 Camera da letto del secondo piano, Palazzo Davanzati, 1910, Archivi Alinari, Florence, Photo credit: Archivi Alinari

Volpi presented his collections and photographs in the Palazzo Davanzati, documenting the rooms as furnished before he had to sell them at auction in 1910 and more famously in 1916 (Figure 12.2).[53] Here we see sparsely furnished rooms with painted friezes, the closest we probably come to an authentic Renaissance interior.[54] Nonetheless, it is a careful reconstruction and restoration of the early twentieth century. As Louis Rosenburg wrote in 1922, "when Prof. Volpi acquired the property, the palace had degenerated into nothing more than a tenement."[55] In order to restore it to its original splendor, careful drawings were made and later additions removed. The original structure, particularly the walls, remained largely intact, but windows and doors were replaced, as were the brick floors and the upper floor.

Recent research undertaken while the restoration of the frescoes was in progress shows the extensive restoration and repainting undertaken by Volpi's friends and assistants Silvio Zanchi and Federigo Angeli, most of which has been removed in recent restorations. At the time, Volpi said he found a remnant of a wall painting. This form of domestic adornment attached to the fabric of the home was uncovered in four bedrooms. He claimed only to conserve and that neither embellishments nor inventions were introduced into the restoration. In fact, the extent of what was actually completely redone

varies between 50 and 80 percent of the whole. In general, Angeli left little evidence of his restoration, although sometimes Volpi left cracks in the paint to show age.[56] This careful reconstitution to replicate the original is also typical of Bardini and is found in the works of other famous contemporaries such as Viollet-le-duc. The result is not the original, but an enhanced version of the original. Such an approach to the contents of the room also seems to be applied by Bardini and Volpi to their furniture. Thus, we would expect to see furniture in the collection replicating the historical understanding of the period; in other words, furniture might not be completely modern, but it could be extensively restored to a degree of finish that the nineteenth-century public appreciated.

From interior views of the palace and the images in the sale catalogs, it appears that Volpi desired historical accuracy for his collection. However, determining the authenticity of surviving physical examples can be challenging. It is one of the difficulties that arise when the art historian needs to match furnishings listed in inventories to the extant physical evidence, and yet that evidence still requires authentication. Among the many items of Renaissance furniture sold by Volpi, the most famous piece, now in the Metropolitan Museum of Art stores, is the so-called bed. Originally believed to be an authentic Renaissance bed, its authenticity was once determined by its close resemblance to beds seen in depictions of fifteenth-century interiors, such as Ghirlandaio's *Birth of the Virgin* in the Tornabuoni Chapel, Santa Maria Novella Florence of c. 1475.[57] Now recognized as a nineteenth-century re-creation, it indicates an archaeological perspective, both from the point of view of the collector and the creator. It is now accepted as being a direct copy of such painted representations, if not a fake. The fact that the source, contemporary paintings, was followed so closely, reminds us that we still are tempted to use paintings for a measure of authenticity. [58]

A second approach is seen in the various types of chairs collected and sold by Volpi. In one instance, the sale catalog carefully compares a chair and a drawing by Andrea del Sarto as proof of attribution and authenticity, whereas it might just as easily be a nineteenth-century copy. The Savonarola or Dante chair, an X-frame chair in walnut, usually with a wooden seat, no doubt existed in the Renaissance and certain examples have been considered genuine, but many others were copies.[59] These usually stand out for the lavishness of the carving or the occasional use of inlaid decoration to embellish them. Some may indeed be essentially authentic, but were embellished with additional decoration, bringing the chairs to the level of distinction and luxury suiting the taste of the nineteenth-century owner. Intermingled with known sixteenth-century furniture, such as the X-frame chair, a number of straight-backed seats, possibly of sixteenth-century manufacture, appeared in large numbers, but were considered to be from the seventeenth century or later. These objects would be recontextualized within the interior, with little understanding of differences, authenticity, or embellishment.

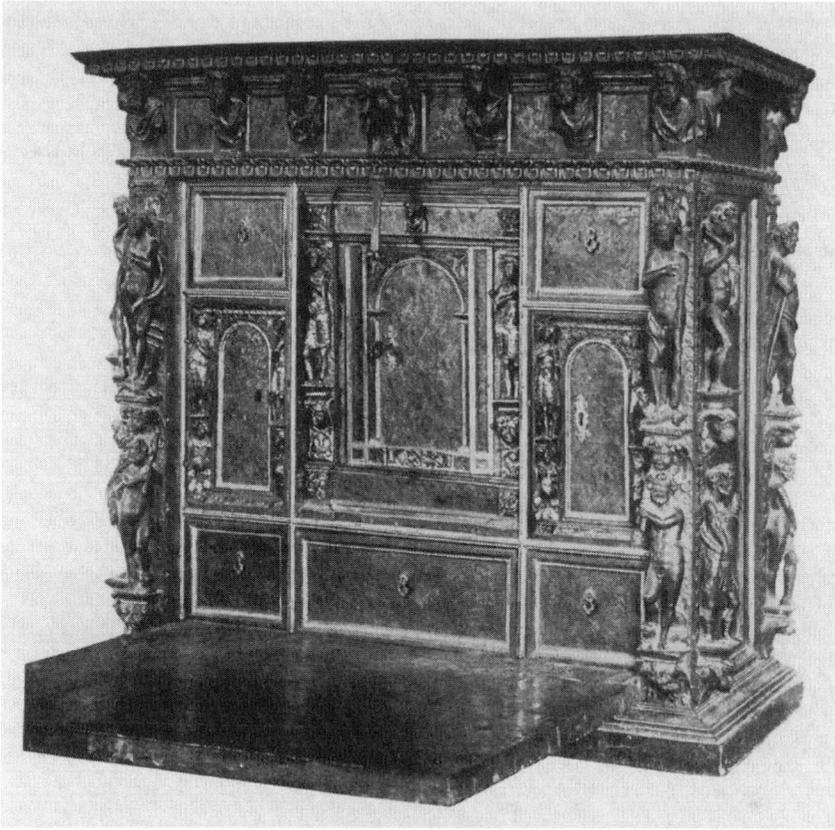

12.3 Lot. 433, a sixteenth-century Florentine carved-walnut cabinet, from the sale of *The Very Rare and Very Valuable Art Treasures and Antiquities Formerly Contained in The Famous Davanzati Palace; Also Those Contained in the Villa Pia*, Florence, Italy, November 21–27, 1916. Photo credit: © Victoria and Albert Museum, London

A further example of Volpi's collecting activities is the number of *cassapanca* (carved chests) that appear in the sale. The accumulation of this type of monumental furniture, which again is found in fifteenth-century Italian paintings, raises the interesting question: was the *cassapanca* an authentic feature of the early modern Italian domestic interior? There was considerable variety among the many examples sold by Volpi in 1916. Some highly elaborate examples might suggest they fit with the taste for carved pieces also found throughout the nineteenth century, making up chests of drawers or cupboards that could possibly date from the sixteenth century, but they are just as likely to be later or even nineteenth-century imitations. Others, such as examples now in the Horne Museum, Florence, have been analyzed and are thought to be of Renaissance manufacture.[60]

Volpi had both examples of carved chests or cabinets, which were highly popular objects among the nineteenth-century collectors (Figure 12.3). Lot 433 included such a Florentine cabinet of a typical format with elaborate sculpted decoration, crossing the boundaries with contemporary versions of French cabinets and chests.[61] These remain a difficult type to authenticate and it has not yet been determined how far these cabinets are original, have been

altered, or merely restored. Certainly, the Volpi catalog sold them as authentic and they entered the museums as genuine. Whether there was any concern as to the items being genuine or copies could only be ascertained from the contemporary inventories of these collections.

The furniture was primarily intended to create an authentic Renaissance presence in the rooms, but without differentiating what was original and what was often an "improved version" of the original, comparable to the blend of Renaissance objects and modern re-creations in the museum installations described by Wegner in her chapter in this volume, but with a concentration on the whole rather than illuminating individual objects.[62] Henry James, describing the interior of his fictitious character Gilbert Osmond, wrote that it "was moreover a seat of ease, indeed of luxury, telling of arrangements subtly studied and refinements frankly proclaimed, and containing a variety of those faded hangings of damask and tapestry ... those perverse-looking relics of medieval brass and pottery, of which Italy has been made the not-quite exhausted storehouse. These things kept terms with articles of modern furniture in which a large allowance had been made for a lounging generation."[63] This description could have referred to genuine interiors in Florence, as James intended, but it is also appropriate as a description of these new interiors, Renaissance rooms transplanted to New York or California. It also addresses values, taste, and refinement. Borrowing from the past as a way of commenting on one's sophistication in the domestic sphere is a theme referenced time and again across the historical spectrum and in many chapters in this volume. From the reinterpretation of the spaces of a Roman villa in Renaissance palaces, to displaying antiquities next to cinquecento Venetian paintings, to Lucrezia Borgia's subtle mimicry of her predecessor, Eleanora d'Aragon, domestic spaces and the objects placed within them were there to suit the tastes and the needs of their owners, family, and visitors, as well as to communicate status.

The sale of the Volpi collection in New York in 1917 unquestionably had an immediate effect both on the collecting of Renaissance works of art and on the interior decoration of the time. The newspapers reported the impact of the contents and the admiration they aroused. The success of the sales helped to promote Renaissance furniture as one of the most desirable styles for use in contemporary interiors. As illustrations of the homes of William Randolph Hearst, Pierpont Morgan, or Samuel Kress bear witness, furniture from the Volpi collection was included in most of the great collections and was eventually bequeathed to major American museums. At the time, they formed an essential core of the overall creation of interiors based on the Italian Renaissance.[64] One possible result of the "Davanzati effect" is the early twentieth-century preference for more austere interiors, furnished with plainer, less elaborately treated furniture, as seen in the display created by Alfred C. Bossom at 680 Fifth Avenue, New York, or the rooms directly copied from the Palace by Volpi's restorers, the Angeli brothers, for Joshua Cosden at his home in Palm Beach.[65] Edith Wharton promoted this type

of interior in her book *The Decoration of Houses* and suggested that medieval and Renaissance architects understood the importance of proportion, adapting their buildings to the uses for which they were intended and "then of decorating them in such a way as to give pleasure to the eye."[66] Her influential book, which was an attack on ill-thought-out, eclectic combinations of different periods, may have been yet another factor in the spread of the Renaissance style in the United States.

The widespread interest in the furnishings of the Italian Renaissance palace from the mid-nineteenth century to the early twentieth century had its origins in many differing aspects of the contemporary art market. What began as historical or antiquarian interest became the subject of collectors' passions and a search for status. Moreover, the qualities seen in Renaissance furnishings appealed to the nineteenth-century sensibility in its emphasis on skill of execution and finish. This in turn would lead to the restoration of objects to achieve such a finish; modern pieces inspired by or in imitation of the originals were brought in and were displayed in the interior as a reflection of this modernity. In spite of the interest in authenticity exhibited by some collectors, what remained important was the atmosphere. As the Volpi sale catalog describes some of the portraits in the palace, "These portraits … recall the two families whose names are associated with the beautiful palace. They are fixed in our minds; they accompany us during the whole of our visit through the palace. They live again in the deserted rooms, they speak of their lives and of themselves. They make us feel the poetry of the past of a very different past."[67] While old monuments and historians can introduce us to details of Florentine life, in order to gain an overall understanding of this period and to enter fully into the spirit of the people, nothing can be more evocative than to be placed within the frame where this very life took place. It was this spirit of the Renaissance that collectors wished to achieve by acquiring and creating the works of art, objects, and furnishings suitable to express their admiration of one of the two foundation stones of European and Western civilization. The richly furnished interiors, often with an eclectic mixture of period styles, were not historically accurate. More research may reveal where and how the great dealers of the nineteenth century acquired the works they sold on to collectors. Nonetheless, the recent publications and awareness of the Renaissance revival of the nineteenth century have already begun to shed much light on the market, collecting, and display of domestic objects, which has led to a more careful approach to Renaissance objects, particularly in museums and period rooms, and affects the interpretation of the Renaissance domestic interior as a whole.

Notes

1 The exhibition at the Victoria and Albert Museum, *At Home in Renaissance Italy* (October 5, 2006–January 14, 2007) was seminal in the reinterpretation of the object inside the interior. Specific attention was paid to approaches in identifying genuine Renaissance furniture at the annual symposium of the Furniture History Society, March 2007 in a paper by Fausto Calderai and

Simone Chirugi. See also the Victoria and Albert Museum online catalog http://www.vam.ac.uk/page/t/the-collections (accessed May 31, 2013) for updated information on new Renaissance galleries with new analysis and research on the Renaissance furniture collection. Museum catalogs analyze the construction of surviving furniture and establish provenance to address potential additions and/or restorations.

2 Francis Haskell, *History and its Images* (New Haven: Yale University Press, 1993), 232–5. Haskell outlines the influence of Hegel and its effect on Victor Cousin and Edgar Quinet, both of whom shaped Jules Michelet.

3 Ibid., 273–4.

4 Lenoir was not a collector; however, he sought to gather and present French historical landmarks to illustrate what Stephen Bann called "the notion of century." See Stephen Bann, *The Clothing of Clio* (Cambridge: Cambridge University Press, 1984), 77. See also Haskell, *History and its Images*, 250.

5 Bann, *The Clothing of Clio*, 91.

6 C. Wainwright, *The Romantic Interior* (New Haven: Yale University Press, 1989), 5–25. On history, see H. Arendt, "Le concept d'histoire: antique et moderne," *La Crise de la Culture* (Paris: Gallimard, 1972); Paul Hamilton, *Historicism* (New York: Routledge, 2003); and for an overview on the development of historical style in the nineteenth century, see Haskell, *History and its Images*, 305–61.

7 Fonthill Abbey, built c. 1796–1803, grew from its origins as a small garden building over a period of some 20 years to a large building in the shape of a cross with a central tower. The house was sold in 1822 to the sugar merchant James Farquar and many of the contents were cataloged for a sale scheduled for September, 1822 that never took place. See Christie's, *The Magnificent Effects at Fonthill Abbey* (London 1822). The sale finally took place in 1823 at Fonthill over 37 days. See Phillips, *The Unique and Splendid Effects of Fonthill Abbey* (London, 1923). Phillips included many items in the sale which did not belong to Beckford. For a full bibliography, see Derek Ostergard (ed.), *William Beckford 1760–1844: An Eye for the Magnificent* (New Haven: Yale University Press, 2001), 438–48.

8 For a detailed account of the homes and collections of William Beckford, see Ostergard, *William Beckford* and in particular the chapter by Bet Mcleod, "A Celebrated Collector," 155–75.

9 Phillips, lots 447–8 and 449–50. The chairs were attributed to Cardinal Wolsey by Horace Walpole at Strawberry Hill. See Wainwright, *The Romantic Interior*, 90. Based on the discovery of an ebony turned chair at the former palace of Cardinal Wolsey at Eckham, all such furniture was considered to have been made in the fifteenth century, when in fact it was imported from Indonesia and Sri Lanka in the seventeenth century. See Amin Jaffer, *Furniture from British India and Ceylon* (London: Victoria and Albert Museum Publications, 2001), 130–142. The "Bernini" cabinet had no documentary connections with Bernini; similarly, the "Holbein" cabinet was a fine sixteenth-century Augsburg cabinet, given a new provenance.

10 Henry Shaw and Sir Samuel Rush Meyrick, *Specimens of Ancient Furniture* (London: William Pickering, 1836). See also Mark Westgarth for a general discussion of the market and collecting of historicist objects in England: "The Emergence of the Antique and Curiosity Dealer 1815–c. 1850: The Commodification of Historical Objects" (PhD dissertation, University of Southampton, 2006).

11 The cabinet (lot 1045, Phillips' sale) also appears in Beckford's letters. See Boyd Alexander (trans. and ed.), *Life at Fonthill 1807–1882* (London: R. Hart-Davis, 1957), 190.

12 Phillips sale, 1823, lot 449: "a Large and Magnificent robe chest, formed of highly scented wood, externally carved with the rose and thistle, double gilt, and coloured in imitation of gems; … of times of James I." Other items were slightly ambiguous. See lots 447 and 448 in the same sale, which were a pair of cabinets of carved work, the "design of Queen Elizabeth's time." Interestingly, these cabinets were nearly twice as expensive at £147 as the robe chest at £81.18s.

13 Christopher Woodward, "Beckford's Tower in Bath," in Ostergard, *William Beckford*, 284.

14 Alessandro Tosi, "Il Viaggio Narrato e Illustrato," in *Viaggio di Toscana: percorsi e motivi del secolo XIX*, edited by Maurizio Bossi and Max Seidel (New York: Marsilio, 1998), 51. For further discussion on the influence of quattrocento architecture on visitors to Ital,y see Gabriele Morolli, "Gli *armonici innesti* della Modernità," also in Tosi, *Viaggio di Toscana*, 203–28.

15 Illustrated in Ostergard, *William Beckford*, 402, where they are said to have been based on the Mausoleum of Galla Placida.

16 A. Turpin, "Filling the Void: the Development of Beckford's Taste and the Market in Furniture," in Ostergard, *William Beckford*, 192.

17 Two recent studies that consider nineteenth-century British and non-Italian approaches to the Renaissance are John E. Law and Lene Østermark-Johansen (eds), *Victorian and Edwardian Responses to the Italian Renaissance* (Burlington, VT: Ashgate, 2005); and Yannick Portebois and Nicholas Terpstra (eds), *The Renaissance in the Nineteenth Century* (Toronto: CRRS Publications, 2003).

18 William Roscoe, *The Life of Lorenzo de Medici called the Magnificent* (Liverpool: J.M Creery, 1794); and *The Life and Pontificate of Leo X* (Liverpool, 1805). Both books were republished throughout the nineteenth century as well as being translated into French, German and Italian, For a complete discussion of Roscoe's text, see Amadeo Quondam, "William Roscoe e l'invezione del rinascimento," in *Gli anglo-americani a Firenze: Idea e costruzione del rinascimento, idea e costruzione del rinascimento : Atti del convegno, Georgetown University, Villa "Le Balze," Fiesole, 19–20 giugno 1997*, edited by Marcello Fantoni with Daniela Lamberini and John Pfordresher (Rome: Bulzoni, 2000), 249–338.

19 J.B. Bullen argues that Roscoe developed his myth of Lorenzo de Medici based on the eighteenth-century interpretation of the Medici as benevolent patriarchs, which was in line with Roscoe's own humanitarian views. See J.B. Bullen, *The Myth of the Renaissance* (Oxford: Clarendon Press, 1994), 15.

20 Jean Charles Leonard Simonde de Sismondi, *L'histoire des républiques italiennes du moyen age* (Paris, 1809).

21 Marcello Fantoni, "Renaissance Republics and Principalities in Anglo-American Historiography," in *Gli anglo-americani a Firenze* (see note 18), 36–40.

22 Jacob Burkhardt, *The Civilisation of the Renaissance in Italy*, 1st published in German in 1860 and translated into English in 1878. For his comments on the individuality of the Renaissance man and his passion, see Jacob Burkhardt, *The Civilization of the Renaissance in Italy* (Oxford and London: Phaidon Press, 1945), Part II, "The Development of the Individual," 81 and "The Discovery of Man," 184.

23 Bullen, *The Myth of the Renaissance*, 12.

24 Fantoni, "Renaissance Republics," 39; Bullen, *The Myth of the Renaissance*, 3–6.

25 J.J. Jarves, "A Lesson for Merchant Princes," in *Italian Rambles: Studes of Life and Manners in New and Old Italy* (London, 1883), 363; quoted by Fantoni, "Renaissance Republics," 39; Bullen, *The Myth of the Renaissance*, 3–6. Jarves, "A Lesson for Merchant Princes," 42.

26 Falke followed Burckhardt in seeing the Italian Renaissance as the ideal source for contemporary design; he recommended the Renaissance style in his *Die Kunst im Hause* (1871), a highly influential text on interior design. Annalisa Zanni argues that the publication of Falke's work in English in Boston 1878 was responsible for the diffusion of the Renaissance style in the United Sates in the 1880s. See Annalisa Zanni, "The Neo-Renaissance as the Image of the Private," in *Reviving the Renaissance: The Use and Abuse of the Past in Nineteenth-Century Italian Art and Decoration*, edited by Rosanna Pavoni (Cambridge: Cambridge University Press, 1997), 29–47. See also Eric Anderson, "Beyond Historicism: Jakob von Falke and the Reform of the Viennese Interior" (PhD dissertation, Columbia University, 2009) for a full discussion of Falke and his influence.

27 Zanni, "The Neo-Renaissance," 132–4.

28 W. Lübke, *Degli stile nell''arte industriale*, as quoted in Ornella Selvafolta, "The Legacy of the Renaissance in Periodicals," in *Reviving the Renaissance* (see note 26), 32.

29 Selvafolta, "Legends of the Renaissance," 38–40.

30 One of the first attempts to acquire Renaissance works of art was the acquisition of the Soulages Collection. See J.C. Robinson, F.S.A. (ed.), *Catalogue of the Soulages Collection: Being a Descriptive Inventory of a Collection of Works of decorative art, formerly in the possession of M. Jules Soulages of Toulouse; now, by permission of the Committee of Privy Council for Trade, exhibited to the public at the Museum of Ornamental Art, Marlborough House* (London, 1856). The collection was exhibited in 1857 and bought for the South Kensington Museum (now the Victoria and Albert Museum) in 1862. However, the museum did not buy the collection outright, but the furniture was bought separately.

31 Joseph Mordaunt Crook, *The Dilemma of Style* (London: John Murray, 1987), 198–200.

32 Joseph Mordaunt Crook, *The Rise of the Nouveaux Riches* (London: John Murray, 1999), 172–6.

33 Leyland had several country houses and London town houses. He leased a large and well-known Tudor house, Speke Hall near Liverpool, in 1867. In 1877 he bought Woolton Hall near Liverpool and decorated it with chiefly Burne-Jones' paintings. During the 1880s after his divorce, he acquired another house, the Covent or Villette, near Broadstairs in Kent, and commissioned Norman Shaw to remodel into the Neo-Gothic style. He acquired his first London residence at 23 Queen's Gate in 1868 and bought 49 Princes Gate in 1874. I am grateful to Eunmin Lim for this account of his properties.

34 To place Leyland's interest in Early Renaissance painters, see Susanna Avery-Quash, "The Growth of Interest in Early Italian Painting in Britain with Particular Reference to Pictures in the National Gallery," in *The Fifteenth Century: Italian Paintings*, vol. 1, edited by Dillian Gordon (New Haven: Yale University Press, 2003), xxv–xxxii. For the connection between Rossetti and Botticelli, see

Adrian S. Hoch, "The Art of Alessandro Botticelli through the Eyes of Victorian Aesthetes," in *Victorian and Edwardian Responses* (see note 17), 55–85.

35 Christie, Manson and Wood, *Catalog … of decorative objects, furniture and tapestry, the property of F.R. Leyland, Deceased late of 49 Princes Gate SW and Woolton Hall near Liverpool*, 27 May, 1892. See also Osborne and Mercer, *Catalog for No. 49 Prince's Gate, S.W. Repair and decoration carried out under the superintendence and assistance of Norman Shaw and James McNeill Whistler* (London, 1892).

36 George Charles Williamson, *Murray Marks and His Friends: A Tribute of Regard by Dr. G. C. Williamson* (London, 1919), 84; and Linda Merrill, *The Peacock Room: A Cultural Biography* (New Haven: Yale University Press, 1998), 156. Clive Wainwright, "A Gatherer and Disposer of Other Men's Stuffe: Murray Marks, Connoisseur and Curiosity Dealer," *Journal of the History of Collections* 14(I) (2002): 161–76.

37 The screen was bought for £1,200 and was offered on loan in 1869 to the Victoria and Albert Museum. It was eventually bought for £900 in 1871. It is now fully reinstated to its dominating position in its Renaissance galleries.

38 Christie, Manson and Wood, *Catalog of … decorative objects, furniture and tapestry, the property of F.R Leyland*. The most expensive item was lot 285, "an old Italian carving in wood of two female figures partly gilt one of whom is holding a banner and the other seated – on carved pillar," which was bought by Prinsep for £325 10s.

39 It is unknown when Leyland acquired the *cassoni*, and thus difficult to determine if their acquisition was a result of the growing interest for such objects during the second half of the nineteenth century. The literature on Renaissance *cassoni* is enormous. For an introduction to the history and terminology of the marriage chest, see Caroline Campbell, *Love and Marriage in Renaissance Florence* (London: The Courtauld Gallery in association with P. Holberton, 2009). For dealing in the nineteenth century, see Ellen Callman, "Renaissance Cassoni in the Nineteenth Century," *Burlington Magazine* 141(1155) (1999): 338–48. See also Cristelle Baskins, *The Triumph of Marriage: Painted Cassoni of the Renaissance* (Boston, Periscope Publishing, 2008). Particularly relevant is Alan Chong's chapter on "The American Discovery of Cassone Painting," 66–93.

40 Such collections are described in Wainwright, *The Romantic Interior*.

41 Donata Levi, "British Public Museums and the Italian Art Market in the Mid-Nineteenth Century," in *Victorian and Edwardian Responses* (see note 17), 39.

42 For an introduction to the collecting of the South Kensington Museum, see Charlotte Gere and Carolyn Sargentson, "The Making of the South Kensington Museum: Curators, Dealers and Collectors at Home and Abroad," *Journal of the History of Collections* 14(1) (2002): Special Issue.

43 For further evidence of J.C. Robinson's approach to collecting Renaissance furniture, see J.C. Robinson, F.S.A. (ed.), *Catalogue of Works of Art on Loan to the South Kensington Museum* (London, 1862).

44 For further details on Temple Leader, see Francesca Baldry, *John Temple Leader e il castello di Vincigliata* (Florence: Leo S. Olshki, 1997).

45 Rosanna Pavoni, "The Nineteenth-Century Palazzo Bagatti Valsecchi in Milan, Italy: A Homage to the Italian Renaissance" in *Reviving the Renaissance* (see note 26), 248.

46 Ibid.

47 Simone Chiarugi, "*Arredi Lignei*," in *Museo Bagatti-Valsecchi*, edited by Rosanna Pavoni, Carlo Pirovano and Sandrina Bandera Bistoletti, vols 1 and 2 (Milan: Electa, 2003). In his catalog on the palace furniture, Simone Chiarugi has analyzed the furniture techniques to disentangle the genuine from the copy or restored. I am grateful to Fausto Calderai for providing me with a copy of this catalog.

48 For example, the Farnese table designed by Vignola, now at the Metropolitan Museum of Art, New York, uses this design, but in marble. The table, museum no. 58 57a–d, is attributed to Jacopo Barozzi da Vignola (1507–73), who worked for the Farnese. It has carved marble bases attributed to Guglielmo della Porta (1506–77) with a top of *pietra dura* attributed to Giovanni Mynardo (1525–82). It was acquired by the tenth Duke of Hamilton and was sold at Christie's on November 13, 1919 to Viscount Leverhulme. The Metropolitan Museum of Art acquired it in 1958.

49 Chiarugi, "*Arredi Lignei*," 70. Approximately 93 out of 273 pieces were cataloged; an additional 42 were altered or repaired out of necessity; a large group made up out of authentic fragments; approximately 46 were in keeping with genuine styles; 18 completely fabricated; and the rest were in new wood. This does not include all the Neo-Renaissance furniture.

50 Roberta Ferrazza, *Palazzo Davanzati e le collezioni di Elia Volpi* (Florence, 1994); and Rosanna Proto Pisani and Francesca Baldry (eds), *Federigo e la Bottega Degli Angeli* (Livorno: Sillabe, 2009).

51 Valerie Niemeyer Chini, *Stefano Bardini e Wilhelm Bode: Mercanite e connoisseur fra Ottocento e Novecento* (Florence: Polistampa, 2009) provides some of the latest research on Bode and Bardini.

52 A great deal of new research is dedicated to Bardini, one of the most important Italian dealers in Renaissance art, whose collection and display influenced many collectors.

53 *Catalogue de Precieues Collections d'Objets d'Art appartenant de Prof. Elie Volpi, dont la vente aux enchères publiques aura lieu à Florence Palazzo Dora d'Istria-Palais Volpi,* sold by Jandola and Tavazzi, Monday April 25 to Tuesday May 3, 1910. The second sale took place in the American Art Galleries, New York, 1916, *The Very Rare and Very Valuable Art Treasures and Antiquities Formerly Contained in the famous Palace Davanzati and those Contained in the Villa Pia, Florence, Italy … November 21st and the Six following week days …* (London: National Art Library, Victoria and Albert Museum).

54 Thus, the main rooms of the palace, the Camera dei Pavoni, the Camera delle Impannate, and, most importantly, the Camera della Castellani di Vergy, were all decorated with fresco cycles.

55 Louis C. Rosenberg, *The Palace* (1922), quoted in Ferrazza, *Palazzo Davanzati,* 33.

56 Pisani and Baldry, *Federigo e la Bottega Degli Angeli,* 41.

57 Lot 453, *Very Rare and Valuable Art Treasures,* 1916.

58 Thus, Roberta Ferrazza in her detailed account of the Palazzo lists much of the furniture, including this bed, as coming from the sixteenth century: Ferrazza, *Palazzo Davanzati,* 187.

59 For example, see lots 362 and 363, *Very Rare and Valuable Art Treasures,* 1916 or lots 353 and 354, *Catalogue de Precieuses Collections d' Objets d'Art,* 1910.

60 Lot 487, a fifteenth-century Italian large throne, now in the Herbert Percy Horne Museum, Florence. See Claudio Paolini, *Il mobile del Rinascimento* (Florence: Edizione delle Meridiana: 2002), 70–72.

61 Lot 411, *Very Rare and Valuable Art Treasures,* 1916 or lot 572, *Catalog de Precieuses Collections d'Objets d'Art,* 1910 are typical examples.

62 Arguably, this representation is still in the spirit of Samoyard's Cluny Museum discussed earlier in this chapter. However, when museums today recreate the interior, they try to avoid the accumulation of objects, often from different time periods and generally more decorated than the original, which is what often characterizes the nineteenth-century approach.

63 Quoted by Daniela Lamberini, "Residenti anglo-americani e genius loci: ricostruzioni e restauri delle dimore fiorentine" in *Gli anglo-americani a Firenze* (see note 18), 125–40.

64 Ferrara, *Palazzo Davanzati,* 145–58. Bardini also did the same, selling entire Renaissance ceilings to Isabelle Stewart Gardner or Nelie André, now installed in their museums in Boston and Paris.

65 Lamberini, "Residenti anglo-americani e genius loci," 125–40.

66 Edith Wharton and Ogden Codman, Jr., *The Decoration of Houses* (London and New York: Batsford and Scribner's Sons, 1898), 91.

67 See the Preface in *Very Rare and Valuable Art Treasures,* 1916.

Recreating the Renaissance Domestic Interior: A Case Study of One Museum's Approach to the Period Room

Susan E. Wegner[1]

The approach to the modern period room faces similar challenges and dilemmas as in the nineteenth century, but the efforts, interpretations, and results are quite new. While Adriana Turpin's chapter in this volume examined the historical processes that shaped the emergence of the period room during the nineteenth century, this chapter explores ethical and practical questions raised in creating a "period room" model for the temporary exhibition *Beauty and Duty: The Art and Business of Renaissance Marriage* at the Bowdoin College Museum of Art, Brunswick, Maine (March 27–July 27, 2008). *Beauty and Duty* centered on the variety of functions served by one special type of household furniture: the Italian Renaissance marriage chest, the *cassone*. As a public proclamation of the new union, the *cassone* accompanied the bride in her transition from girlhood under her father's roof to her married life within her husband's home. Installed in the couple's bedroom, the *cassone* helped to define the roles of wife, mother, pious educator of children, and trusted steward of household resources, through its decoration, contents such as devotional books, and its ample storage space secured with lock and key. By focusing on the *cassone*, the exhibition helped to elucidate the process of shaping a new household and the object's part in mapping expectations for a wife's duties and behavior within that evolving space.

This chapter argues in support of an expositive approach to exhibition installation, such as that used for *Beauty and Duty* that evoked a portion of an Italian Renaissance bedroom through reasoned juxtaposition of objects from disparate centuries and regions. This method of installation stays true to the intention of recontextualizing art objects undertaken by the Samuel H. Kress Foundation's Old Masters in Context Initiative, which generously helped to support the exhibition. Such an approach deliberately aims at exploring relationships among a living space, its furnishings and decorative and useful objects that were part of daily life in Europe 500 years ago. As discussed in

Adriana Turpin's chapter in this volume, some similar aims underpinned the creation of Renaissance room assemblages by nineteenth-century collectors.

The *Beauty and Duty* exhibition was designed to be accessible to a general audience. The goal of the exhibition was to engage, entertain, and educate viewers by comparing historical household objects with contemporary domestic items. The installation invited the play of curiosity and imagination while maintaining scholarly integrity by acknowledging through labels, publications, and curators' presentations the liberties taken when combining objects of diverse dates and provenance. All of the features were intended to reveal some of the characteristics of a bedroom in Renaissance Italy.

Although it is just one example of a modified "period room" approach to exhibition, *Beauty and Duty* underlines the special potential that domestic interior studies – in their very subjects, questions, and expansive methods of investigation – have to contribute to imaginative transformations in standard exhibition and installation practices. In turn, exhibitions that risk breaking the high art/domestic art dichotomies in the service of recontextualization can vividly present new scholarship on domestic interiors to a public audience far wider than a narrow cadre of specialists.

Exhibiting Renaissance Domestic Interiors

Several recent exhibitions focused on the daily life of Italy in the Renaissance (or the early modern period). In London, the Victoria and Albert Museum's impressive offering *At Home in Renaissance Italy* (October 5, 2006–January 14, 2007)[2] set a high standard for historical presentation by combining pieces of surviving domestic architecture (water font, cornice, fireplace), which provided a framework for educational interpretations of costume, wedding customs, wedding gifts, portraits of marriageable young people, documents, plans, and elevations of Renaissance houses in Florence and Venice.

The curators, Marta Ajmar-Wollheim and Flora Dennis, mapped out principal rooms of typical but elite Florentine and Venetian homes of the Renaissance and appointed them with representative items of furniture, architectural elements, and moveable objects appropriate to each room: the *sala* (reception room), the *camera* (bedroom), and the *scrittoio* (study). This organization was created with an open framework fashioned on the physical scale consistent with a Renaissance room. The open-walled structure allowed paintings to be presented without the tyranny of the museum wall that isolates them. Instead, the objects were experienced against the enclosing environment, conjuring up through fragments the specific type of room in which they could have stood. This innovative installation made a bracing change from traditional formats.[3]

Bowdoin College sought to employ a similarly flexible variation on a period room display, though on a much more modest scale. The College aspired to set together diverse objects within the period room format, yet it

lacked the vast resources of a national museum. Further, a college museum has to grapple with the tension between scholars' preferences and those of the non-specialist museum visitors who would make up the majority of its viewers. It was decided that the exhibition should speak to a general audience, telling the story of how broad classes of objects – wooden furniture, painted portraits, ceramic tableware – might have functioned together in a Renaissance household. Exhibition-goers who wanted to learn more about particular works as unique objects, not just as representatives of broad categories, made use of gallery talks, object labels, and the exhibition publication to investigate individual objects more deeply.

Period Rooms as Popular Favorites

Vigorous debate marks the history of period rooms in US museums,[4] and the term can refer to quite a few different kinds of constructions. Period rooms range from the scrupulously meticulous reinstallation of an authentic fifteenth-century interior decorative program, such as the Gubbio Room at the Metropolitan Museum of Art, New York, to imagined recreations of spaces using modern materials to stand in for the old. The latter concoctions have raised suspicion and active dislike among scholars. As Philippe de Montebello, former Director of the Metropolitan Museum of Art, has noted: "Some scholars and experts in the field of decorative arts do not agree on their [period rooms'] appropriateness in an art-museum setting, their purpose, and their degree of authenticity. Some would prefer to have such rooms confined to historical houses, where they may be seen in their original architectural context."[5]

The scholarly debate over the validity of period rooms is further fueled by the fact that such displays are often some of the most popular exhibits in the museum. Having considerably fallen out of favor between the 1940s and the 1980s, the period room has experienced a revival in the past few decades. For example, the new installation of the Metropolitan's Gubbio Room in 1996 brought forth a tremendous positive response, as did the reinterpretation of its English rooms in 1995 and the reopening of the Wrightsman Galleries for French Decorative Arts, also at the Metropolitan, in 2008.[6] The Victoria and Albert Museum's recent refashioning of its British Galleries also enjoyed acclaim.[7]

There is no doubt that there is keen contemporary enthusiasm for all things Renaissance, which bursts out in a spate of popular entertainments, such as television series and video games.[8] In the face of popular cultural misconstructions of Renaissance art and life, museums have a unique opportunity to make accessible surviving art and artifacts, and provide the viewing public with a contextual historical and art-historical understanding of the actualities of these distant times. The differences in social attitudes, family relations, language, sexual practice, finance, and religion between the

twenty-first-century North American culture and fifteenth-century Italian culture are far more interesting and thought-provoking than the ripe imaginings of a virtual world. An exhibition speaks to acutely visually attuned twenty-first-century viewers, presenting them with a wide field of objects and ideas: actual paintings, bronze medals, furniture, and costumes richer in surface texture and meaning than screen-based games. Museum displays do not rely on speed, but rather invite the mind to ponder, prompting the viewer to reflect, and formulate his or her own questions, instead of responding only to an historically inaccurate pre-formulated script.

Evocation Rather than Thoroughgoing Reconstruction

One mode for long-term installation of a fifteenth-century European "period room" that major museums currently embrace and effectively employ is the thoughtfully constructed composite of two or more rooms. The Cloisters' Campin Room (the Metropolitan Museum of Art, New York) represents an outstanding example of this strategy, which presents the Mérode Altarpiece by Robert Campin within the context of a small, modestly lit chamber. The Campin Room draws together a fifteenth-century Spanish wood-beamed ceiling, French furniture, German glass, a Lowlands chandelier,[9] and the exquisite early Netherlandish panel painting that gives the room its name. Curator Mary Shepard explains that the room "does not replicate the actual appointments of a specific private chamber of the period."[10] Instead, the space and objects come together to evoke the intimacy of a late medieval domestic space. One may object that the Campin Room is not strictly "accurate." However, this flexible approach to a recombination that draws together objects from different geographic regions and from roughly the same historical period does find support in trade patterns for art and moveable goods in fifteenth- and sixteenth-century Europe.[11] Further, an evocative period room such as the Campin Room reinforces how the flexible exchange of goods and objects between rooms and households, not to mention geographies, is in fact a key characteristic of the early modern home, which was not a static rigid environment, a fact that is noted in several chapters in this volume.

The five-month-long Bowdoin College Museum of Art *Beauty and Duty* exhibition was modeled on this happy solution. The idea for the show developed around the nucleus of a Florentine painted panel from a marriage chest, a *cassone*, to use the term commonly yet anachronistically employed in current scholarship.[12] This core object is a tempera painting on wood bordered with a relief pattern of alternating small birds and grouped triple nails in gold.[13] Its subject, identified by Paul Watson, unfolds several scenes from Giovanni Boccaccio's *Ninfale Fiesolano* (1344–6) telling the fraught love story of the youthful shepherd, Africo, and his beloved nymph, Mensola.[14]

We still know nothing of the original owners of the *cassone* on which this tale of forbidden love was painted. However, Laurence Kanter, the Lionel Goldfrank III Curator of Early European Art at the Yale University Art Gallery and former Curator-in-Charge of the Robert Lehman Collection of the Metropolitan Museum of Art, recently suggested that the panel may date from as early as 1410 or 1412. He included it in the 2006 Fra Angelico exhibition at the Metropolitan with a tentative attribution to the young Fra Angelico, who may have painted it when he was present in the studio of Lorenzo Monaco. This stimulating conjecture encouraged the Bowdoin College Museum of Art to make the newly cleaned panel accessible to a wide audience.[15]

While drawing attention to this intriguing suggestion for a new attribution, the Bowdoin College Museum of Art did not wish to present the work solely as a potential early work by Fra Angelico. It wanted to recontextualize the panel, to disrupt expectations of viewers who had long seen the work hung on the wall like an easel painting. Rehanging the *cassone* panel at knee level, closer to where it would have originally been viewed on the front of a marriage chest, would have certainly jarred museum-goers into seeing it anew. For the safety of the object, this radical move was not chosen. Instead, two full *cassoni* were provided from the Cincinnati Art Museum and the Yale University Art Gallery (Figure 13.1). Visitors could view from all sides the relatively intact Cincinnati chest, observing the roughly painted geometrical designs on the back and fragments of painted textile decoration that once ornamented the lid. The Yale example, exhibited with its lid open, revealed the painted nude female figure, one of several types of decoration chosen for the interiors of such ornamented chests. Before both *cassoni*, visitors could sit down on the wooden floor to examine closely the fronts and sides painted with battle scenes and allegories.

To further impress upon visitors that the Bowdoin painting of nymphs was once part of a piece of household furniture integrated into the daily life of men, women, and children, the exhibition featured the faces of known and unknown individuals recorded in painted portraits and bronze medals dating from the early 1400s through to the early 1600s. For example, a Milanese bronze medal from around 1550 showed Ippolita Gonzaga, married at the age of 13, widowed at 16, and remarried at 19.

Here an ethical concern regarding historical accuracy arose. Was this gathering of Renaissance faces with dates ranging over 200 years and a geographic span from Naples to Florence and to northern courts a serious distortion of the kinds of people who could have viewed the nymph panel? To address this concern, it was noted that multiple generations of a household could have seen a *cassone*.[16] Also, Italian manufactured goods and art objects were exported to distant locations, as were brides. In one case, when the 14-year-old Paola Gonzaga of Mantua traveled to Austria to marry the Count of Gorizia in 1477, she brought along *cassoni* decorated with Roman histories.[17]

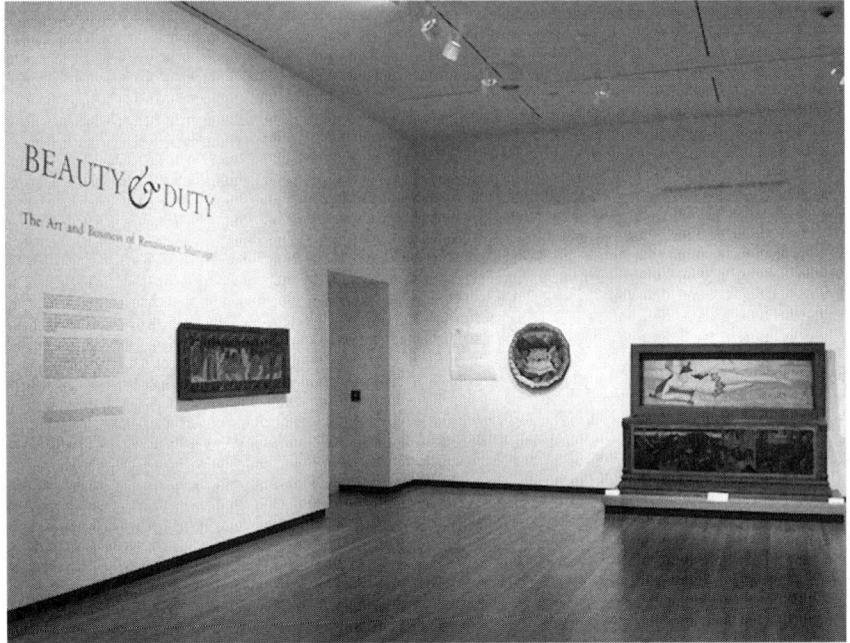

13.1 *Beauty and Duty* exhibition installation (2008), with nymph *cassone* panel, Bowdoin College Museum of Art, Bowdoin College, Brunswick, Maine (left) and open-lidded full *cassone*, Yale University Art Gallery, New Haven, Connecticut (right). Photo credit: Bowdoin College Museum of Art

Thus, the circle of potential viewers and consumers of a *cassone* and its painted panel could very well have been quite broad over the fifteenth and sixteenth centuries.

The question of a wide geographic range and a temporal expanse arose not only with the portraits, but also with the possibility of displaying the early fifteenth-century *cassone* panel beneath a late sixteenth-century Neapolitan painted ceiling in the company of sixteenth-century furnishings. Here the dangers of anachronism were moderated by realities of human living spaces subject to change, rearrangement, and redecoration over time. European domestic interiors during the Renaissance were often the result of generations of accumulations; things neither of the same date nor from the same city of manufacture could sit cheek by jowl.[18] This rationale for combining chronologically diverse architectural elements and furnishings is supported by evidence from Renaissance inventories that chart the course of cherished paintings handed down through families, reused for different purposes, and moved from location to location over time. Botticelli's paintings for the Medici are well-known examples.[19] Several chapters in this volume, such as that by Elizabeth Carroll Consavari, affirm how domestic spaces as well as the objects in the early modern period evolved to suit the tastes and needs of a family. For instance, Renaissance paintings once owned and hung as an expression of domestic familial piety and devotion (see the chapter by Margaret Morse in this volume) could eventually be hung in rooms with antiquities in an effort to define a family's artistic and cultural refinement (see the chapter by Consavari).

The argument for Bowdoin's choice to exhibit together artistic productions from Florence, Naples, and Bologna is supported by recorded trade patterns and by the collecting habits of elites such as Isabella d'Este, who sought out works from masters beyond their own regional boundaries. There is also the well-documented example of the Florentine brothers Benedetto and Giuliano da Maiano, who crafted a resplendent day bed (*lettuccio*) for King Ferrante of Naples in 1473.[20] In 1476, they sent down an even more elaborate one for the Duke of Calabria. While these examples stem from the highest level of elite society, they do underline the potential mobility of even large household objects deliberately fashioned for the display of wealth, prestige, and taste. Susan Nalezyty's chapter in this volume is a literal case-in-point to support such fashioning and mobility.

With such historical precedents in mind, the Bowdoin show conceived of a Renaissance domestic interior as a palimpsest where early decorations could be overlaid by the possessions of subsequent generations of a family or even a new owner, and where products from many different cities could indeed have resided together.

Practical Challenges

Numerous practical problems confronted the efforts to suggest a Renaissance interior with an imaginative approach. Bowdoin's objects were housed in various collections, the Museum of Art, Special Collections of the Library, and college public spaces overseen by an artifacts team. Each college entity has its own standard for security, policy on access, and conservation requirements. One of the monuments overseen by the Special Collections of the Library is an historic ceiling, which, like the fifteenth-century Spanish ceiling in the Cloisters, has been reinstalled in a modern building. Bowdoin's painted, stuccoed, and gilded wooden ceiling, according to early twentieth-century library records, dates to the late sixteenth century and is believed to be from a palace in Naples.[21] The gilded wooden ceiling is now built into a small library room, the Susan Dwight Bliss Room, named after its donor and located in Hubbard Hall, a building completely separate from the Museum of Art on the Bowdoin campus. One of the four large allegorical panels at the center of the ceiling uses the visual language of the ill-assorted couple, a theme that could well have enhanced our focus on the business of Renaissance marriage.[22]

Unfortunately, we could not follow the Cloisters' example and unite the *cassone* panel, large wooden furniture, and other objects in this single space with the ceiling. The Bliss room is just too small to hold massive *cassoni*. Removing the ceiling and remounting it within the Museum would have been a costly and difficult engineering feat, disrupting library, classroom, and office spaces. Undertaking such a Herculean effort for a temporary exhibition was unfeasible. A solution of compromise would have been to project a digital image of the ceiling within the Museum's gallery. That idea, too, was abandoned due to

enormous challenges faced in adequate photography of the ceiling (which is in need of conservation) and orchestrating museum-quality projection. In the end, the ceiling had to be left in its separate venue, which was open to visitors on request, but was not well integrated into the exhibition.

Other practical challenges arose in relation to the "Bliss throne," which is a massive wooden furniture piece intended to stand as an example of the large items such as the bed and daybed that had dominated a *camera*. As with much furniture believed to be of Renaissance manufacture, this work raised questions of authenticity. It was granted to the College in 1945 as part of the Susan Dwight Bliss gift (see Appendix I) and was described in the donation document as a 12-foot-long "throne" of carved walnut, made in the second half of the sixteenth century in Italy. No provenance was provided at this time. Thirty years later, it was assessed as "a long carved oak Elizabethan seat."[23] It resembles a *lettuccio*, but with carved acanthus pilasters that project out into the seating area and separate the three hinged lids covering storage spaces beneath the seat. This could not have made for very comfortable lounging, even with a cushion. Still, the work compares roughly with the *lettuccio* shown in a woodcut from Savonarola's *Sermon on the Art of Dying Well* (1496).[24] Including this piece of furniture as a part of the exhibition involved risks. There was the possibility that it might prove to be a nineteenth-century reproduction. However, by transferring this object from storage, it was brought before furniture specialists to examine. With great effort, the body of the seat was removed from its dais and was transported to the East Point Conservation Studio. There, head conservator Jon Brandon and his team cleaned and stabilized the work, revealing new information regarding its antique hardware, ancient repairs, and decorative touches such as a marbleized veneer. After a thorough examination, the conservators judged that it was indeed of Renaissance manufacture with some nineteenth-century additions.[25]

The imposing walnut bench proved to be one of the favorites of the exhibition, engaging visitors with its enormous bulk and ornate carved decoration of satyrs, birds, weapons, and flowers. Visitors were tempted to touch the carving, lift the hinged lids, and peer around the back of the behemoth. A gallery talk by Jon Brandon satisfied some of those cravings, allowing visitors to observe the interior of the storage spaces under the seats. After the exhibition's closing, the seat was returned to its relatively unmonitored public space, but with the addition of a rope cordoning it off for protection and a descriptive wall label.

The carved walnut bench had a commanding presence in a small gallery niche that had been painted with a rich red backdrop (Figure 13.2). Two humble paintings, possibly north Italian, of the Madonna and Child, a staple of domestic interiors, were hung on either side of the bench to foster a personal, yet inviting atmosphere; such qualities were, in fact, desired by Renaissance residents for their own *camere*.[26] Paintings functioning in a personal and moralizing capacity in the seventeenth-century Bolognese interior are specifically addressed by Erin Campbell's chapter in this volume.

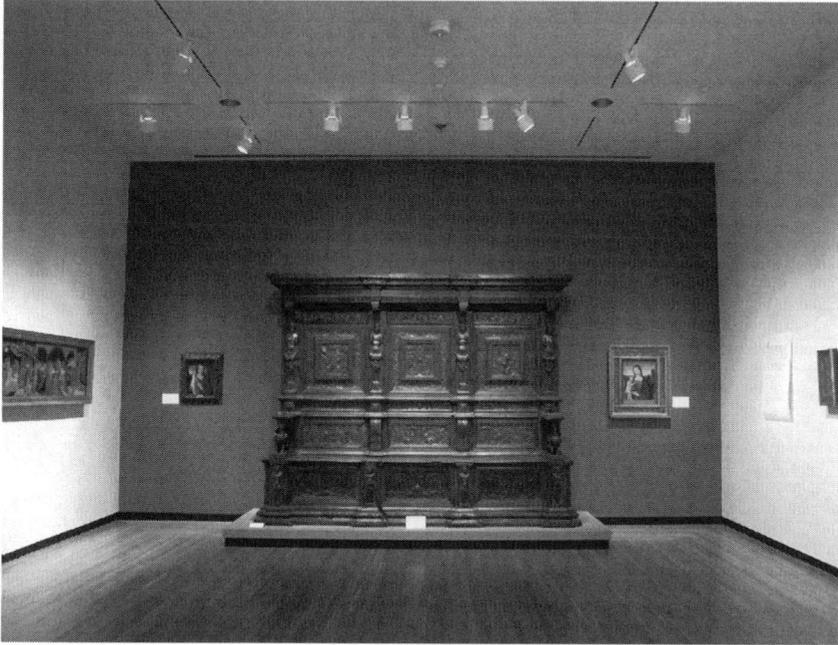

13.2 *Beauty and Duty* exhibition installation (2008), with Italian bench, 49.5 x 304.5 x 71 cm, carved walnut, sixteenth century, Bowdoin College Museum of Art, Bowdoin College, Brunswick, Maine. Photo credit: Bowdoin College Museum of Art

A diminutive saint's picture, St Bernardino of Siena, placed on the short sidewall completed the group, creating an intimate enclosure. Fashioned in this manner, the museum gallery space could approximate a "period room" effect, providing a closed-in space, minimal wall labeling, reduced lighting, wooden floor, and a vantage point that excluded all other modern cases and materials. Perhaps the effect might be more properly called a "period niche." On an adjacent wall and the wall facing the bench, we installed several life-size portraits of married or soon-to-be-married women, Maria de'Medici, future Queen of France (1594), and Maria Maddalena of Austria, Grand Duchess of Tuscany (1610), who activated the gallery space with their direct gazes and overpowering physical presences. It was not hard to imagine these women as the guiding force within a wealthy household, as addressed in the chapters by Burgess Williams, Campbell, and Consavari in this volume.

Modern Interpretation of the *cassone*: Reconstruction or Reproduction?

Early in planning the exhibition, the Museum considered how a reproduction of a full yet unpainted *cassone* might facilitate museum visitors' understanding of the original chest to which the nymph panel had belonged. Consulting precedents revealed that major museums remain split over the issue of using reproductions. The Metropolitan does regroup original objects, but never shows reproductions, although it does display historically accurate recreations of period textiles.[27]

13.3 Brad
Thompson,
twenty-
first-century
interpretation
of a *cassone*, 66.5
x 162.5 x 53.5
cm, unpainted
poplar (2008),
Bowdoin College,
Brunswick,
Maine. Photo
credit: Brad
Thompson

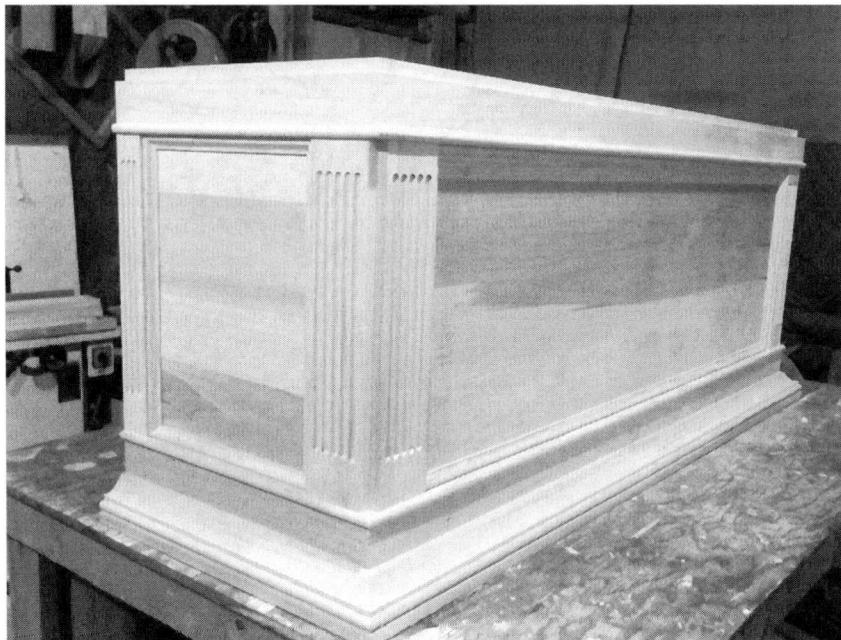

In contrast, the Museum of Fine Arts, Boston, has exhibited exact reproductions such as those of the funeral furniture for the Old Kingdom Egyptian Queen Hetepheres.[28] The Bowdoin College Museum of Art elected to follow Boston's example.

A skilled twenty-first-century woodworker, Brad Thompson, interpreted the craft of *cassone* manufacture by emulating the planing of surfaces and joining of the segments, and by following the proportions mapped in the analysis of the Courtauld Institute's Morelli-Nerli *cassoni*.[29] This solidly physical mode of interpretation was complemented by the less costly, if no less complex, virtual "reconstruction" of the object. Such virtual remakings are common to archaeological displays and are perhaps more palatable to museum staff because they do not fashion a physical object that might be confused with Renaissance works. Twenty-first-century viewers comfortable with manipulation of a screen image could view a short animation on the exhibition's website depicting a reconstruction of how the nymph panel may have functioned as part of a fifteenth-century chest. The animation took the viewer around the front, sides, and back, opening and closing the lid to display textile decoration.

In contrast to the computer model, the full-size three-dimensional reconstruction rendered in poplar wood had the advantage of giving viewers an immediate sense of scale and mass, along with the heft and feel of actual wood (Figure 13.3). To avoid confusion between the modern chest and 500-year-old constructions, the unpainted reconstruction was displayed with an explanatory label in the Museum's atrium, not in the galleries themselves.

Viewers used to seeing Bowdoin's nymph panel as a framed painting hung on a wall remarked upon how striking it was to be greeted by a full-scale, raw wood coffin-like facsimile chest as they prepared to enter the galleries housing the exhibition. The work succeeded in recognizing the contributions of the different kinds of craftsmen required to deliver the finished Renaissance marriage chest. The installation informed viewers that the nymph painting was only one part of the colossal piece of utilitarian furniture. Museum staff were allowed to touch and open the facsimile chest for museum-goers, even revealing the secret compartment built into the bottom of the object.

Along with the goal of recontextualizing the *cassone* panel back into its domestic "frame," we wanted to inform general audiences more fully of the object's function by "unpacking" one of the marriage chests. We did not literally set contents of a chest back into the container, but designed an "exploded" display of medals, books, an illuminated manuscript, paintings and tableware, along with images of the dresses, combs, textiles, jewelry, and silver commonly inventoried among a new bride's possessions. The jewel-encrusted skirts, sleeves, and bodices, among the most precious possessions protected within the silk-lined chests, fascinated visitors. They marveled at the picture of the bejeweled *zibellino* (sable fur piece) adorning a Bolognese bride.

Conclusions

Contextual installations encourage serious examination of Renaissance rooms assembled in nineteenth-century homes, the source of many museums' holdings. As Adriana Turpin's chapter in this volume eloquently argues, the traditions of such rooms and their furnishings underlie some of our current assumptions of what a Renaissance interior was like. Since the Bowdoin College exhibition drew from the extensive collections of the New York Bliss family and their Renaissance-inspired library space, it launched recent efforts at conservation, documentation, and analysis of the formation of those collections. Research into the family's motives for the original shaping of that room, now reconstituted at Bowdoin, is underway. As a result, the Bliss Room will take its place as one more stage in the life history of practical objects, wall and ceiling ornaments that even in the sixteenth century had already been bought and resold, given as gifts, loaned, inherited, refashioned for new owners, and reset into fresh arrangements over time.[30] Thus, in the end, the *Beauty and Duty* exhibition persuades one to believe that such composite displays, even though created out of many compromises, still yield enough compensatory benefits to warrant a legitimate place in twenty-first-century museum practice.

At the same time that contextual displays enhance the general public's engagement with Renaissance materials, they can augment research into the very objects and spaces they curate. One objective of the *Beauty and*

Duty exhibition was to give specialists the opportunity to reconsider objects in a fresh way, perhaps gaining unanticipated insights into decorative strategies that could tie together architecture, furniture, and a fine miniature. Examining works of disparate type not previously seen together might help answer questions of authenticity or origin. When museum-goers "inhabit" a contextual display, their presence can remind them of how initial owners may have participated as co-creators of the meanings of the works. An evocative "period room" approach pries attention away from the still-dominant monographic approach to studying individual great artists. For example, in this specific case, *Beauty and Duty* explicitly emphasized the team of anonymous makers required for the making of a *cassone*, stressing the corporate effort of the workshop over that of a lone master.

Ultimately, home is central to our humanity; it is a daily, shared experience. At the end of the Museum's ruminations on the ethical and practical questions considered in this chapter, the potential benefits for learning and enjoyment offered by even a fragment of a "period room" were judged to outweigh the risk of misrepresentation. Within an enveloping environment that unites tempera paintings, carved wooden furniture, gold, bronze, and maiolica, viewers gained impressions of relative scale, relished contrasting textures, and enjoyed how meanings expressed within objects might have played off one another. For example, the exhibition highlighted the combination of the sacred and the profane by showing how a devotional work, like an illuminated book of hours, could have been protected and stored within a chest decorated with a nymph's overheated love life. In fifteenth- and sixteenth-century Italy, objects proclaiming the revival or appropriation of ancient classical myths and legends could reside easily within a Christian household.

In the view of the Bowdoin College Museum of Art, a gathering of Renaissance objects from various provenances was more eloquent, more inviting, and more moving than a display parceled out into individual glass cases. And, in fact, very rarely would an "authentic" Renaissance home have had such discrete and segregated objects in a *camera, studiolo*, or *sala*. Research into the early modern domestic interior in Italy, including the chapters in this volume, argues for dynamic interiors and objects, and a desire for well-crafted objects made locally or afar from different times and places. In effect, this research supports exhibitions such as that at the Bowdoin College Museum of Art by encouraging a broad, museum-going public to appreciate the eclecticism offered by a museum period room, or niche. Works seen in isolation can be interpreted as only exotic or odd, offering little connection to modern audiences. When these same objects are integrated into a shared context, they can connect strongly to the viewers' own physicality, draw on sense memory, spark imagination, and engage intellect.[31] Like an actual early modern home, period rooms weave together past and present and occasionally different geographies. The display of a disparate array of objects becomes logical (perhaps even appropriate) for period rooms as new and ongoing research promotes such evocative interconnections that in a museum

setting are best represented in a period room. Exhibitions such as *Beauty and Duty* and period rooms bring the study and research of the domestic interior into the larger, public discourse.

Appendix I

Susan Dwight Bliss Room and Furniture, Hubbard Hall, Bowdoin College, Brunswick, Maine

This room and its furnishings were donated to Bowdoin College anonymously by Susan Dwight Bliss (1882–1966) in 1945. There followed gifts of a library of roughly 1,200 volumes and a collection of almost 1,000 prints. These gifts, as records of the formation of taste in early twentieth-century New York elite society, have only begun to receive thorough analysis and interpretation.

The room itself formed part of a complete complex of Renaissance Italian and eighteenth-century French décor for the Bliss New York townhouse at 9 East 68th Street, designed by architects George Lewis Heinz and Christopher Grant LaFarge in 1905, and constructed by 1907, for Jeannette Atwater Dwight Bliss (1852–1924; m. 1879), the widow of George T. Bliss (c. 1851–1901), a New York financier. The new structure encompassed whole rooms such as the late eighteenth-century polyhedral mirrored boudoir from the Hôtel de Crillon, 10, Place de la Concorde, Paris, which had been designed for the eighteenth-century collector Louis-Marie-Augustin, Duc d'Aumont;[32] and the Boudoir from the Hôtel de Crillon, the Metropolitan Museum of Art.[33] Mrs Bliss purchased the entire room in 1906, possibly envisioning herself as a twentieth-century inheritor of the duke's tradition of collecting and support of the arts.

The gilded, wooden and painted ceiling now in the Bliss Room at Bowdoin was acquired in Rome in 1906 from the dealer Alessandro Imbert and is described as sixteenth-century Neapolitan in the Bliss inventory. A letter from Imbert, from Paris on August 28, 1935, to Susan Dwight Bliss, states that the ceiling came from the old palazzo near the University of Naples, called "il palazzo d'Anjou".[34] The ceiling's central moralizing program is described above in note 21. The ceiling once capped the townhouse's library[35] constructed to include a presumed late fifteenth-early sixteenth-century Italian doorway ornament, marble fireplace (listed as fifteenth-century Italian) tables, chairs, and fireplace implements, among other items, variously described as Italian, French, or Spanish from the fifteenth to the eighteenth centuries. Photographs reveal that the room held the prized Luca della Robbia *Madonna and Child* (now in the Metropolitan Museum of Art), among other works in marble, oils, and enamel. When the library room came to Bowdoin, the architectural firm of McKim, Mead, and White resized and refashioned it for installation on the second floor of Hubbard Hall.

The "Bliss Throne," cleaned and stabilized for the *Beauty and Duty* exhibition, originally stood in a hallway in the New York townhouse and seems not to have formed part of Mrs Bliss' recorded arrangement for the

library.[36] The inventory cards that accompanied the "throne" to Bowdoin College include citations from Wilhelm von Bode's and Frida Schottmüller's publications testifying that the Renaissance furniture type, the *trono*, was present in state drawing rooms of the palaces of the foremost Florentines and that it was a place from which high-born couples received their guests.

The Bliss family collection, presumably begun by George T. Bliss and greatly augmented by his wife, Jeannette, and their daughter, Susan Dwight Bliss, evinces a fascination with holding the memory of famous historical figures, particularly women, through their letters (Lucrezia Borgia), their furniture, and their portraits (Marie Antoinette and Infanta Isabella Clara Eugenia of Spain). That the Bliss collection held multiple portraits of the latter through her life stages, from marriageable royal princess, to Archduchess of Austria and finally to widow-nun, indicates an intimate interest in life journeys of notable women of the past. For Jeannette, the life of Mary Queen of Scots held special meaning, and her vast collection of manuscripts, books, prints, and medals related to the ill-fated queen was donated to the Bibliothèque nationale in 1927.

That the Bliss collections and in particular their library functioned as a site of personal commemoration is suggested by photographs of the library alcove. Set off from the library proper by three ascending steps, the almost shrine-like space once held a large painted portrait of the late George T. Bliss (now in the New York State Museum). While not on the same scale as the holdings of Isabella Stewart Gardner in Boston, the Bliss collection and its display within a household may be found to share some of Gardner's intentions and results.

Notes

1 This chapter is based on a paper delivered in the session "New Perspectives on the Italian Renaissance Interior, 1400–1600" at the College Art Association Conference in New York City, February, 2007. I thank the organizers of the session, Dr Stephanie Miller and Dr Maria DePrano, for their interest and encouragement, and I thank respondent Dr Beth Holman for her insightful comments on the session.

2 *Beauty and Duty: The Art and Business of Renaissance Marriage*, Bowdoin College Museum of Art, Brunswick, Maine (March, 27–July 27, 2008); *The Triumph of Marriage: Painted Cassoni of the Renaissance*, Isabella Stewart Gardner Museum, Boston (October 16, 2008–January 18, 2009) and the John and Mable Ringling Museum of Art, Sarasota (February 14–May 17, 2009); *Art and Love in Renaissance Italy*, Metropolitan Museum of Art, New York (November 18, 2008–February 16, 2009) and Kimbell Art Museum, Fort Worth (March 15–June 14, 2009); *Love and Marriage in Renaissance Florence: The Courtauld Wedding Chests*, Courtauld Gallery, London (February 12–May 17, 2009).

3 Aislinn Loconte, "Reviews of Exhibitions," review of *At Home in Renaissance Italy*, edited by Marta Ajmar-Wollheim and Flora Dennis, *Renaissance Studies* 21(5) (2007): 704–12; for a more jaundiced view of the installation, see Michael Kimmelman, "At the End of a Day In London, An Epiphany," *The New York Times*, November 22, 2006, ART: p. E13.

4 Julius Bryant, "Museum Period Rooms for the Twenty-First Century: Salvaging Ambition," *Museum Management and Curatorship* 24(1) (2009): 73–84, with bibliography. Bryant's paper was originally presented at "The Past, Present and Future of the Period Room. A Symposium in Honor of the Reopening of the Wrightsman Galleries for French Decorative Arts," the Metropolitan Museum of Art, New York, February 15, 2008; Marjorie Schwarzer, "Literary Devices: Period Rooms as Fantasy and Archetype," *Curator: The Museum Journal* 51(4) (2008): 355–60; Danielle Labbate, "From Period Rooms to Period Environments: A Look at How Museums are Redefining the Scope of the Period Room" (MA thesis, Seton Hall University, 2007) http://domapp)1.shu. cdu/depts/uc/apps/libraryrepository.nsf/resourceid/9EC83F724361B80C852573B7004C5207/$File/

Labbate-Danielle_Masters.pdf?Open (accessed July 15, 2013); Sarah Medlam, "The Period Rooms," in *Creating the British Galleries at the V&A: A Study in Museology*, edited by Christopher Wilk and Nick Humphrey (London: V&A Publications, 2004), 165–74; Sally Anne Duncan, "From Period Rooms to Public Trust: The Authority Debate and Art Museum Leadership in America," *Curator: The Museum Journal* 45(2) (2002): 93–108.

5 Philippe de Montebello, introduction to *Period Rooms in the Metropolitan Museum of Art*, by Amelia Peck et al. (New York: Metropolitan Museum of Art: H.N. Abrams, 1996); Joan DeJean, "Rooms Worth Keeping," *The New York Times*, September 2, 2010, http://opinionator.blogs.nytimes.com/2010/09/02/rooms-worth-keepiong/ (accessed July 15, 2013); Nicole Belolan, "Interpreting the 'Period Room'," *Picking for Pleasure: Understanding Antiquing Acquisitions*, September 2, 2010, http://pickingforpleasure.blogspot.com/2010/09/interpreting-period-room.html (accessed July 15, 2013). See also Adriana Turpin's chapter in this volume.

6 "Five Must-See Pieces at the Met" posted by Annie Fitzsimmons, May 28, 2013, *Intelligent Travel*, *National Geographic*, http://intelligenttravel.nationalgeographic.com/2013/05/28/5-must-see-pieces-at-the-met-afitz (accessed July 15, 2013); De Montebello, introduction to *Period Rooms in the Metropolitan Museum of Art*, 9.

7 Christopher Wilk and Nick Humphrey (eds), *Creating the British Galleries at the V&A: A Study in Museology* (London: V&A Publications, 2004).

8 See, for example, the immensely popular television series *Game of Thrones* built out of an amalgam of European historical periods from the fourteenth through the sixteenth centuries, or the action-adventure video games such as *The Inferno* or *Assassin's Creed*, which is set in fifteenth-century Florence, using names of historical personages, yet freely fantasizing their dialogue, appearance, and actions, which focus primarily on highly choreographed and glamorized bloodshed. Also, re-enactors and costumed participants flock every year to dozens of "Renaissance Faires" held in almost every state in the United States and some provinces in Canada. For a sample of current festivals, see: *Renaissance, Medieval & Pirate Faire Directory*, http://www.renfaire.com/Sites/index.html (accessed July 15, 2013).

9 Mary Shepard, "The Campin Room," in Amelia Peck et al., *Period Rooms in the Metropolitan Museum of Art*, 34–8.

10 Ibid., 38.

11 See Mari-Tere Alvarez, "Artistic Enterprise and Spanish Patronage: The Art Market during the Reign of Isabel of Castile (1474–1504)," in *Art Markets in Europe, 1400–1800*, edited by Michael North and David Ormrod (Aldershot: Ashgate, 1998), 45–59. On purchases made from Rome, Genoa, Bologna, Milan, Florence, and Venice for the Ferrarese d'Este courts, see Guido Guerzoni, "Italian Renaissance Courts' Demand for the Arts: The Case of d'Este of Ferrara (1471–1560)," in *Art Markets in Europe, 1400–1800*, 61–80.

12 On precise terminology, such as *forzieri* and *cassoni*, used in fifteenth-century inventories, see John Kent Lydecker, "The Domestic Setting of the Arts in Renaissance Florence" (PhD dissertation, The Johns Hopkins University, 1987), 52–5; Peter Thornton, *The Italian Renaissance Interior, 1400–1600* (New York: H.N. Abrams, 1991), 192–204; James R. Lindow, "For Use and Display: Selected Furnishings and Domestic Goods in Fifteenth-century Florentine Interiors," *Renaissance Studies* 19(5) (2005): 634–46.

13 Recently proposed attribution to "Fra Angelico ?", formerly attributed to Giovanni di Francesco Toscani, *Scenes from Boccaccio's Il Ninfale Fiesolano*, 11 3/8 x 49 13/16 inches (28.9 x 126.5 cm), gift of the Samuel H. Kress Foundation. Bowdoin College Museum of Art, 1961.100.1. See Susan Wegner, "Unpacking the Renaissance Marriage Chest, Ideal Images and Actual Lives," in *Beauty and Duty, The Art and Business of Renaissance Marriage* (Brunswick, Maine: Bowdoin College Museum of Art, 2008), 10–22.

14 Paul Watson, "Boccaccio's Ninfale Fiesolano in Early Florentine Cassone Painting," *Journal of the Warburg and Courtauld Institutes* 34 (1971): 331–3; Giovanni Boccaccio, *The Nymph of Fiesole, Il Ninfale Fiesolano*, translated by Daniel J. Donno (New York: Columbia University Press, 1960).

15 Laurence B. Kanter and Pia Palladino et al., *Fra Angelico* (New York: Metropolitan Museum of Art; New Haven: Yale University Press, 2005), 19–21. Some scholars have stated doubts that the panel's style accords with a date from the 1410s.

16 Giorgio Vasari's oft-quoted comment in the life of Dello Delli where he mentions the fashion in the old days for great tomb-like chests indicates that the modern generations knew of centuries-old furniture, examples of which were presumably still visible in some Florentine homes. Giorgio Vasari, *Le vite de' più eccellenti pittori scultori e architettori* [1550, 1568], vol. 3, edited by Rosanna Bettarini and Paola Barocchi (Florence: Sansoni, 1971), 37.

17 Graham Hughes, *Renaissance Cassoni, Masterpieces of Early Italian Art: Painted Marriage Chests 1400–1550* (Polegate, Sussex: Starcity Publishing; London: Art Books International, 1997), 64–7 with bibliography.

18 Ann Matchette, "Dismembering the Home in Renaissance Italy," in *Imagined Interiors: Representing the Domestic Interior Since the Renaissance*, edited by Jeremy Aynsley and Charlotte Grant (London: V&A Publications, 2006), 48–9. Curator Joan R. Mertens makes this same assertion in her comments on the Roman Boscoreale bedroom recreation in Amelia Peck et al., *Period Rooms in the Metropolitan Museum of Art*, 18.

19 Ronald Lightbown, *Sandro Botticelli: Life and Work* (New York: Abbeville Press, 1989), 152–3. For the Morelli-Nerli *cassoni*'s 200 years within the Morelli household, see Hughes, *Renaissance Cassoni*, 209. Documents show that goods were frequently borrowed, traded, and sold. See Ann Matchette, "To Have and Have Not: The Disposal of Household Furnishings in Florence," *Renaissance Studies* 20(5) (2006): 701–16.

20 For Ercole di Roberti's nuptial bed and 12 ornamented "coffers" for Isabella d'Este, see Joseph Manca, *The Art of Ercole de'Roberti* (Cambridge: Cambridge University Press, 1992), 13, 199–205. On the *lettuci* for Naples, see Thornton, *The Italian Renaissance Interior*, 149; also 144 for Bianca Maria Sforza's bed and camp bed transported when she traveled north from Milan to marry the Holy Roman Emperor Maximilian I. For an example of exports of smaller items, see Marco Spallanzani, "Un invio di maioliche di Urbino a Lione nel 1539," *Faenza* 66(1–6) (1980): 301–4 on the export of maiolica from Urbino to Lyons.

21 George J. Mitchell, Department of Special Collections &Archives, Bowdoin College Library, Susan Dwight Bliss Room Files: File Box 5.1.4, Accounting Box One, Library Office Files, Memoranda and Correspondence.

22 After continuing research sparked by the exhibition, I now propose that the five central panels make up a moral guide, offering three bad examples, one good one, and an image of the final reward for the humble, poor, and pure of heart.
 The three bad examples feature allegorical meditations on the love of money and material goods, the wages of lust, and the folly of entrapment in frivolous, slothful and incontinent pastimes that indulge the senses but lead to the extinction of the soul.
 Lust for Wealth (South panel). A disconsolate man sits in an ornate canopied chair at a small table laden with gilded treasures instead of with nourishing food and drink. He spreads his arms in dismay as if lamenting how empty this miser's hoard really is. Surrounded by earthly wealth, this fool for loot embodies the painful lessons learned by King Midas and the miser on his deathbed.
 Foolish Lust (North panel). The prototypical mismatched couple, a cloaked graybeard with prayer beads and a young woman in pseudo-classical garb, moodily ignore one another, though they are chained together by their foolish choices. An immodest, bare-breasted female (Lust) emerging from dark clouds above holds the chain that binds the unhappy pair. A black-and-white magpie, emblematic of nagging chatter, sits on the young woman's head. A stand of reeds, weak, hollow, and fruitless like the ill-advised union, presses in upon the couple.
 Waste of Life in Foolish Pursuits (West panel). A richly robed gray-bearded man reclines inertly before a bower and balustrade, entwined with lush leaves and grapes that serve as perches for distinctive and colorful birds (perhaps, parrot, thrush, goldfinch, hoopoe, turtledove, long-tailed exotics?). Chains at the elder's wrists and ankles bind him to fancy vessels, a large bowl filled with gold, and a musical score and lute. A repellent thick-bodied serpent twines around his right thigh and rises suggestively between his legs. This man, despite his years, which ought to have brought him wisdom, languishes among symbols of idle pursuits, signaling intemperance (grapes and wine vessels), lust (lute, score, birds, snake) and avarice (gold, crown).
 Devotion rejecting Vanity, Lust, Avarice (East panel). A semi-nude woman with long tresses looks piously upward while crossing her arms over her bosom. Following the model of the penitent saint Mary Magdalen in the wilderness (as painted by Titian and others), she embodies the Penitent seeking the heavenly sphere after discarding all earthly pomp. This shapely ascetic ignores all the temptations lying on the ground at her feet: a lute and music, a jeweled collar and golden crown, a dress and other fancy trifles. She is not chained or entrapped by love of wealth, indulgence in fleshly pleasures or life-wasting frivolities; her pious model points us toward the central panel.
 Reward in Heaven (Central panel). Benevolent God the Father reaches out to bless the devout saved who are rewarded with victors' palms by two wingless angels. The Heavenly father is rightly enthroned, with crown and scepter. Kneeling prayerfully, the blessed inhabit a pleasant green paradise encircling God's throne. The vessel at God's feet remains full of palm fronds, a promise that there is plenty of room for those who follow the correct path.
 The moralizing lessons are presented through a charmingly homely style. The four outer panels give such detailed renderings of material temptations that viewers are likely to linger at length with the bad examples and skim quickly over the rather bland central picture of spiritual reward. The engrossing imagery used in the paintings has many ties to northern prints such as those satirizing the Foolish World or showing the drunken Noah in contemporary dress under his vine.

23 George J. Mitchell, Department of Special Collections & Archives, Bowdoin College Library, Bliss Collection and Room Correspondence file, inv. no. 355.

24 Illustrated in Thornton, *The Italian Renaissance Interior*, 148. As Adriana Turpin's chapter in this volume rightly cautions, relying solely on comparisons to artists' images is insufficient proof of a piece of furniture's authenticity.

25 Jon Brandon, East Point Conservation Studio, "Bowdoin College Museum of Art, The 'Bliss Throne'," 2008.

26 On the ubiquity of Madonna and Child images in the home, see Peta Motture and Luke Syson, "Art in the Casa," in *At Home in Renaissance Italy*, edited by Marta Ajmar-Wollheim and Flora Dennis (London: V&A Publications, 2006), 273, 278; Thornton, *The Italian Renaissance Interior*, 261–4.

27 De Montebello, *Period Rooms in the Metropolitan Museum of Art*, 11; Daniëlle O. Kisluk-Grosheide and Jeffrey Munger, *The Wrightsman Galleries for French Decorative Arts, the Metropolitan Museum of Art* (New Haven: Yale University Press, 2010), 19 and 98, no. 38, for example. On discoveries made during attempts to reproduce historic textiles, see Janet Arnold, "Make or Break: The Testing of Theory by Reproducing Historic Techniques," in *Textiles Revealed: Object Lessons in Historic Textile and Costume Research*, edited by Mary M. Brooks (London: Archetype Publications, 2000), 39–47.

28 Canopy and bed of Queen Hetepheres (reproductions, acc. nos. 38.873 and 29.1858) with other exact duplicate reproductions of objects from the same tomb, on display at Museum of Fine Arts, Boston. The Isabella Stewart Gardner Museum in its fall 2008 installation that opened after *Beauty and Duty* used a hybrid reproduction, a modern box set at eye level to which it applied the front and side panels of a dismembered *cassone*. On the installation, see Patricia Simons and Monica Schmitter, "Review of Exhibition: Review of 'The Triumph of Marriage: Painted Cassoni of the Renaissance'," *Renaissance Studies* 23(5) (2009): 719. On the *cassone* fragments, Cristelle Baskins, "Catalogue," in Cristelle Baskins et al., *The Triumph of Marriage, Painted Cassoni of the Renaissance* (Boston: Isabella Stewart Gardner Museum, 2008), 154.

29 Arabella Davies, "The Morelli-Nerli Cassoni and Spalliere: A Technical Examination and Cultural Appraisal," *The Conservator* 19 (1995): 36–44, ii–iii.

30 For images of the Bliss library as installed in the family's New York townhouse, see Bowdoin College Library, George J. Mitchell Department of Special Collections & Archives, Bowdoin College, http://coburn.bowdoin.edu:8180/luna/servlet/view/search;jsessionid=A814BE26E9EB6 39CF6BEC326FF8FC886?QuickSearchA=QuickSearchA&q=bliss&sort=Title%2CFilename&sear ch=Search (accessed July 15, 2013). For the library's current configuration as the Susan Dwight Bliss Room at Bowdoin College, see "About The Susan Dwight Bliss Fine Bindings Collection & The Susan Dwight Bliss Room," Bowdoin College, http://www.bowdoin.edu/about/qtvr/ art-museum/bliss (accessed July 15, 2013), with additional links regarding Susan Dwight Bliss's extensive philanthropy, including gifts of manuscripts, books and works of art to many museums, educational institutions, and libraries. See Appendix I here for a brief overview of the Susan Dwight Bliss Room and its genesis.

31 For a formal assessment of an exhibition's public value, see the Arts and Humanities Research Council's commissioned study of *At Home in Renaissance Italy*: At Home in Renaissance Italy – An Impact Case Study, Arts and Humanities Research Council, http://media.vam.ac.uk/media/ documents/legacy_documents/file_upload/44451_file.pdf (accessed July 15, 2013). Its visitor survey elicited comments such as "This is the only way it should be shown. The art remains outstanding in its own right. The function is up for study always. This eliminates the possibility of seeing the art in a vacuum" And "The positioning added to my appreciation greatly. Existing scholarship has tunnel vision. All everyone ever thinks about is what masterpieces are on the wall" (8).

32 Kisluk-Grosheide and Munger, *The Wrightsman Galleries*, 9.

33 http://www.metmuseum.org/Collections/search-the-collections/120014575 (accessed July 15, 2013).

34 George J. Mitchell Department of Special Collections & Archives, Bowdoin College Library, Bliss Collection and Room correspondence; letter of 1935 among correspondence regarding the purchase of the ceiling, Susan Dwight Bliss Donor file, Bowdoin College Museum of Art.

35 For plans, see Stephen Ferguson, "Susan Dwight Bliss (1882–1966), Collector, Philanthropist," Rare Book Collections @ Princeton, Princeton University, http://blogs.princeton.edu/rarebooks/2009/04/ susan_dwight_bliss_1882-1966_c.html (accessed July 15, 2013).

36 Photographs in Bowdoin College Special Collections, c. 1943; see note 30 above.

Selected Bibliography

Aikema, Bernard. "The Lure of the North: Netherlandish Art in Venetian Collections." In *Renaissance Venice and the North: Crosscurrents in the Time of Bellini, Dürer, and Titian*, edited by Bernard Aikema and Beverly Louise Brown. Milan: 1999, 83–91.

Ajmar, Marta. "Toys for Girls: Objects, Women and Memory in the Renaissance Household." In *Material Memories*, edited by Marius Kwint, Christopher Breward and Jeremy Aynsley. Oxford: 1999, 75–89.

Ajmar-Wollheim, Marta and Flora Dennis (eds), *At Home in Renaissance Italy*. London: 2006.

Ajmar-Wollheim, Marta, Flora Dennis, and Ann Matchette (eds), *Approaching the Italian Renaissance Interior: Sources, Methodologies, Debates*. Malden, MA and Oxford: 2007.

Albala, Ken. *The Banquet, Dining in the Great Courts of Late Renaissance Europe*. Chicago: 2007.

Alberti, Leon Battista. *I primi tre libri della famiglia*, edited by F.C. Pellegrini and R. Spongano. Florence: 1946.

Alberti, Leon Batista. *I libri della famiglia*, translated by R.N. Watkins as *The Family in Renaissance Florence*. Columbia, SC: 1969.

Alberti, Leon Battista. *The Albertis of Florence: Leon Battista Alberti's Della Famiglia*, translated by Guido A. Guarino. Lewisburg, PA: 1971.

Alberti, Leon Battista. *On the Art of Building in Ten Books*, translated by Joseph Rykwert, Neil Leach, and Robert Tavernor. Cambridge, MA and London: 1988.

Antonelli, Armando and Marco Poli. *Il palazzo dei Bentivoglio*. Venice: 2006.

Appadurai, Arjun. "Introduction: Commodities and the Politics of Value." In *Social Life of Things: Commodities and the Politics of Value*, edited by Arjun Appadurai. Cambridge: 1986, 3–63.

Bachelard, Gaston. *The Poetics of Space*, translated by Maria Jolas. New York: 1964.

Ballarin, Alessandro and Maria Lucia Menegatti. *Il Camerino delle pitture di Alfonso I*, Vol. 4, I Camerini di Alfonso I nella via coperta ed in castello. Cittadella (Padua): 2002.

Bann, Stephen. *The Clothing of Clio*. Cambridge: 1984.

Bargagli, Girolamo. *Dialogo de' Giuochi che nelle vegghie sansei si usano di fare*, edited by Patrizia D'Incalci Ermini. Siena: 1982.

Barriault, Anne. *Spalliera Paintings of Renaissance Tuscany: Fables of Poets for Patrician Homes*. University Park, PA: 1994.

Baskins, Cristelle. *Cassone Painting, Humanism, and Gender in Early Modern Italy*. Cambridge: 1998.

Baskins, Cristelle, Adrian B. Randolph, and Jacqueline Marie Musacchio. *The Triumph of Marriage, Painted Cassoni of the Renaissance*. Boston: 2008.

Bayer, Andrea (ed.), *Art and Love in Renaissance Italy*. New Haven: 2008.

Bellonci, Maria. *Lucrezia Borgia, sua vita e suoi tempi*. Milan: 1960.

Benporat, Claudio. *Feste e banchetti: Convivialità italiana fra tre e quattrocento*. Florence: 2001.

Bollnow, O.F. *Human Space*, edited by Joseph Kohlmaier, translated by Christine Shuttleworth. London: 2011.

Brown, Clifford M. *Isabella d'Este in the Ducal Palace in Mantua*. Rome: 2005.

Brown, Patricia Fortini. *Private Lives in Renaissance Venice: Art, Architecture and the Family*. New Haven: 2004.

Bryant, Julius. "Museum Period Rooms for the Twenty-first Century: Salvaging Ambition." *Museum Management and Curatorship* 24(1) (2009): 73–84.

Bullen, J.B. *The Myth of the Renaissance*. Oxford: 1994.

Bulst, Wolfger A. "Uso e trasformazione del palazzo mediceo fino ai Riccardi." In *Il Palazzo Medici Riccardi di Firenze*, edited by Giovanni Cherubini and Giovanni Fanelli. Florence: 1990, 98–129.

Burroughs, Charles. "Florentine Palaces: Cubes and Context." *Art History* 6 (1983): 359–63.

Campbell, Stephen J. "Giorgione's 'Tempest,' 'Studiolo' Culture, and the Renaissance Lucretius." *Renaissance Quarterly* 56(2) (2003): 299–332.

Campori, Giuseppe. *Raccolta di cataloghi inventarii inediti*. Modena: 1870.

Capatti, Alberto and Massimo Montanari. *Italian Cuisine, A Cultural History*. New York: 1999.

Casey, Edward S. "Body, Self and Landscape: A Geophilosophical Inquiry into the Place-World." In *Textures of Place: Exploring Humanist Geographies*, edited by Paul C. Adams, Steven Hoelscher and Karen E. Till. Minneapolis and London: 2001, 403–25.

Catalano, Michele. *Lucrezia Borgia*. Ferrara: 1920.

Cavallo, Sandra and Silvia Evangelisti (eds), *Domestic Institutional Interiors in Early Modern Europe*. Burlington, VT: 2009.

Ciappelli, Giovanni and Patricia Rubin (eds), *Art, Memory, and Family in Renaissance Florence*. Cambridge: 2000.

Clough, Cecil H. *The Duchy of Urbino in the Renaissance*. London: 1981.

Coffin, David R. *The Villa in the Life of Renaissance Rome*. Princeton: 1979.

Cohen, Elizabeth and Thomas Cohen, "Open and Shut: The Social Meaning of the Cinquecento Roman House." *Studies in the Decorative Arts* (Fall–Winter, 2001–2): 61–84.

Cohen, Elizabeth S. and Thomas V. Cohen. *Daily Life in Renaissance Italy*. Westport, CT: 2001.

Coonin, Arnold Victor. "Portrait Busts of Children in Quattrocento Florence." *Metropolitan Museum Journal* 30 (1995): 61–71.

Corazza, Bartolomeo di Michele del. "Diario Fiorentino, anni 1405–1438," edited by Giuseppe Odoardo Corazzini. *Archivio storico italiano*, series V, vol. XIV (1894): 233–98.

Coté, A.B. "Blessed Giovanni Dominici. Regola del governo di cure familare, parte Quarta. On the Education of Children." PhD dissertation, Catholic University of America, 1927.

Cuppini, Giampiero and Anna Maria Matteucci. *Ville del Bolognese*, 2nd edn. Bologna: 1969.

Cuppini, Giampiero. *I palazzi senatorii a Bologna: Architettura come immagine del potere*. Bologna: 1974.

Del Gaizo, Vittorio (ed.), *Grande enciclopedia antiquariato e arredamento*. Rome: 1968.

De Maria, Blake. *Becoming Venetian: Immigrants and the Arts in Early Modern Venice*. New Haven: 2010.

DeMause, Lloyd (ed.), *The History of Childhood*. New York: 1974.

Dempsey, Charles. *The Portrayal of Love: Botticelli's Primavera and the Humanist Culture at the Time of Lorenzo the Magnificent*. Princeton: 1992.

Dennis, Flora. "Unlocking the Gates of Chastity: Music and the Erotic in the Domestic Sphere in Fifteenth and Sixteenth-century Italy." In *Erotic Cultures in Renaissance Italy*, edited by Sara F. Matthews-Grieco. Burlington, VT: 2010, 223–45.

Dennis, Flora. "Resurrecting Forgotten Sound: Fans and Handbells in Early Modern Italy." In *Everyday Objects: Medieval and Early Modern Material Culture and Its Meanings*, edited by Tara Hamling and Catherine Richardson. Burlington, VT: 2010, 191–209.

DePrano, Maria. "At Home with the Dead: The Posthumous Remembrance of Women in the Domestic Interior in Renaissance Florence." *Source* 29(4) (2010): 21–8.

Dominici, Giovanni. *Regola del governo di cura familiare, parte quarta: On the Education of Children*, translated by Arthur Basil Coté. Washington, DC: 1927.

Douglas, Mary. "The Idea of a Home: A Kind of Space." *Social Research* 58(1) (1991): 287–307.

Duncan, Sally Anne. "From Period Rooms to Public Trust: The Authority Debate and Art Museum Leadership in America." *Curator: The Museum Journal* 45(2) (2002): 93–108.

Eiche, Sabine (ed.), *Ordine et Officij de Casa de lo Illustrissimo Signor Duca de Urbino*. Urbino: 1999.

Eisenbichler, Konrad (ed.), *The Premodern Teen: Youth in Society, 1150–1650*. Toronto: 2002.

Fantoni, Marcello, Daniela Lamberini, and John Pfordresher (eds), *Gli anglo-americani a Firenze: Idea e costruzione del rinascimento, idea e costruzione del rinascimento*. Atti del convegno, Georgetown University, Villa "Le Balze," Fiesole, June 19–20, 1997. Rome: 2000.

Ferrazza, Roberta, *Palazzo Davanzati e le collezioni di Elia Volpi*. Florence: 1994.

Filarete, Francesco and Angelo Manfidi. *The Libro Cerimoniale of the Florentine Republic*, edited by Richard C. Trexler. Geneva: 1978.

Findlen, Paula. "The Museum: Its Classical Etymology and Renaissance Genealogy." *Journal of the History of Collections* 1 (1989): 59–78.

Findlen, Paula. *Possessing Nature: Museums, Collecting, and Scientific Culture in Early Modern Italy*. Berkeley: 1994.

Fletcher, Catherine. "'Furnished with Gentlemen': The Ambassador's House in Sixteenth-Century Italy." *Renaissance Studies* 24 (2010): 518–35.

Frati, Lodovico. *La vita privata di Bologna*. Rome: 1968.

Frick, Carole Collier. *Dressing Renaissance Florence: Families, Fortunes, and Fine Clothing*. Baltimore: 2002.

Frigo, Daniela. *Il padre di famiglia: Governo della casa e governo civile nella tradizione dell' "economica" tra cinque e seicento*. Rome: 1985.

Frigo, Daniela. "Civil conversatione e pratica del mondo: Le relazioni domestiche." In *Stefano Guazzo e La civil conversazione*, edited by Giorgio Patrizi. Rome: 1990.

Gere, Charlotte and Carolyn Sargentson (eds), "The Making of the South Kensington Museum: Curators, Dealers and Collectors at Home and Abroad." Special Issue, *Journal of the History of Collections* 14(1) (2002).

Goldthwaite, Richard A. *The Building of Renaissance Florence*. Baltimore: 1980.

Goldthwaite, Richard A. *Wealth and the Demand for Art in Italy 1300–1600*. Baltimore: 1995.

Gregorovius, Ferdinand. *Lucrezia Borgia*. New York: 1904.

Gurrieri, Francesco. *Il Palazzo Tornabuoni Corsi: sede a Firenze della Banca Commerciale Italiana*. Florence: 1992.

Haas, Louis. *The Renaissance Man and His Children: Childbirth and Early Childhood in Florence, 1300–1600*. New York: 1998.

Haskell, Francis. *History and its Images*. New Haven: 1993.

Heidegger, Martin. "Building, Dwelling, Thinking." In *Rethinking Architecture: A Reader in Cultural Theory*, edited by Neil Leach. London and New York: 1997, 100–109.

Herlihy, David and Christiane Klapisch-Zuber. *Tuscans and their Families*. New Haven: 1985.

Hochmann, Michel, Rosella Lauber, and Stefania Mason. *Il collezionismo d'arte a Venezia. Dalle origini al Cinquecento*. Venice: 2008.

Hollingsworth, Mary. *The Cardinal's Hat, Money, Ambition and Housekeeping in a Renaissance Court*. London: 2004.

Horodowich, Elizabeth. *Language and Statecraft in Early Modern Venice*. New York: 2008.

Hughes, Graham. *Renaissance Cassoni, Masterpieces of Early Italian Art: Painted Marriage Chests 1400–1550*. Polegate, Sussex and London: 1997.

James, Carolyn. "The Palazzo Bentivoglio in 1487." *Mitteilungen des Kunsthistorischen Institutes in Florenz* 41 (1997): 188–96.

Johnson, Geraldine. "Art or Artefact: Madonna and Child Reliefs in the Early Renaissance." In *The Sculpted Object: 1400–1700,* edited by Stuart Currie and Peta Motture. Aldershot: 1997, 1–24.

Johnson, Geraldine. "Beautiful Brides and Model Mothers: The Devotional and Talismanic Functions of Early Modern Marian Reliefs." In *The Material Culture of Sex, Procreation, and Marriage in Premodern Europe,* edited by Anne L. McClanan and Karen Rosoff Encarnacíon. New York: 2002, 135–61.

Kasl, Rhonda. "Holy Households: Art and Devotion in Renaissance Venice." In *Giovanni Bellini and the Art of Devotion,* edited by Rhonda Kasl. Indianapolis: 2004, 59–89.

Kecks, Ronald G. *Madonna und Kind: Das häusliche Andachtsbild im Florenz des 15. Jahrhunderts.* Berlin: 1988.

Kent, Dale. *Cosimo De' Medici and the Florentine Renaissance: The Patron's Oeuvre.* New Haven: 2000.

Kent, Dale. "'The Lodging House of all Memories': An Accountant's House in Renaissance Florence." *Journal of the Society of Architectural Historians* 66(4) (2007): 451–60.

Kent, F.W. "Palaces, Politics and Society in Fifteenth-century Florence." *I Tatti Studies* 2 (1987): 41–70.

Klapisch-Zuber, Christiane. *Women, Family, and Ritual in Renaissance Italy,* translated by Lydia Cochraine. Chicago and London: 1985.

Kress, Susanne. "Die *camera di Lorenzo, bella* im Palazzo Tornabuoni: Rekonstruktion und künstlerische ausstattung eines Florentiner Hochzeitszimmers des späten Quattrocento." In *Domenico Ghirlandaio: Künstlerische Konstruktion von Identität im Florenz der Renaissance,* edited by Michael Rohlmann. Weimar: 2003, 245–85.

Lanteri, Giacomo. *Della economica.* Venice: 1560.

Latour, Bruno. *Reassembling the Social: An Introduction to Actor Network Theory.* Oxford: 2005.

Law, John E. and Lene Østermark-Johanse (eds), *Victorian and Edwardian Responses to the Italian Renaissance.* Burlington, VT: 2005.

Lenygon, Francis. "Gilt Leather Rooms." *The Art Journal* (September, 1911): 281–5.

Levi, Cesare Augusto. *Le collezioni veneziane d'arte e d'antichità dal secolo XIV ai nostri giorni.* Venice: 1900.

Lillie, Amanda. *Florentine Villas in the Fifteenth Century: An Architectural and Social History.* Cambridge: 2005.

Lindow, James R. "For Use and Display: Selected Furnishings and Domestic Goods in Fifteenth-Century Florentine Interiors." *Renaissance Studies* 19(5) (2005): 634–46.

Lindow, James R. *The Renaissance Palace in Florence: Magnificence and Splendour in Fifteenth-Century Italy.* Burlington, VT: 2007.

Luzio, Alessandro. "Federco Gonzaga ostaggio alle corte di Guilio II." *Archivio della R. societa Romana di storia patria* 9 (1886): 511–24.

Luzio, Alessandro. "Isabella d'Este e il sacco di Roma." *Archivio storico Lombardo* 4(10) (1908): 365.

Luzio, Alessandro. "Isabella d'Este e i Borgia." *Archivio Storico Lombardo* 5, 61, and 62 (1914–15): 469–753; 115–67; 412–564.

Lydecker, John Kent. "The Domestic Setting of the Arts in Renaissance Florence." Unpublished PhD dissertation, the Johns Hopkins University, 1987.

Malpas, J.E. *Place and Experience: A Philosophical Topography.* Cambridge and New York: 1999.

Malvasia, Carlo Cesare. *Felsina pittrice. Vite de' pittori bolognesi.* Bologna: 1678; edited by G. Zanotti. 2 vols. Bologna: 1841.

Manno, Antonio. *Arredi et armi di Sinibalda Fieschi da un inventario del 1532.* Genoa: 1876.

Mason, Stefania. "Di mano di questo maestro pochissime sono le cose che si vedono." In *Giorgione: "le maraviglie dell'arte,"* edited by Giovanna Nepi Scire and Sandra Rossi. Venice: 2003, 64–71.

Matchette, Ann. "Dismembering the Home in Renaissance Italy." In *Imagined Interiors: Representing the Domestic Interior Since the Renaissance,* edited by Jeremy Aynsley and Charlotte Grant. London: 2006, 48–9.

Matchette, Ann. "To Have and Have Not: The Disposal of Household Furnishings in Florence." *Renaissance Studies* 20(5) (2006): 701–16.

Matthews-Grieco, Sara F. "Models of Female Sanctity in Renaissance and Counter-Reformation Italy." In *Women and Faith: Catholic Religious Life in Italy from Late Antiquity to the Present,* edited by Lucetta Scaraffia and Gabriella Zarri. Cambridge, MA and London: 1999, 160–75.

Mattox, Philip. "Domestic Sacral Space in the Florentine Renaissance Palace." *Renaissance Studies* 20 (2006): 658–73.

McClanan, Anne L. and Karen Rosoff Encarnación (eds), *The Material Culture of Sex, Procreation, and Marriage in Premodern Europe.* New York: 2002.

McIver, Katherine. *Women, Art, and Architecture in Northern Italy 1520–1580.* Burlington, VT: 2006.

McKeon, Michael. *The Secret History of Domesticity: Public, Private, and the Division of Knowledge.* Baltimore: 2005.

Medlam, Sarah. "The Period Rooms." In *Creating the British Galleries at the V&A: A Study in Museology,* edited by Christopher Wilk and Nick Humphrey. London: 2004, 165–74.

Messisbugo, Cristoforo. *Banchetti composizioni di vivande e apparecchio generale,* edited by Fernando Bandini. Ferrara: 1549; reprint: Vicenza: 1992.

Michiel, Marcantonio. *Notizia d'opere del disegno,* edited by D. Jacopo Morelli Bassano: 1800.

Miller, Daniel and Christopher Tilley, "Editorial." *Journal of Material Culture* 1(1) (1996): 5–14.

Modesti, Adelina. *Elisabetta Sirani: Una virtuosa del Seicento bolognese.* Bologna: 2004.

Monnas, Lisa. *Merchants, Princes and Painters: Silk Fabrics in Italian and Northern Paintings 1300–1550.* New Haven: 2008.

Morse, Margaret. "Creating Sacred Space: The Religious Visual Culture of the Renaissance Venetian Casa." *Renaissance Studies* 21 (2007): 151–84.

Morselli, Raffaella. *Repertorio per lo studio del collezionismo del seicento.* Bologna: 1997.

Morselli, Raffaella. *Collezioni e quadrerie nella Bologna del seicento: Inventari 1640–1707.* Los Angeles: 1998.

Murphy, Caroline P. "Lavinia Fontana and *Le Dame della Città*: Understanding Female Artistic Patronage in Late Sixteenth-Century Bologna." *Renaissance Studies* 10(2) (1996): 190–208.

Murphy, Caroline P. "In Praise of the Ladies of Bologna: The Image and Identity of the Sixteenth-Century Bolognese Female Patriciate." *Renaissance Studies* 31(4) (1999): 440–54.

Murphy, Caroline P. *Lavinia Fontana: A Painter and Her Patrons in Sixteenth-Century Bologna.* Cambridge: 2003.

Musacchio, Jacqueline. *The Art and Ritual of Childbirth in Renaissance Italy.* New Haven: 1999.

Musacchio, Jacqueline Marie. *Art, Marriage, and Family in the Florentine Renaissance Palace.* New Haven: 2008.

Neher, Gabriele, and Rupert Shepherd (eds), *Revaluing Renaissance Art.* Aldershot: 2000.

Nickel, Helmut, Stuart W. Pyhrr, and Leonid Tarassuk. *The Art of Chivalry: European Arms and Armor from the Metropolitan Museum of Art.* New York: 1982.

North, Michael and David Ormrod (eds), *Art Markets in Europe, 1400–1800.* Brookfield, VT: 1998.

Nuttall, Paula. "Dancing, Love and the 'Beautiful Game': A New Interpretation of a Group of Fifteenth-Century 'Gaming' Boxes." *Renaissance Studies* 24(1) (2010): 119–41.

Orlin, Lena Cowen. "Fictions of the Early Modern English Probate Inventory." In *The Culture of Capital*, edited by Henry S. Turner. New York and London: 2002, 51–83.

Ostergard, Derek (ed.), *William Beckford 1760–1844: An Eye for the Magnificent.* New Haven: 2001.

Palladio, Andrea. *I quattro libri dell'architettura.* Venice: 1570.

Palmer, Richard. "'In this Our Lightey and Learned Time': Italian Baths in the Era of the Renaissance." *Medical History* 10 (1990): 14–22.

Palumbo-Fossati, Isabella. "L'interno della casa dell'artigiano e dell'arte nella Venezia del Cinquecento." *Studi Veneziani* 8 (1984): 109–53.

Palumbo-Fossati, Isabella. "La casa veneziana." In *Da Bellini a Veronese: temi di arte veneta*, edited by Gennaro Toscano and Francesco Valcanover. Venice: 2004, 443–92.

Palumbo-Fossati Casa, Isabella. *Intérieurs Vénitiens à la Renaissance.* Paris: Michel de Maule, 2012.

Panizza, Letizia (ed.), *Women in Italian Renaissance Culture and Society.* Oxford: 2000.

Paolozzi Strozzi, Beatrice and Marc Bormand (eds), *The Springtime of the Renaissance: Sculpture and the Arts in Florence 1400–60.* Florence: 2013.

Pavoni, Rosanna (ed.), *Reviving the Renaissance: The Use and Abuse of the Past in Nineteenth-Century Italian art and Decoration.* Cambridge: 1997.

Pavoni, Rosanna (ed.), *Arredi Lignei in Museo Bagatti-Valsecchi*, 2 vols. Milan: 2003.

Pearson, Andrea. *Envisioning Gender in Burgundian Devotional Art, 1350–1530: Experience, Authority, Resistance.* Aldershot: 2005.

Perry, Curtis (ed.), *Material Culture and Cultural Materialisms in the Middle Ages and the Renaissance.* Turnhout, Belgium: 2001.

Peruzzi, Piergiorgio. "Lavorare a Corte 'ordine et officij' Domestici, familiari, cortigiani e funzioni al servizio del Duca d'Urbino." In *Federico di Montefeltro: lo stato, le arti, la cultura*, edited by Giorgio Cerboni Baiardi, Giorgio Chittonni and Piero Floriani, 3 vols. Rome: 1986, I: 225–96.

Platina (Bartolomeo Sacchi). *On Right Pleasures and Good Eating*, edited by Mary Ella Milham. Tempe, AZ: 1998.

Pomian, Krzysztof. *Collectors and Curiosities: Paris and Venice, 1500–1800*, translated by Elizabeth Wiles-Portier. Oxford: 1990.

Pope-Hennessy, John and Keith Christiansen, "Secular Painting in 15th-Century Tuscany: Birth Trays, Cassone Panels, and Portraits." *Bulletin of the Metropolitan Museum of Art* 38(1) (1980): 4–64.

Portebois, Yannick and Nicholas Terpstra (eds), *The Renaissance in the Nineteenth Century.* Toronto: 2003.

Preyer, Brenda. "Planning for Visitors at Florentine Palaces." *Renaissance Studies* 12(3) (1998): 357–74.

Prizer, William F. "Games of Venus: Secular Vocal Music in the Late Quattrocento and Early Cinquecento." *Journal of Musicology* 9(1) (1991): 3–56.

Reiss, Cheryl E. and David Wilkins (eds), *Beyond Isabella: Secular Women Patrons of Art in Renaissance Italy*. Kirksville, MO: 2001.

Romano, Dennis. *Housecraft and Statecraft: Domestic Service in Renaissance Venice, 1400–1600*. Baltimore: 1996.

Rossetti, Giovanni Battista. *Dello Scalco*. Ferrara: 1584; reprint: Bologna: 1991.

Roversi, Giancarlo. *Palazzi e case nobili del '500 a Bologna: La storia, le famiglie, le opere d'arte*. Bologna: 1986.

Sarti, Raffaella. *Europe at Home: Family and Material Culture 1500–1800*, translated by Allan Cameron. New Haven: 2002.

Savini Branca, Simona. *Il collezionismo veneziano nel Seicento*. Padua: 1965.

Scalini, Mario. "The Weapons of Lorenzo de' Medici." *Art, Arms and Armour* 1 (1979): 12–20.

Scalini, Mario. *A Bon Droyt: Spade di uomini liberi, cavalieri e santi*. Milan: 2007.

Scappi, Bartolomeo. *The Opera of Bartolomeo Scappi (1570)*, translated by Terence Scully. Toronto, Buffalo, and London: 2008.

Schmitter, Monika. "The Dating of Marcantonio Michiel's Notizia in the Works of Art in Padua." *Burlington Magazine* 145(1205) (2003): 564–71.

Schmitter, Monika. "The Quadro da Portego in Sixteenth-Century Venetian Art." *Renaissance Quarterly* 64(3) (2011): 693–751.

Serlio, Sebastiano. *Architettura civile. Libro sesto, settimo e ottavo nel manoscritti di Monaco e Vienna*, edited by F.P. Fiore. Milan: 1994.

Spallanzani, Marco, and Giovanna Gaeta Bertelà. *Libro d'inventario dei beni di Lorenzo il Magnifico*. Florence: 1992.

Strozzi, Alessandra. *Lettere di una gentildonna fiorentina del secolo XVI ai figliuoli esuli*, edited by Cesare Guasti. Florence: 1877.

Syson, Luke. "Holes and Loops: The Display and Collection of Medals in Renaissance Italy." *Journal of Design History* 15(4) (2002): 229–44.

Syson, Luke and Dora Thornton. *Objects of Virtue: Art in Renaissance Italy*. London: 2001.

Taylor, Valerie. "Banqueting Plate and Renaissance Culture: A Day in the Life." *Renaissance Studies* 19(5) (2005): 621–33.

Thornton, Dora. *The Scholar in his Study: Ownership and Experience in Renaissance Italy*. New Haven: 1997.

Thornton, Peter. *The Italian Renaissance Interior, 1400–1600*. New York: 1991.

Tönnesmann, Andreas. "Le palais ducal d'Urbino: humanisme et réalité sociale." In *Architecture et vie Sociale*, edited by Jean Guillaume. Paris: 1994, 137–53.

Trexler, Richard. *Dependence in Context in Renaissance Florence*. Binghamton, NY: 1994.

Tuohy, Thomas. *Herculean Ferrara: Ercole d'Este (1471–1505) and the Invention of a Ducal Capital*. Cambridge: 1996.

Vasari, Giorgio. *Le vite de' più eccellenti architetti, pittori, et scultori italiani*, edited by Luciano Bellosi and Aldo Rossi. Turin: 1986.

Voaden, Rosalynn and Diane Wolfthal (eds), *Framing the Family: Narrative and Representation in the Medieval and Early Modern Periods*. Tempe, AZ: 2005.

Waddy, Patricia. *Seventeenth-Century Roman Palaces: Uses and the Art of the Plan*. Cambridge, MA: 1990.

Wainwright, Clive. *The Romantic Interior*. New Haven: 1989.

Wall, Thomas. *The Voyage of Nicholas Carewe to the Emperor Charles V in the Year 1529*, edited by R.J. Knecht. Cambridge, MA: 1959.

Wallace, William E. "The Bentivoglio Palace: Lost and Reconstructed." *Sixteenth Century Journal* 10 (1979): 97–113.

Waterer, John W. *Spanish Leather*. London: 1971.

Weddle, Saundra. "Women's Place in the Family and the Convent: A Reconsideration of Public and Private in Renaissance Florence." *Journal of Architectural Education* 55(2) (2001): 64–72.

Wegner, Susan. *Beauty and Duty: The Art & Business of Renaissance Marriage*. Brunswick, ME: 2008.

Weil-Garris, Kathleen and John F. D'Amico. "The Renaissance Cardinal's Ideal Palace: A Chapter from Cortesi's 'De Cardinalatu'." *Memoirs of the American Academy in Rome* 35 (1980): 45–119, 121–3.

Welch, Evelyn. *Art and Authority in Renaissance Milan*. New Haven: 1996.

Westermann, Mariët ed. *Anthropologies of Art*. New Haven: 2005.

Williams, Allyson Burgess. "*Le donne, i cavalier, l'arme, gli amori*: Artistic Patronage at the Court of Alfonso I d'Este, Duke of Ferrara." Unpublished PhD dissertation, University of California, Los Angeles, 2005.

Wilson, Bronwen and Paul Yachnin (eds), *Making Publics in Early Modern Europe: People, Things, Forms of Knowledge*. New York and London: 2010.

Woodward, Ian. *Understanding Material Culture*. Los Angeles: 2007.

Zorzi, Marino. *Collezioni di antichità a Venezia nei secoli della Repubblica (dai libri e documenti della Biblioteca Marciana)*. With essay by Irene Favaretto. Rome: 1988.

Zucchetta, Emanuela. *Antichi ridotti: Arte e società dal cinquecento al settecento*. Rome: 1988.

Index

Page numbers in **bold** type refer to figures in the text.